PERFORMING LIVE

Richard Shusterman is author of
The Object of Literary Criticism
T. S. Eliot and the Philosophy of Criticism
Pragmatist Aesthetics: Living Beauty, Rethinking Art
Practicing Philosophy: Pragmatism and the Philosophical Life

and editor of
Analytic Aesthetics
Bourdieu: A Critical Reader
The Interpretive Turn (with James Bohman and David Hiley)
Interpretation, Relativism, and the Metaphysics of Culture
(with Michael Krausz)

Richard Shusterman

performing live

AESTHETIC ALTERNATIVES FOR THE ENDS OF ART

live

Cornell University Press

ITHACA AND LONDON

First published 2000 by Cornell University Press
First printing, Cornell Paperbacks, 2000

Printed in the United States of America

Library of Congress Cataloging-in-Publication Data

Shusterman, Richard.
 Performing live : aesthetic alternatives for the ends of art / Richard Shusterman.
 p. cm.
 Includes bibliographical references and index.
 ISBN 0-8014-3753-9 (alk. paper)—ISBN 0-8014-8650-5 (pbk. : alk. paper)
 1. Aesthetics. 2. Popular culture. 3. Body, Human. 4. Conduct of life. I. Title.
 BH39 .S5255 2000
 111'.85—dc21

 00-009764

Cornell University Press strives to use environmentally responsible suppliers and materials to the fullest extent possible in the publishing of its books. Such materials include vegetable-based, low-VOC inks and acid-free papers that are recycled, totally chlorine-free, or partly composed of nonwood fibers. Books that bear the logo of the FSC (Forest Stewardship Council) use paper taken from forests that have been inspected and certified as meeting the highest standards for environmental and social responsibility. For further information, visit our website at www.cornellpress.cornell.edu.

Cloth printing 10 9 8 7 6 5 4 3 2 1
Paperback printing 10 9 8 7 6 5 4 3 2 1

For Hans-Peter Krüger

contents

preface

This book advocates the value of aesthetic experience by exploring its different roles, methods, and meanings, especially in areas that were marginal to traditional aesthetics but that now seem most vibrantly alive in today's culture of democracy. These include the mass media arts of popular music and film, but also the somatic arts of self-improvement and the wider arts of self-stylization to which they belong. All these lively arts seem deeply integrated in our pursuit of what the ancients held to be the greatest art of all: the art of living. This art, of course, requires live performance from each of us, even when we prefer to contemplate the performances (live or recorded) of others.

If performing live is unavoidable, so, it seems, is an occasional sense of performance anxiety. Presenting a new book can be such an occasion, but the performance anxieties of *Performing Live* have a longer history. The chapters of this book reflect the original sense in which Montaigne coined the modern essay genre. They are assays—trials or tests of my own judgment and experience against conventional wisdom and the reasoned opinions of other theorists. These essays reflect my pragmatist commitment to experience as both topic and method of inquiry: experience, for me, bears not only the sense of personal observation or encounter but the sense of personal trial or experiment, as in the French word *expérience* or the original Latin *experientia*. The book's essays therefore involve some self-exposure, even when their aim is to explore very different topics than myself. One more reason for anxiety.

All these essays had their origins in lectures I was invited to perform for very different publics, not always within the protected walls of academe, and often in foreign lands and foreign languages that I am still struggling to navigate. The criticism gleaned from these experiences generated progressive revisions, and those essays that were later published profited from still more criticism, which informs their further revision here. At one stage or another, almost all the essays benefited from translation, and several of the translations preceded the English publication.

I find such prior translation particularly useful in two ways. First, its distance from my home field of Anglo-American philosophy allows

more freedom for riskier experimentation, since one's foreign language publications are fairly sure to escape the notice (and censure) of the English-speaking world. As any good body therapist knows, there is typically far more flexibility and liberty in one's distal areas than one's proximal ones. Second, translation into a foreign language helps expose unnoticed ambiguities and helps test whether one's argument is conceptually sound or whether it simply relies on the rhetorical seductions and linguistic illusions of one's own language. In thanking the various institutions and individuals who helped to stage and refine the philosophical performances that constitute this book, I want to single out those translators whose frequent questions about my exact meaning often produced much better formulations: Fuminori Akiba, Adam Chmielewski, Gisela Domschke, Catherine Durand, Christian Fournier, Barbara Reiter, and especially Heidi Salaverria (who translated three of these essays into German).

Most of the essays were written while on study leaves from Temple University. I am also grateful for Senior NEH and Fulbright Fellowships that allowed me enough time in France and Germany to reach a certain fluency in their philosophically rich tongues. Several of the essays were tested in my seminars on "Aesthetics and Modernity" that were given at the Collège International de Philosophie in Paris between 1995 and 1999. Versions of the essays were also presented at the following institutions: the Academy of Fine Arts in Vienna, the Pompidou Center in Paris, the Academy of Graz, Brecht Haus in East Berlin, the Hannover Museum of Art, the Montreal Cinémathèque, Tokyo's Ecole des Hautes Etudes en Sciences Culturelles, the Slovenia Academy of Science, Freie Universität and Humboldt Universität in Berlin, and the universities of Berne, Erlangen, Gdansk, Hamburg, Helsinki, Kyoto, Magdeburg, Montpellier, Munich, New Mexico, Rio de Janeiro, Penn State, Seoul, Stockholm, Uppsala, Tübingen, Virginia, and Wroclaw.

I thank Lars-Olof Åhlberg, Marianne Alphant, Jean-Marie Brohm, Vincent Colapietro, Reed Way Dasenbrock, Christian Delacampagne, Roger-Pol Droit, Bohdan Dziemidok, Ales Erjavec, Winfried Fluck, Astrid Franke, Russell Goodman, Arto Haapala, Rudolph Haller, Eva Ignaczak, Tsenumichi Kambayashi, Jinyup Kim, Leszek Koczanovicz, Karlheinz Ludeking, Christoph Menke, Herta and Ludwig Nagl, Andrzej Orzechowski, Heinz Paetzold, Chantal Pontbriand, Jacques Poulain, Richard Rorty, Kenichi Sasaki, Goran Sorbom, Daniel Soutif, John Stuhr, Wolfgang Welsch, Tetsuji Yamamoto, and others too numerous

to mention for making these events not only possible but pleasurable. I especially want to thank Jean-Pierre Cometti, who not only invited me to give a paper on "The End of Aesthetic Experience" at the Chateau of Cerisy-la-Salle in the magically romantic hills of Normandy, but also greatly improved the French translation of that text (and several others in this book) through his expert knowledge of pragmatism and analytic aesthetics.

Closer to home, I am grateful to Princeton University for inviting me to give the 1996–1997 Eberhard L. Faber Class of 1915 Memorial Lectures. I thank Thomas Pavel, then of Princeton's Comparative Literature Department, for extending the invitation, and also Alexander Nehamas for providing a very challenging critical response to my lecture on aesthetic experience. Several essays profited from the critical sensibility of James Miller, with whom I have enjoyed working at the New School for Social Research. Michael Scoville and Josh Michael Hayes, my research assistants at the New School, helped with a variety of tasks in preparing the manuscript. Special thanks go to Carolyn Korsmeyer, who (I later learned) read preliminary versions of all the essays for Cornell University Press and made some very useful suggestions. I am also especially indebted to Cornell's editor Roger Haydon, whose winning combination of enthusiasm, insight, and professionalism pushed the book happily toward improvement and completion.

This book's essays in somatic philosophy would never have been written without the impetus of my personal experience in the body disciplines I here discuss. Performing them live, I discovered, can be far more difficult than talking, reading, or even writing about them. As an academic philosopher accustomed to the ease of words and the comfort of books, my more physical assays of somatic exploration were often awkward and embarrassing, sometimes deeply disturbing, or even painful. But they were most of all instructive and, on occasion, blissfully transformational. In acknowledging my many teachers for their encouragement and patience, I want to single out three who have been especially helpful: George Downing, a long-time friend and all-around master of somatic theory and practice, and two of my Feldenkrais trainers, Yvan Joly and Robbie Ofir.

In retrospect, the hardest part of writing this book was my difficult adjustment to life in Berlin, far from the figure of loveliness who remains the epicenter of my affection. Luckily, a sensitive philosopher perceived my distress and sustained my spirits through the harsh, cold,

lingering darkness of that lonely time; he taught me East from West and made the city shine with the glow of friendship. Berlin became a home away from home. I dedicate this book to him.

Six of the essays in this book were published in earlier (sometimes very different) versions. I list only English publications, but bibliographical data on translations can be found on my webpage (www.temple.edu/ aesthetics): "The End of Aesthetic Experience," *The Journal of Aesthetics and Art Criticism* 55 (1997): 29–41; "Don't Believe the Hype," *Poetics Today* 14 (1993): 101–122; "The Fine Art of Rap," *New Literary History* 22 (1991): 613–632; "Moving Truth: Affect and Authenticity in Country Musicals," *Journal of Aesthetics and Art Criticism* 57 (1999): 221–233; "The Urban Aesthetics of Absence," *New Literary History* 28 (1997): 739–755; "Somaesthetics and the Body/Media Issue," *Body and Society* 3 (1997): 33–49. I am grateful for permission to revise these articles but also for the earlier helpful suggestions of the journals' editors: Philip Alperson, Ralph Cohen, Mike Featherstone, Meir Sternberg, and Brian McHale. A version of "Beneath Interpretation" initially appeared in *The Interpretive Turn*, which I coedited (with David Hiley and James Bohman) for Cornell University Press in 1991.

Richard Shusterman

PERFORMING LIVE

aesthetic renewal for the ends of art

AN OVERTURE

> The end is where we start from.
>
> T. S. ELIOT

I

At the start of a new millennium, aesthetics remains sadly dominated
by visions of the end, theories that take art's current crisis of credibility
not as a transitory slump or transition but as the necessary, permanent
result of deep principles governing our culture. The theories of art's
end date back at least to Hegel, who, already in the nineteenth century,
famously argued that art had reached a developmental terminus. As a
formative stage in the evolution of Spirit, art logically had to develop
toward (and eventually yield to) higher stages of spiritual expression that
are less bound by material embodiment. Art, for Hegel, ended its role
as spiritual trailblazer by leading into the more transcendent realm of
Christian religion and ultimately into idealist philosophy, the pinnacle of
spiritual progress. Since "art no longer affords that satisfaction of spiri-
tual wants" that once made it a formative force, Hegel brands it "a thing
of the past," even if it still dimly lingers in the present.[1]

The subsequent burst of nineteenth-century progress in art and natu-
ral science made Hegel's story less compelling. As science increasingly
shook religious conviction, so the spirit of philosophy seemed sadly
weighed down by the mustiness of academic pedantry. Art survived
into the twentieth century as the most attractively embodied, creatively
free, and progressively original expression of Spirit. It became the prime
focus for spiritual transcendence in an increasingly mechanical world, a
more convincing secular substitute for discredited religious faith, spirit-
less scientific materialism, and lifeless philosophical abstraction. But
in the 1930s, narratives of art's end began to resurface among post-
Hegelian philosophers, taking rather different forms and deploying a
variety of arguments.

Walter Benjamin formulates two of these eschatological narratives.[2]
Originating in the power of magic and cultic ritual, art long maintained
a compelling aura through the authoritative uniqueness of its works,
which betokened the original inimitable touch of authentic genius, a

force that seemed of transcendental, distantly divine origins. But the new media of mechanical reproduction destroyed this sense of almost magical uniqueness, thus generating the progressive "decay of the aura" of art. With the growing exploitation of reproducible artistic images for tawdry commercial gain and unsavory political agendas, art as a sublime realm of value seemed to reach an end.

Benjamin plots his second narrative of end not on the gradual loss of art's aura but on the loss of the special sort of coherent, enduring, slowly savored, and deeply felt experience that made art so profoundly satisfying and significant. Here art's traditional power and role are ended not so much by the specific reproducibility of artistic images but by the general overflow of unrelated information that fragments our sense of well-ordered experience into a pressured jumble of rapid-fire sensations and conglomerated items. Symbolized, for Benjamin, by the gradual end of the storyteller's art and its replacement by the labyrinth of juxtaposed news reports in the daily paper, this disintegration of experience into information spells the end of the traditional aesthetic experience that long defined art.

Building on these insights, recent thinkers have added new variations to the story of art's end. Gianni Vattimo sees "the death of art" and its loss of aura as part of the general weakening of transcendental values through "the end of metaphysics." But this decline, he adds, is aggravated by a corresponding loss of art's autonomy as a special domain. Through its exploitation in the everyday practical world, art evaporates into "a general aestheticization of existence," disintegrating "into a world of hybrid artistic products." Weaving yet a third strand into the tale of art's end, Vattimo notes how the twentieth-century avant-garde undermined not only art's claim to privileged autonomy but the legitimacy of the traditional pleasures of aesthetic experience.

In Arthur Danto, the end of art even finds an analytic philosopher as storyteller. If Hegel argued that art, as representative of a certain stage of Spirit's evolution, logically must develop toward and yield to the higher stages of religion and philosophy, Danto elaborates that art has indeed already evolved into its own philosophy. It has made its central concern not aesthetic but philosophical, by focusing on the crucial question of what makes an object art and why. Art has turned to this philosophical end, Danto argues, because it lost its traditional option of developmental progress that the goal of *mimesis* had, for centuries,

supplied. The new mechanical media of image reproduction meant the loss of a clear visual mimetic criterion for structuring art's progress. And art's subsequent failure to find a clear sense of progress either in terms of expression or in terms of further philosophical advancement has left art with no real notion or direction of progress at all. But without such a notion we can no longer speak meaningfully of art's continuing development toward its envisioned goal. Hence we must regard art as having reached an end, though one that does not entail its disappearance.

Performing Live will engage these different stories. But I want to begin by sketching yet another philosophical argument for the end of art. Not because it convinces me any more than the others, but because it most sharply poses the polemical background for the prime purpose of this book—to seek the seeds of aesthetic renewal among the debris of art's alleged terminal exhaustion. This new argument, then, links art's end (and its beginning) to modernity's.

Art, it claims, is neither a natural nor a universal phenomenon, but instead a particular sociohistorical institution. Although activities of painting, sculpture, poetry, music, and drama thrived in ancient Greek and Roman (and non-Western) cultures, the concept of art that informs both our thought and our aesthetic experience is in fact only a modern product. First forged in the eighteenth century, our concept of art as essentially *fine art* grew stronger with the continuing project of modernity in the nineteenth and twentieth centuries, fostered by the general modernizing trend toward specialist development through compartmentalized autonomy that Max Weber so convincingly described. Art here becomes a specialized autonomous cultural field or institution, with its own specific aims, experts, and logic.

The argument for art's end then invokes the recent shift toward postmodernity. If we have made the postmodern turn, as the challenging of modernist notions of art's autonomy and progress would suggest, and if art is essentially a historical product of modernity, then art should reach its end with the end of modernity, since modernity constitutes its generative base and structure. The pangs and throes of this end are witnessed in the series of convulsive crises that mark art's recent history and in its increasing loss of power, faith, and direction.

This argument is especially troubling, because it suggests a parallel end for the whole aesthetic domain. Philosophers as different as Jürgen

Habermas and Richard Wollheim claim that aesthetic experience, like art itself, is simply a concept created by modernity, and could never be realized before or outside its institutions of art.[3] First coined by Alexander Baumgarten in the mid-eighteenth century, the concept of "aesthetic" was refined and definitively established through the work of Kant and later German idealists to express the idea of an autonomous realm of disinterested appreciation of form (most notably the sensuous form in which ideal contents are represented). But if postmodernity subverts the modern ideology of autonomy, disinterestedness, and formalism on which aesthetics was established, it then spells the end for the entire aesthetic dimension, not just for art.

This argument must be resisted. The end of a particular and particularly constrictive (though productive) concept of art should not mean the end of art *tout court* and certainly not the end of aesthetic experience. Accepting this argument denies perhaps the most promising option for revitalizing art in postmodern conditions: to recall wider notions of aesthetic experience and value so as to renew art's energies and find new directions for progress beyond the traditional modern confines of compartmentalized fine art.

In *Pragmatist Aesthetics*, I first sketched this strategy of aesthetic renewal, and the following essays reformulate essential moments of that project. But they take it further by exploring its application to a wider range of aesthetic issues and new artistic genres: from affect and authenticity to genius and style, from techno clubs and country musicals to somaesthetics and cyberspace.

When *Pragmatist Aesthetics* challenged the presumption that modernity's compartmentalizing vision is the only way to see art, it affirmed that aesthetic experience could exist before and beyond the modern mind. I was therefore charged with promoting a historically blind and naively essentialistic naturalism (even though I chided Dewey for courting precisely these faults). Rather than refuting this charge by showing the anti-essentialism of that book, I prefer to begin this new volume with a chapter that demonstrates the historicist perspective of my pragmatism, an analysis of aesthetic experience that highlights the history of the concept's development and misuse in order to understand its present crisis and redeem its value. Does this appreciation of historical context mean a rejection of the natural roots of aesthetic experience that Dewey taught me to appreciate? Not at all, unless one is a prisoner of

the dualistic mind that mistakes distinctions for dichotomies. For pragmatism, which sees the world as a complex mix of many mixed things, the burden of proof lies on those who presume that natural roots and historical construction are incompatible.[4]

But since naturalism and historicism constitute perhaps the most potent general orientations that dominate and polarize contemporary aesthetics, let me take a moment to probe their apparent conflict. Naturalism defines art as something deeply rooted in human nature which finds expression in every culture, primitive as well as advanced. Here art is seen as arising from natural human needs and drives: a natural desire for balance, form, or meaningful expression, a thirst for a kind of enhanced, aesthetic experience that gives the live creature not only pleasure but a more vivid, heightened sense of living. According to this conception, art is not only deeply grounded in the natural but also instrumental in the survival and development of human nature.[5]

Evolutionists recognize that, by and large, the things that naturally give us pleasure are good for the survival and growth of the species, since we have survived and evolved not by conscious planning but by making the choices that natural pleasures have unreflectively drawn us to. The intense pleasure of sex, for example, impels us toward procreation for the survival of the species, even if it is not in the individual's rational best interest to take the risks involved in such dangerously close encounters. Art's beauty and pleasures, it can be argued, have evolutionary value, not only for sharpening our perception, manual skill, and sense of structure, but for creating meaningful images that help bind separate individuals into an organic community by their shared appreciation of symbolic forms. Finally, art's pleasures by their very pleasure have evolutionary value in that they make life seem worth living, which is the best guarantee that we will do our best to survive. The long survival of art, its passionate pursuit despite poverty and oppression, and its cross-cultural presence can all be explained by such naturalistic roots.

In contrast, historicism defines our concept of art more narrowly as a particular historical cultural institution produced by the Western project of modernity. Partisans of this view construe earlier and non-European artistic forms not as art proper but as objects of craft, ritual, and tradition that at best are precursors of autonomous art. The historicists point to the fact that our current concepts of fine art and aesthetic experience did not really begin to take definite shape until the eigh-

teenth century and achieved their present "autonomous" form only through social developments of the nineteenth century that culminated in the notion of "art for art's sake."

Twentieth-century art, the argument continues, has taken this autonomy and made art not only its own purpose but its own subject. As art is thought to be the product of its sociohistorical differentiation from real-world contexts, so art's meaning and value are seen as constituted simply by the social, institutional setting which distinguishes art from the rest of life. It is, of course, the sociohistorical institutional setting which makes a ready-made art and distinguishes it from its ordinary nonartistic counterpart. Museums, galleries, and other art institutions do not simply display art, they help create the social space without which art cannot even be properly constituted as such. And its constitution depends not at all on beauty, satisfying form, or pleasurable aesthetic experience, which contemporary art has shown to be inessential, if not altogether *dépassé*.

How should we choose between naturalism and historicism? It seems folly to simply choose one of these polarized views, since each has severe limitations. If the naturalistic view does not sufficiently account for the social institutions and historical conventions that structure art's practice and govern its reception, the sociohistorical view cannot adequately explain the ends for which art practices and institutions were developed, what human goods they are meant to serve, and why non-Western, nonmodern cultures also pursue what seem to be artistic practices. To define art simply as the product of modernity puts in question the deep historical continuities that constitute the tradition of Western art from Greek and Roman times through medieval and Renaissance art and into the modern period where art is said to originate.

Another reason why we should not simply choose between aesthetic naturalism and historicist conventionalism, between lived experience and social institutions, is that these notions are as much interdependent as they are opposed. Our very notion of a natural language, which is nonetheless constituted by social conventions and history, shows the folly of the natural/sociohistorical dichotomy. Natural life without history is meaningless, just as history without life is impossible.

If there is no escaping art's history, there is at least the possibility of recognizing that it extends back to premodern times and is currently open to postmodern historical transformations. The recent flourishing of alternative aesthetic forms outside the sacralized modernist realm of

fine art provides a good argument for the persistent presence of an artistic impulse beyond the confines of modernity's compartmentalizing ideology. Since the power of these alternatives seems to wax with the waning of art's modernist paradigm, one could venture that the end of modernity's artistic monopoly augurs some vibrant new beginnings for different forms of art. The two most prominent sites for today's aesthetic alternatives are clearly the mass-media popular arts and the complex cluster of disciplines devoted to bodily beauty and the art of living as expressed in today's preoccupation with aesthetic lifestyles. Common to these two cultural domains is a concern for performance. But they also share a deep recognition of the value and pleasures of aesthetic experience, our need for beauty and intensified feeling, and the integration of such enriching experience into our everyday living.

II

The essays of Parts I and II explore the aesthetics of these two alternative artistic fields. I begin, however, with the core concept of aesthetic experience. Tracing its uses and increasing abuses by theorists in both continental and Anglo-American philosophy, I probe its differing conceptions, its links to pleasure and cognition, and the growing threats to its survival. More perilous to aesthetic experience than the critique of philosophers is its rejection by a puritanically intellectualist artworld that falsely spurns feeling as a foe of understanding. Still more threatening are the corrosive effects of an increasingly frenetic, fragmented, and insensitive lifeworld, which all the more underscores the need for the healing unity and affect of aesthetic experience, even as it frustrates its achievement by eroding our capacities of feeling.

If popular art is popular not only because of commercial marketing but partly because it still seeks (and frequently provides) enjoyable aesthetic experience, it remains, on the whole, very unpopular with philosophers of art, who often assert its intrinsic worthlessness. The next three chapters of this book provide an aesthetic defense of popular art in terms of a critical meliorism that recognizes the current defects and limitations of this art but also its success and potential. I start (in Chapter 2, "Don't Believe the Hype") by challenging the major arguments advanced against the very possibility of popular art's value, the alleged "theoretical reasons why [it] is not and can never be any good."[6] These include allegations of its spurious satisfactions, its corruptive passivity, its mindless shallowness, its lack of creativity, autonomy, and form.

But popular art cannot be properly defended without demonstrating the actual artistry of its specific genres and particular works; so in Chapters 3 and 4 I examine two of today's most popular and distinctive musical genres: rap and country. "The Fine Art of Rap" was written when rap was still young and vulnerably uncertain of long-term survival. Since then, much has changed on the rap scene (mostly, to my mind, for the worse); but the basic aesthetic principles of hip hop still endure and remain potent. Part of rap's shocking aesthetic power derives from its embodying a challenge to modernity's aesthetics of disinterested distance and form, of pure unity and originality, of the clear separation of art from politics and everyday life. Though my treatment of rap has been expanded and updated in later writings, this first essay provoked the sharpest critical attention and still provides the best brief introduction to my aesthetic appreciation of the genre. In reprinting it here, I have added references to some of the later discussion it generated.

Two thinkers I much admire, Richard Rorty and Pierre Bourdieu, criticized my choice of rap to defend popular art because they thought that rap's conscious posture of difference and defiant resistance to official mainstream culture too easily aligned it with the avant-garde tradition of high art. Rather than merely defending my choice by stressing the tradition of popular cultural resistance (as outlined by the likes of Bakhtin and Gramsci), I took on the challenge of making an aesthetic case for a popular music that intellectuals seem to scorn even more than rap. In showing how country music succeeds through strategies of affect and archetypal themes that give it an air of authenticity despite its slickly commercialized production, Chapter 4 also explores how this logic of affect and authenticity is displayed in the new film genre that this music has generated—the country musical. For all their obvious differences, both rap and country appeal through deeply embodied and unashamed expression of strong feeling. This aesthetic not only generates their distinctive dance cultures but finds expression in their artful lifestyles, replete with special modes of fashion, grooming, and behavior, along with characteristic idioms of posture, movement, and speech. The human drive for artistic self-fashioning through aesthetic experience remains irrepressible, even if displaced from the traditional frame of institutional fine art and threatened by the withering whirl and grind of postmodern life.

Turning from rap and country, Chapter 5 opens with a noisy night of techno music in East Berlin in order to explore its theme of city life as

an alternative site for popular aesthetic experience. With its integration of rich variety into the unity of a single *polis*, the city has always promoted aesthetic experience by fostering the creation of great artworks and often constituting in itself an aesthetic masterpiece that all its citizens could in some way enjoy. Aesthetic appeal looms as the prime factor in the ever growing popularity of cities, despite the problems of overcrowding that make city life so unbearably expensive and exhausting, and despite the new telecommunications media that make such urban concentration no longer essential for business. Yet precisely this dense abundance and frenetic intensity of urban life paradoxically threatens our achievement of aesthetic experience by wearing away our capacities for feeling.

Exploring this dialectic in which aesthetic profusion generates a form of anaesthesia, Chapter 5 makes a case for the use of absence as a principle of urban aesthetics. Drawing on my own experience of city life, but critically engaging the urban theories of Lewis Mumford, Walter Benjamin, and Georg Simmel (who strikingly defined city life by its unfeeling attitude), I try to show the value of the void as a necessary ground and means for aesthetic fullness, visible even in the self-fashioning efforts of the modern *flanêur*.

The chapters of Part II continue this turn from the popular arts of music to what many regard as the highest art of all, the art of living. To make one's life a work of art surely demands the complex skills of self-interpretation, but I begin in Chapter 6 by insisting on the important *uninterpreted* dimension of life and art, a dimension not only profoundly neglected but explicitly rejected by most current analytic and continental philosophy in making the renowned "linguistic turn." While deeply devoted to the crucial role and multiple logics of interpretation, my pragmatism expresses that commitment partly by critical exploration of interpretation's limits in the noninterpretive experiences that provide interpretation both a formative, orienting ground and a defining contrast. Without something beneath or beyond interpretation, this powerful concept degenerates into a uselessly bloated abstraction that, by including everything, means virtually nothing.

Though the human body is surely shaped to some extent by linguistic and interpretive practices, it has often been identified as the site of more immediate, uninterpreted experience. When philosophy is so thoroughly conceived as the study of reality through language, the body's nonlinguistic experience tends to be ignored, when not derisively de-

nied. Thus even today's philosophers who advocate their profession as an art of living limit its scope to the textual arts of reading, writing, and propositional argumentation. When my *Practicing Philosophy* urged a more robustly embodied aesthetics of philosophical life, I provoked not only critique but ridicule.[7]

Chapters 7 and 8 are therefore devoted to clarifying my theory of somaesthetics and challenging the pervasive premise that reading and writing exhaust the bodily practice of philosophy. Modern philosophy's traditional somatic neglect is heightened by the growing cyberspace fantasy that the body can be so thoroughly mediatized that our nontextual, undigitalized bodies of experience—flesh, blood, bones, nerves, and hormones—will soon be rendered altogether unnecessary. If the new media are achieving the old philosophical dream of freeing us from the body, why are people today increasingly preoccupied with somatic form and fitness? And why should philosophy per se concern itself with cultivation of the body?

Chapter 7 shows how the disciplines of somaesthetics serve the most central aims of philosophy, and then goes on to argue for the body's indispensable role as the *ur*-medium and instrument of human existence, a view which could account for the waxing of interest in body care in a culture so deeply influenced by media technology. Chapter 8 continues my explanation of the reasons for today's increasing preoccupation with somatic care and provides a more detailed study of three major psychosomatic disciplines (Alexander Technique, Reichian bioenergetics, and Feldenkrais Method) to see how they might be incorporated into philosophy as a reflective, robustly embodied art of living.

Life poses an artistic project in calling for creative self-expression and aesthetic self-fashioning—the desire to make ourselves into something fulfilling, interesting, attractive, admirable, yet somehow true to what we are. The selves we both inherit and create are not merely embodied but also inescapably cultural. Today's passion for multicultural identity politics reflects the need to have one's specific ethnic heritage respected so that self-expression through its particular cultural resources can be appreciated for its distinct value. On the other hand, affirming one's culture by stressing its radical difference could promote cultural divisiveness more than shared multicultural understanding. Chapter 9 probes the puzzling ambiguities and dialectics of multiculturalism while developing an aesthetic option of multicultural self-creation through exploration and acceptance of the culturally other.

More than the affirmation of a group identity, the art of creative self-fashioning calls for the achievement and expression of the individual's own style. What, then, constitutes individual style, and how extraordinary or radically original must it be to constitute authentic, aesthetic self-expression? Achieving an original style is often seen as the special privilege of transcendent genius. But can genius be construed in less restrictive but still laudatory terms, so that more individuals could rightly see themselves as the artists of their lives? Such questions form the crux of the book's final chapter. If the modern institution of sacralized, autonomous art has reached some kind of end, today's aesthetic energies seem powerfully refocused on the art of living. In our new age of multiple, marketed lifestyles that sadly seem to foster as much conformism as creativity, the concept of individual style needs more attention.

To close with a critically self-reflective turn that is typical to philosophy, we could question the style of this very book. Do its diverse texts manifest an individual style, or at least a reasonably consistent one? The writing of these essays span a period of almost ten years. Some are brand new, but most are based on previously published articles, though often here significantly revised. Given this style of compilation, I might be taken for a shameless "mix-master" of philosophy who spent too much time with rap's recycling aesthetic of scratch mixing. My best defense should be the quality of the mix that the book in fact brings together, and that the reader must judge for herself.

PART I
AESTHETIC EXPERIENCE AND POPULAR ART

the end of aesthetic experience

The end crowns all.

SHAKESPEARE

I

Experience, quipped Oscar Wilde, is the name one gives to one's mistakes. Does aesthetic experience then name the central blunder of modern aesthetics? Though long considered the most essential of aesthetic concepts, as including but also surpassing the realm of art, aesthetic experience has in the last half-century come under increasing critique. Not only its value but its very existence has been questioned. How has this once vital concept lost its appeal? Does it still offer anything of value? The ambiguous title "the end of aesthetic experience" suggests my two goals: a reasoned account of its demise and an argument for reconceiving and thus redeeming its purpose.[1]

Though briefly noting the continental critique of this concept, I shall mostly focus on its progressive decline in twentieth-century Anglo-American philosophy. Not only because here its descent is most extreme, but because it is in this tradition—that of John Dewey, Monroe Beardsley, Nelson Goodman, and Arthur Danto—that I situate my own aesthetic work.[2] While Dewey celebrated aesthetic experience, making it the very center of his philosophy of art, Danto virtually shuns the concept, warning (after Duchamp) that "aesthetic delectation is a danger to be avoided."[3] The decline of aesthetic experience from Dewey to Danto reflects, I shall argue, deep confusion about this concept's diverse forms and theoretical functions. But it also reflects a growing preoccupation with the *anaesthetic* thrust of this century's artistic avant-garde, itself symptomatic of much larger transformations in our basic sensibility as we move increasingly from an experiential to an informational culture.

To appreciate the decline of the concept of aesthetic experience, we must first recall its prime importance. Some see it as playing a major role, *avant la lettre* and in diverse guises, in premodern aesthetics (e.g., in Plato's, Aristotle's, and Aquinas's accounts of the experience of beauty, and in Alberti's and Gravina's concepts of *lentezza* and *delirio*).[4] But there can be no doubt that its dominance was established in moder-

nity, when the term "aesthetic" was officially established. Once modern science and philosophy had destroyed the classical, medieval, and Renaissance faith that properties like beauty were objective features of the world, modern aesthetics turned to subjective experience to explain and ground them. Even when seeking an intersubjective consensus or standard that would do the critical job of realist objectivism, philosophy typically identified the aesthetic not only *through* but also *with* subjective experience.

"Beauty," said Hume in arguing for a standard of taste, "is no quality in things themselves; it exists merely in the mind which contemplates them," though some minds are, of course, more judicious and authoritative than others. Kant explicitly identified the subject's experience "of pleasure or displeasure" as "the determining ground" of aesthetic judgment.[5] The notion of aesthetic experience moreover helped provide an umbrella concept for diverse qualities that were distinguished from beauty but still closely related to taste and art: concepts like the sublime and the picturesque.

In the nineteenth and early twentieth centuries, aesthetic experience gained still greater importance through the general celebration of experience by influential *Lebensphilosophien* aimed at combating the threat of mechanistic determinism (seen not merely in science but also in the ravages of industrialization). In these philosophies, experience replaced atomistic sensation as the basic epistemological concept, and its link to vividly felt life is clear not only from the German term *Erlebnis* but also from the vitalistic experiential theories of Bergson, James, and Dewey. As art subsumed religion's role by providing a nonsupernatural spirituality in the material world, so experience emerged as the naturalistic yet nonmechanistic expression of mind. The union of art and experience engendered a notion of aesthetic experience that achieved, through the turn of the century's great aestheticist movement, enormous cultural importance and an almost religious intensity.

Aesthetic experience became the island of freedom, beauty, and idealistic meaning in an otherwise coldly materialistic and law-determined world; it was not only the locus of the highest pleasures but a means of spiritual conversion and transcendence; it accordingly became the central concept for explaining the distinctive nature and value of art, which had itself become increasingly autonomous and isolated from the mainstream of material life and praxis. The doctrine of *art for art's sake* could

only mean that art existed for the sake of its own experience. And seeking to expand art's dominion, its adherents argued that anything could be rendered art if it could engender the appropriate experience.

This hasty genealogy of aesthetic experience does not, of course, do justice to the complex development of this concept, nor to the variety of theories and conceptions it embraces. But it should at least highlight four features that are central to the tradition of aesthetic experience and whose interplay shapes yet confuses twentieth-century accounts of this concept. First, aesthetic experience is essentially valuable and enjoyable; call this its evaluative dimension. Second, it is something vividly felt and subjectively savored, affectively absorbing us and focusing our attention on its immediate presence and thus standing out from the ordinary flow of routine experience; call this its phenomenological dimension. Third, it is meaningful experience, not mere sensation; call this its semantic dimension. (Its affective power and meaning together explain how aesthetic experience can be so transfigurative). Fourth, it is a distinctive experience closely identified with the distinction of fine art and representing art's essential aim; call this the demarcational-definitional dimension.

These features of aesthetic experience do not seem, prima facie, collectively inconsistent. Yet, as we shall see, they generate theoretical tensions that have propelled recent analytic philosophy to marginalize this concept and have even inspired some analysts (most notably George Dickie) to deny its very existence.[6] Before concentrating on the Anglo-American scene, we would do well to note the major lines of recent continental critique. For only by comparison can we grasp the full measure of the analytic depreciation of aesthetic experience.

II

From critical theory and hermeneutics to deconstruction and genealogical analysis, the continental critique of aesthetic experience has mostly focused on challenging its phenomenological immediacy and its radical differentiation. Although Theodor Adorno rejects its claim to pleasure as the ideological contamination of bourgeois hedonism, he joins the virtually unanimous continental verdict that aesthetic experience is not only valuable and meaningful but a crucial concept for the philosophy of art. Unlike facile subjective pleasure, "real aesthetic experience," for Adorno, "requires self-abnegation" and submission to "the objective con-

stitution of the artwork itself."[7] This can transform the subject, thereby suggesting new avenues of emancipation and a renewed *promesse de bonheur* more potent than simple pleasure.

Here we see the transformational, passional aspect of aesthetic experience; it is something undergone or suffered. Though the experiencing subject is dynamic, not inert, she is far from a fully controlling agent and so remains captive and blind to the ideological features structuring the artwork in which she is absorbed. Hence a proper, emancipatory understanding of art requires going beyond immediate experience, beyond immanent *Verstehen*, to external critique ("secondary reflection") of the work's ideological meaning and the sociohistorical conditions which shaped it. "Experience is essential," Adorno dialectically concludes, "but so is thought, for no work in its immediate facticity portrays its meaning adequately or can be understood in itself" (*AT*, 479).

In the same dialectical manner, while affirming aesthetic experience's marked differentiation from "ungodly reality," he recognizes that such apparent autonomy is itself only the product of social forces, which ultimately condition the nature of aesthetic experience by constraining both the structure of artworks and our mode of responding to them (*AT*, 320–322, 478–479). Since changes in the nonaesthetic world affect our very sensibilities and capacity for experience, aesthetic experience cannot be a fixed natural kind.

Such change is a central theme in Walter Benjamin's critique of the immediate meaning of *Erlebnis* privileged by phenomenology. Through the fragmentation and shocks of modern life, the mechanical repetition of assembly-line labor, and the haphazardly juxtaposed information and raw sensationalism of the mass media, our immediate experience of things no longer forms a meaningful, coherent whole but is rather a welter of fragmentary, unintegrated sensations—something simply lived through (*erlebt*) rather than meaningfully experienced. Benjamin instead advocated a notion of experience (as *Erfahrung*) that requires the mediated, temporally cumulative accretion of coherent, transmittable wisdom, though he doubted whether it could still be achieved in modern society.[8]

Modernization and technology, Benjamin likewise argued, have eroded aesthetic experience's identification with the distinctive, transcendent autonomy of art. Such experience once had what Benjamin called *aura*, a cultic quality resulting from the artwork's uniqueness and distance from the ordinary world. But with the advent of mechanical

modes of reproduction like photography, art's distinctive aura has been lost, and aesthetic experience comes to pervade the everyday world of popular culture and even politics. Aesthetic experience can no longer be used to define and delimit the realm of high art. Unlike Adorno, Benjamin saw this loss of aura and differentiation as potentially emancipatory (although he condemned its deadly results in the aesthetics of fascist politics). In any case, Benjamin's critique does not deny the continuing importance of aesthetic experience, only its romantic conceptualization as pure immediacy of meaning and isolation from the rest of life.

Clearly inspired by Heidegger's critique of aesthetic experience,[9] Hans-Georg Gadamer attacks the same two features of immediacy and differentiation, which in fact seem conceptually linked. By radically differentiating the artwork from the sociohistorical world in which it is created and received, by treating it purely as an object of direct aesthetic delight, aesthetic consciousness reduces the work's meaning to what is immediately experienced. But, Gadamer argues, this attitude simply cannot do justice to art's meaning and lasting impact on our lives and world:

> The pantheon of art is not a timeless presence which offers itself to pure aesthetic consciousness but the assembled achievements of the human mind as it has realized itself historically. . . . Inasmuch as we encounter the work of art in the world, . . . it is necessary to adopt an attitude to the beautiful and to art that does not lay claim to immediacy, but corresponds to the historical reality of man. The appeal to immediacy, to the genius of the moment, to the significance of the "experience," cannot withstand the claim of human existence to continuity and unity of self-understanding.[10]

To take the work as merely experienced immediacy is to rob it of enduring wholeness and cumulative meaning through communicative tradition, disintegrating "the unity of the aesthetic object into the multiplicity of experiences" (*TM*, 85) and ignoring art's relation to the world and its claims to truth.

Such critique of immediate, differentiated aesthetic consciousness does not, however, constitute a repudiation of the central importance of experience for aesthetics. Indeed, Gadamer claims it is undertaken "in order to do justice to the experience of art" by insisting that this experience "includes understanding," which must exceed the immediacy of pure presence (*TM*, 89, 90).[11] Rather than identifying art with its objects as is typical in analytic philosophy, Gadamer insists "that the work

of art has its true being in the fact that it becomes an experience chang-
ing the person experiencing it"; this experience "is not the subjectivity
of the person who experiences it, but the work itself" (92), which, as a
game plays its players, submits those who wish to understand it to the
rigors of its structures.

Although it rejects Gadamer's faith in experiential unity and stability,
the deconstructionism of Derrida and Barthes takes a roughly similar
stand: its radical critique of firm disciplinary boundaries and of the "myth
of presence" challenges the radical differentiation and immediacy of aes-
thetic experience without dismissing its importance and power of *jouis-
sance*. From a quite different perspective, that of sociologically informed
genealogical critique, Pierre Bourdieu attacks the very same two tar-
gets. "The experience of the work of art as being immediately endowed
with meaning and value" that are pure and autonomous is an essentialist
fallacy. Aesthetic experience is "itself an institution which is the product
of historical invention," the result of the reciprocally reinforcing dimen-
sions of art's institutional field and inculcated habits of aesthetic contem-
plation.[12] Both take considerable time to get established, not only in the
general social field but also in the course of each individual's aesthetic
apprenticeship. Moreover, their establishment in both cases depends on
the wider social field that determines an institution's conditions of pos-
sibility, power, and attraction, as well as the options of the individual's
involvement in it.

What shall we make of the two main thrusts of the continental cri-
tique? Aesthetic experience cannot be conceived as an unchanging con-
cept narrowly identified with fine art's purely autonomous reception.
For not only is such reception impoverished, but aesthetic experience
extends beyond fine art (to nature, for example). Moreover, aesthetic
experience is conditioned by changes in the nonartistic world that affect
not just the field of art but our very capacities for experience in general.

The second charge, that aesthetic experience requires more than mere
phenomenological immediacy to achieve its full meaning, is equally
convincing. Immediate reactions are often poor and mistaken, so inter-
pretation is generally needed to enhance our experience. Moreover,
prior assumptions and habits of perception, including prior acts of in-
terpretation, are necessary for the shaping of appropriate responses that
are experienced as immediate. This insistence on the interpretive is also
the crux of the Goodman-Danto critique of aesthetic experience. So

when Gadamer urges that "aesthetics must be absorbed into hermeneutics" (*TM*, 146), he is expressing precisely the dominant analytic line.

However, the claim that aesthetic experience must involve *more* than phenomenological immediacy and vivid feeling does not preclude that such immediate feeling is crucial to aesthetic experience. Likewise, Bourdieu's convincing claim that aesthetic experience requires cultural mediation does not entail that its content cannot be experienced as immediate. Though it surely took some time for English to become a language and for me to learn it, I can still experience its meanings as immediate, grasping them as immediately as the smell of a rose (which itself may require the mediation of gardening and complex cognitive processes of sense and individuation).[13]

The decline of aesthetic experience in analytic philosophy partly reflects such false inferences. But it also stems from confusions arising from the changing role of this concept in Anglo-American philosophy from Dewey to Danto, and especially from the fact that this diversity of roles has not been adequately recognized. Viewed as a univocal concept, aesthetic experience seems too confused to be redeemed as useful; so the first task is to articulate its contrasting conceptions.

III

The contrasting conceptions of aesthetic experience are best mapped in terms of three different axes of contrast whose opposing poles capture all four of its already noted dimensions. First, we can ask whether the concept of aesthetic experience is intrinsically honorific or instead descriptively neutral. Second, is it robustly phenomenological or simply semantic? In other words, are affect and subjective intentionality essential dimensions of this experience, or is it rather just a certain kind of meaning or style of symbolization that renders an experience aesthetic? Third, is this concept's primary theoretical function *transformational*, aiming to revise or enlarge the aesthetic field, or is it instead *demarcational*, that is, to define, delimit, and explain the aesthetic status quo?

My claim is that, since Dewey, Anglo-American theories of aesthetic experience have moved steadily from the former to the latter poles, resulting eventually in the concept's loss of power and interest. In other words, Dewey's essentially evaluative, phenomenological, and transformational notion of aesthetic experience has been gradually replaced by a purely descriptive, semantic one whose chief purpose is to explain

and thus support the established demarcation of art from other human domains. Such changes generate tensions that make the concept suspicious. Moreover, when aesthetic experience proves unable to supply this demarcational definition, as Danto concludes, the whole concept is abandoned for one that promises to do so—interpretation. That aesthetic experience may nonetheless be fruitful for other purposes is simply, but I think wrongly, ignored. To substantiate this line of narrative and argument, we must examine the theories of Dewey, Beardsley, Goodman, and Danto.

Dewey's prime use of aesthetic experience is aimed not at distinguishing art from the rest of life but rather at "recovering the continuity of its esthetic experience with the normal processes of living," so that both art and life will be improved by their greater integration.[14] His goal was to break the stifling hold of what he called "the museum conception of art," which compartmentalizes the aesthetic from real life, remitting it to a separate realm remote from the vital interests of ordinary men and women. This "esoteric idea of fine art" gains power from the sacralization of art objects sequestered in museums and private collections. Dewey therefore insisted on privileging dynamic aesthetic experience over the physical objects that conventional dogma identifies and then fetishizes as art. For Dewey, the essence and value of art are not in such artifacts per se but in the dynamic and developing experiential activity through which they are created and perceived. He therefore distinguished between the physical "art product" that, once created, can exist "apart from human experience" and "the actual work of art [which] is what the product does with and in experience" (AE, 9, 167, 329). This primacy of aesthetic experience not only frees art from object fetishism but also from its confinement to the traditional domain of fine art. For aesthetic experience clearly exceeds the limits of fine art, as, for example, in the appreciation of nature.[15]

Dewey insisted that aesthetic experience could likewise occur in the pursuit of science and philosophy, in sport, and in haute cuisine, contributing much to the appeal of these practices. Indeed, it could be achieved in virtually any domain of action, since all experience, to be coherent and meaningful, requires the germ of aesthetic unity and development. By rethinking art in terms of aesthetic experience, Dewey hoped we could radically enlarge and democratize the domain of art, integrating it more fully into the real world, which would be greatly improved by the pursuit of such manifold arts of living.

Its potential pervasiveness did not mean that aesthetic experience could not be distinguished from ordinary experience. Its distinction, however, is essentially qualitative. From the humdrum flow of routine experience, aesthetic experience stands out, says Dewey, as a distinctly memorable, rewarding whole—as not just experience but "*an* experience"—because in it we feel "most alive" and fulfilled through the active, satisfying engagement of all our human faculties (sensual, emotive, and cognitive) that contribute to this integrated whole. Aesthetic experience is differentiated, not by its unique possession of some specific element or its unique focus on some particular dimension, but by its more zestful integration of all the elements of ordinary experience into an absorbing, developing whole that provides "a satisfyingly emotional quality" of some sort and so exceeds the threshold of perception that it can be appreciated for its own sake (*AE*, 42, 45, 63).[16] An essential part of that appreciation is the immediate, phenomenological feel of aesthetic experience, whose sense of unity, affect, and value is "directly fulfilling" rather than deferred for some other time or end.

The transformational, phenomenological, and evaluative thrust of Deweyan aesthetic experience should now be clear. So should the usefulness of such a concept for provoking recognition of artistic potentialities and aesthetic satisfactions in pursuits previously considered nonaesthetic. It is further useful in reminding us that, even in fine art, our directly fulfilling experience, rather than the collecting of artworks or scholarly criticism, is the primary value. Nor does this emphasis on phenomenological immediacy and affect preclude the semantic dimension of aesthetic experience. Meaning is not incompatible with qualia and affect.

Unfortunately, Dewey does not confine himself to transformational provocation, but also proposes aesthetic experience as a theoretical definition of art. By standard philosophical criteria, this definition is hopelessly inadequate, grossly misrepresenting our current concept of art. Much art, particularly bad art, fails to engender Deweyan aesthetic experience, which, on the other hand, often arises outside art's institutional limits. Moreover, though the concept of art (as a historically determined concept) can be somewhat reshaped, it cannot be convincingly redefined in such a global way so as to be coextensive with aesthetic experience. No matter how powerful and universal is the aesthetic experience of sunsets, we are hardly going to reclassify them as art.[17] By employing the concept of aesthetic experience both to define what art

in fact is and to transform it into something quite different, Dewey creates considerable confusion. Hence analytic philosophers typically dismiss his whole idea of aesthetic experience as a disastrous muddle.

The major exception is Monroe Beardsley, who reconstructs this concept as the core of his analytic philosophy of art, which, like most analytic aesthetics, is preoccupied with projects of differentiation. Instead of Dewey's quest to unite art to the rest of life, Beardsley's aim is to clearly distinguish art and the aesthetic from other practices. This means renouncing the transformational use of aesthetic experience. Instead, this concept serves to define what is distinctive of works of art and what is constitutive of their value (issuing in what Beardsley calls a "persuasive analysis of artistic goodness," *APV*, 79).

Beardsley's strategy is to argue that art can be defined as a distinctive function class if there is a particular function that works of art "can do that other things cannot do, or do as completely or fully" (*A*, 526). The production of aesthetic experience is claimed as this function, and so he explains both the general value of art and the differing value of its particular works through the basic value and intrinsic pleasure of that experience; better works, for Beardsley, are those capable of producing "aesthetic experiences of a greater magnitude" (531). Beardsley thus retains the Deweyan evaluative, affective, and phenomenological features of aesthetic experience. It is, he says, an "intrinsically enjoyable" "experience of some intensity" where "attention" and "the succession of one's mental states" is focused on and directed by some phenomenal field in a way that generates a satisfying "feeling" of coherence or "wholeness" and "a sense of actively exercising constructive powers of the mind" (527; *APV*, 287–289). And he clarifies such defining characteristics of this experience in considerable detail.[18]

After careful scrutiny, analytic aesthetics rejected Beardsley's theory on three major grounds. One is skepticism about its phenomenological validity. George Dickie, an influential advocate of this line of critique, offers two principal arguments.[19] First, Beardsley must be wrong to describe the aesthetic experience as unified, coherent, etc., because doing so is simply a category mistake—treating the term "experience" as if it denoted a real thing that could bear such descriptions instead of recognizing that it is merely a empty term denoting nothing real. Talk about aesthetic experience is just a roundabout and ontologically inflationary way of talking about the aesthetic object as perceived or experienced. Beardsley's claim of the "unity of experience" is simply a misleading way

of describing the experienced, phenomenal unity of the artwork. It alone can have such properties of coherence or wholeness. Particular subjective affects resulting from the work cannot have these properties, and the global aesthetic experience that purports to have them is just a linguistically constructed metaphysical phantom. Secondly, Dickie argues, even what is wrongly identified as aesthetic experience does not always have the affective content that Beardsley claims; and this critique can be extended to traditional claims that aesthetic experience is always pleasurable or unified.

What should one make of these two arguments? To the first, we can reply that empirical psychologists *do* accept the reality of experiences (including aesthetic ones) and the validity of describing them in terms of predicates (like unity, intensity, etc.) that, admittedly, are more often used to describe the objects of such experiences.[20] Of course, one could challenge this response by dismissing it as confused folk psychology and adopting philosophy of mind's once fashionable trend of dismissing the role of consciousness or first-person experience. For many reasons (including aesthetic ones), I think this trend should be resisted, and consciousness is indeed making a powerful comeback in recent philosophy of mind.[21]

The argument that Beardsley's phenomenological ascriptions of affect, unity, and pleasure are, in fact, phenomenologically incorrect can be considered along with the second major criticism of his theory: that (the capacity to produce) aesthetic experience just cannot serve to identify and individuate works of art. Here the standard strategy is to show that such a definition would be both too wide and too narrow. It has been charged, for instance, that by Beardsley's criteria of aesthetic experience, good sexual experience would be falsely included as art, a conclusion Dewey might have welcomed but which runs against Beardsley's analytic aim of explaining established classifications.[22]

However, Beardsley's definition is most often attacked for being too narrow. It wrongly excludes all the many artworks that are not capable of producing enjoyable experiences of unity and affect. Certain good works neither produce nor even try to produce such experiences, but clearly the problem is most severe with bad works of art. Since Beardsley's concept of aesthetic experience is essentially honorific and definitional, it cannot accommodate bad works as aesthetic objects or works of art, and yet clearly this is how we analytic philosophers think they must be classified. The concepts of art and aesthetic must allow for bad instances.

Being a work of art cannot entail being a good work of art, otherwise negative evaluations of artworks would be impossible.

This leads to the third major difficulty: the inadequacy of Beardsley's theory of aesthetic experience to explain our judgments of value. Because this experience is by definition enjoyable or positive, it can in no way account for strongly negative aesthetic judgments (e.g., of hideousness, repulsion, etc.), which cannot be explained by the mere absence of a positive aesthetic experience. Yet negative verdicts are central to the field of aesthetics, and any concept which claims to define this field must be able to account for bad as well as good art.[23]

Two conclusions emerge from all this critique. If aesthetic experience is to do the job of demarcating the entire realm of art, then its essentially evaluative content must be abandoned. Moreover, if one is suspicious of subjectivity and immediate feeling, then one must find a notion of aesthetic experience that is centered not on first-person phenomenology but rather on nonsubjective accounts of meaning. These two inferences determine the new semantic direction of Nelson Goodman's theory of aesthetic experience. Though he shares Beardsley's analytic goal of demarcational definition, of "distinguishing in general between aesthetic and nonaesthetic objects and experience" (*LA*, 243), Goodman insists that such distinction must be "independent of all consideration of aesthetic value," since the existence of bad art means "being aesthetic does not exclude being . . . aesthetically bad" (244, 255). Aesthetic experience must also be defined independently of phenomenological accounts of mental states or immediate feelings and meanings, for Goodman rejects intentional entities. Preferring to explain all meaning in terms of varieties of reference, he also renounces the very idea of an immediate given before or apart from its symbolic representation.

Nor can aesthetic experience be distinguished by its peculiarly emotive character, since "some works of art have little or no emotive content." Even when emotion *is* present, its role, Goodman argues, is simply the cognitive one "of discerning what properties a work has and expresses" by providing "a mode of sensitivity" to it (*LA*, 248, 250, 251). But such cognitive use of emotion (as Dewey also tirelessly urged) is equally present in science. Goodman concludes that while emotion is not an aesthetic constant, cognition of some sort is. He therefore defines aesthetic experience as "cognitive experience distinguished [from science and other domains] by the dominance of certain symbolic characteristics"(262).[24]

Goodman calls these features "symptoms of the aesthetic" and individuates five of them:

(1) syntactic density, where the finest differences in certain respects constitute a difference between symbols—for example, an ungraduated mercury thermometer as contrasted with an electronic digital-read-out instrument; (2) semantic density, where symbols are provided for things distinguished by the finest differences in certain respects (not only the ungraduated thermometer again but also ordinary English, though it is not syntactically dense); (3) relative repleteness, where comparatively many aspects of a symbol are significant—for example a single-line drawing of a mountain by Hokusai where every feature of shape, line, thickness, etc. counts, in contrast with perhaps the same line as a chart of daily stock market averages, where all that counts is the height of the line above the base; (4) exemplification, where a symbol, whether or not it denotes, symbolizes by serving as a sample of properties it literally or metaphorically possesses; and finally (5) multiple and complex reference, where a symbol performs several integrated and interacting referential functions, some direct and some mediated through other symbols.

WW, 67–68

If an object's "functioning exhibits all these symptoms," Goodman claims, "then very likely the object is a work of art. If it shows almost none, then it probably isn't" (*OMM*, 199). Although these symptoms may fall short of being disjunctively necessary and conjunctively sufficient conditions for defining our concept of art, Goodman blames this on the fact that ordinary usage of this concept is too "vague and vagrant" to allow any clear definition and thus requires reform (*WW*, 69). His symptoms are therefore offered provisionally in the "search for a definition" (*OMM*, 135) that will achieve this clarification.

Rather than focusing on provisional symptoms, criticism of Goodman's theory should be directed at the underlying premises that generate their proposal. Three problems seem most central. First is the premise of radical aesthetic differentiation, with its consequent presumption that the function of the concept of aesthetic experience is to explain art's compartmentalized distinction. Goodman's theory, like Beardsley's, is haunted by this goal of clearly defining art from all other realms, of seeking (in his words) "a way of distinguishing aesthetic from all other experience" (*LA*, 251). Thus, though keen to emphasize the great affinities between art and science, he feels compelled to seek a definition that

will clearly mark off aesthetic from scientific experience. Invoking his symbolic symptoms to achieve this, he rightly worries that they cannot adequately do the job by providing necessary and sufficient conditions.

Yet such worries only arise by presuming that the concept of aesthetic experience should be coextensive with art, that aesthetic experience cannot occur in science and other standardly nonartistic pursuits, but must apply in all art no matter how bad. There is ample testimony to challenge this presumption, but Goodman must ignore it. Methodologically wedded to the project of demarcating art by aesthetic experience, he cannot recognize a concept of aesthetic experience that cuts across disciplinary boundaries while maintaining its evaluative sense as enjoyably heightened, affective, and meaningful experience. Yet such a concept is fruitfully employed in common usage, not only in Dewey.

A second problem with Goodman's definition of aesthetic experience is that it seems to render the very notion of experience—the conscious, phenomenological feel of things—entirely superfluous. If the aesthetic is defined entirely in terms of the dominance of certain modes of symbolization, with no essential reference to sentience, immediate feeling, and affect, then what is the point of speaking about aesthetic experience at all? We might as well just talk about the semantic symptoms of art and aesthetics, and simply drop the term "experience" (as Goodman indeed does in his most recent discussions). But apart from the once chic suspicions about consciousness, is there any reason why the concept of aesthetic experience must omit this phenomenological dimension with its immediacy of quality and affect? Goodman's discussion suggests (though never fully articulates) the following argument: Aesthetic experience is essentially meaningful and cognitive through its use of symbols. Use of symbols implies mediation and dynamic processing of information, while phenomenological feeling and affect imply passivity and immediacy that cannot account for meaning. Hence, aesthetic experience cannot be essentially phenomenological, immediate, or affective.

This argument is very problematic. First, even assuming all its premises, what follows is only that aesthetic experience requires *more* than these phenomenological features, not that they are not central to such experience. Second, we can challenge the premises by arguing that phenomenological consciousness *can* include immediate perceptions of

meaning, even if such immediate understandings on the conscious level require unconscious mediated processing or rely on a background of past conscious mediation. Further, one can argue that phenomenological feeling involves more than immediacy, just as affect (on both psychological and physiological levels) involves more than passivity. Moreover, if Goodman brings the argument that affect is not central to aesthetic experience because it is not always present in the experience of artworks, we can counter by challenging the presumption that aesthetic experience can only be understood as an artistically demarcational concept, applying necessarily to our encounter with all (and only) artworks, no matter how feeble the encounter and the works may be.

Finally, Goodman's semiotic theory of aesthetic experience has a third grave problem. Not only does it neglect the phenomenology and nonartistic extension of that experience, it is also wholly inadequate for its designated role of demarcating the realm of art. For its use in this role requires that we already know whether or not we are dealing with artworks. Here is the argument. According to Goodman an object is an artwork when its symbolic functioning saliently employs the symptomatically aesthetic modes of symbolization. But an object does not wear its symbolic use on its sleeve; a visually identical sign may function differently in different symbolic systems. For instance, as Goodman remarks, the same drawn line may be a "replete" character artistically representing a mountain or instead a nonreplete character merely representing profits in a chart. But we do not know which symbolic functioning the object has until we know whether the object is an artwork or just a chart. Hence symbolic functioning (and thus aesthetic experience as symbolic functioning) cannot be the basis for defining the artistic status of an object.

This argument is, of course, a variation of the argument from indiscernibles employed by Arthur Danto to argue that perceptual properties alone, including those involved in aesthetic experience, are insufficient for distinguishing between artworks and nonart, between Warhol's *Brillo Boxes* and their nonartistic counterparts. Our experience should differ, Danto says, "depending upon whether the response is to an artwork or to a mere real thing that cannot be told apart from it." But "we cannot appeal to [such differences] . . . in order to get our definition of art, inasmuch as we [first] need the definition of art in order to identify the sorts of aesthetic responses appropriate to works of art in

contrast with mere real things"(*TC*, 94–95). Aesthetic experience has the further problem, Danto notes, of being traditionally defined as inherently positive, while many artworks, being bad, induce negative responses (92).

Since aesthetic experience cannot adequately demarcate art, Danto virtually ignores it, subordinating it to another concept that he thinks can do the definitional job (and do it with the same semantic emphasis that Goodman advocated). This concept is interpretation. "There is," he says "no appreciation without interpretation," since "interpretations are what constitute works"; and "interpretation consists in determining the relationship between a work of art and its material counterpart" (*TC*, 113; *PD*, 45). As I argue in "Beneath Interpretation" (Chapter 6 of this book) I think these claims are problematic. But even granting them does not nullify the idea of aesthetic experience. Its failure to provide a nonevaluative definition of our current concept of art does not entail that it has no important role to play in aesthetics, though we need, of course, to specify what role this could be.

Danto, however, suggests a further argument. The concept of aesthetic experience is not only useless but a "danger," because the very notion of the aesthetic intrinsically trivializes art by seeing it as "fit only for pleasure," rather than for meaning and truth (*PD*, xiv, 13). This argument not only falsely equates the aesthetic per se with a caricature of the narrowest of Kantian formalisms. It also wrongly suggests a divide between pleasure and meaning, feeling and cognition, enjoyment and understanding, when instead they tend, in art, to constitute each other. As T. S. Eliot remarked, "To understand a poem comes to the same thing as to enjoy it for the right reasons."[25]

We can reinforce this point and the centrality of aesthetic feeling by adopting Danto's argument from indiscernibles, but applying it this time not to objects but to subjects. Imagine two visually identical art viewers who offer identical interpretations of the very powerful paintings and poems before them. One is a human who thrills to what he sees and interprets. The other, however, is only a cyborg who, experiencing no qualia, feels no pleasure, indeed no emotion at all, but merely mechanically processes the perceptual and artworld data to deliver his interpretive propositions. We would surely say here that the cyborg, in an important sense, doesn't really understand these works. He doesn't, in a big way, get the point of such art, even if he recognizes that some feel-

ing he cannot feel is somehow appropriate. For much of the point is precisely to feel or savor art's qualia and meaning, not just compute an interpretive output from the work's signs and artworld context.

For this reason, even if the cyborg's interpretive propositions were descriptively more accurate than the human being's, we would still say that the human's general response to art was superior and that the cyborg, since he feels absolutely nothing, does not really grasp what art is all about. Now imagine further that aesthetic experience was entirely expunged from our civilization, since we were all transformed into such cyborgs or exterminated by them. Art might linger on a bit through inertia, but could it continue to flourish and robustly survive? What would be the point of creating and attending to it, if it promised no enriching phenomenological feeling or pleasure?

The uncertainty of art's future in such a sci-fi scenario implies the centrality of aesthetic experience—in its evaluative and phenomenological sense—for the concept of art. Though surely neither a necessary or sufficient condition for application of this concept, it might be regarded as a more general background condition for art. In other words, though many artworks fail to produce aesthetic experience—in the sense of satisfyingly heightened, absorbing, meaningful, and affective experience—if such experience could never be achieved and never be achieved through the production of works, art could probably never have existed.[26] If artworks universally flouted this interest (and not just on occasion to make a radical point), art, as we know it, would disappear. In contrast to necessary and sufficient conditions that aim at mapping art's demarcational limits, such a background condition concerns the *point* rather than the *extension* of the concept of art. In naming and so marking this point, aesthetic experience is not a useless concept.[27]

IV

My futuristic cyborg parables are not so hard to imagine because they reflect real developments in recent aesthetics and contemporary life. Rejecting what he calls the traditional "strong and cold" "grip of aestheticism on the philosophy of art" (*PD*, 33), Danto joins Goodman and many others in what might be termed a radical *anaestheticization of aesthetics*. Felt experience is virtually ignored and entirely subordinated to third-person semantic theories of artistic symbolization and its

interpretation. Once a potent embodiment of art's sense and value, aesthetic experience is now "hermeneutered."

Forsaking such experience for semiotic definitions of art should not be seen as merely the arbitrary preference of linguistic philosophers addicted to semantic theory. Goodman and Danto were sensitively reflecting developments in the artworld, which required ever more interpretation as art became more cerebrally conceptual in pursuing what Danto describes as its Hegelian quest to become its own philosophy: art as theory of art. Goodman and Danto were also responsive to artworld realities in claiming against Beardsley and Dewey that much contemporary art neither evokes nor aims to evoke powerful experiences having enjoyable affect and coherent meaning.

So much the worse, one might say, for contemporary art, which, having completed its philosophical transformation and lost the financial prop of 1980s speculation, now finds it has lost an experiential point and a public to fall back on. For the public retains a deep need for aesthetic experiences, and as these became artistically *dépassé*, it learned to satisfy this need outside the official realm of contemporary art, beyond the white cube of gallery space. So aesthetic interest is increasingly directed toward popular art, which has not yet learned to eschew the experiential goals of pleasure, affect, and meaningful coherence, even if it often fails to achieve them. Mourning the artworld's loss of public, the prominent artists Komar and Melamid, together with *The Nation*, engaged a scientific marketing-survey of popular aesthetic taste in the (perhaps ironic) quest to develop a new plastic art that would engage people as broadly and as powerfully as popular music does. One point emerging from the polling statistics is the demand that art provide positive affective experience through coherence.[28]

Branding this demand as stiflingly conservative, we may insist that art should *not* be confined to supplying agreeable unities or emotions. We may rightly claim that today some of our most exciting, rewarding artistic encounters involve unpleasant shock and fragmentation. But can we make sense of art as a whole without admitting the traditional and still formative centrality of vivid, meaningful phenomenological experience that is directly felt as valuable, even if not always as pleasant and unified?

Of course, the presence of such experience does not entail the presence of art; so it cannot in itself legitimize popular art as true art, just

as it cannot alone justify the claim that a given work is good art. In all these cases, since experience itself is mute, critical discourse is needed. Still, the power of aesthetic experience impels one to undertake such legitimating discourse through its felt value, just as it impels the public toward the arts wherein it can be found. If the experience has this power, then the concept of such experience has value in reminding us of it and directing us toward its use.

If art is *in extremis*, deprived (through completion) of its sustaining narrative of progress and thus groping without direction in what Danto calls its "posthistory," where anything goes; if art's groping is as lonely as it is aimless, cut off from the popular currents of taste in a democratic culture, then the concept of aesthetic experience is worth recalling: not for formal definition but for art's reorientation toward values and populations that could restore its vitality and sense of purpose.[29]

Art's turn from the aesthetic experience of enjoyable affective unities is no more an act of perverse willfulness than Danto's and Goodman's semantic anaesthetics. Like them, contemporary artists are simply responding to changes in our lifeworld, as we move from a more unified experiential culture to an increasingly modular, informational one. This results in art that highlights fragmentation and complexities of information flow that are often too helter-skelter to provide the coherence needed for traditional aesthetic experience's pleasurable sense of focused, funded affect. Already in the 1930s Walter Benjamin drew a stark contrast between experience and information, expressing the fear that through the fragmentation of modern life and the disjointed sensationalism of the newspapers, we were losing the capacity for deep experience and feeling. We have since undergone a far more extensive series of informational revolutions—from television and facsimile to the internet and newer interactive systems of cyberspace and virtual reality.

Given this informational overload, it is not surprising that "the waning of affect" (in Fredric Jameson's phrase) is diagnosed as a prime symptom of our postmodern condition.[30] There is growing concern, far beyond the academy, that we are being so thoroughly reshaped by our informational technology that our experiential, affective capacities are wearing thin, so thin that we risk assimilation to the mechanical information processors that are already our most intimate companions in work and play. This worry is expressed nowhere more clearly than in cyborg fiction. The only way of distinguishing human beings from their

visually identical cyborg Terminators or Replicants is the human capacity to feel, which itself is continuously buffeted and jeopardized by the unmanageable flux and grind of futuristic living. In the story *Blade Runner* (though not in the film), there is even a crucial device to reinforce these affective experiential capacities—an "empathy box" that produces through virtual reality a powerful aesthetico-religious experience of empathetic fusion with others likewise plugged in.[31]

It may seem very "retro" to suggest that aesthetic experience can function something like an empathy box, restoring both our ability and inclination for the sorts of vivid, moving, shared experience that one once sought in art. Perhaps our informational evolution has already gone too far, so that an evening of beauty at the Met can do nothing to counter a life on Wall Street's chaotic trading floor. Perhaps aesthetic experience, and not just the philosophical value of its concept, has almost reached its end. How could philosophy do anything to forestall its total loss?

First, it can remind us of the variety this concept still embraces as heightened, meaningful, and valuable phenomenological experience. So the threatened loss of one traditional form does not entail its utter extinction. Second, in any of its rewarding forms, aesthetic experience will be strengthened and preserved the more it is experienced; it will be more experienced, the more we are directed to such experience; and one good way of directing us to such experience is fuller recognition of its importance and richness through greater attention to the concept of aesthetic experience.

We thus find at least one good use for philosophical recognition of this concept: its orientation toward having the experience it names. Rather than defining art or justifying critical verdicts, the concept is directional, reminding us of what is worth seeking in art and elsewhere in life. Wittgenstein said: "The work of the philosopher consists in assembling reminders for a particular purpose."[32] If the same holds for philosophical concepts, that of aesthetic experience should not go unemployed.[33]

don't believe the hype

Art hath an enemy called Ignorance.

<div align="center">BEN JONSON</div>

I

Despite some notable exceptions, popular art has not been popular
with philosophers and theorists of culture, at least not in their profes-
sional moments.[1] Repeatedly vilified as mindless, tasteless trash, devoid
of any worthwhile form or content, it is still more viciously denounced
as an addictive and stupefying narcotic of escape which manipulates its
audience for purely mercenary motives and undermines critical and
creative thought by affirming its own standardized illusions and false
satisfactions. This denigration of popular art or mass culture—the de-
bate over the proper term is significant and instructive[2]—seems partic-
ularly compelling since it is widely endorsed by intellectuals of violently
different sociopolitical views and agendas. Indeed, it provides a rare in-
stance where right-wing conservatives and Marxian radicals join hands
and make common cause. United by a deep devotion to high art and an
uncritical perception of its purity, they regard it as civilization's great
white hope (whether for the preservation of traditional cultured society
or for its revolutionary liberation), and they repudiate popular art as an
inferior impostor, inimical to the aims and values of high art and pitifully
lacking in aesthetic qualities and rewards.

To challenge that powerful coalition, this chapter reformulates my
pragmatist defense of popular art. Critical of the alienating esotericism
and totalizing claims of high art, I am also acutely suspicious of any es-
sential and unbridgeable divide between its products and those of popu-
lar culture. History itself clearly shows us that the popular entertain-
ment of one culture (e.g., Greek or even Elizabethan drama) can become
the high classics of a subsequent age. Indeed, even within the very same
cultural period, a given work can function either as popular or as high
art depending on how it is interpreted and appropriated by its public.
In nineteenth-century America, Shakespeare was both high theater and
vaudeville.[3]

Since the boundaries between high and popular art seem neither
clear nor uncontested (much film, for example, apparently straddles the

two), to speak of them simply and generally, as I shall be doing, involves a great deal of philosophical abstraction and simplification. But since the global condemnations of popular art are made in such simplifying binary terms, I feel justified to use them for its defense, even if I hope that such defense will eventually lead to the dissolution of the high art/popular art dichotomy and to a more fine-grained and concrete analysis of the various arts and the differing forms of their appropriation.

Perhaps the deepest and most urgent reason for defending popular art is that it provides us (even us intellectuals) with too much aesthetic satisfaction to accept its wholesale denunciation as debased, dehumanizing, and aesthetically illegitimate. To condemn it as fit only for the barbaric taste and dull wit of the unenlightened, manipulated masses is to divide us not only against the rest of our community but against ourselves. We are made to disdain the things which give us pleasure and to feel ashamed of the pleasure they give. Thus, while conservative and Marxian critics of popular culture repeatedly bemoan our contemporary societal and personal fragmentation (blaming it on such forces as modernization, industrialization, secularization, capitalism), the rigid line of legitimacy they draw between high and popular culture reinscribes and reinforces those same painful divisions in society and, still more deeply, in ourselves. Similarly, while the delegitimating critique of popular art is typically pursued under the banner of safeguarding our aesthetic satisfaction, it actually represents a form of ascetic renunciation, one of the many forms that intellectuals since Plato have employed to subordinate the unruly power and sensual appeal of the aesthetic. For such reasons, even if the defense of popular art can hardly achieve the sociocultural liberation of the dominated masses who consume this culture, it can at least help liberate those dominated parts of ourselves which are similarly oppressed by the exclusive claims of high culture.

In defending popular art against these claims, I am not attempting a full-scale aesthetic whitewash. I admit that the products of popular art are often aesthetically wretched and lamentably unappealing, just as I recognize that their social effects can be noxious, particularly when they are consumed in a passive, all-accepting way.[4] What I shall contest are the philosophical arguments that popular art is always and necessarily an aesthetic failure, inferior and inadequate by its intrinsic constitution, that (in the words of Dwight Macdonald) "there are theoretical reasons why Mass Culture is not and can never be any good."[5]

In the debate over popular art, my defense needs to be located between the familiar poles of condemnatory pessimism and celebratory optimism. If the former pole denounces popular art in near paranoid terror as maniacal manipulation devoid of redeeming aesthetic or social merit, the latter embraces it with ingenuous optimism as the free expression of the best of American life and ideology, an optimism that might well be regarded as the most cynical of pessimisms. My intermediary position is a *meliorism*, which recognizes popular art's flaws and abuses but also its merits and potential. It holds that popular art should be improved both because it leaves much to be desired and because it can and often does achieve real aesthetic merit and serve worthy social goals. The long-range aim of meliorism is to direct inquiry away from general condemnations or glorifications so that attention may be better focused on more concrete problems and specific improvements. But for the moment the general philosophic arguments for popular art's intrinsic aesthetic worthlessness are too potently influential to leave unanswered.

I I

1. Perhaps the most basic aesthetic complaint against popular art is that it simply fails to provide any real aesthetic satisfaction. Of course, even the most hostile critics know that movies have entertained millions of viewers and that rock music has thrilled audiences who literally dance and throb with pleasure. But such obvious and discomforting facts are neatly sidestepped by denying that these satisfactions are genuine. The apparent gratifications, sensations, and experiences that popular art provides are dismissed as spurious and fraudulent, while high art in contrast is held to supply something genuine.

Leo Lowenthal, for example, sees "the differences between popular culture and high art" in terms of the difference "between spurious gratification and genuine experience," and Clement Greenberg likewise condemns the popular arts (which he collectively and pejoratively labels "kitsch") for supplying only "vicarious experience and faked sensations."[6] Adorno, who similarly inveighs against the "washed-out" and "fake" satisfactions of popular art, explains that it is only "because the masses are denied real enjoyment [that] they, out of resentment, enjoy the substitutes that come their way . . . [through] low art and entertainment."[7] Moreover, critics like Bernard Rosenberg and Ernest van den Haag fur-

ther insist that the pseudo-pleasures and "substitute gratifications" of "the entertainment industry" prevent us from achieving "any really satisfying experience," because the "diversion" they provide "distracts [us] from life and real gratification."[8]

In its various but repetitive formulations, the charge of spuriousness has become so familiar that one might overlook the self-betraying exaggeration of its scope. But scrutiny of these citations will reveal that the anxious fervor to strip popular art of anything so positive as pleasure has led its critics not merely to deny that its experiences and enjoyments are *aesthetically* genuine but, more radically, to deny that they are real or genuine at all. In short, the claim of spuriousness, a strategy of imperious intellectualist presumption, implies that the cultural elite not only have the power to determine, against popular judgment, the limits of aesthetic legitimacy but also the power to legislate, against empirical evidence, what can be called real experience or pleasure.

Yet how can such a radical claim be substantiated? It in fact never is, but instead is sustained by the authority of its proponents and the virtual absence of opposition. Quite understandably, it faces no strong challenge either from the intellectuals whom it flatters or from the nonintellectuals, who lack the strength or interest to contest it and who typically just ignore it as "abstract palaver" devoid of practical effect on their world.

What in fact is meant in asserting that "the gratifications of popular culture are spurious"?[9] Is it anything more than a rhetorical gesture of denying the legitimacy and value of these gratifications by challenging their reality? Perhaps the most straightforward interpretation and justification of the charge of spuriousness is that popular art's alleged gratifications are not real because they are only superficially and never deeply felt, that they are spurious because they are merely "washed-out," "faked sensations." But the experience of rock music, which can be so intensely absorbing and powerful that it is likened to spiritual possession, surely gives the lie to such a charge. Even rock's severest critics recognize the passionately real potency and intoxicating satisfactions of its experience, just as they mourn the dire educational consequences and the ruthlessly commercialized exploitation of this power. Indeed their critique rings so desperately shrill and strident precisely because they realize rock's captivating pleasures have essentially won the day and undermined the authoritative monopoly of traditional aesthetic forms and of many traditionalist ideas that are embodied in them. Dis-

tressed by rock's unrivaled power to engage and express the longings and experience of youth, which makes its influence even "much larger and deeper than [that of] TV," Allan Bloom blasts rock music as "a gutter phenomenon." It belongs in the gutter not because it fails to provide real pleasure but because the intense pleasure it gives young people "makes it very difficult for them to have a passionate relationship to the art and thought that are the substance of a liberal education," an education which Bloom conceives in extremely traditionalist and intellectualist terms.[10]

Obviously and threateningly real in their intensity and appeal, the gratifications of popular art are sometimes scorned as spurious in another sense, that of ephemerality. These gratifications, it is argued, are not real because they are fleeting. "We are diverted temporarily . . . but not gratified." "What you consume now may please you for the moment; . . . in another moment it will leave you ravenous again."[11] Such an argument, however, will not withstand analysis. First, on the logical level, it is simply false to infer the unreality of something from its ephemerality. This non sequitur may seem convincing not only because it has a grand philosophical pedigree extending back to Plato but also because it serves an equally strong psychological motive in our deeply entrenched desire for stability, which is typically misconstrued as requiring the certainty of total permanence. But despite this support from such powerful and long-standing prejudices, the inference is clearly wrong. Something which exists for a time nonetheless really exists, and a temporary gratification is a gratification all the same.

Moreover, the argument that transience entails spuriousness, that gratifications are unreal and fraudulent if they later leave us hungering for more, cannot serve to discredit popular art in contrast to high culture. If accepted, the argument would be equally effective against the gratifications of high art. Are we permanently or even lastingly satisfied by the reading of a single sonnet or the viewing of a dozen paintings? Does the passing of these gratifications imply that they are somehow fraudulent? Not at all, because one of the positive features of genuine aesthetic pleasure is that while it gratifies it also stimulates the desire for more such pleasure.[12] Moreover, the whole insistence on lasting gratification needs to be questioned. It smacks of the theological and otherworldly. In our world of continuous change and desire, no gratifications are permanent, and the only end to the passing of pleasure and the desire for more is death.

A somewhat different charge of ephemerality commonly made against popular art refers not to the transience of the gratifications themselves but to the fleetingness of its capacity to gratify. Works of popular art do not weather the test of time. They may top the charts for a season, but they quickly lose the power to entertain us and soon fade into oblivion; their charms and pleasures are thus revealed as ultimately illusory. High art, on the other hand, retains its power to gratify. The works of Homer and the drama of ancient Greece, we are too often told, demonstrate the legitimacy of the gratifications they proffer by having provided them to multitudes for centuries and by still providing them today. There is nothing in popular art to match this history of durability, not even in the classics of film and the "golden oldies" of popular music.

But even granting all this, the argument remains badly flawed. First, it is too early to conclude that none of this century's classics of popular art will not survive as objects of aesthetic enjoyment. And it is easier to believe they will survive than to believe that many people still read Homer for pleasure. Moreover, we tend to forget the sociocultural and institutional reasons that underwrite the continued pleasurability of the classics of high art. Education and availability of choice play an enormous but often forgotten role in determining the objects of our pleasure. To a large extent we enjoy what we are trained and conditioned to enjoy and what our options allow us to enjoy. Since the classics have long been systematically disseminated and their appreciation rigorously inculcated through powerful institutions of education, while (at least until the age of mass media) there was never such an organized or effective framework for transmitting and preserving works of popular art, it should come as no surprise that the former have better survived as objects of attention and hence as objects of aesthetic entertainment.

Critics of popular art are fond of arguing that TV viewers don't really like the programs they watch but that they "enjoy" them nevertheless because there is nothing better available on the other channels; that the consumer of popular art is like "the prisoner who loves his cell because he has been left nothing else to love."[13] But this same argument from paucity of options can be turned on the "eternal" enjoyment of Homer, which today is so negligible that it almost seems as mythical as his gods and heroes. Indeed it is precisely because the mass media now provide an alternative system of dissemination and education that the exclusive adoration of the classics inculcated by the traditional scholastic system has been largely undermined by interest in the popular arts. Again, this

is not to argue that the classics and high art no longer deserve and reward aesthetic interest, it is only to argue against their traditional monopoly of legitimate aesthetic attention.

The argument that popular art is spurious because ephemeral is also flawed in forgetting that many of the great classics of high art were originally produced and consumed as popular art. Greek drama was a very popular and raucous affair, as was the Elizabethan theater; many now esteemed novels (like *Wuthering Heights*) were once condemned as sensationalist commercial trash in much the same way that movies, TV, and rock music have been condemned in more recent times. To claim that works of popular art cannot survive, when one has simply ignored the popular origins of those that in fact do, is more than an innocent error. It is an exploitative expropriation of the culture of the dominated majority by a dominant elite. For once these works are exclusively reclassified as high art, their mode of appropriation is redefined in order to ensure that their popular appreciation will be demeaned and discounted, so that they will henceforth be essentially reserved for the more distinguished delectation of the culturally elite.

Finally, even if we concede that works of popular art are transient and their power to please is relatively brief, this neither makes them valueless nor renders their gratifications spurious. To presume that it does is to equate all pleasure and value with permanence. But there is value in transient things, and indeed sometimes in their very transience. Brief encounters may be sweeter and more fruitful than abiding relationships. To reject the value of the ephemeral has been a permanent prejudice of our intellectual culture, and it perhaps was a serviceable one for past conditions where survival was so insecure that attention and value had to be fixed on the most enduring. But it is a prejudice nonetheless, and one that blights and blunts our pleasures. Indeed it even blocks a major path for constructing a more consistently satisfying life. For once ephemeral pleasures are discounted as relatively valueless and unworthy of attention, serious thinking is not devoted to how they can best be achieved, repeated, and securely integrated into life. Consequently such pleasures and their sometimes explosive effect on life are dangerously left to the vagaries of chance, blind desire, and the indoctrinating pressures of advertising.

Popular art's gratifications have been censured as spurious in yet another sense: as mere substitutes for pleasures that are somehow more basic or real. Adorno, who rightly protests the social conditions which

deny us "real gratification in the sphere of immediate sense experience," complains that popular art purveys false surrogates for such enjoyment as a form of narcotic escape. "Because the masses are denied real enjoyment, they, out of resentment, enjoy the substitutes that come their way" (*AT*, 19, 340). Yet the pleasures of high art, as Adorno must admit, are no less mediated and removed from actual living; and they can also serve escapist ends.

Just as often, the charge of surrogacy locates genuine gratification not in the immediate but in the ultimate, in a deferred and consequently more complete satisfaction. Explicitly likening popular art to masturbation, as providing mere discharges of tension rather than real satisfaction, van den Haag condemns it for glutting us with energy-draining "substitute gratifications [that] incapacitate the individual for real ones" and thus prevent us from any "ultimate gratification." In much the same style of prurient innuendo, Allan Bloom implies the fraudulence of rock's satisfactions by associating them with undeferred and deviant sexual pleasure: "Rock music provides premature ecstasy" to children and teens "as if they were ready to enjoy the final or complete satisfaction."[14]

Certainly, deferral and resistance frequently augment satisfaction, but where is the "complete" and "final" satisfaction to be found? Hardly in this world, which knows no end to desire. Real satisfaction is rather relegated to some transcendental domain—for Bloom the realm of Platonistic ideals, for Adorno a Marxian utopia, and for van den Haag the Christian afterlife. The only pleasures they seem willing to legitimate are those which we cannot attain, at least not in this world. Even the aesthetic pleasures of high art cannot be spared sanction. "In a false world," Adorno bitterly avows, "all *hedone* is false. This goes for aesthetic pleasure too"(*AT*, 18). And van den Haag somberly intones the same message of abject anguish: "As far as the pleasures of this life, they are not worth pursuing."[15] Thus, as I earlier suggested, the critique that popular art provides only spurious pleasures is not so much a defense of real pleasure as a mask for the wholesale denial of all worldly pleasure, a strategy adopted by ascetic minds who fear pleasure as a dangerous diversion from their transcendental goals, or simply as a discomforting threat to their fundamentally ascetic ethos.

Two final reasons sometimes offered for the spuriousness of popular art's satisfactions are importantly related both to each other and to the intellectual *askesis* reflected in previous arguments. The first maintains

that since "genuine experience . . . presupposes effortful participation," popular art cannot provide any such "really satisfying experience." The second insists that its experience cannot be genuine because it fails "to involve the whole individual and his relation to reality."[16] Both arguments lead us beyond the charge of spurious satisfactions to two other criticisms of popular art which are important and complex enough to demand individual attention: the charges of effortless passivity and of empty superficiality.

2. Popular art is often condemned for not providing any aesthetic challenge. In contrast to high art whose appreciation demands "aesthetic work," thus stimulating aesthetic activity and a resultant aesthetic satisfaction, popular art both induces and requires a lifeless and unrewarding passivity. Its "simple and repetitive structures," says Pierre Bourdieu, only "invite a passive, absent participation."[17] This effortless passivity is thought to explain not only its wide appeal but its failure to truly satisfy. Its "effortlessness" easily captivates those of us who are too weary and beaten to seek something challenging. But since enjoyment (as Aristotle realized) is a by-product attendant upon and essentially bound to activity, our lack of active effort ultimately translates into joyless boredom. Rather than energetically responding to the work (as we can in high art), we lazily receive it in a passive, listless torpor. Nor could such art tolerate more vigorous scrutiny and response. Thus the audience of popular art is necessarily reduced from active participants to "passive consumers," who must be "as passive as possible."[18]

Adorno and Horkheimer ingeniously link the passive boredom of popular art with the passive and mechanized, yet oppressively exhausting, labor of the modern workplace.

Amusement under late capitalism is the prolongation of work. It is sought after as an escape from the mechanized work process, and to recruit strength in order to be able to cope with it again. But at the same time mechanization has such power over a man's leisure and happiness, and so profoundly determines the manufacture of amusement goods, that his experiences are inevitably after-images of the working place. . . . All amusement suffers from this incurable malady. Pleasure hardens into boredom because, if it is to remain pleasure, it must not demand any effort and therefore moves rigorously in the worn grooves of association. No independent thinking must

be expected from the audience: the product prescribes every reaction: not by its natural form (which collapses under reflection), but by signals. Any logical connection calling for mental effort is painstakingly avoided.[19]

Much popular art conforms to Horkheimer and Adorno's analysis. But their critique also betrays the misguided and simplistic conflation of all legitimate activity with serious thinking, of "any effort" with "mental effort" of the intellect. Critics of popular culture are loath to recognize that there are humanly worthy and aesthetically rewarding activities other than intellectual exertion. So even if all art and aesthetic enjoyment do indeed require some active effort or the overcoming of some resistance, it does not follow that they require effortful "independent thinking." There are other more somatic forms of effort, resistance, and satisfaction.

Rock and roll songs are typically enjoyed through moving, dancing, and singing along with the music, often with such vigorous efforts that one breaks into a sweat and eventually becomes exhausted. And such efforts, as Dewey realized, involve overcoming resistances like "embarrassment, . . . awkwardness, self-consciousness, [and] lack of vitality."[20] Clearly, on the somatic level, there is much more effortful activity in the appreciation of rock than in that of highbrow music, whose concerts compel us to sit in a motionless silence which often induces not mere torpid passivity but snoring sleep. The term "funky," used to characterize and commend many rock songs, derives from an African word meaning "positive sweat" and is expressive of an African aesthetic of vigorously active and communally impassioned engagement rather than dispassionate judgmental remoteness.[21] The more energetic and kinaesthetic aesthetic response evoked by rock music exposes the fundamental passivity of the traditional aesthetic attitude of disinterested, distanced contemplation—a contemplative attitude which has its roots in ascetic idealism, in the quest for individual transcendence rather than communal interaction or social change. Popular arts like rock thus suggest a radically revised aesthetic with a joyous return of the somatic dimension, which idealist philosophy has long repressed to preserve its own hegemony (through that of the intellect) in all realms of human value. No wonder the aesthetic legitimacy of such art is vehemently denied and its embodied and embodying efforts are ignored or rejected as irrational regression from art's true (that is, intellectual) purpose. The fact that much

popular art has roots in non-Western civilization renders it even more unacceptably retrograde.

For Adorno, pop music is "regressive" and aesthetically invalid because "it is a somatic stimulus" (*AT*, 170); for Allan Bloom, the problem with rock is its deep appeal to "sensuality" and "sexual desire," which renders it "*alogon*." "It is not only not reasonable, it is hostile to reason." Mark Miller makes the same mistake of inferring aesthetic illegitimacy and intellectual corruption from the mere fact of rock's more immediate sensuous appeal. "Rock 'n' Roll music," he complains in citing John Lennon, "gets right through to you without having to go through your brain"; and this sensuous immediacy is negatively misconstrued as entailing effortless nullity and passive "immobility," so that "all rock aspires to the condition of Muzak." In short, since rock can be enjoyed without intellectual "interpretation," it is therefore not sufficiently "cerebral" to be aesthetically legitimate; and its so-called "artists and listeners are anti-intellectual and usually stoned." Rock's only and short-lived value was the critical consciousness induced by its first transgressional challenge; and in a remark which betrays the body-despising Cartesianism of popular culture's critics, Miller laments that rock's "body went on dancing . . . [after] it had lost its soul" of original protest.[22]

Along with their antisomatic animus, the arguments of Adorno, Bloom, and Miller share two vitiating logical blunders. First, the sensuous appeal of rock does not entail anti-intellectualism (in either its creators or audience). Only if the sensuous were essentially incompatible with the intellect would this follow; and why should we sensuous intellects suppose this? It is only the presumption of intellectualist exclusiveness (a powerful philosophical prejudice with a platonic pedigree) that leads these thinkers to regard them as mutually exclusive. The second fallacy is to infer that because rock music can be enjoyed without hard thinking and interpretation, its enjoyment therefore cannot sustain or be enhanced by such reflective analysis. If popular art can reward without serious intellectual effort, this does not mean that it cannot profit by and reward such effort. If it can be enjoyed mindlessly, it does not follow that it must be so enjoyed and has nothing else to offer.

3. We must then face the charge that popular art is in fact too superficial to be intellectually satisfying. For if popular art could only engage and satisfy the somatic and mentally jejune dimensions of human expe-

rience, its value would be seriously limited, though still, I believe, far from negligible. But are there compelling reasons to think popular art is utterly and irremediably devoid of meaningful and intellectually stimulating content? The arguments for its necessary superficiality can be usefully analyzed in terms of two more specific claims.

a. The first is that popular art cannot deal with the deep realities and real problems of life, and therefore strives to distract us with an escapist dream world of pseudo-problems and clichéd solutions. In contrast to high (or true) art, which "tends to engage life at its deeper levels" and treats "the essential" in reality, popular art "distracts from life" and "the human predicament."[23] Its works "distract people from the real and most important problems of life"; in particular they "distract the masses from becoming more clearly aware of their real needs."[24] Popular art, Dwight Macdonald explains, is obliged to ignore or "void . . . the deep realities (sex, death, failure, tragedy) . . . since the realities would be too real . . . to induce . . . [the] narcotized acceptance" that it seeks.[25]

But this again presumes without argument that the aim of popular art is always a drugged quiescent stupor, while in fact there is ample evidence to the contrary. Long before Woodstock, rock music had often been a strident and potently mobilizing voice of protest with respect to deep and topical issues; and in recent years, through such rock concert projects as Live Aid, Farm Aid, and Human Rights Now, it has proven an effective source of collaborative social action for worthy political and humanitarian causes.

Van den Haag provides the most common argument why reality cannot be handled, but only eschewed, by all mass-media products. Popular art must appeal to more than a highbrow audience and so must tailor its products to the comprehension of this wider public. But this, for van den Haag and other culture snobs, means tailoring them too small to encompass any real issues or significant experience.

> They must omit, therefore all human experience likely to be misunderstood—all experience and expression the meaning of which is not obvious and approved. Which is to say that the mass media cannot touch the experiences that art, philosophy, and literature deal with: relevant and significant human experience presented in relevant and significant form. For if it is such, it is new, doubtful, difficult, perhaps offensive, at any rate easily mis-

understood. . . . [Hence] the mass media . . . cannot touch real problems or real solutions.[26]

At least two fundamental fallacies invalidate this argument. One mistake is the presumption that popular art cannot be popular unless its form and content are completely transparent and totally approved. But there is no justification for this view except the equally false presumption that consumers of popular art are just too stupid to understand more than the obvious, and too psychologically naive to appreciate the presentation of views with which they may ultimately disagree. Recent studies of television drama demonstrate that the mass-media audience can take a critical and complex attitude to the "heroes" and views presented there;[27] and the point is reinforced by the evidence of rock and rap enthusiasts who enjoy songs suggestive of drug taking and violent living while in fact disapproving of such behavior. Moreover, even assuming its audience is indeed moronic, we still cannot conclude that popular art's content must be fully obvious and approved in order to please. For there remains the possibility that it may please even when only partially understood and indeed misunderstood. Certainly the middle-class white youth who first took to rock and roll had no real understanding of the lyrics they thrilled to, many of whose words bore hidden Afro-American meanings, like the term "rock and roll" itself, which meant "to fuck."

The other fallacy in van den Haag's argument is falsely conflating the relevant and significant in human experience and expression with the new and the difficult. No grounds are given for equating these clearly distinct notions, and any such equation is refuted by the abiding significance that our more familiar experiences and traditional forms (e.g., falling in love, kissing our children good-night, gathering together for holiday meals) often have in our lives. But van den Haag and others are misled to make this equation by their blind allegiance to the high modernist aesthetic of avant-garde originality and difficulty, which is unconsciously smuggled in as a general standard of experiential significance. Still worse, it becomes the standard of "the real," so that the ordinary problems treated by popular art—disappointed love, economic hardship, family conflicts, alienation, drugs, sex, and violence—can be denied as unreal; while the "real problems" worthy of artistic expression are only those novel and esoteric enough to escape the experience and

the comprehension of the general public. This is surely a convenient strategy for the privileged to ignore and suppress the realities of those they dominate by denying the artistic legitimacy of their expression — a strategy which vividly exemplifies Bourdieu's point that aesthetic conflicts are often fundamentally "political conflicts . . . for the power to impose the dominant definition of reality, and social reality in particular."[28] Though unattractively banal to the cultural aesthete, such "unreal" problems (and the common "unreal" people whose lives they exhaust) constitute an important dimension of our world. Poverty and violence, sex and drugs, "spare parts and broken hearts" (to quote Bruce Springsteen) "keep this world spinnin' around";[29] and they have a way of reasserting their repressed reality with a brutal vengeance, as one departs the theater and is hit by the street.

b. Popular art has also been condemned as superficial and empty, not because it fails to appeal to deal with "deeper essential realities" and "real problems," but because it lacks sufficient complexities, subtleties, and levels of meaning to be in any way mentally stimulating or capable of "sustaining serious interest." In contrast to high art, which "tends to be complex" so that its "content can be perceived and understood on several levels," popular art, in order to achieve its widest comprehension and appeal, must only engage in "broad, easily recognizable images," flat stereotypes, and empty clichés.[30] Hence, unable to exercise our intelligence, it can only (in Adorno's words) "fill empty time with more emptiness."[31]

Certainly too many mass-media products are boringly simple and painfully devoid of intelligent complexity. But cultural critics wrongly conclude that all of them must be that way. Implicitly appealing to the homogenizing prejudice that "all mass culture is identical," these critics resolutely ignore the subtle complexities that can in fact be found in popular artworks. Yet, as even Adorno came to recognize, popular works often "consist of various levels of meaning, superimposed on one another, all of which contribute to the effect."[32] And John Fiske's study of television narratives shows that their popularity requires that they be multileveled, multivocal, and polysemic so that they can simultaneously be read differently by and thus appeal to a wide "variety of groups with different, often conflicting interests." For, as media and marketing experts now realize, the popular TV audience is "not a homogeneous mass" but a shifting constellation of many different social groups who

"actively read television in order to produce from it meanings that connect with their social experience."[33]

Intellectualist critics typically fail to recognize the multilayered and nuanced meanings of popular art either because they are "turned off" from the outset and unwilling to give these works the sympathetic attention needed to tease out such complexities, or more simply because they just can't understand the works in question. Rock music has long been the carrier of covert messages. Emerging as it did from conditions of social and cultural oppression, rock's complex levels of meaning (somatic as well as discursive) enabled it to dissemble its message of protest with a guise of innocuous mindlessness. From black culture to youth culture the tradition persisted, so that Bob Dylan could tell an interviewer in 1965, "If I told you what our music was really about we'd probably all get arrested."[34] Though most of our adult population is young enough to have been raised on Elvis and Little Richard, and hence hip enough not to complain too much about the noise and nonsense of the classic rock tradition, the charge of meaningless sound and vile empty lyrics is now directed at genres like punk and rap, where both noise and linguistic deviance are consciously thematized to form part of the semantic and formal complexity of certain songs.[35]

4. Our culture regards art as quintessentially creative and original, as necessarily engaged in innovation and experimentation. This is why many aestheticians claim that an artwork is always unique, and why even a traditionalist like T. S. Eliot insists that a work which "would not be new . . . would therefore not be a work of art."[36] In contrast, popular art is globally denigrated not only as unoriginal and monotonous, but as necessarily so by its motives and methods of production. Its products are inevitably "tepid and standardized," because they are technologically constructed from "formulas" and "ready-made clichés" (*AT*, 348) by a profit-hungry industry aimed at "catering to consumer tastes rather than developing or cultivating autonomous ones."[37] Hence, in contrast to the creative originality and other "features of genuine art, . . . popular culture proves to have its own genuine characteristics: standardization, stereotypy, conservatism, mendacity, manipulated consumer goods."[38]

The claim that popular art is necessarily uncreative and unaesthetically monotonous relies on three lines of argument: first, that standardization and technological production, because they put limits on indi-

viduality, preclude real creativity;[39] second, that popular art's group production and division of labor, because they involve more than one artist's decision, frustrate original expression; third, that the desire to entertain a large audience is incompatible with individual self-expression and hence with original aesthetic expression.[40] All of these arguments rest on the premise that aesthetic creation is necessarily individualistic, a questionable romantic myth (nourished by bourgeois liberalism's ideology of individualism) which belies art's essential communal dimension. In any case, none of these arguments are compelling, nor can they serve to isolate popular works from high art.

Standardization can be found in high as well as popular art. Both employ conventions or formulae to facilitate communication, to achieve certain aesthetic forms and effects whose value has been proven, and to provide a solid basis from which to develop creative elaborations and innovations. The sonnet's length is just as rigidly standard as the TV sitcom's, and neither limit precludes creativity. What determines the aesthetic validity of formulae, conventions, and generic standards is whether they are imaginatively deployed. If popular art too often exploits them in a routine mechanical fashion, high art has its own deadly forms of monotonous standardization like academicism, where, in Clement Greenberg's words, "creative activity dwindles" and "the same themes are mechanically varied in a hundred different works."[41] As for the use of technological inventions, rather than curtailing innovation, it has always been an impetus to aesthetic creativity (as the history of architecture clearly indicates). The technology of popular art has helped create new artistic forms like the movie, the TV series, and the rock video; and this adventurous and unpredictable creative power, so threatening to the weakening authority of high art and its custodians, is probably what motivates their charge that popular art is creatively impotent.

The second argument is no less problematic. We can grant no inconsistency between collective production and artistic creativity without challenging the aesthetic legitimacy of Greek temples, Gothic cathedrals, and the works of oral literary traditions. It is undeniable that creative artistic aims are often frustrated or corrupted by corporate pressures (perhaps most famously in Hollywood). But this, as Dewey would say, is something to combat and rectify in practice, not to reify into a principle of necessary contradiction between original expression and group work. Although collective production will no doubt place constraints on the flights of individual fancy, it is also true that the collaboration of

several minds can compensate creativity with added imaginative resources. In any case, we must remember that even the individual imagination is always working in some sort of collaboration with a larger community: an artistic tradition with inherited conventions and an audience with anticipated reactions. This last consideration also helps challenge the third argument by suggesting that even high-culture artists, as socially constructed and socially motivated selves, are, in the very act of pleasing themselves, also trying to please a large audience, even if it be only the imagined legions of posterity.

But the third argument needs further criticism, since it is the one most often advanced for popular art's intrinsic lack of creativity. It asserts, we recall, that popularity requires artistic form and content to be easily understood and appreciated by the entire mass audience and that this accessibility, in turn, means denying personal creative expression in order to appeal to the lowest common denominator. Hence only the most basic "stereotypes in both content and form" can be presented. The conclusion is that since the art of "mass media must offer homogenized fare to meet an average of tastes," it can say nothing creative or provocative, but is confined to expressing only "the obvious and approved."[42] We know the conclusion is false, if only by the fact that products of popular art, in both form and content, have regularly shocked and offended the sensibilities of "average" people. But we need to expose the fallacies which make this argument seem plausible to so many culture critics.

The first error is confusing a "multitudinous audience" with a "mass audience." Popularity only requires the former, while the latter implies a homogenized undifferentiated whole. Highbrow culture critics falsely assume that the popular art audience is such a mass. They fail to recognize that this audience is actually structured into different taste groups, reflecting different social and educational backgrounds and ideologies, and employing different interpretive strategies for "reading" popular art's texts. Media studies show that an artwork expressing a particular view can be very popular with audiences who reject that view, simply because such audiences systematically misread the work, creatively "decoding" or reconstituting its meaning to make the work more interesting and serviceable to them. This is why feminists, Marxists, and traditionalist Moroccan Jews in Israel could be devoted fans of *Dallas*, and why *"Dynasty* has become a cult show among gays in the USA."[43]

But even if we ignore this appeal to creative misreadings, which more democratically locates popular art's creativity in its consumers and not

only in its official creators, there is further reason for distinguishing between a multitudinous and a mass audience. A particular taste group sharing a distinctive social or ethnic background, or a common ideology or artistic tradition, may be clearly distinguishable from what is considered the homogeneous mass audience of average Americans and yet still be numerous enough to constitute a multitudinous audience whose satisfaction will render an art sufficiently popular to count as popular art and reach mass-media coverage. That such distinctive large audiences exist means that popular art need not confine itself to styles, stereotypes, and views that are understood and accepted by the so-called (and perhaps ultimately mythical) general public.

The record scratching, the black English lyrics, the sexually explicit content, and the anti-American anger of many hit rap songs are not at all "obvious and approved" to the vast majority of "middle America," but this does not prevent such songs from immense popularity. Indeed their popularity may derive precisely from their distinctive ethnic and ideological focus and their challenge of accepted public standards—derive, in other words, from being a "Public Enemy," as the once popularly celebrated but publicly denounced rap crew shrewdly named itself. Nor is this distinctive popularity necessarily confined to the young black ghetto audience. Without any diluting homogenization, rap's message of bitter injustice and violent protest against oppressive authority can be taken up by "alienated" youth from different social backgrounds, or even by "marginalized" intellectuals discontent with the system, who are willing to be educated in its styles, tropes, and vernacular. In short, as rock showed before rap, popularity does not require conformity to a global "average of tastes," nor does it preclude the creation of meanings only properly understood by initiates in a subculture or in a counter-cultural artistic tradition. In building on such traditions, popular artists can create imaginative intertextual meanings that neither the general public nor the highbrow aesthete can easily fathom.

Popular artists are also consumers of popular art and form part of its audience. Often their taste is not very different from the particular audiences toward which their work is directed. Here there can be no real conflict between wanting to express oneself creatively and wanting to please one's large audience. Highbrow critics assume the necessity of such a conflict, because they falsely believe that true artists can never be faithful to themselves if they aim to entertain others. This error stems from the romantic myth of individual genius, which insisted that isola-

tion from society and contempt for its popularity were crucial to artistic integrity and vision. The historical and socioeconomic pressures that fostered this myth are now widely acknowledged: social changes during the nineteenth century cut artists off from their traditional forms of societal patronage and left them uncertain of both their role and their audience. Few today give the myth credence, and even seemingly elitist artists like T. S. Eliot have explicitly denied it by asserting the necessary connection of the artist to his community and by affirming the desire to reach as large a portion of that community as possible. "I believe that the poet naturally prefers to write for as large and miscellaneous an audience as possible," Eliot wrote. "I myself should like an audience which could neither read nor write."[44]

Finally, the argument that popular art's popularity requires slavish conformity to accepted stereotypes and values rests on the premise that its consumers are too simple minded to appreciate the presentation of views they may find unfamiliar and unsatisfactory. But, as already noted, empirical evidence of media consumption shows this to be false; media viewers are not (in Stuart Hall's phrase) the "cultural dopes" that intellectual highbrows take them to be.[45] Indeed, the very idea that the popular art audience is psychologically too naive and one-dimensional to entertain and be entertained by conflicting ideas and ambiguity of values is clearly refuted by the baffling experience of postmodern living, where everyday coping frequently requires the simultaneous inhabiting of contradictory roles and conflicting language games. No longer an aesthetic luxury, multiplicity of attitude and the vacillating suspension of both belief and disbelief are a necessity of life. For in what can we still commit full faith and total investment without self-deception or irony?

5. The effortlessness and shallowness of popular art are often linked to its lack of formal complexity. Inadequacy of form is one of the most common and damning indictments of popular art, and one for which Bourdieu provides a powerful argument. Defining the aesthetic attitude as a capacity to regard things as "form rather than function," Bourdieu sees this detached, life-distancing attitude as the key to high art's achievement of "formal complexity." It is only through this attitude that we can reach ("as the final stage in the conquest of artistic autonomy") "the production of an open work, intrinsically and deliberately polysemic" (D, 3, 33–35). For Bourdieu, popular art's greater connection with the

content of life "implies the subordination of form to function" and the consequent failure to achieve formal complexity. In popular art we are more immediately drawn to the work's content or substance; and this, Bourdieu argues, is incompatible with aesthetic appreciation, "given the basic opposition between form and substance" (197). Aesthetic legitimacy is achieved only "by displacing the interest from the 'content' to the form, to the specifically artistic effects which are only appreciated relationally, through a comparison with other works which is incompatible with immersion in the singularity of the work immediately given" (34).

This sense of relation to other works and styles in the given artistic tradition is surely a rich source of formal complexity in high art. But it is also powerfully present in many works of popular art, which self-consciously allude to and quote from one another to produce a variety of aesthetic effects including a complex formal texture of implied art-historical relations. Nor are these allusions lost on the popular art audience, who are often more literate in their artistic traditions than are the audiences of high art in theirs.[46]

What is more disturbing about Bourdieu's argument is its apparent assumption that form and content are somehow necessarily opposed, so that we cannot properly experience (or create) a work formally unless we distance ourselves from any interest in content. Not only does this beg a very contested form/content distinction, but it confuses two senses of "formal": that which displays formality or formalization and that which simply has form, structure, or shape. Only the first sense entails a posture of ceremonious distance and denial of life's investments. Rather than something essentially opposed to life, form is, as Dewey stressed, an ever present part of the shape and rhythm of living; and aesthetic form (as Bourdieu himself recognizes) has its deep but denied roots in these organic bodily rhythms and the social conditions which help structure them.[47] Form can be discovered in more immediate and enthusiastic bodily investment as well as through intellectual distance; form can be funky as well as austerely formal.

6. Form, function, and funk all lead into the final charge I shall consider: popular art's lack of aesthetic autonomy and resistance. Aestheticians typically regard autonomy as an "an irrevocable aspect of art" (AT, 1) which is crucial to its value. Even Adorno and Bourdieu, who recognize that this autonomy is the product of sociohistorical factors and serves a

social agenda for class distinction, nevertheless insist that it is essential to artistic legitimacy and the very notion of aesthetic appreciation. For art to be created and appreciated qua art and not something else, requires, says Bourdieu, "an autonomous field of artistic production . . . capable of imposing its norms on both the production and the consumption of its products" and of refusing external functions "or any necessity other than that inscribed in . . . [its] specific tradition." The core of such autonomous norms is granting "primacy to that of which the artist is master, i.e., form, manner, style, rather than the 'subject', the external referent, which involves subordination to functions—even if only the most elementary one, that of representing, signifying, saying something" (D, 3). Similarly, for Adorno, art's norms are exclusive of any function other than the service of art itself. Art "will not play a serving role" and should eschew "even the childish notion of wanting to be a source of pleasure," so that the "autonomous work of art . . . is functional only with reference to itself" (AT, 89,136, 281). In contrast, popular art forfeits aesthetic legitimacy simply by having more than purely artistic functions, by serving also other needs of life. But why does functionality entail artistic and aesthetic illegitimacy?

Ultimately, the entailment rests on defining art and the aesthetic as essentially opposed to reality or life. For Adorno, art defines and justifies itself "by being different from the ungodly reality" of our world and divorced from its practical functional exigencies (AT, 322). Bourdieu likewise maintains that the very notion of aesthetic attitude implies a break with the world and the concerns of ordinary life (D, 4). Since popular art affirms "the continuity between art and life, which implies the subordination of form to function" (32), Bourdieu concludes it cannot count as legitimate art. It cannot be legitimated by any so-called popular aesthetic, because such an aesthetic, Bourdieu argues, is not worthy of the name. First, because this aesthetic is never positively formulated ("for itself") but merely serves as a negative reference point through which the legitimate life-opposing aesthetic can define itself by contrast (4, 41, 57). Moreover, by accepting real-life concerns and pleasures (and thus challenging art's pure autonomy), the popular aesthetic is disqualified as anti-aesthetically engaged in a "systematic reduction of the things of art to the things of life" (5).

These antifunctionalist arguments all hang on the premise that art and real life are and should be essentially opposed and strictly separated. But why should this dogma be accepted? Its provenance and motivation

should certainly make us suspicious. Originating in Plato's attack on art for its double removal from reality, it has been sustained by a philosophical tradition that was always eager, even in defending art, to endorse its distance from the real so as to ensure philosophy's sovereignty in determining reality, including the real nature of art.

But looking beyond philosophical prejudice, we can see art as part of life, just as life forms the substance of art and even constitutes itself artistically in "the art of living." Both as objects and experiences, artworks inhabit the world and function in our lives. Certainly in ancient Athenian culture, from which our concept of art first developed, the arts were intimately integrated into everyday life. Bourdieu knows this well, and his own work insists on the historical evolution of the nineteenth century, when art was transformed into *autonomous* art and the aesthetic into a *pure* aesthetic. But his narrow definition of the aesthetic suggests that history's changes are irrevocably permanent, and that once transfigured into pure autonomy, art and the aesthetic can no longer be legitimate in a less pure, less life-denying form. History, however, continues its transformations: and recent developments in postmodern culture suggest the disintegration of the purist ideal and the implosion of the aesthetic into all areas of life.

Moreover, though Bourdieu penetratingly exposes the deeper material conditions and unconscious social interests involved in aesthetic purity (which render it far from pure though it be globally misperceived as pure), he seems unwilling to entertain the idea that we can break with this collective misperception of pure autonomy and still maintain a viable aesthetic. He neglects the possibility of an alternative aesthetic where life plays a central role and popular art can be redeemed. Such an aesthetic is not only possible; it is explicitly formulated in pragmatism, which makes the energies, needs, and pleasures of "the live creature" central to aesthetic experience.[48]

Bourdieu further argues that popular art denies its own aesthetic validity by implicitly accepting the domination of the high art aesthetic which haughtily denigrates it.[49] Our culture, for Bourdieu, is one where high art's aesthetic of "the pure disposition . . . is universally recognized." Hence, simply by existing in this culture, the popular aesthetic which he links to the working class must be a "dominated aesthetic which is constantly obliged to define itself in terms of the dominant aesthetics" (*D*, 41,48). Since by these dominant standards popular art fails to qualify as art, and since it fails to assert or generate its own indepen-

dent legitimation, Bourdieu concludes that in a sense "there is no popular art" and that popular culture is a "paradoxical notion" which implies willy-nilly the dominant definition of culture and hence its own invalidation or "self-destruction"(48, 395).

However compelling this argument may be for the French culture Bourdieu studies, it fails as a global argument against popular art. For, at least in America, such art *does* assert its aesthetic status and provides its own forms of aesthetic legitimation. Not only do many popular artists regard their role as more than mere entertainment, but the artistic status of their art is frequently thematized in their works. Awards such as the Oscar, Emmy, and Grammy, which are neither determined by nor reducible to box-office sales, confer, in the eyes of most Americans, not only aesthetic legitimation but a degree of artistic prestige. There is also a very large and growing array of aesthetic criticism of the popular arts, including some aesthetically orientated historical studies of their development. Such criticism, disseminated not only in journals and books but in the mass media, is clearly a form of legitimating discourse, and it employs the same sort of aesthetic predicates and aesthetic analysis that one applies to high art. Its sharing of these predicates does not entail its subordination to high art, unless we presume from the outset that high art has exclusive control of the legitimate use of aesthetic terms; and this already begs the question of exclusive aesthetic legitimacy, which is precisely what popular art is contesting.

Similarly, it is wrong to presume that popular art's lack of an articulated philosophical aesthetic somehow precludes its aesthetic legitimacy. Legitimation takes other and more powerful forms than philosophical theory. Just as it is wrong to equate legitimation with philosophical legitimation, it is wrong to confine cultural legitimacy to that which is granted by the socially marginalized intellectual community. Certainly, Americans take neither philosophy nor the cultural hegemony of intellectuals as seriously as do the French and other Europeans. The insouciantly rebellious attitude embodied in American popular culture is, I believe, a large part of its captivating appeal and genuine value for Europeans, particularly for the young and culturally dominated. For this culture provides an invaluable tool for their growing liberation from a long entrenched and often stifling tradition of disembodied philosophy and high courtly art.

To criticize Bourdieu's global claim by appeal to American cultural difference, is only to reinforce his more general view that art and the

aesthetic are not unchanging essences but mutable products of historical and social conditions—variant functions of varying sociocultural fields. Certain sociohistorical factors could well explain why it is in America that the popular arts have thrived and most successfully challenged high art's stranglehold on aesthetic and cultural legitimacy. Mapping these factors would require sociohistorical research beyond the scope of this chapter. But the following points seem a promising start.

First, though America is far from a classless society, its societal structure is more flexible and decentered than traditional European societies. Second, as a New World nation which had to fight for independence from Old World domination, America is more inclined to resistance against and independence from European cultural domination. Third, as a nation of immigrants from different cultures, it had no unique national tradition of high art which could be unproblematically imported from the Old World and held as binding; nor was there a centralized educational system to enforce cultural uniformity.[50] The liberating effect of cultural plurality for popular art can clearly be seen in the growth of jazz and rock, which were developed from African cultural sources by African Americans whose exclusion from the dominant culture allowed them to create with greater freedom from its limiting aesthetic.

Perhaps the most important reason for America's greater cultural freedom is its lack of two traditional institutions that structured high culture and sustained its dominating power: an aristocratic court and a national church. As many have argued, the notion of high art was in large part an invention by aristocrats to insure their continued social privilege over the increasingly prosperous bourgeoisie, a strategy of distinction that the socially aspiring bourgeoisie later aped.[51] The ecclesiastical tradition, on the other hand, provided a powerful and institutionally entrenched ideal of highly spiritualized experience, as well as a habit of very pious religious attention to art. It further provided an intellectual priestly class to direct and regulate the propriety of such transcendent experience and its discourse. When theological faith was lost but religious sentiments and somber spiritualizing habits were still enormously potent, these were projected into the religion of high art, a new realm of unworldly experience and devotional seriousness, with a new priestly class of intellectual artists and critics. America's religious tradition was much weaker, and its dominant dour puritanism was markedly uncongenial to aesthetic appropriation. As a secular republic having no traditional aristocracy and embracing many religious denominations,

America could better resist what Bourdieu describes as the essential "aristocracy of culture" and thus could aesthetically affirm popular arts that claim neither aristocratic distinction nor quasi-religious value.[52]

Bourdieu's analyses in *Distinction* are based on materials that date primarily from the 1960s and extend only to the mid-1970s. Now, as we enter a new century, the growing global influence of American mass-media culture clearly seems to be bringing greater recognition of the popular arts, even in Bourdieu's own Europe. Though I welcome this progress, it is also important to the note the dangers of any one-sided cultural hegemony. This includes American popular culture. My plea for the aesthetic legitimacy and potential of popular art is not to advocate its dominance or the obliteration of the high art tradition, which I value equally and which is often hard to separate clearly from popular forms. It is not high art that I challenge but its exclusionary claim to value and the hypercritical arguments of its ideologues against popular aesthetics. "Don't believe the hype!" urged Public Enemy in a 1988 hit track. This attitude of discriminating incredulity remains a good critical posture, whether we are told that our popular arts are worthless or totally wonderful. Beyond this, of course, we need more concrete aesthetic criticism of the actual genres and works of popular art. The following two chapters take up this challenge.

the fine art of rap

. . . rapt Poesy,
And arts, though unimagined, yet to be.

SHELLEY, *Prometheus Unbound*

I

In the view of both the culturally elite and the so-called general public, rap music lurks in the underworld of aesthetic respectability. Though it is today's "fastest growing genre of popular music,"[1] its claim to artistic status has been drowned under a flood of abusive critique. Rap has suffered not only moral and aesthetic condemnations but also organized censorship, blacklists, arrests, and the police-enforced stopping of concerts.[2] Moreover, on a different level of cultural combat, we find attempts to dilute and undermine rap's ethnic and political content by encouraging and exploiting its most bland, "sanitized," and commercialized forms.

None of this should be surprising. For rap's cultural roots and prime following belong to the black underclass of American society; and its militant black pride and thematizing of the ghetto experience represent a threatening siren to that society's complacent status quo. The threat is of course far more audible and urgent for the middlebrow public, who interact more closely and competitively with the poor black population, compete for the same mass-media channels of cultural transmission, and need to assert their sociocultural (and ultimately political) superiority over black America.[3]

Armed with such powerful political motives for opposing rap, one can readily find aesthetic reasons which seem to discredit it as a legitimate art form. Rap songs are not even sung, only spoken or chanted. They typically employ neither live musicians nor original music; the sound track is instead composed from various cuts (or "samples") of records already made and often well known. Finally, the lyrics seem to be crude and simple minded, the diction substandard, the rhymes raucous, repetitive, and frequently raunchy. Yet, as my title suggests, these same lyrics insistently claim and extol rap's status as poetry and fine art.[4]

In this chapter I wish to examine more closely the aesthetics of rap or "hip hop" (as the cognoscenti often call it).[5] Since I enjoy this music, I have a personal stake in defending its aesthetic legitimacy. But the cul-

tural issues are much wider and the aesthetic stakes much higher. For rap, I believe, is a postmodern popular art that challenges some of our most deeply entrenched aesthetic conventions, conventions that are common not only to modernism as an artistic style and ideology but to the philosophical doctrine of modernity and its differentiation of cultural spheres. By considering rap in the context of postmodern aesthetics, I hope to provide academic aestheticians with a better understanding of this much maligned but little studied genre of popular art. I also hope to enhance our understanding of postmodernism through the concrete analysis of one of its unique cultural forms.

Postmodernism is a vexingly complex and contested phenomenon, whose aesthetic consequently resists clear and unchallengeable definition. Nonetheless, certain themes and stylistic features are widely recognized as characteristically postmodern, which is not to say that they cannot also be found to varying degrees in some modern art.[6] These characteristics include recycling appropriation rather than unique originative creation, an eclectic mixing of styles, an enthusiastic embracing of new technology and mass culture, a challenging of modernist notions of aesthetic autonomy and artistic purity, and an emphasis on the localized and temporal rather than the putatively universal and eternal. Whether or not we wish to call these features postmodern, rap not only saliently exemplifies them but often consciously highlights and thematizes them. Thus, even if we reject the whole category of postmodernism, these features are essential for understanding rap.[7]

II

Artistic appropriation is the historical source of hip-hop music and still remains the core of its technique and a central feature of its aesthetic form and message. The music derives from selecting and combining parts of prerecorded songs to produce a "new" soundtrack. This soundtrack, produced by the DJ on a multiple turntable, constitutes the musical background for the rap lyrics. These in turn are frequently devoted both to praising the DJ's inimitable virtuosity in sampling and synthesizing the appropriated music, and to boasting of the lyrical and rhyming power of the rapper (called the MC from "master of ceremonies"). While the rapper's vaunting self-praise often highlights his sexual desirability, commercial success, and property assets, these signs of status are all presented as secondary to and derivative from his verbal power.

Some whites may find it difficult to imagine that verbal virtuosity is

greatly appreciated in the black urban ghetto. But sociological study reveals it is very highly valued there; while anthropological research shows that asserting superior social status through verbal prowess is a deeply entrenched black tradition which goes back to the griots in West Africa and which has long been sustained in the New World through such conventionalized verbal contests or games as "signifying" or "the dozens."[8] Failure to recognize the traditional tropes, stylistic conventions, and constraint-produced complexities of Afro-American English (such as semantic inversion and indirection, feigned simplicity, and covert parody—all originally designed to conceal the real meaning from hostile white listeners)[9] has induced the false belief that all rap lyrics are superficial and monotonous, if not altogether moronic. But informed and sympathetic close reading will reveal in many rap songs not only the cleverly potent vernacular expression of keen insights but also forms of linguistic subtlety and multiple levels of meaning whose polysemic complexity, ambiguity, and intertextuality can sometimes rival that of high art's so-called "open work."[10]

Like its stylized aggressively boasting language, so rap's other most salient feature—its dominant funky beat—can be traced back to African roots, to jungle rhythms that were taken up by rock and disco and then reappropriated by the rap DJs—musical cannibals of the urban jungle. But for all its African heritage, hip hop was born in the disco era of the mid-seventies in the grim ghettos of New York, first the Bronx, and then Harlem and Brooklyn. As it appropriated disco sounds and techniques, it undermined and transformed them, much as jazz (an earlier black art of appropriation) had done with the melodies of popular songs. But in contrast to jazz, hip hop did not take mere melodies or musical phrases, that is, abstract musical patterns exemplifiable in different performances and thus having the ontological status of "type entities." Instead it lifted concrete sound-events, prerecorded token performances of such musical patterns. Thus, unlike jazz, its borrowing and transformation did not require skill in playing musical instruments but only in manipulating recording equipment. DJs in ordinary disco clubs had developed the technique of cutting and blending one record into the next, matching tempos to make a smooth transition without violently disrupting the flow of dancing. Dissatisfied with the tame sound of disco and commercial pop, self-styled DJs in the Bronx reapplied this technique of cutting to concentrate and augment those parts of the records that could provide for better dancing. For them:

the important part of the record was the break—the part of a tune in which the drums took over. It could be the explosive Tito Puente style of Latin timbales to be heard on Jimmy Castor records; the loose funk drumming of countless '60s soul records by legends like James Brown or Dyke and the Blazers; even the foursquare bass-drum-and-snare intros adored by heavy metal and hard rockers like Thin Lizzy and the Rolling Stones. That was when the dancers flew and DJs began cutting between the same few bars on the two turntables, extending the break into an instrumental.[11]

In short, hip hop began explicitly as dance music to be appreciated through movement, not mere listening. It was originally designed only for live performance (at dances held in homes, schools, community centers and parks), where one could admire the dexterity of the DJ and the personality and improvisational skills of the rapper. Not intended for a mass audience, for several years it remained confined to the New York City area and outside the mass-media network. Though rap was often taped informally on cassette and then reproduced and circulated by its growing body of fans and bootleggers, it was only in 1979 that rap had its first radio broadcast and released its first records. These two singles, "Rapper's Delight" and "King Tim III (Personality Jock)," which were made by groups outside the core rap community but who had connections with the record industry, provoked competitive resentment in the rap world; yet also the incentive and example to get out of the underground and onto disc and radio. But even when the groups moved from the street to the studio where they could use live music, the DJ's role of appropriation was not abandoned and continued to be thematized in rap lyrics as central to the art.[12]

From the basic technique of cutting between sampled records, hip hop developed three other formal devices which contribute significantly to its sound and aesthetic: "scratch mixing," "punch phrasing," and simple scratching. The first is simply overlaying or mixing certain sounds from one record to those of another already playing.[13] Punch phrasing is a refinement of such mixing, where the DJ moves the needle back and forth over a specific phrase of chords or drum slaps of a record so as to add a powerful percussive effect to the sound of the other record playing all the while on the other turntable. The third device is a wilder and more rapid back-and-forth scratching of the record, too fast for the recorded music to be recognized but productive of a dramatic scratching sound which has its own intense musical quality and crazed beat.

These devices of cutting, mixing, and scratching give rap a variety of forms of appropriation, which seem as versatile and imaginative as those of high art—as those, say, exemplified by Duchamp's mustache on the Mona Lisa, Rauschenberg's erasure of a De Kooning drawing, and Andy Warhol's multiple re-representations of prepackaged commercial images. Rap also displays a variety of appropriated content. Not only does it sample from a wide range of popular songs, it feeds on classical music, TV theme songs, advertising jingles, and the electronic music of arcade games. It even appropriates nonmusical content, such as media news reports and fragments of speeches by Malcolm X and Martin Luther King.

Though some DJs took pride in appropriating from very unlikely and arcane sources and sometimes tried to conceal (for fear of competition) the exact records they were sampling, there was never any attempt to conceal that they were working from prerecorded sounds rather than composing their own original music. On the contrary, they openly celebrated their method of sampling. What is the aesthetic significance of this proud art of appropriation?

First, it challenges the traditional ideal of radical originality and uniqueness that has long enslaved our conception of art. Romanticism and its cult of genius likened the artist to a divine creator and advocated that his works be altogether new and express his singular personality. Modernism, with its commitment to artistic progress and the avant-garde, reinforced the dogma that radical novelty was the essence of art. Though artists have always borrowed from each other's works, this fact was generally ignored or implicitly denied through the ideology of originality, which posed a sharp distinction between original creation and derivative borrowing. Postmodern art like rap undermines this dichotomy by creatively deploying and thematizing its appropriation to show that borrowing and creation are not at all incompatible. It further suggests that the apparently original work of art is itself always a product of unacknowledged borrowings, the unique and novel text always a tissue of echoes and fragments of earlier texts.

Originality thus loses its absolute originary status and is reconceived to include the transfiguring reappropriation and recycling of the old. In this postmodern picture there are no ultimate, untouchable originals, only appropriations of appropriations and simulacra of simulacra; so creative energy can be liberated to play with familiar creations without

fear that it thereby denies itself the opportunity to be truly creative because it does not issue in a totally original work. Rap songs simultaneously celebrate their originality and their borrowing.[14] And as the dichotomy of creation/appropriation is challenged, so is the deep division between creative artist and appropriative audience; transfigurative appreciation can take the form of art.

III

Rap's sampling style also challenges the work of art's traditional ideal of unity and integrity. Since Aristotle, aestheticians have often viewed the work as an organic whole so perfectly unified that any tampering with its parts would damage the whole. Moreover, the ideologies of romanticism and art for art's sake have reinforced our habit of treating artworks as transcendent and virtually sacred ends in themselves, whose integrity we should respect and never violate. In contrast to the aesthetic of organic unity, rap's cutting and sampling reflects the "schizophrenic fragmentation" and "collage effect" characteristic of the postmodern aesthetic.[15] In contrast to an aesthetic of devotional worship of a fixed untouchable work, hip hop offers the pleasures of deconstructive art—the thrilling beauty of dismembering (and rapping over) old works to create new ones, dismantling the prepackaged and wearily familiar into something stimulatingly different.

The DJ's sampling and the MC's rap also highlight the fact that the apparent unity of the original artwork is often an artificially constructed one, at least in contemporary popular music where the production process is frequently quite fragmented: an instrumental track recorded in Memphis combined with a backup vocal from New York and a lead voice from Los Angeles. Rap simply continues this process of layered artistic composition by deconstructing and differently reassembling prepackaged musical products and then superimposing the MC's added layer of lyrics so as to produce a new work. But rap does this without the pretense that its own work is inviolable, that the artistic process is ever final, that there is ever a product that should be so fetishized that it could never be submitted to appropriative transfiguration. Instead, rap's sampling implies that an artwork's integrity as an object should never outweigh the possibilities for continuing re-creation through use of that object. Its aesthetic thus suggests the Deweyan message that art is more essentially process than finished product, a welcome message in

our culture whose tendency to reify and commodify all artistic expression is so strong that rap itself is victimized by this tendency while defiantly protesting it.

In defying the fetishized integrity of artworks, rap also challenges traditional notions of their monumentality, universality, and permanence. No longer are admired works conceived (in T. S. Eliot's sense) as "an ideal order" of "monuments" timelessly existing and yet preserved through time by tradition.[16] In contrast to the view that "a poem is forever," rap highlights the artwork's temporality and likely impermanence: not only by appropriative deconstructions but by explicitly thematizing its own temporality in its lyrics. For example, several songs by BDP include lines like "Fresh for '88, you suckers" or "Fresh for '89, you suckers."[17] Such declarations of date imply a consequent admission of datedness; what is fresh for '88 is apparently stale by '89, and so superseded by a new freshness of '89 vintage. But, by rap's postmodern aesthetic, the ephemeral freshness of artistic creations does not render them aesthetically unworthy; no more than the ephemeral freshness of cream renders its sweet taste unreal.[18] For the view that aesthetic value can only be real if it passes the test of time is simply an entrenched but unjustified presumption, ultimately deriving from the pervasive philosophical bias toward equating reality with the permanent and unchanging.

By refusing to treat artworks as eternal monuments for permanent hands-off devotion, by reworking works to make them work better, rap also questions their assumed universality — the dogma that good art should be able to please all people in all ages by focusing only on universal human themes. Hip hop does treat universal themes like injustice and oppression, but it is proudly localized as "ghetto music," thematizing its commitment to the black urban ghetto and its culture. While it typically avoids excluding white society (and white artists),[19] rap focuses on features of ghetto life that whites and middle-class blacks would rather ignore: pimping, prostitution, and drug addiction, as well as rampant venereal disease, street killings, and oppressive harassment by white policemen. Most rappers define their local allegiances in quite specific terms, often not simply by city but by neighborhood, like Compton, Harlem, Brooklyn, or the Bronx. Even when rap goes international, it remains proudly local; we find in French rap, for example, the same targeting of specific neighborhoods and concentration on local problems.[20]

Though localization is a salient characteristic of the postmodern breakdown of modernism's international style, rap's strong local sense

is probably more the product of its origins in neighborhood conflict and competition. As David Toop notes, hip hop helped transform violent rivalries between local gangs into musical-verbal contests between rapping crews (*RA*, 12–15, 70–71).[21] By now it is difficult to point to sharp stylistic differences between the music of the different locales, though Los Angeles rappers seem less concerned with black militancy and white oppression than their brothers in New York. Of course, local differences are hard to maintain once the music begins circulating through the mass media and is subjected to its commercializing pressures. For such reasons, rap lyrics often complain about hip hop's commercial boom, just as they also (for other reasons) celebrate it.

IV

Rap's complex attitude toward mass circulation and commercialization reflects another central feature of postmodernism: its fascinated and overwhelming absorption of contemporary technology, particularly that of the mass media. While the commercial products of this technology seem so simple and fruitful to use, both the actual complexities of technological production and its intricate relations to the sustaining socioeconomic system are, for the consumer public, frighteningly unfathomable and unmanageable. Mesmerized by the powers technology provides us, we postmoderns are also vaguely disturbed by the great power it has over us, as the all-pervasive but increasingly incomprehensible medium of our lives. But fascination with its awesome power can afford us the further (perhaps illusory) thrill that in effectively employing technology, we prove ourselves its master. Such thrills are characteristic of what Fredric Jameson dubs the "hallucinatory exhilaration" of the "postmodern or technological sublime" (*NLR*, 76, 79).

Hip hop powerfully displays this syndrome, enthusiastically embracing and masterfully appropriating mass-media technology, but still remaining unhappily oppressed and appropriated by that same technological system and its sustaining society. Rap was born of commercial mass-media technology: records and turntables, amplifiers and mixers. Its technological character allowed its artists to create music they could not otherwise make, either because they could not afford the musical instruments required or because they lacked the training to play them (*RA*, 151). Technology constituted its DJs as artists rather than mere consumers or mere executant technicians. "Run DMC first said a deejay could be a band / Stand on its own feet, get you outta your seat," ex-

claims a rap by Public Enemy.[22] But without commercial mass-media technology, the DJ band would have had nothing to stand on.

The creative virtuosity with which rap artists have appropriated new technology is indeed astounding and exhilarating, and it is often acclaimed in rap lyrics. By acrobatically juggling the cutting and changing of many records on multiple turntables, skillful DJs showed their physical as well as artistic mastery of commercial music and its technology. From the initial disco equipment, rap artists have gone on to adopt more advanced technologies: electronic drums, synthesizers, sounds from calculators and touch-tone phones, and sometimes computers which scan entire ranges of possible sounds and then can replicate and synthesize the desired ones.

Mass-media technology has also been crucial to rap's impressively growing popularity. As a product of an essentially oral black culture, rap needs to be heard and felt immediately as energetically moving sound in order to be properly appreciated. No notational score could transmit its crazy collage of music, and even the lyrics cannot be adequately conveyed in mere written form, divorced from their expressive rhythm, intonation, and surging stress and flow. Only mass-media technology allows for the wide dissemination and preservation of such oral performance events. Both through radio and television broadcasting and through the recording media of records, tapes, and compact discs, rap has been able to reach out beyond its original ghetto audience and thus give its music and message a real hearing even in white America and Europe. Only through the mass media could hip hop become a very audible voice in our popular culture—a voice that many however, would like to suppress, since it often stridently expresses the frustrating oppression of ghetto life and the proud and pressing desire for social resistance and change. Without such media, rap could not have achieved its "penetration to the core of the nation" (Ice-T) or its opportunity to "teach the bourgeois" (Public Enemy).[23] Similarly, only through the mass media could hip hop have achieved artistic fame and fortune, its commercial success enabling renewed artistic investment and serving as an undeniable source of black cultural pride.

Rap not only relies on mass-media techniques and technologies, it derives much of its content and imagery from mass culture. Television shows, sports personalities, arcade games, and familiar name-brand commercial products (for example, Adidas sneakers) are frequently referred to in the lyrics, and their musical themes or jingles are some-

times sampled; a whole series of rap records was based on Smurf cartoons. Such items of mass-media culture help provide the common cultural background necessary for artistic creation and communication in a society where the tradition of high culture is largely unknown or unappealing, if not also oppressively alien and exclusionary.

But for all its acknowledged gifts, the world of mass media is not a trusted and unambiguous ally. It is simultaneously the focus of deep suspicion and angry critique. Rappers inveigh against its false and superficial fare, its commercially standardized and sanitized but unreal and mindless content. "False media, we don't need it, do we? It's fake," urge Public Enemy,[24] who also lament (in "She Watch Channel Zero") how standard television shows undermine the intelligence, responsibilities, and cultural roots of black women. Rappers are constantly attacking the radio for refusing to broadcast their more politically potent or sexually explicit raps, and instead filling the air with tame "commercial pap" (BDP). "Radio suckers never play me," complain Public Enemy, a line which gets sampled and punch phrased by Ice-T in an eponymous rap condemning the radio and the FCC for a censorship which denies both freedom of expression and the hard realities of life so as to insure the continuous media fare of "nothin' but commercial junk."[25] Scorning the option of a "sell-out," Ice-T raises (and answers) the crucial "media question" troubling all progressive rap: "Can the radio handle the truth? Nope." But he also asserts the reassurance that even with a radio ban he can reach and make millions through the medium of tapes, suggesting that the media provides its own ways of subverting attempts at regulatory control: "They're makin' radio wack, people have to escape / But even if I'm banned, I'll sell a million tapes."[26]

Finally, apart from their false, superficial content and repressive censorship, the media are linked to a global commercial system and society which callously exploits and oppresses hip hop's primary audience. Recognizing that those who govern and speak for the dominating technological-commercial complex are indifferent to the enduring woes of the black underclass ("Here is the land that never gave a damn about a brother like me . . . but the suckers had authority"), rappers protest how our capitalist society exploits the disenfranchised blacks both to preserve its sociopolitical stability (through their service in the military and police) and to increase its profits by increasing their demand for unnecessary consumer goods.[27] One very prominent theme of hip hop is how the advertised ideal of conspicuous consumption—luxury cars,

clothes, and high-tech appliances—lures many ghetto youth to a life of crime, a life which promises the quick attainment of such commodities but typically ends in death, jail, or destitution, thus reinforcing the ghetto cycle of poverty and despair.

It is one of the postmodern paradoxes of hip hop that rappers extol their own achievement of consumerist luxury while simultaneously condemning its uncritical idealization and quest as misguided and dangerous for their audience in the ghetto community to which they ardently avow their solidarity and allegiance. In the same way, self-declared "underground" rappers at once denigrate commercialism as an artistic and political sellout but nonetheless glorify their own commercial success, often even regarding it as indicative of their artistic power.[28] Such contradictions are perhaps expressive of the postmodern fragmentation of the self into inconsistent personae, but they may be equally expressive of more fundamental contradictions in the sociocultural fields of ghetto life and so-called noncommercial art.[29] Certainly there is a very deep connection in Afro-American culture between independent expression and economic achievement, which would impel even noncommercial rappers to tout their commercial success and property. For, as Houston Baker so well demonstrates, Afro-American artists must always, consciously or unconsciously, come to terms with the history of slavery and commercial exploitation which forms the ground of black experience and expression.[30] As slaves were converted from independent humans to property, their way to regain independence was to achieve sufficient property of their own so as to buy their manumission (as in the traditional liberation narrative of Frederick Douglass). Having long been denied a voice because they were property, Afro-Americans could reasonably conclude "that *only* property enables expression."[31] For progressive rappers, then, commercial success and its luxury trappings may function essentially as signs of an economic independence which enables free artistic and political expression, and which is conversely also enabled by it. A major dimension of this celebrated economic independence is its independence from crime.[32]

V

I have already mentioned the wide-ranging eclecticism of rap's appropriative sampling, which extends even to nonmusical sources. Though rap often honors the music it samples (especially from the black music tradition), its plundering and mixing of past sources has no respect for

period, genre, and style distinctions: it cannibalizes and combines what it wants with no concern to preserve the formal integrity, aesthetic intention, or historical context of the records it plunders, absorbing and transforming everything it cuts and takes into its funky collage.

Rap historian David Toop gives a sense of rap's wild eclecticism: "Bambaataa mixed up calypso, European and Japanese electronic music, Beethoven's Fifth Symphony and rock groups like Mountain; Kool DJ Herc spun the Doobie Brothers back to back with the Isley Brothers; Grandmaster Flash overlayed speech records and sound effects with The Last Poets; Symphonic B Boys Mixx cut up classical music on five turntables" (RA, 105; see also 149, 153).

Perhaps more than any other contemporary art form, rap not only exemplifies but proudly thematizes the eclectic pastiche and cannibalization of past styles that is central to the postmodern. Some, like Jameson, regret this "random cannibalization of all the styles of the past" and its unprincipled "play of random stylistic allusion" (NLR, 65–66) for its disintegration and derealization of a coherent and real past, one which might otherwise be retrieved to help us better understand our problematic present and guide us toward a more liberated future. For Jameson, postmodernism's eclectic "historicism effaces history" (65). Instead of "real history" and "genuine historicity," the organic reconstruction of "some putative real world" (68, 71), we are supplied with nostalgia, a jumble of stereotypical images from an imagined past. We are thus confined to the prisonhouse of ideological representations, "condemned to seek History by way of our own pop images and simulacra of that history, which itself remains forever out of reach" and hence unavailable as a source for political critique and liberation (71).[33]

But the whole idea of one real History, the one true account of a fully determinate past whose structure, content, and meaning are fixed and unrevisable, is itself a repressive ideological construction and a vestige of absolute realism which cannot compel much conviction in our age of postfoundationalist philosophy. Neither the past nor the present is ever purely given or reported; they are always selectively represented and shaped by discursive structures reflecting dominant interests and values, which are often simply those of the politically dominant. This does not mean an "anything goes" relativism. In being historicized, history is not so much lost as pluralized and openly politicized, instead of having its implicit political agenda concealed under the guise of neutral objectivity where it cannot be challenged or even recognized as political. History, as univocally conceived, is a meta-

physical naturalization of *his*-story, the story of "The Man"—the term black culture uses to denote not only the police but the dominating, oppressive white male society which controls and polices the institutions of cultural legitimacy, including the writing and teaching of history.[34] A fascinating feature of much underground rap is its acute recognition of the politics of culture: its challenge of the univocal claims of white history and education and its attempt to provide alternative black historical narratives that stimulate black pride and foster emancipatory impulses. Such alternative narratives extend from biblical history to the history of hip hop itself, which is thus constituted and valorized as a phenomenon worthy of historical testimony and documentation.[35]

If rap's freewheeling eclecticism violates high modernist conventions of aesthetic purity and integrity, its belligerent insistence on the deeply political dimension of culture challenges one of the most fundamental artistic conventions of modernity: aesthetic autonomy. Modernity, according to Max Weber and others, emerged with the project of occidental rationalization, secularization, and differentiation, which disenchanted the traditional religious worldview and carved up its organic domain into three separate and autonomous spheres of secular culture: science, art, and morality, each governed by its own inner logic of theoretical, aesthetic, or moral-practical judgment.[36] This tripartite division was powerfully reflected and reinforced by Kant's critical analysis of human thinking in terms of pure reason, practical reason, and aesthetic judgment.

In this division of cultural spheres, art was distinguished from science as not being concerned with the formulation or dissemination of knowledge, since its aesthetic judgment was essentially nonconceptual and subjective. It was also sharply differentiated from the practical activity of the realm of ethics and politics, which involved real-world interests and practical will (as well as conceptual thinking). Instead, art was consigned to a disinterested, imaginative realm which the poet-theorist Friedrich Schiller later described as the realm of play and semblance.[37] As the aesthetic was distinguished from the more rational realms of knowledge and action, it was also firmly differentiated from the more sensate and appetitive gratifications of embodied human nature—aesthetic pleasure residing, rather, in distanced, disinterested contemplation of formal properties.

Hip hop's genre of "knowledge rap" (or "message rap") is dedicated to the defiant violation of this compartmentalized, trivializing, and evis-

cerating view of art and the aesthetic. Such rappers repeatedly insist that their role as artists and poets is inseparable from their role as insightful inquirers into reality and teachers of truth, particularly those aspects of reality and truth which get neglected or distorted by establishment history books and contemporary media coverage. KRS-One of BDP claims to be not only "a teacher and artist, startin' new concepts at their hardest," but a philosopher (indeed, according to the jacket notes on the *Ghetto Music* album, a "metaphysician") and also a scientist ("I don't drop science, I teach it. Correct?").[38] In contrast to the media's political whitewash, stereotypes, and empty escapist entertainment, he proudly claims: "I'm tryin' not to escape, but hit the problem head on / By bringing out the truth in a song. . . / It's simple; BDP will teach reality. / No beatin' around the bush, straight up; just like the beat is free. / So now you know a poet's job is never done. / But I'm never overworked, 'cause I'm still number one."[39]

Of course, the realities and truths which hip hop reveals are not the transcendental eternal verities of traditional philosophy, but rather the mutable but coercive facts and patterns of the material, sociohistorical world. Yet this emphasis on the temporally changing and malleable nature of the real (reflected in rap's frequent time tags and its popular idiom of "knowing what time it is")[40] constitutes a respectably tenable metaphysical position associated with American pragmatism. Though few may know it, rap philosophers are really "down with" Dewey, not merely in metaphysics but in a noncompartmentalized aesthetics which highlights social function, process, and embodied experience.[41]

For knowledge rap not only insists on uniting the aesthetic and the cognitive but equally stresses that practical functionality can form part of artistic meaning and value. Many rap songs are explicitly devoted to raising black political consciousness, pride, and revolutionary impulses; some make the powerful point that aesthetic judgments, and particularly the question of what counts as art, involve political issues of legitimation and social struggle, which rap, as progressive praxis, advances by its very self-assertion as art. Other raps function as street-smart moral fables, offering cautionary narratives and practical advice on problems of crime, drugs, and sexual hygiene (for example, Ice-T's "Drama" and "High Rollers," Kool Moe Dee's "Monster Crack" and "Go See the Doctor," BDP's "Stop the Violence" and "Jimmy"). Finally, we should note that rap has been used effectively to teach writing and reading skills and black history in the ghetto classroom.[42]

Since postmodernism challenges the autonomy of the artistic sphere crucial to the differentiating project of modernity—and equally crucial to the high modernist aesthetic which refuses contamination by the impurities of practical life, politics, and the common vulgarities of mass culture—Jameson suggests that its disintegration of traditional modernist boundaries could provide the redemptive option of "a new radical cultural politics," a postmodern aesthetic which "foregrounds the cognitive and pedagogical dimensions of political art and culture" (*NLR*, 89). Jameson regards this new cultural form as still "hypothetical," but I think it can be found in rap, whose artists often explicitly aim at teaching and political activism, just as they seek to undermine the socially oppressive dichotomy between legitimate (that is, high) art and popular entertainment by asserting both the popular and artistic status of hip hop.

Like most culture critics, Jameson is worried about the potential of postmodern art to provide effective social criticism and political protest, because of its "abolition of critical distance" (*NLR*, 85). Having undermined the fortress of artistic autonomy and enthusiastically appropriated the content of workaday and commercial living, postmodern art seems to lack the "minimal aesthetic distance" necessary for art to stand "outside the massive Being of capital" (87) and thus represent an alternative to (and hence critique of) what Adorno called "the ungodly reality."[43] Though anyone tuned in to the sound of Public Enemy, BDP, or early Ice-T can hardly doubt the authenticity and power of their oppositional energy, the charge that all contemporary "forms of cultural resistance are secretly disarmed and reabsorbed by a system of which they themselves might be considered a part" (*NLR*, 87) might well be directed at rap. For while it condemns media stereotypes, violence, and the quest for luxurious living, rap just as often exploits or glorifies them to make its points. While denouncing commercialism and the capitalist system, rap's lyrics simultaneously celebrate its commercial success and business histories; some songs, for example, describe and justify the rapper's change of record company for commercial reasons.[44]

Hip hop surely does not lie wholly outside what Jameson, in a questionable organicist presumption, regards as the "global and totalizing space of the new world system" of multinational capitalism (*NLR*, 88), as if the congeries of contingent events and chaotic processes that help make up what we call the world could ever be fully totalized into one space or system. But granting for the moment that there is this all-embracing system, why should rap's profitable connection with some of

its features void the power of its social critique? Do we need to be fully outside something in order to criticize it effectively? Does not the postmodern and poststructuralist critique of definitive, ontologically grounded boundaries put the whole notion of being "fully outside" seriously into question?

With this challenging of a clear inside/outside dichotomy we should similarly ask, Why does proper aesthetic response traditionally require distanced contemplation by a putatively transcendent and coolly disinterested subject? This assumption of the necessity of distance is yet another manifestation of the modernist convention of artistic purity and autonomy which hip hop repudiates. Indeed, rather than an aesthetic of distanced, disengaged, formalist judgment, rappers urge an aesthetic of deeply embodied participatory involvement—with content as well as form. They want to be appreciated primarily through energetic and impassioned dance, not through immobile contemplation and dispassionate study.[45] Queen Latifah, for example, insistently commands her listeners, "I order you to dance for me." For, as Ice-T explains, the rapper "won't be happy till the dancers are wet" with sweat, "out of control" and wildly "possessed" by the beat, as indeed the captivating rapper should himself be possessed so as to rock his audience with his God-given gift to rhyme.[46] This aesthetic of divine yet bodily possession is strikingly similar to Plato's account of poetry and its appreciation as a chain of divine madness extending from the Muse through the artists and performers to the audience, a seizure which for all its divinity was criticized as regrettably irrational and inferior to true knowledge.[47] More important, the spiritual ecstasy of divine bodily possession should remind us of Vodun and the metaphysics of African religion to which the aesthetics of African-American music has indeed been traced.[48]

What could be further from modernity's project of rationalization and secularization, what more inimical to modernism's rationalized, disembodied, and formalized aesthetic? No wonder the established modernist aesthetic is so hostile to rap. If there is a viable space between the modern rationalized aesthetic and an altogether irrational one whose rabid Dionysian excess must vitiate its cognitive, didactic, and political claims, this is the space for a postmodern aesthetic. I think the fine art of rap inhabits that space, and I hope it will continue to thrive there.

affect and authenticity in country musicals

Affection bends the judgement to her ply.

<div align="right">DANTE</div>

I

In a famous essay, William James describes an aesthetic blindness produced by the bias of our socially constructed taste. Driving through the North Carolina mountains to appreciate their natural beauty, he was shocked by the sight of crude farming homesteads that blotched the sublime mountain green like a "hideous . . . ulcer."[1] What seemed an intrusive eyesore, James later learned, was fondly viewed by its dwellers as an attractive haven of comforting cultivation, a stirring symbol of hard-won survival in a wild landscape that they struggled to tame, not simply visit for a brief taste of nature before returning to sophisticated Boston life.

If James was blind to the aesthetic charms of these hillbilly homes, today's philosophers remain deaf to the appeal of the popular music with which such mountain homes have always been associated. Though country music has blossomed into America's most popular sound, it remains, among intellectuals, the most scorned and unexamined musical genre.[2] If studies repeatedly show that the more educated one is, the less likely one will be a country music fan, then country hits like Aaron Tippin's "Working Man's Ph.D." and John Conlee's "Common Man" strengthen this trend by blasting academics for "not pullin' their weight" and by charging that all "highbrow people lose their sanity."[3]

Because its *locus geni* is neither the cosmopolitan city nor the erudite campus but down-home rural America, because its values are far more traditional than transgressive, country music has none of rock's radical chic. Nor does it sport the sort of modish multicultural cachet that attracts progressive intellectuals to music like jazz, rhythm and blues, rap, reggae, or techno. Indeed, the stereotype of country's old links to white trash and redneck racial prejudice might even threaten to demean any thinker who gave it sympathetic attention. Nonetheless, we intellectuals *can* escape the Jamesian blindness and enjoy country music, sharing to some extent the appreciative pleasures of its lowbrow target audience, just as to some extent we share their concerns and life experience.

This chapter seeks both to explain country music's enormous appeal and to appreciate the genre in intellectual terms. Since country's popularity is overdetermined by a complex cluster of reasons too elaborate to explicate in full, I shall concentrate on those reasons that are most philosophically interesting and involve intriguing doctrines about human nature, emotion, belief, and authenticity—some of them advocated by William James himself. These philosophical issues become especially clear in the film genre generated by country's great commercial success. I call this genre "the country musical," distinguishing it from the traditional "singing cowboy film" made famous by Gene Autry, Roy Rogers, and Tex Ritter.[4] Before probing country's philosophical import as revealed in its new musicals, we should begin by noting the sociocultural factors that greatly contribute to country music's popularity, for the philosophy of any cultural form (including philosophy itself) is unwise to ignore the sociocultural space that shapes the production and use of its products.

II

One crucial factor in the increasing popularity of country music is the demographic aging of America. Partly through its affirmation of traditional values, country music has always appealed to an older audience than rock and rap. While the latter pop genres focus on the teens and early twenties, country music's audiences cluster between the mid-twenties and late-forties. As the children of the postwar baby boom moved into this age range, country music evolved from an eccentric, minor musical genre into a mainstream popular force. Song lyrics sometimes recount how rock radicals of the sixties evolved, by the nineties, into country fans advocating mainstream America and family values. But the correlation of country music's growth with the aging of the baby boomers is perhaps more convincingly told in statistics. In 1961 there were only 81 full-time country music stations in the entire United States; in 1974 the number had reached about 1,000; by 1992 it had rocketed to over 2,200; and by the end of 1996 it had climbed to 2,600.[5]

A second factor in country's new popularity is America's increased preoccupation with ethnic identity and multiculturalism. As traditional class identities and community identities lose their power to provide the individual an adequate social definition, there is a greater need to construct one's identity through cultural affiliation. Music has long been extremely significant in forming such cultural identity. But if the broad

concept of American culture is too vague and bland to provide an attractively thick sense of cultural identity, then so is the notion of American music. As today's most exciting options for distinctive cultural definition are the emancipatory consciousness-raising movements of minority ethnicities (along with feminism and gay culture), so ethnicity now offers perhaps the most absorbing musical cultures (e.g., rap, reggae, salsa) that go beyond mere music by providing a comprehensive lifestyle for self-fashioning. But however attractive such musical cultures may be for white Americans, our racially divided society denies whites a trouble-free identification with nonwhite culture. Beset by the dialectic of reciprocal exclusion, where excluded minorities exercise their own exclusionary power, such attempts at transcultural affiliation are often doubly rejected: they are as unsavory to the courted minority culture (who fear the plunder of their hard-won heritage) as to mainstream white society (who fear the loss of their cultural hegemony).

Where, then, can one find a specifically white American ethnicity expressed in a distinctive, ethnic popular music? Country music is the obvious answer.[6] Like rap and reggae, it provides a complete cultural style replete with distinctive dance, fashion, food, and behavioral ethos. Here whiteness can mean more than a mere pale background of conformity that highlights nonwhite ethnicity. Indeed country culture distinguishes itself by its defiance of the bland, corporate, white-collar establishment—not only by its cowboy fashion and down-home, twangy speech, but in its oppositional attitude. By invoking the cowboy image of rebelliously rugged individualism while also recalling its reputed roots in the South (land of the Civil War rebels), country music can project an image that is traditional, white, and all-American, yet also attractively distinctive and not blandly conformist. Thus, in his hit "Against the Grain," Garth Brooks circumvents his image as a country-mainstream crossover by claiming the nonconformist heroism of going "against the grain" to "sing a different song" and "buck the system"—portraying this nonconformism as being true to the "mav'rick" tradition of classic cowboy hero John Wayne and to Brook's own "rebel blood."[7]

Though defiant of the white corporate establishment and intellectual elite, country music (partly through its traditional ties to working-class white culture) favors whiteness per se. It thus can recruit American whites from all different ethnic backgrounds, rallying them around a distinctive white image, whose cultural roots they may not have inherited but which they can adopt without the contradiction of color. Even

an actor of salient Italian ethnicity like John Travolta can suddenly don honky-tonk cowboy gear and be unproblematically accepted as the deep-rooted white Texan hero Bud Davis of *Urban Cowboy* (1980). For the millions of lower- and middle-class white Americans seeking a distinctive identity that simultaneously enables them to *stand out* from the nondescript blandness of white American mainstream culture while still *fitting in* as true to its traditions, country must be the music of choice.

A third factor fueling country's rocketing popularity is the dearth of competitive alternatives in the 1990s musical field. Rock and roll's long swell of creative energy has largely waned, and the most exciting popular new genres developing out of its transgressive tradition—rap, techno, and heavy metal—are very unappealing to the vast majority of Americans. Their sound is too fiercely young, loud, and strident for most adult ears; their verbal message is not only hard to grasp over the blaring music but is also (in the words of the *New York Times* culture critic Peter Applebome) "either inscrutable or off-putting" to white Americans over twenty, projecting values and lifestyles that they simply cannot share.[8] Country's greatest new star, Garth Brooks, exemplifies this trend. Originally a hard rock fan and aspiring performer, he confessed that he moved to country partly by recognizing that he "couldn't stand that [rock] lifestyle longer than three minutes."[9]

Always ready to profit by incorporating popular musical trends and crossover artists (even the Australian pop singer Olivia Newton-John),[10] country could absorb the genres of light commercial pop, soft rock, and folk music. Thus, with the rest of the pop field polarized and dominated by the more radical rap and heavy metal styles, country has been able to capture the largest demographic niche. Moreover, by skillfully deploying the newer genre of music videos to recruit attractive young performers as potential teenage heartthrobs (who seem far more "wholesome" and socially acceptable than those of rap or heavy metal), country has recently succeeded in also capturing a far greater teen and young-adult audience.[11]

For most Americans, not only are country music's words easy to understand, but its truths are easy to believe, and its feelings easy to share and accept as real. More philosophically interesting, however, is that it is easy to accept the truths and share the feelings *because* one gets the words, while one believes the words because one gets the feelings. This reinforcing dialectic of affect, credence, and verbal narrative constitutes, I shall argue, the philosophical core of country music's aura of authen-

ticity and its ability to sustain this appealing image of down-home purity that, paradoxically, clearly flouts the hard facts of its past. To clarify the detailed workings of this persuasive dialectic, I now consider its concrete deployment in the narratives of country musicals, concentrating primarily on *Pure Country* (1992) but concluding with a brief comparative analysis of *Honeysuckle Rose* (1980).

III

As its title declares, *Pure Country* is devoted to affirming the enduring power of country music's authenticity and purity. Though partly a reply to highbrow critiques of country's commercialist fraudulence (paradigmatically in Robert Altman's biting satire *Nashville,* but also in Daryl Duke's earlier and more nuanced *Payday*), *Pure Country* is also a response to real commercializing pressures arising within the genre as a result of its recent mainstream success.

With adroit casting to combine authenticity and box-office appeal, the film stars the clean-cut and boyishly good-looking George Strait. Probably the most wholesome and commercially successful of the so-called neotraditionalist country singers, Strait rose to stardom in the early 1980s and has managed to stay there and sustain his neotraditionalist image until today.[12] Strait moreover perfectly embodies one of country's prime images of authenticity, the cowboy. In the words of the premier country music historian Bill Malone, "Strait is a genuine cowboy who grew up on a ranch near Pearsall, Texas," and only began singing publicly while serving in the Army in the late 1970s.[13]

Urging its title theme of purity from the very outset, even before the pictures begin to move and the dialogue begins, *Pure Country* opens with a series of old-fashioned, orange-tinted stills — suggesting old photographs and glorious morning sunshine. Focusing first on a young boy's hopeful eyes and innocent face, the photos then show him with a guitar, alongside a barefoot boy drummer seated on a rustic porch, followed by other photo images suggesting innocent country childhood: an old hanging-tire-on-a-tree swing, a wood cabin, and a windmill.

Audibly reinforcing these images of traditional purity, the movie's soundtrack (simultaneously released as a George Strait album) begins with a child's voice (that of Strait's son, George Strait Jr.) singing *Pure Country*'s theme song ("Heartland"), which opens and closes both film and album. Confirming the message of purity and authentic roots in the still uncorrupted heartland of America, the lyrics portray country mu-

sic as the cultural home where the life and feelings of hard-working Americans find true expression.

> When you hear twin fiddles and a steel guitar,
> You're lis'nin' to the sound of the American heart.
> And Opry music on a Saturday night
> Brings a smile to your face and a tear to your eye.
> Sing a song about the heartland,
> The only place I feel at home.
> Sing about the way a good man,
> Works until the daylight's gone.
> Sing the rain on the roof on a summer night,
> Where they still know wrong from right.
> Sing a song about the heartland,
> Sing a song about my life.

As the song moves into its second verse, the adult voice of George Strait takes over. The lyrics still praise country's heartland as a place of pure simplicity (where "you feel Mother Nature walk along with you / Where simple people livin' side by side / Still wave to their neighbors when they're drivin' by"). But the photo images grow ever farther from the original idyll of childhood innocence: the drummer boy, now sporting a thick mustache and cowboy hat, stands together with the adult George (also with cowboy hat) in front of a pickup truck: first with a sweet grandma type, who is replaced in later stills by a pretty young woman, and then amongst what seems to be a small group of rural onlookers. We then see the three young adults, still rather simply dressed, but in performance poses inside a rustic-looking music hall; the non-talking sequence of stills concludes with the image of an upturned hat filled with dollar bills—a hat passed around in that traditional (not yet slickly commercialized) form of paying entertainers.

Complementing the opening close-up of the boy's face, the camera next focuses (with zoomed enlargement) on the face of the dollar bill, till the eyes of George Washington dissolve. The next thing we see, as the movie suddenly launches into standard cinematic movement and color, are the bright blue eyes of George Strait, shifting worriedly and rapidly, through a thin smoky mist surrounded by a dark background and the din of a screaming audience. The film immediately turns to overview shots of this huge stadium audience and the spectacular show

of multiple moving spotlights and flashing colored strobes. As the camera zooms back and forth from audience to stage, George Strait makes his top-act entry (in a pillar of smoke) as country singing-star Dusty Chandler, wearing a smile of brave resignation, almost like a Christian gladiator entering the brutal arena of a Roman circus.

In tracing how a happy child blessed by Mother Nature's pure light devolves into a frightened adult surrounded by the smoky din and darkness of big-business entertainment, this two-minute opening title sequence already articulates *Pure Country*'s motivating theme: the lucrative but dangerous path from innocent authenticity to commercialized corruption, the ontogeny of the hero Dusty Chandler recapitulating the phylogeny of country music as a genre. The movie's whole subsequent plot then argues that country's purity can nonetheless be sustained, without sacrificing its commercial success, by returning to the music's alleged authentic roots.

This return to simple roots is symbolized by country star Dusty's flight from his high-tech road tour to make a secret trip back home. In this process of purification, he first sheds his fancy show-business clothes and trendy ponytail and stubble, then receives guidance from his Grandma Ivy, and soon falls in love with a wholesome rodeo cowgirl on whose family ranch Dusty stays to practice cowboy life and skills, unrecognized as a country music star because of his humble manners and unfamiliar clean-cut look.

The cowboy theme is so important that the film devotes two whole minutes to a ceremonious rodeo opening, where a galloping cowboy dramatically parades Old Glory to the tune of "America the Beautiful." Country's image of proudly authentic Americanism is linked to racial purity, since all the film's musicians, fans, reporters, bartenders, waitresses, etc., are clearly white. The only nonwhite (briefly shown and laughed at) is a pigmy-sized black valet who (with exaggerated breakdance movements) opens limousine doors at the Las Vegas Mirage Hotel, where Dusty makes his climactic return to performance and to the traditionalist "pure country" style.

Country music's identification with old-fashioned, rural, all-American purity could not be claimed more clearly; and it is also affirmed in other country films (e.g., *Tender Mercies, Honeysuckle Rose, Coal Miner's Daughter, Sweet Dreams, Honky Tonk Man*). This pure rustic image is much more than a mere Hollywood convention. Resounding in the music's own lyrics, it is further reinforced by advocates outside the mainstream

entertainment industry. Henry Ford, for example, supported early country music's image of old-time authenticity (partly by staging fiddling contests), because he held that "real" American culture "lies outside the cities." A similar quest for a native "essentially Anglo-Saxon" music led the composer, conductor, and music educator Lamar Stringfield to claim (with disturbing racist undertones) that country culture's remote location "has left [its] people in a natural state of human feeling and their music free from minstrelsy." [14]

Such traditionalist images of all-American purity are, however, very far from the truth. Though the fiddle was always central to the genre and part of its originating folk culture, the steel guitar (likewise claimed in *Pure Country*'s theme song) was in fact an importation from Hawaii that did not become a trademark of country music until the 1940s. This allegedly all-American genre was first considered by music's leading trade magazine, *Billboard,* as part of its foreign music coverage, and later grouped with "race" music until finally achieving the label of "American Folk Music." [15] Nor is country's cowboy image authentic. As Malone maintains, "the cowboy contributed nothing to American music" but merely provided a romantically attractive (hence commercially effective) image that country music skillfully deployed in order to escape its narrow identification with the negative, far less marketable image of hillbilly culture. [16]

Finally, the image of country's all-white and noncommercial origins is pure myth. Malone and other scholars document how it always "borrowed heavily from the black" music culture. The banjo came from Africa, and black blues was such a strong influence on some country songs that they were sometimes falsely catalogued as "race" music. Jimmie Rodgers, called "the father of modern country music," developed his skills playing with black musicians in his Mississippi hometown and began his professional career "as a blackface entertainer with a medicine show"; Roy Acuff of Grand Old Opry fame also began by doing blackface in a touring "physik wagon," and even the Grand Old Opry itself had blackface acts. As a twelve-year-old boy, Hank Williams learned guitar and singing techniques from a black street singer called Tee-Tot. Ray Charles cut a country album and also did songs with country star George Jones, while black singer Charley Pride won the Country Music Association's Entertainer of the Year Award in 1971.

As Malone concludes, if country music "was neither pure white nor 'Anglo' in origin or manifestations, neither was it exclusively rural or

noncommercial."[17] Most country singers grew up in close contact with cities, and many of country's early classics (e.g., "Lovesick Blues") were actually born in New York's "Tin Pan Alley." From its early links to traveling medicine shows and to vaudeville and blackface minstrelsy, complemented by its close ties to the pop music business of New York, country was never free from commercial motives. But today's country music (with its media hype, mainstream crossover strategies, and advertising uses) has acquired such a strong commercial image that it seems to render the notion of "pure country" a blatant chimera. Yet despite its factual incredibility, this myth of authenticity persists, perpetuated by country performers and fans who both clearly know better. If the above-noted impurities are not common knowledge to the average country listener, surely all must recognize the blatant historical falsity in Barbara Mandrell's song "I Was Country, When Country Wasn't Cool," where she claims country authenticity for having enjoyed "Roy Rogers at the movies when the West was really wild."

IV

Given its obvious impurities, how does country music nonetheless convince its fans of its pure authenticity? What, indeed, are the basic sources for creating credence and for forming our standards of authenticity? These questions reach beyond the specifics of country music toward the deepest philosophical issues of belief and reality. To seek answers we return to William James.

Insisting on the essentially affective nature of human animals (a view inherited from both Hume and Darwin), James argues that in the everyday practical sense in which "we contrast reality with simple unreality, and in which one thing is said to have *more* reality than another, and to be more believed, *reality means simply relation to our emotional and active life. . . . In this sense, whatever excites and stimulates our interest is real*; whenever an object so appeals to us that we turn to it, accept it, fill our mind with it, or practically take account of it, so far it is real for us and we believe it. . . . *Every exciting thought in the natural man carries credence with it. To conceive with passion is eo ipso to affirm.*"[18]

Two central ideas that James expresses here can help explain how country music wins acceptance of its pure authenticity despite recognized evidence to the contrary. The first point is that credence comes through emotion. The second is that reality—and, by extension, authenticity and purity—can be conceived in comparative terms of more

or less. Through this logic of relativity, country music can claim an all-American, rustic authenticity, despite full recognition of its actual impurities and inauthenticities, by nonetheless affirming its contrast to the much greater impurity and commercialization of other pop music (and even of country's own impure, degenerate forms).[19]

Extreme emotion or sentimentality is a trademark of country music and a prime reason why intellectuals dismiss it as vulgar kitsch.[20] Yet both scholars and singers of country music see its "open display of emotion" as the key to its success and sense of authenticity. Jimmie Rodgers, for example, is described as compensating for his musical limitations by "the simple authenticity and intense emotion he brought to every performance," emotionally singing "as if he'd lived every line and suffered every change." Rodgers himself insists: "It's gotta have pathos. Make folks feel it—like we do, but we gotta have the feelin' ourselves first." Despite his poor fiddling, Grand Old Opry star Roy Acuff first won his job because his "emotional style" ("often crying openly while singing") conveyed great "sincerity." Even today's mediatized megastars, like Garth Brooks, still claim their preference "for one song that was from the heart [more] than 80 songs that were clever and went to No. 1 on the charts," a preference affirmed in so many song lyrics. The "utter sincerity" that scholars see as crucial to country's success is conveyed not by factual demonstration but by emotional conviction: pathos proving that the song comes so directly from the heart that no falseness is possible. Historians link country's pathos to Southern traditions of pietism, where theological sermons took the form of emotional tales and appeals to mercy rather than judgment. "Sentimentality—the appeal to the heart, even in contradiction to the dictates of the head—had been raised to an ultimate principle."[21]

Though it is incontestable that country music is strongly sentimental, it is equally incontestable that intellectuals and other critical listeners recognize the sentiment but remain immune to its appeal or contagion. They find it mawkish, unconvincing, commercialized kitsch: in short, the very opposite of authentic. How to explain such difference of reaction and belief? James himself recognized that the same idea has variable emotional suggestiveness for different people and, consequently, variable power to "prove efficacious over belief." The causes of these differences, James argued, "lie chiefly in our differing susceptibilities of emotional excitement, and in the different impulses and inhibitions which these bring in their train."[22]

The exemplary intellectual attitude of cold, rational, critical thinking (so deeply cherished by philosophy) surely aims to supply precisely such an inhibition to emotional excitement and consequent facile credence. A prolonged habit of inhibiting emotional excitement in order to insure that it be subordinated to our rational and cognitive interests can become so deeply ingrained and automatic that it works unnoticed, becoming an unconscious reflex, an instinctive distaste for emotional gush. The disciplinary (and also social) training of intellectuals would tend to instill such habits of inhibition regarding the rapid surrender of self to strong emotions.

It is hardly surprising, then, that intellectuals prove less susceptible to country's sentimental charms than do those "simpler" laboring folk less trained in the inhibition of critical thinking.[23] Such working-class people, moreover, have far less leisure and energy to take a very selective or critical view of the positive emotional content that country music offers. Too harried to be extremely discriminating, they seize and savor enjoyable emotional fare (that indisputable spice of life) where they can readily find it. Moreover, the very fact that country's hard-stressed, hard-working target audience both needs easy emotional release and easily finds it in country music further strengthens the habitual link of this music with emotion, making the emotional trigger of country music ever stronger and surer.

At work here is a somewhat circular mechanism of emotional satisfaction and reinforcement. The habitual desire for enjoyable emotion and its proven past arousal in country music tend to reinforce the emotional suggestiveness of the music, creating in the target listener an anticipatory tension to emote at the hearing of a country song: an anticipation, tension, or tendency that in realizing itself reinforces still further the emotional liveliness of country music. This circularity is best understood not as a vitiating logical fallacy but as a psychological fact of habitual conditioning and reinforcement.

We must, of course, go beyond these theoretical generalities and examine more closely some particular cases of country's emotional creation of credence. We need to see examples of how pathos serves country music's claims to authenticity and how it dovetails with the comparative notion of the real and pure; how country exploits the psychological mechanism wherein perception of greater authenticity in (some form of) country music combines with a strong emotional longing for the

pure and authentic, thereby generating a seductive sense of authenticity *tout court*—pure and simple. But before examining the deployment of such strategies in specific country musicals, we should note a third basic device that helps create credence and authenticity: the use of narrative. Since William James neglects this factor, we must turn to another (and still more "uncountry") philosopher of experience, the cosmopolitan sophisticate Walter Benjamin.

In his famous essay "The Storyteller," Benjamin mourns the progressive loss of storytelling through the fragmentation of experience (which thus "has fallen in value") and the weakening of tradition. In contrast to history, the validity of a story is "not subject to verification" and does not depend on detailed explanation. Its belief-creating authority, Benjamin argues, depends on links to the powerful "chain of tradition" and to the invariant life cycle of human experience that ends in death. But what ultimately generates the story's conviction is its capturing the listener's interest. Benjamin employs the term "listener" because he insists on "the oral tradition" in storytelling, its link to the "living immediacy" and communion of oral exchange, in contrast to the book-dependent privacy of the novel.

Oral narrativity also implies the need for memory in preserving the story, which requires a more accepting participation on the part of the listener. Hence "the listener's naive relationship to the storyteller is controlled by his interest in retaining what is told." Finally, the storyteller's narrative commands credence because it claims to be based on personal experience, direct or witnessed: "his raw material is life, particularly his own."[24]

This is precisely the stance of the typical country song, a first-person telling of some life episode or a longer life story, most typically that of the singing narrator. Though the singer's tale gains power from links to oral traditions of storytelling and balladry and from the traditional values and stories it relates, its authority also comes from its sense of authentic life experience. Often the story is a painful one, involving the narrator's own error, loss, and regret. But precisely by virtue of this painful self-exposure, the singer can claim not only the authenticity of sincere confession but even a measure of authority and distinction, as someone having the courage to share his painful lessons so as to instruct his public. Here the country singer approaches what Benjamin describes as the source of the storyteller's "incomparable aura" and affinity to

"teachers and sages": his ability "to relate his life," to "let the wick of his life be consumed completely by the gentle flame of his story."[25]

Describing country music as a storyteller's art is no mere attempt to give it an intellectual Benjaminian chic. Its self-conception as "a story-teller's medium," widely recognized by scholars, is even clear from the way that "other song elements are generally kept simple to highlight the story. The chord structure is simple and predictable, the melodic range is slight, the rhythm is regular, and the orchestration is sparse or at least clearly in the background so that the words can be understood." In the words of one country singer-songwriter, "If you can't hear each word, it ain't country, son."[26] Country's words get their importance not from their specific poetry but from the stories they embody, stories that can capture an audience far beyond those who prefer country's simple melodies and rhythms. Challenged about his taste for country music, jazz great Charlie Parker replied that he simply loved the stories.[27]

Country's narratives succeed not only through the elements of tradition, orality, and life experience that Benjamin notes. Narrative form itself intensifies the pathos and comparative authenticity that country deploys. The progression, development, and anticipation that constitute all narratives contribute to the buildup of emotions. The archetypal commonality of country's stories (with their focus on fundamental feelings of love, failure, and mourning) serve to trigger emotional memories that reach both deep and wide. And this same archetypal, formulaic simplicity of story line permits extreme plot condensation, thus promoting emotional intensity by forestalling fatigue of attention.

Condensation and credibility are further enabled by the fact that country's sung stories are often recognized as being about the singers' own lives, thus allowing listeners to enrich the tales with facts they know about them (e.g., George Jones's bouts of drinking and Garth Brooks's marital infidelity and reconciliation). To heighten its power of pathos, country thus productively blurs the presumed division between art and life, artistic persona and real individual. Finally, the narrative frame that country deploys is most useful for making contrasts of comparative authenticity that are emotionally charged and hence more convincing. Narrative temporality not only provides the retrospective memory of country's older days of purer authenticity, but suggests the on-going struggle to develop or recover greater authenticity in the face of present corruptive pressures.

V

How do the credence strategies of pathos, comparative authenticity, and narrative reinforce each other in concrete cases of country musicals? Consider *Pure Country*. Its opening theme song, "Heartland," more clearly suggests the presumed anatomical home of emotion than a specific geographical reference to rural America. Its lyrics affirm old "Opry" standards of musical authenticity as constituted by emotional reactions (of "a smile" or "a tear"), reactions that the film's plot and music seek to evoke: right from the initial title sequence, with its tender sound of a child's singing voice and its subsequent sentimental suggestion of lost innocence. The pure authenticity of Strait's neotraditional yet commercially crossover brand of country is then hammered home by a narrative structured on comparative authenticity.

In the plot, Dusty Chandler (the homespun, rural Texan hero Strait portrays) has won huge stardom, engineered by the commercial strategies of his strict manager and former lover—the ambitious and vampishly attractive Lula (played by Lesley Ann Warren), whose younger and far more innocent looks graced the title sequence. Exploiting country's crossover commercial potential through the style of high-glitz rock performance, Lula has modeled the Dusty show into a noisy, pyrotechnic, stadium extravaganza, while turning Dusty himself into a flashy rock-style heartthrob, replete with white leather jacket, snakeskin boots, pony tail, and sexy "designer" stubble (à la George Michael). She even tells him what songs to sing and what words to use to close his concerts. Complaining to Lula that the glitzy show denies him authentic self-expression and true communication with his audience ("I'm tired of all the smoke and the lights. It ain't me. . . . The people can't see me with all the smoke and lights and they can't hear me because the music's so loud"), Dusty is tempted "to drop the whole deal, including [his] stupid-looking outfit" of cowboy *haute couture*.

After Dusty's drummer friend Earle confirms this critique, we see Dusty walk off-camera,[28] and in the next shot he is hitching a ride in a truck, where he soon exchanges his snakeskin boots for the trucker's "real" cowboy pair. Further rides lead him deeper into the Texas countryside of his youth (a return to innocence symbolized by Dusty's removing of his ponytail, beard, and his remaining fancy duds) until he reaches home, where Grandma Ivy also confirms his critique of Lula's showbiz aesthetic. Complaining of the concert's "smoke and lights" and

amplified background "noise" that prevented her from really seeing and hearing Dusty at his concert, she underlines the message: "Without the words, there's no song."

The return to authenticity is further symbolized by Dusty's return to his old acoustic guitar and visit to his parents' grave (for death, ever a symbol of life's basic realities, is, as Benjamin notes, an ancient source of storytelling authority). Dusty even goes back to the simple bar and dance hall where he first performed as a country singer. Getting drunk there, Dusty literally falls off his chair and gets beaten up because of his attraction to a sweet-looking redhead (named Harley) dancing a country line-dance. Pitying him but not recognizing who he is (apparently because of his transformed looks and simple ways), she takes him home.

Home turns out to be a real ranch, and Harley a real cowgirl who competes in the professional rodeo circuit in order to win enough money to save her family's no longer economically viable ranch, whose land has been steadily sold off to keep the family (Harley, two brothers, and her father) financially afloat. Dusty, who reverts to his original name of Wyatt, convinces the brothers to let him stay on at the ranch by paying them huge sums of money for room and board, a horse, and roping lessons. As the love story between Dusty and Harley blossoms, she confesses an earlier love for a stranger who turned out to be married and, questioning Dusty, learns that he was never married.

During Dusty's return to pure country realities, Lula has been desperately trying to locate him, while also insuring that the show goes on without him: by using a handsome stagehand (her current lover) as a Dusty impersonator who lip-synchs his songs in concert. Though this goes undetected (since Lula increases the concert smoke and noise), the band protests the fraud and threatens to quit. Dusty's loyal old friend and drummer Earle runs off to look for Dusty at wise Grandma Ivy's and is told "if you follow the roots you'll find him." Earle does, but so does Lula, who (unbeknown to Dusty) falsely tells Harley that Dusty is her husband before whisking him off to his next concert in Las Vegas, which also happens to be the site of Harley's next rodeo.

By now, the publicity-hungry stagehand has leaked his story to the media, inciting a raging controversy that country's authenticity has been corrupted by the fraudulent commercial tactics of pop music as notoriously exposed in the Milli Vanilli lip-synching scandal, which the film's dialogue explicitly cites. All the mass-media attention thus focuses on Dusty's Las Vegas concert as a crucial test case of country mu-

sic's purity and authenticity. Dusty insists that Lula must let him do the concert his way ("no more smoke, no volcano blasts, no light show") and that Harley and family be invited to the concert and be told of Lula's lies. After a short segment about Harley's rodeo (which focuses more on American flags and anthems than on her riding), the film reaches its climactic conclusion in Dusty's concert at the Mirage Hotel, at which Harley and her family, as well as Grandma Ivy, arrive in limousines (greeted by the laughable pigmy valet, an unwitting symbol of the shrunken, token recognition of black culture's gifts to country).

Holding his old acoustic guitar, Dusty walks onstage, this time with no smoke, no flashing lights, and no background noise. He tells the cheering crowd that tonight he's going to do something "a little different" and asks the stage director, "Could you follow me with the spotlight right here in front, please." He sits on the edge of the stage facing Harley and sings her a love song ("I Cross My Heart"), gazing tenderly at her through a very thin haze of smoke that seems merely the product of the club's smokers and the bright spotlight. As Dusty sings, Harley trembles with tears of happiness, whose flow continues to surge till the song's conclusion, when Dusty descends from the stage and embraces her to the emotional clapping, hoots, and whistles of the cheering crowd.

It should be clear from this plot description that the film's affirmations of purity, authenticity, and "the real" are only established by contrast, thereby suggesting (even to nonphilosophic viewers) the relativity of these notions. Though Dusty's opening concerts may be condemned as a commercial corruption in comparison to what we imagine were his innocent youthful performances, they are still far more authentic than the fraudulence of his lip-synching stagehand or the pop group Milli Vanilli. Again, while the fancy-dressed "show-biz" Dusty may not be the real Dusty, he is surely more the real Dusty than his stagehand impersonator.

Moreover, Dusty's withdrawal from commercial show-business values is only partial and temporary. To remain at Harley's ranch he offers not hard work but a fistful of cash to her money-hungry brothers, who need the money because the ranch—the film's paradigm of country cowboy authenticity—is no longer financially functional. Nor is Harley, strictly speaking, a real "cowgirl" who rides the range driving cattle. She is simply a rodeo or "show" cowgirl, whose major shows include such impure venues as Las Vegas. Nor can she boast of virginal innocence, for we learn of other men in her past. Still, in contrast to

Lula's business greed and casual sex, Harley shines with country purity and authenticity. In similar fashion, though the still unmarried Dusty is obviously no virgin, his essential (yet *relative*) purity is shown by contrast to his band of divorcés, including his old friend Earle.

Finally, how pure is the film's climactic return to country authenticity in both music and courtship? Dusty's musical declaration of love to Harley is sung, not spontaneously in a country meadow, barn, or honky-tonk, but staged as a show performance at Vegas's Mirage Hotel in front of hundreds of people. Though eschewing Lula's flashing strobe lights and smoke, Dusty still calls for a spotlight to make his singing more effective, a light that reveals the nightclub's own smoky haze.

In short, while country's purest music and authentic love confessions still involve artificial light, smoke-polluted air, and a commercial audience, they convince by their contrast to worse impurities and by their emotional appeal to our need to believe, an unavoidable need that pragmatism recognizes when it defines belief as an essential (though not necessarily explicit) guide for action. So when Dusty sings, "In all the world, you'll never find, a love as true as mine," Harley believes him (and we know she believes him), not because she has adequate empirical evidence, but because she has no conclusive proof to the contrary and because he seems truer than her last love and captures her emotions. Her smiling tears are presented as proof not only of her belief but of Dusty's sincerity. The ardently approving smiles of Grandma Ivy and Harley's family confirm this credence, as do the heartfelt cheers of the audience. In fact, so do the feelings of the film's real audience, who, having identified with the lovers and impatiently awaited their long deferred first embrace, seek an emotional release from this tension of anticipation.

In introducing the film's audience, we reach another level of reality (one of real viewers and actors rather than mere fictional characters) that reinforces country narrative's sense of authenticity. Belief in the truth of Dusty's love and music gains power from country fans' knowledge that the "real" Dusty (actor-singer George Strait) has proven true both to his neotraditional style and to his one and only real-life marriage.

The musically neotraditionalist but three-time divorced Willie Nelson could hardly make Dusty's purity so credible. But Nelson, in *Honeysuckle Rose,* does succeed in portraying his own philandering, honky-tonk form of country authenticity in the singing star Buck Bonham, who is every bit the macho, good-timing ham that his name suggests.

Already known for adultery and divorce, Buck betrays his still

youngish wife and former singing partner (played by Dyan Cannon), despite their close relationship and much-loved young son. While Buck adores the country singer's road life (the film's title song and alternative title is "On the Road Again"), wife Viv insists that their Honeysuckle Rose homestead is the only proper place to have a family. When Buck's old playing partner Carlin retires and his prospective replacement fails to come through, Carlin's talented daughter Lily (who idolizes Buck and teaches his son music) joins the road tour. The emotional energy of their musical collaboration leads to a love affair that becomes increasingly evident onstage in their passionate duets: sensually kissing as they sing, "There ain't nothin' sweeter than naked emotion / You show me your tongue and I'll show you mine." At this point, Viv (who is suddenly alerted to the danger) arrives and goes onstage, surprising Buck and Lily in the act, exposing Lily's status as a trusted family friend, and announcing to the entire public that she is getting a divorce. To the stunned cries of the crowd, Viv icily responds: "Isn't that the kind of things that country songs are all about?" The stunned Buck (much like Dusty) suddenly vanishes, abandoning both Viv and Lily—and his show.

As the intimacy of adultery and marital breakdown are played out onstage, so is the couple's reconciliation, a week or so later at a concert honoring Buck's retired partner Carlin. While Viv does a song about forgiveness ("there must be two sides to every story . . . come home and tell me yours"), Buck arrives from the back without her noticing and gives her instrumental accompaniment. Though relieved at last to see him, she remains visibly angry. Without stopping to exchange any purely private words, Buck treats the private publicly, launching into a love song of repentance, delivered very softly and almost a cappella, with just a few framing chords: "I'm living out my love on stages; ten thousand people watching," he sings, voicing the apology "I treated you unkind," insisting there is "no one more important to me," promising to remain close to her forever so that "when my life is over I want you to remember how we were all alone, and I was singing my song for you."

Visibly moved by the passion of Buck's musical message and by her own strong emotional need for his love, Viv's tearful smile shows her faith in his sincerity and vow to reform, despite all past evidence to the contrary. Simultaneously sensing and sealing their reconciliation, Buck and Viv then spontaneously break into a duet of "Uncloudy Day." Sung with impassioned love and physical closeness (though in a style far more chaste than the Lily duets), this old gospel song of paradise signals to

them and their cheering audience (including even a bravely smiling Lily) that their marital future will be untroubled bliss.

Why should Viv (or anyone) believe Buck's sincerity? Why should we give credence to her forgiveness and their future together? Besides the mere openness of the future and the instinctive hope that we forward-looking creatures nurture, our belief is impelled by the irresistible sweetness of "naked emotion" expressed in Buck's song and echoed by Viv's strong emotional response and need to believe him. The sense of truth in their reconciliation is reinforced by the emotional approval of the audience of faithful fans, who represent (like an ancient Greek chorus) the authority of community and tradition.[29] Buck's reform gains still greater credibility through strategic comparison. Even if he is still far from pure, he is surely purer than when he was onstage, or in bed, with Lily.

To enable the workings of this comparative strategy and the buildup of emotion, we need the structure of narrative. And country narratives can be especially quick at summoning up both comparisons and emotion by deploying traditional stereotypes whose simple familiarity tends to trigger habitual emotional response and concomitant credibility (unless checked by a habitual critical inhibition).[30] Through the same emotional logic of familiarity, Willie Nelson's reputation as a real-life Buck Bonham struggling to make a marriage finally work renders the fictional Buck's good intentions still more credible to country fans.

VI

Should belief that relies so much on feeling not simply be scorned as the feeble epistemology of country cretins? We critical, rational, empirical philosophers are very quick to make this condemnation, but William James (whose pragmatism embraced empiricism) would suggest otherwise. As practical creatures who must act, we human beings need to believe "ahead of the scientific evidence."[31] As affective creatures whose evolutionary survival has largely relied on our feelings, we justifiably believe with our hearts (and other muscles) before our minds, though such belief is not immune to error and revision. Love that we deeply feel is always taken as true, till it proves false. Pragmatism's hopeful fallibilism extends to romance as well as to science.

From Walter Benjamin's storytelling perspective, faith in country narratives may also find some comfort. Though damned by modernist standards of originality and cognitive discovery, country's formulaic

plots and stereotypes have not only emotional persuasiveness but even the aura of a deep, redemptive kind of truth. If we look past their banality, we may see the expression of a deep collective memory, recalling the sadly universal (archetypal) realities of lost innocence, corrupted values, betrayed love, disappointed hopes, the common failures of life, and the inevitable loss of death.

But what then becomes of country's hopeful credence—the faith that music and love can, just like Dusty and Buck, overcome corruption to regain both purity and success? This may seem a credulous illusion that damns the genre philosophically. But for us striving creatures, hope is (and must be) as permanent a reality as disappointment. In such light, country's emotional conviction of the possible triumph of good, its belief (in advance of the evidence and despite past error) that love can prove true and the corrupt be purified, could seem more than hillbilly folly. It can be seen not as blindly refusing to face the facts, but as wisely looking also beyond them so as to affirm the truth of ideals that both heart and mind embrace, yet repeatedly fail to achieve. Such ideals remain very real and redemptive, despite our failure to realize them in our imperfect lives.

5 |

the urban aesthetics of absence

Both clay and the absence of clay are needed to produce a vessel, . . .
thus as we profit from what is present, so we benefit from the absent.

LAO TZU

I

Pragmatism, as I practice it, is a philosophy of embodied, situated expe-
rience. Rather than relying on a priori principles or seeking necessary
truths, the pragmatist works from experience, trying to clarify its
meaning so that its present quality and its consequences for future ex-
perience might be improved.[1] Experience is inevitably contextual, since
it involves the interaction of an experiencing subject and the environing
field, both of which are in flux and are affected by their interaction. But
this contextuality of experience does not entail a hopeless subjectivism
that precludes all generalizations. For human subjects and environments
share many contextual features. Nonetheless, a philosophy that argues
from experience and recognizes its contextuality should be reflective
enough to declare its own experiential situatedness.

This seems especially important in theorizing something as contextu-
ally diverse as the city, which varies from the geometric New York grid
and Parisian *grands boulevards* to the labyrinths of Rome's old *centro storico*
and the Medina mazes of Fez. Though one's philosophical points may
have pan-urban validity, one's own specific urban experience will and
should come into play.

I wrote this essay in Berlin after a year's experience of its often dark
pleasures and morbid fascinations; its moods, motions, and milieus now
press more strongly on my mind than older and longer experiences of
city life in Paris, New York, and Tel Aviv.[2] The essay's theme of absence
emerged after a long night of techno music in East Berlin's Mitte quarter,
at a club reopened (with a new name) in a new but still illegal locale,
after having been closed by the authorities at an earlier, abandoned site
also in the East.

Complementing the loud music and flashing lights that filled the dark,
cavernous space of the shabby hall, a silent video was soberly projected
high on one of the room's degenerating plaster walls. A bright yellow
U-Bahn train, from whose front window the video was shot, winded its

seemingly endless way through Berlin's enormous expanse, sometimes moving underground, sometimes surfacing, but always revealing nothing but the empty track ahead and the empty darkness without. The darkness was occasionally punctuated by a dimly lit and equally empty station, where the train would stop, as if to admit the comings and goings of passengers, conspicuous by their total absence. Beyond the thick crush of the sweating, shaking, beer-stinking techno crowd—packed too tight to allow free breathing let alone free dance, high above the break beats and the loops blaring from the speakers, the U-Bahn flashed a utopian vision of silent, smooth, unfettered movement through unencumbered space, an escape from the crowded tumult of the underground city "scene" into a deeper underground city, an escape into absent freedom.

Several hours later I took this escape, riding an empty carriage of the S-1 toward my West Berlin home in Friedenau. As the train crossed under Potsdamer Platz, I wondered where exactly overhead was the dividing East-West boundary. There was of course nothing of the famous Berlin wall to see in the train tunnel, nor could I have seen it from above, even if the sun had risen. Only a few small sections of the once 165-kilometer-long wall remain in place, protected now by law as historic monuments. But Potsdamer Platz, though once a crucial section of the wall, is not one of them.

Yet despite its physical absence here and elsewhere in Berlin, the dividing wall maintains a vivid presence. Indirectly visible through its historical traces in the otherwise puzzling layout of certain streets and buildings, it can also be seen in the differing visual cultures of East and West: not only in the different styles of architecture and levels of building maintenance, but in different styles of interior design, like the East Berlin taste for oilcloth table coverings, artificial flowers, and regimented white-lace curtains. To the frequent dismay of motorists and public transport commuters, the wall is still strongly felt through the chaos of continuing traffic changes that its sudden disappearance has engendered after over a generation of walled Berlin life (e.g., detours due to road or building construction, or disrupted service and altered routes for bus, U-Bahn, and S-Bahn lines). The enormous, frenetic mass of continuing construction that has overwhelmed Potsdamer Platz paradoxically reasserts the wall it has effaced, not only as a constructed obstacle of monumental scale but as an international tourist attraction (it is Europe's largest building site). In short, the now absent wall dividing

East and West remains in many ways the structuring principle of this unified city, just as the divided cities of East and West Berlin were defined essentially by their contrasting absent parts.

More than forty years before this wall was built, the renowned Berlin writer Kurt Tucholsky had already thematized the concept of wall as a surface where absences could be all the more present and meaningful. In his story "Die Flecken" (The Spots), he describes the spots of absent color in the brown granite wall of a former military academy in Mitte's Dorotheenstrasse. These missing spots of color appeared where the "endless" casualty lists of the Great War had been posted, lists that are now as decomposed and absent as the casualties they listed, but still ghostly visible through the white spots, symbols of black memories of bitter loss. "In the course of the years," Tucholsky writes, "these white spots will gradually be washed away by the rain and disappear. But those other spots cannot be effaced. There are traces engraved on our hearts that will not go away."[3] Ineffaceable, we are left to conclude, precisely because they are already visually absent. More powerfully present, paradoxically, by their invisibility.

The same point, but in another medium, was made in the summer of 1995 by the artist Christo's wrapping of the Reichstag, whose concealing shrouds rendered the building (and its symbolic history) infinitely more visible in Berlin life. For me at least, Berlin's deepest meaning and fascination lies in the layering play of its present absences, as in the ghostly Palast der Republik of what was once East Germany. Erected in white marble on a site cleared by the communist effacing of the old Stadtschloss, it now stands (since 1990) totally empty, blocked for the moment from either habitation or destruction because of its poisoned asbestos walls. To complicate this play of present absences, a model of the ancient Stadtschloss was temporarily erected alongside it (in 1993) so as better to assess the public's desire to have this absent aristocratic palace rebuilt to erase the empty communist Palast, just as the old name of its environing public square has been recently restored to Schlossplatz after having been renamed as Marx-Engels-Platz by the East German regime.

Not far away is the reconstructed, golden-domed Neue Synagoge on Oranienburger Strasse. Rebuilt as a memorial museum rather than a fully functional synagogue, its old principal prayer hall remains an unrestored absence, as do its worshippers. More stirring was the discovery

of a fuller, unmarked absence: that my regular jogging route went right past the site of the old Wilmersdorf Synagogue (on Prinzregenten-strasse). Destroyed not by enemy bombs but by Berlin barbarians on Kristallnacht, it was never reconstructed, its site not simply veiled but renumbered by an ugly fifties apartment block. Such experiences persuade me that Berlin's holocaust memory is more powerfully served by the controversial absence of an official memorial to its victims than by any concrete monument proposed to fill this gap.[4]

Absence even marked my official dealings with Berlin city authorities. When I presented my American passport at the different police centers for resident and alien registration, I was asked why the 'c' and final 'n' were missing from my German-sounding name of Shusterman, and why I had no known German ancestors from whom the name derived. Such absences, I refrained from explaining, were telling testimonies of a complex history of failed German-Jewish assimilation, if only one learns to read what is not there. My Israeli passport remained in my pocket.

Berlin's kaleidoscope of absences was a crucial aspect of its fascination for me. But it also made me think that absence may be an essential structural principle of city aesthetics in general, a paradoxical part of their economy of plenty. So I tried to develop my experience into a more general, philosophically principled reflection on the role of absence in the city, enlisting the help of modern urban thinkers, some of whom (like Simmel and Benjamin) were likewise inspired by Berlin.[5]

Absence is, of course, a very difficult, elusive concept with a long and complex philosophical history. Even its etymology (*ab* + *esse*: "away from being") reveals its link to the ancient philosophical puzzle of non-being, the paradoxical nature of "things" that don't exist or simply fail to be "here and now" (that is, present). Yet absence has also been regarded as something at the core of all being, as the crucial ground for whatever exists or is present.[6] Compounding such complexities, the notion of "here and now" is itself so vague and contextual that it strikes a pragmatist as folly to demand a general definition of absence that precisely captures all its different meanings. Eschewing such general theory, my strategy aims to illuminate the notion of absence by exploring its complex variety of forms and functions in the more limited context of the city, itself an ancient concept rich in philosophical meaning and ambiguity—reflected in the two French words *ville* and *cité* that suggest the city's dual image as residential and political identity.

II

Celebrated already in Plato and Aristotle, the city seems a symbolic so-
lution to one of philosophy's most central problems—the many and the
one. This problem is at once metaphysical and epistemological, as well
as ethical, political, and aesthetic: the unity of substance in change, of
truth in the manifold of appearance, of the self in plurality of action,
of the unified *polis* with its many citizens and households, of beauty as
unity in variety. The city symbolizes the embracing of multiplicity and
diversity within a single unit, often concretely represented by their col-
lection within city walls. Rather than dividing the city (as in Berlin),
such encompassing walls aimed at asserting the city's integrity as a clear
unit with definite limits, distinct from the indefinite sprawl of the sur-
rounding countryside. The Greeks saw definite limits as essential to the
values of clarity, rationality, and beautiful form. But when modern ur-
banization overwhelmed the old city walls, the charm and power of the
cities was not thereby destroyed. For romantic thought intervened to
privilege the infinite and unlimited. Though poets like Blake and Words-
worth attacked the city (in their poems on London) for its grimy grid of
oppressive limits, the small-minded greed of narrow "chartered" streets
in contrast to Nature's vast bounty,[7] the city could nonetheless be val-
orized as a site of unlimited growth, endless activity, boundless variety,
and infinite possibilities. Logically, a town or village would lose its sta-
tus by growing too large and thus becoming a city. But the city, at least
in principle, knows no limits to growth and variety.

All the world, it seemed, could be experienced in the single city. Its
dense wealthy population enabled the import of even the most exotic
and costly products to the city shops and museums. Too vast and varied
to be captured or viewed from a single main street or square, the city's
promise of ever new discoveries through its seemingly endless web of
streets, set the *flâneur* in constant motion. Huge parks and zoos pro-
vided the modern metropolis with varieties of even country and jungle
life, while urban commuter trains showed that the city could also allow
its residents to travel extensively without ever really leaving the city.
Circumscribed infinity is a powerful, though paradoxical image. So
thoughtful theorists of city life, like Georg Simmel, insist that part of
the city's distinctive liberating power is in transcending its physical
boundaries, thus providing not only a means but a symbol of boundless
freedom.

It is not only the immediate size of the area and the number of persons which . . . has made the metropolis the locale of freedom. It is rather in transcending this visible expanse that any given city becomes the seat of cosmopolitanism. . . . The sphere of life of the small town is, in the main, self-contained and autarchic. . . . The most significant characteristic of the metropolis is the functional extension beyond its physical boundaries.[8]

Simmel's solution to the logical problem of city-infinity is thus by appeal to what is absent from the physical site with which the city is identified and has its center; it is only "in transcending this visible expanse that any given city becomes the seat of cosmopolitanism" (S, 419).

Urbanists like Simmel were, however, not concerned with the logic of infinity. They were preoccupied by the concrete problems resulting from city plenty, where overwhelming quantities of people, products, and activities could overstrain and endanger the very quality of human experience, of personal and social life. This painful paradox of more meaning less is a leitmotif in urban criticism from Friedrich Engels through Baudelaire and Benjamin, and still extending into the postmodern hip hop of Grandmaster Flash, whose 1983 classic "New York, New York" bears the blunt refrain: "Too much, too many people, too much!"[9]

Such critics did not deplore the multitudinous variety of city life per se; they relished it. What they instead attacked was the threat of disorientating, dehumanizing, shocking chaos (symbolized by the formless crowd) which resulted from the enormous urban bustle of quantities, complexities, and diversities overwhelming our human powers of assimilation. In Benjamin's terms we thus have the fragmented shock of *Erlebnis*, something merely lived through, rather than the funded, ordered, convergent assimilation of experience. The urbanist's aim is not to decrease the rich bustling variety of city life but to order it so that it ceases to be threateningly overwhelming and unmanageable. The problem, then, is one of *Ordnung*, as other German urbanists would concur.

Friedrich Engels, for example, marveled at London's vastness and achievements but found "the bustle of the streets" "distasteful" and "abhorrent to human nature" through its lack of structuring social relations. The only redeeming relation, he notes (perhaps ironically), is a tacit one of ordered noncontact: "that everyone should keep to the right of the pavement, so as not to impede the stream of people moving in the opposite direction."[10]

Developing the ancient trope that contrasted the city as developed *mind* to the less conscious, more corporeal country *body*, Simmel regarded the complex multiplicities and sensory intensities of city life as the stimulus that necessitated "a heightened awareness and predominance of intelligence in metropolitan man." To protect his psyche, the urbanite "reacts with his head instead of his heart," with intellectual order rather than spontaneous feeling. Though this weakens affective social bonds, it is a "necessity . . . brought about by the aggregation of so many people with such differentiated interests, who must integrate their relations and activities into a highly complex organism." Otherwise, Simmel warns, "the whole structure would break down into an inextricable chaos."

What would such a nightmare be, for Simmel the urban *Ordner*? "If all clocks and watches in Berlin would suddenly go wrong in different ways, even if only by an hour, all economic life and communication of the city would be disrupted for a long time . . . [and] long distances would make waiting and broken-appointments result in an ill-afforded waste of time." "Metropolitan life," he concludes (with apparent disregard of Naples, Marseilles, or Marrakech), "is unimaginable without the most punctual integration of all activities and mutual relations into a stable and impersonal time schedule."

This means suppressing the individual's personal inclinations, which threaten the clockwork unity of the whole: hence "the exclusion of those irrational, instinctive, sovereign traits and impulses which aim at determining the mode of life from within, instead of receiving the general and precisely schematized form of life from without" (*S*, 412–413). Yet despite this impersonal order, the city for Simmel remains the site of the greatest "personal freedom" and "personal subjectivity" (413, 415); indeed it becomes so through the very factors that necessitate its impersonality. The deepest principle of order that permits this paradox, one which Simmel only faintly recognizes and fails to name, is the economy of absence, which also underlies the urban aesthetics of Benjamin and Baudelaire.

Before considering how the ordering economy of absence works in their theories, let me note its role for the American urbanist Lewis Mumford, whose vision of the city can be usefully contrasted with Simmel's.[11] Mumford's "principles of urban order" insist on picturing the city in more humanly biological, affectively social, and organically aesthetic terms. Rather than Simmel's view of the city as "a social-technical

mechanism" with its model of mechanical clockwork unity and its images of "punctuality, calculability, and exactness"—suggesting that social connections are best modeled on rigid, time-efficient train connections (S, 409, 413)—Mumford speaks of an antimechanical "bio-technic" approach emphasizing the dynamic "flexibility" of "organic plans" that can better cope with change so as "to create a new biological and social environment in which the highest possibilities of human existence will be realized" (M, 381, 478, 492). This is symbolized by the dynamic unity of aesthetic experience.

The city, he argues, is "an esthetic symbol of collective unity"; it not only fosters art by creating a complex, demanding stage for personal expression (as Simmel also notes) but the city also "*is* art" (M, 480, 492). As art is communicatively social, "social facts are primary" in urban planning. Rather than the physical plant or transport system, "the social nucleus [is] the essential element in every valid city plan: the spotting and inter-relationships of schools, libraries, theatres, community centres" (483). If the traditional undifferentiated social bonds of the small town are lost, one should seek a more multiform cable through the weaving of partially linking bonds to produce "a more complex and many-colored strand." Urban planning's aesthetic "aim is the adequate dramatization of communal life" so that individual and group activity become more meaningful (481, 485).

Whatever the practical viability of Mumford's program, certain interesting conclusions are suggested by the logic of his biological and aesthetic metaphors. First, life and aesthetic experience imply the need for change and conflict as well as harmony. Without space for change and conflict, there can be no human growth or aesthetic drama. The flawless regularity of clockwork mechanism does not provide this; its smooth-running harmony would stultify. The planning of urban aesthetic unity thus requires its spots of absence, its disharmonious conflicts and its disruptions, what today Richard Sennett calls its "discontinuity and disorientation." [12] As a postmodern pragmatist, I would add that the city, like art and life, also needs spots of contingency, absences of the planned and predetermined, gaps for us to interpret and fill with significance.

Another conclusion to be drawn from analogy with biological organisms and artworks is the limitation of city size. Deploring the bloated, suburb-swallowing megalopolis, Mumford insists that good city life requires respecting and nurturing what lies outside it. This absence is essential to the city, not simply as a structuring other (that defines city

limits) and as a breathing space, but also as a source of different attitudes, new resources, and ways of life that can both challenge city ideas and enrich them through incorporation. Mumford's key unit of planning is not just the city but the region, in which the city functions as a nucleus which respects its limits, neither usurping the space nor overwhelming the functions of its environing cell. Even within the city, Mumford advocates functional gaps or absences to balance density. Hence rather than an urbanism of dense, centralized spreading, he favors a polynucleated city of distributed functions that involves spacing and gaps. In urbanism as in regionalism, Mumford calls this logic "functional *spotting*" (*M*, 491); and, like Tucholsky's "spots," it suggests the functional play of presence and absence that gives life greater meaning and aesthetic power, while also making it more manageable.[13]

III

Absence, as a tool for urban coping, centrally structures Simmel's case for the unmatched personal freedom of city life, though his argument lacks clarity and stumbles in many details. One major axis of argument is that urban freedom comes through greater intellectualism. Modern urban life is praised for sharpening mental faculties and higher consciousness, because this is required for coping with the greater "intensification of nervous stimulation" resulting from the city's distinctive richness of sensory stimuli, jolts, and irregularities. But don't we also find this jostling overload of stimuli in a Bedouin camel market, a suburban amusement park, or a savage jungle—that paradigmatic trope of the fearful complexity, threatening violence, and sudden jolts of city life? Moreover, if dealing with complexities of vivid sensory stimuli helps improve our mental powers, why then should Simmel posit a perfect, smoothly functioning order as the ideal of city organization? Wouldn't its realization dull the minds of city dwellers? Whose consciousness is lower than the urban subway rider, who in daily hypnotic habit takes the same train and makes the same connection, whose disciplined habit of muscle memory leads him mindlessly to work, just as the assembly line leads him mindlessly through it?

Leaving these troubling questions aside, we note that Simmel describes the higher urban consciousness in two related ways. First, by curbing "irrational, instinctive . . . impulses" and "emotional relations," it constitutes a more intellectual attitude of "calculability," "exactness," and "quantitative" values that Simmel relates not only to the system of

money but to "the universal diffusion of pocket watches" (*S*, 411–413). Secondly, urban mentality is characterized as "the blasé attitude." This attitude, which Simmel says is "unconditionally reserved to the metropolis," results from the same "rapidly changing and closely compressed contrasting stimulations of the nerves" that promote cold urban intellectualism. The nerves are so spent that they fail "to react to new sensations with the appropriate energy"; "the essence of the blasé attitude consists in the bluntness of discrimination . . . the meaning and differing values of things, and thereby the things themselves, are experienced as insubstantial. They appear to the blasé person in an evenly flat and gray tone; no one object deserves preference over any other" (414).

Here again Simmel seems confused. First, physiologically speaking, contrasting stimulations tire and blunt the nerves far less than sustained identical sensations. More important, the blasé attitude of leveling indifference can be found outside the bustling sensorium of the metropolis. In fact, one classic site for its emergence is the empty desert. As an intelligence officer long stationed in the Sinai, I had to alert myself and my soldiers to this danger, diagnosed by the Israeli medical corps as "apathia." The term is instructive: absence of feeling, absence of affective investment, leads to lack of discrimination; we do not see or react to differences because we simply don't care; we mentally withdraw ourselves in pathological disinterest; we are absent.

For us reluctant desert dwellers, absence of affective investment derived from the absence of things to care about in the landscape. But in the metropolis, the absence of feeling in the blasé attitude becomes a necessary withdrawal of feeling, since there are too many people, products, and activities to which the heart would instinctively turn. (Just think of the dozens of beggars or buskers that one must learn to coldly pass by in everyday city life). This protective taking of distance, of affective absence, is the deep logic common to Simmel's urban intellectualism and *Blasiertheit*.

Such absence also constitutes the mechanism of Simmel's other main argument for the greater personal freedom of city life: the dissolution of traditionally strong social bonds which, though constructing and empowering the individual, also greatly constrain him. The wider circle of urban life involves too many different people in too many different, quickly changing relationships for it to be psychologically healthy or even possible to form strong affective bonds with most of our fellow residents. Hence, an attitude Simmel calls "reserve" and "indifference"

arises, which frees the urbanite from social obligations of courteous concern (and socially entrenched prejudices) that centripetally "hem in" the narrower circle of "small-town" life. This reserved attitude, argues Simmel, is "never felt more strongly" than in the individual's "independence [and loneliness] . . . in the thickest crowd of the big city . . . because the bodily proximity and narrowness of space make the mental distance only the more visible," and psychically necessary (S, 418). This withdrawal of the self through mental distance underlies the crucial point of urban absence I have been stressing: its redemptive role in coping with the bursting saturation of city presence, a cure not immune from possible unhappy side-effects — as the threat of urban loneliness and callousness makes clear.

Absence is also the motivating fulcrum of Simmel's final argument for the personal freedom of urban life. Having robbed the individual of traditionally subjective spontaneity, affective impulse, and personally meaningful social bonds, the overwhelming organization of city life threatens the utter extinction of personality, reducing the individual (in Simmel's words) to a "*quantité négligeable*," a "mere cog" in the enormous municipal machine. Spurred by this personal void and fear of total nullity, the individual responds by "summoning the utmost in uniqueness and particularization, in order to preserve his most personal core" (S, 422). The modern metropolis thus provokes a new model of personal freedom: not mere individual independence from oppressive social bonds, but "the elaboration of individuality" as "qualitative uniqueness" so as to survive the conformist pressure of city crowds where individuality and qualitative difference are drowned (423).

We see here the Baudelairian figures of the *dandy* and *flâneur*, who try to defy the utilitarian uniformity of urban life. For Walter Benjamin and his political vision of the "streets . . . [as] the dwelling place of the collective," the *flâneur* is especially important in defining himself not only against but *through* the conformist crowd and the city streets they share. Benjamin is more careful than Baudelaire to distinguish the *flâneur* from "the man of the crowd." Resisting the "manic behavior" of "metropolitan masses" hectically bent on their practical pursuits, the *flâneur* distances himself from the crowd by his absence of practical purpose and urgency. He demands his "leisure" and "elbow room," so as not to be "jostled" and overwhelmed by the crowd. But in contrast to provincials and fastidious aristocrats, the *flâneur* could also enjoy "the temptation to lose himself" in the crowd, to savor a momentary absence of selfhood's

pressures.[14] Linked to the crowd yet somehow absent from it, the *flâneur* is like the streets of Baudelaire's verse, whose beauty derives from suggesting the crowd yet providing a deserted expanse for free movement and exploration. The same strategy of aesthetic absence can be seen in those photos of Prague's enchanting empty streets, whose magic dissolves once the streets are actually brimming with the city's swarming crowds.

Neither at home in the bustling crowd nor "in an atmosphere of complete leisure," the *flâneur* of Benjamin is characterized by being essentially "out of place" (*B*, 172–173). This absence of proper place or purpose keeps him moving through the city streets, resisting the seductive presences that could arrest him, driving him on toward the ever more distant places and possibilities that the metropolis promises endlessly to offer. Consider the defining absences in the following description of Benjaminian *flânerie* from the *Passagen-Werk*:[15]

> An intoxication comes over the person who trudges through the streets for a long time and without a goal. The going wins a growing power with every step. Ever narrower grow the seductions of the stores, the bistros, the smiling women; ever more irresistible the magnetism of the next street corner, a distant mass of foliage, a street name. Then comes the hunger. He desires to know nothing of the hundred possibilities to still it. Like an ascetic animal, he strides through unknown quarters, until finally in his room, which strange to him, lets him in coldly, he collapses in the deepest exhaustion.

Absence of goal, a preference for the absent "next street corner" and "distant mass of foliage" over those present to hand, direct the *flâneur*'s movement; the mere *name* of a street, signaling new spaces to explore, thus draws him more than the actual charms of stores, bistros, and women on the present street. The *flâneur*'s defining hunger marks the presence of an absence that he does not wish to fill, for it provides its own intoxication; so does his lack of reassuring knowledge of the "unknown quarter" of his *flânerie* as well as his ever waning energy. Even his own room is defined by the absence of familiarity and warmth that characterize one's home.

Big multi-ethnic cities like Paris or New York are famous as homes for the homeless, not simply for those lacking roofs but more distinctively for those missing homelands. The foreign big city dweller, though

out of place, feels less so because of all the other foreigners. For those sensitive about being alien, *flânerie* seems the surest public pastime. The embarrassment of being "outed" as a foreigner should not occur as long as one keeps moving through the streets in the right rhythm. But to address the seductions of the stores, bistros, and women means exposing one's foreignness—through one's accent, at the very least. It is tempting to see Benjamin's ascetically driven *flâneur* (in contrast perhaps to Baudelaire's) as the urban analogue of the wandering Jew. Though lacking a conscious concrete goal, he seems hungrily seeking a utopian home, an absent place pursued relentlessly but unsuccessfully in the promise of unknown quarters, in distant streets with magic names, that once present must yield to newer absent ones. As a Jewish-fellow traveler and lapsed Israeli, I wonder whether Jerusalem is just one such magic name or instead that strange, cold room (a poor excuse for home) where the wandering, free-thinking Jew simply returns to collapse in failed exhaustion. It is, of course, both.

Beyond the tired Jewish question lies the broader issue of the ethnic Other, for which the Jew long served as tortured trope. From New York to Paris, London to Los Angeles, multicolored ethnicity provides the cosmopolitan city with one of its most important visual dimensions— both aesthetically rewarding and politically rich with meaning and promise. Despite its large Turkish population, Berlin does not yet deliver this dimension, and its tradition of *Ausländerhass* and ethnic violence does not encourage it.[16] Of all the absences that mark my Berlin experience, the deepest is paradoxically only skin deep: the lack of nonwhite faces, one in particular who graced my early days there:

Je t'adore à l'égal de la voûte nocturne
O vase de tristesse, ô grande taciturne
Et t'aime d'autant plus, belle, que tu me fuis,
Et que tu me parais, ornément de mes nuits,
Plus ironiquement accumuler les lieus
Qui séparent mes bras des immensités bleues.[17]

[I adore you to the extent of night's vaulted heaven.
O vase of sadness, o deeply silent one.
And I love you still more, my beauty, as you flee from me
And seem to me, ornament of my nights,
More ironically to multiply the miles
That separate my arms from blue immensities.]

IV

Benjamin cites these lines from Baudelaire not to evoke an absent lover but to insist on the quintessentially absent, fleeting, degenerate quality of urban eros, "the stigmata in which life in a metropolis inflicts upon love." Rather than the enduring bonds of closeness of Goethe's "Keine Ferne macht dich Schwierig, Kommst geflogen und gebannt," Baude- laire's city love flashes with the promise of absence and evanescence, blooms through "the magic of distance" (*B*, 169, 189–191). Should this surprise us? Ephemerality is simply the temporal dimension of absence, while distance denotes a gap to be bridged by movement, and eros (as Socrates recognized) implies movement motivated by a lack.

Baudelaire links the eros of both spatial and temporal absence with the captivating flux of city life in the image of the beautiful, veiled, fleeting heroine of his love sonnet "A Une Passante." After a sudden, silent, mo- mentary meeting of the poet's eyes [18] in "the deafening street," this un- known widow in mourning "passed" by; her passage toward absence poetically elaborated through images both of time and space, in terms of "elsewhere, far away," "too late" or "never."

> Un éclair . . . puis la nuit!—Fugitive beauté
> Dont le regard m'a fait soudainement renaître,
> Ne te verrai-je plus que dans l'éternité?
>
> Ailleurs, bien loin d'ici! Trop tard! *Jamais* peut-être!
> Car j'ignore où tu fuis, tu ne sais où je vais,
> O toi que j'eusse aimée, ô toi qui le savais!
>
> [A lightning-flash . . . then night! O fleeting beauty
> Whose gaze gave me suddenly new birth.
> Shall I see you again only in eternity?
>
> Elsewhere, far from here! Too late! Never, perhaps!
> For I know not where you flee, you don't know where I go.
> O you whom I would have loved, o you who knew it!]

Benjamin sadly describes this ephemeral meeting as "a farewell for- ever" and thus a "catastrophe." But the lines strike me as more ambigu- ous, expressive also of the positive possibilities of urban absence. The possibility of a second meeting is left open, as we see through the ques- tion mark and "peut-être." The flux of city passage through which she

came and went can bring her back again. "Elsewhere, far away" from their point of meeting can still remain within the ambit of the large metropolis. The "peut-être" marks the productive space of possibility, just as the narrative suggests choice and room for action. Why does the *flâneur* not follow the woman's passage to know her better? Perhaps he fears the consequences of closer contact, and is even right to? These themes of flux and contingency and of the possibilities they bring for choice, action, meaning, and value (all reciprocally understood in terms of consequences) are central to pragmatism and its aesthetic.

But let me stay with the themes of urban eros and the ethnic Other, who could well be personified by the mysterious veiled lady (mourning a homeland as well as a husband), but who anyway can symbolize the variety of different people, products, and ways of life that at once enrich and confuse city life. We want the variety of urban richness, but we cannot enjoy all of it permanently and deeply. As Baudelaire knows, there is just too much, too many lovely eyes that we meet in the street to follow them all home. His poet was also in movement, perhaps already toward a rendezvous with another blazing gaze, or even home to the steady warmth of more familiar eyes.

The wonderful diversity of cultures that we can see, learn, and love in the cosmopolitan city are also too many and different to track them *all* home and unite with in the sticky, permanent bonds of old-fashioned *Gemeinschaft*. Nor does this condemn us to that new form of ghettoizing multicultural politics that respects plurality only by projecting and policing essentialist ethnic identities. Remember Benjamin's notion of "the streets [as] the dwelling place of the collective" (*AP*, 417). These streets, through which the city's many classes, cultures, and ethnicities move and mix, can create a dynamic, hybrid collective. Its constitution can be flexibly voluntary, since the same streets can be used to walk away, not just to come together.

Far too many and confusingly complex to be scrutinized from any panoptical point or power, the city streets can cleverly conceal the variety they present. Its endless options of changing, hidden spots—momentarily absent from police surveillance—can shelter even the blaring sounds of alternative aesthetics or politics. But when their experienced intensities demand relief, other streets provide the wanted absence (that is not *Blasiertheit*). Most great cities also have an underground "metro," offering its own routes of escape with its own erotic movement through

the city's deepest centers. Though the subway's fixed paths and grimy stops hardly match the nostalgically imagined chic and freedom of Baude-lairian *flânerie*, they at least provide, in the empty carriage of a 6 A.M. Sunday train, an exemplary site to reflect on the varieties and values of urban absence.

6 |

beneath interpretation

Give it an understanding but no tongue.

SHAKESPEARE

I

Koheleth, that ancient postmodern who already remarked that all is
vanity and there is nothing new under the sun, also insisted that there
is a time for everything: a time to be born and a time to die, a time to
break down and a time to build up, a time to embrace and a time to re-
frain from embracing. There is no mention of a time for interpretation,
but surely there is one; and just as surely that time is now. Our age is
even more hermeneutic than it is postmodern, and the only meaningful
question to be raised at this stage is whether there is ever a time when
we refrain from interpreting. To answer affirmatively by citing dream-
less sleep is to dodge the real issue, which is whether we can ever refrain
from interpreting without thereby refraining from intelligent activity
altogether. A host of universal hermeneuts answer this firmly in the
negative, maintaining that simply to perceive, read, understand, or be-
have intelligently at all is already, and must always be, to interpret, They
hold that whenever we experience anything with meaning, such mean-
ingful experience must always be a case and product of interpretation.

This position of hermeneutic universalism dominates most current
interpretive theory.[1] Loss of faith in foundationalist objectivity has
made it the current dogma. Having abandoned the ideal of reaching a
naked, rock-bottom, unmediated God's-eye view of reality, we seem
impelled to embrace the opposite position — that we see everything
through an interpretive veil or from an interpretive angle. Indeed, on a
pragmatist account of meaning, one might further assert that since the
terms "veil" and "angle" inappropriately suggest that we can even make
sense of the idea of a naked, perspectiveless reality, we do not merely
see everything through interpretation, but everything is in fact consti-
tuted by interpretation. In other words, there is nothing real (and cer-
tainly nothing real for us) that is not interpreted. This theory can,
of course be traced back to Nietzsche's famous remark that "facts are
precisely what there is not, only interpretations,"[2] and it is not sur-
prising that today's hermeneutic universalists have turned to him as a

major philosophical inspiration. Alexander Nehamas's fine book on Nietzsche is in large part a contemporary defense of Nietzschean perspectivism and universal hermeneutics. Nehamas in fact identifies the two positions by defining Nietzsche's perspectivism as "the thesis that every view is an interpretation," and he goes on to assert that not only all views but "all practices are interpretive," since "all our activity is partial and perspectival."[3]

Pragmatists, like Nietzscheans, insist on rejecting the very idea of any foundational, mind-independent, and permanently fixed reality that could be grasped or even sensibly thought of without the mediation of human structuring. Such structuring or shaping of perception is today typically considered to be interpretation, and so we find contemporary pragmatists like Stanley Fish repeatedly insisting that interpretation comprises all of our meaningful and intelligent human activity, that "interpretation is the only game in town."[4] All perception and understanding must be interpretation, since "information only comes in an interpreted form." Thus, even in our most primitive and initial seeing of an object, "interpretation has already done its work."[5] Moreover, quite apart from such radical Nietzschean and pragmatist perspectives, we find hermeneutic universalism firmly endorsed by a traditionalist like Hans-Georg Gadamer, who baldly asserts that "all understanding is interpretation."[6]

In short, the various camps of the ever-growing antifoundationalist front seem united by the belief that interpretation subsumes all meaningful experience and reality. This was brought home to me, gently but relentlessly, by my friends from the National Endowment for the Humanities institute on interpretation held at Santa Cruz.[7] These independent thinkers from divergent philosophical perspectives and professional disciplines converged almost unanimously on the motto that "interpretation goes all the way down," that there is nothing beneath interpretation which serves as the object of interpretation, since anything alleged to be such is itself an interpretive product.

Perhaps a perverse nonconformity (or still worse the posture thereof) made me begin to suspect such a widely held philosophical view, one that I myself had initially found so convincing. Though I remain deeply impressed with the pervasive role of interpretation in human life, I have come to think it may best be understood and sustained by more modest pretensions than hermeneutic universalism. I think interpretation is best served by leaving room for something else (beneath or before it), by

slimming it down from a bloated state that courts coronary arrest; by saving it from an ultimately self-destructive imperialist expansion.

In this chapter then, and in a Nietzschean spirit of affirming by negating, I wish to question the faith in hermeneutic universalism by critically examining what appear to be its best arguments. Having shown that those arguments need not compel belief in hermeneutic universalism, I shall go on to suggest why such a belief is more dangerous and unprofitable than the contrary idea that our intelligent and meaningful intercourse with the world includes noninterpretational experience, so that we should not think interpretation is the only game in town. Finally, I shall try to determine what distinguishes interpretation from those uninterpreted understandings and experiences that hermeneutic universalists regard as fully subsumable under the concept of interpretation. In drawing this distinction I am not claiming it is a rigid ontological one, where interpretation and understanding are different natural kinds that can never share the same objects. But I hope to show that some functional distinction between them is pragmatically helpful and illuminating, and can itself be helpfully illuminated.

II

Before undertaking these tasks, however, I need to distance my challenge of interpretation from an earlier and influential critique advanced by Susan Sontag in "Against Interpretation."[8] Sontag's attack is directed not at interpretation per se but at the global claims of interpretation over *art*. Indeed, she explicitly endorses hermeneutic universalism's notion of "interpretation in the broadest sense, the sense in which Nietzsche (rightly) says, 'There are no facts, only interpretations'" (*AI*, 5). But what *are* the claims of interpretation's dominion over art? Arthur Danto and others have argued that a work of art is ontologically constituted by interpretation. Since physically identical things can be different works if they have different interpretations, "interpretations are what constitutes works, there are no works without them"; without them, works would be the "mere things" of their material substance.[9] This view that the art object is not a physical or foundational fact but must itself be constituted by an interpretive perspective is essentially an application of the Nietzschean view of objects that Danto here confines to the domain of art, elsewhere remaining a realist. Such *constitutive* interpretation of art,

as Danto notes, should not be the target of Sontag's attack, though its alleged omnipresent ineliminability—that art cannot be meaningfully experienced without being interpreted—will be a target of mine.

The interpretation she instead impugns is the deliberate act of explaining, disclosing, or decoding the content or meaning of the object (interpretively) constituted. Such interpretation of content is indicted as a corruptive act "of translation. . . . The interpreter, without actually erasing or rewriting the text, *is* altering it," making it "into something else," distracting us from "experiencing the luminousness of the thing in itself" by putting us on a false quest for its meaning (*AI*, 5, 6, 8, 13). Rather than opening us up to the powerful sensuous experience of art's surface form, which is the essence of art's liberational challenge to the primacy of the cognitive and discursive, interpretation "poisons our sensibilities" and represents "the revenge of the intellect upon art" at the expense of our "sensual capability" (7). Sontag therefore urges, "In place of a hermeneutics we need an erotics of art," and she conceives this erotics in terms of a criticism that gives "more attention to form in art," "that dissolves considerations of content into those of form," and that "would supply a really accurate, sharp, loving description of the appearance of a work of art," "to show *how it is what it is*" (12–14).

Though I support Sontag's protest against hermeneutics' imperialist conquest of all artistic understanding and share her insistence on greater recognition of sensuous immediacy in aesthetic experience, I cannot accept her critique of interpretation. This is not because its repudiation of content for pure form and eros seems to reflect and legitimate what is arguably the worst of American culture—meaningless sex, empty formalism, and contempt of intellect. Such deep ideological complaints we can leave to students of Adorno and to our own moments of alienated discontent. What I instead wish to show is that whatever our verdict on its ideological stance, Sontag's critique is severely crippled by deep confusions and unwarranted assumptions.

First, in claiming that all interpretation "sustains the fancy that there really is such a thing as the content of a work of art" and in subsequently demanding that criticism instead confine itself to form, which is contrastingly real, Sontag relies on a naively rigid content-form distinction which suggests that form itself has no content and which she herself later wishes to deny (*AI*, 5, 11–12). Second, Sontag betrays a naive realism about the work of art's identity and form which is not only unconvincing but totally at odds with the Nietzschean interpretive position

she claims to endorse. Her attack on interpretation for necessarily "altering" or "translating" the work "into something else" rather than describing the work as "just what it is," "the thing in itself," presumes first that there is some foundational identity of the work "just as it is" apart from our constitutive and perspectival grasping of it, and second that we can transparently grasp that identity (6, 8, 11, 13). "Transparence," which Sontag claims as the highest value in art and criticism, "means experiencing the luminousness of the thing in itself" (13). But the Nietzschean notion of constitutive identity not only rejects such non-perspectival transparency, it repudiates the very idea of the uninterpreted "thing in itself" as a dogmatic notion.[10]

Sontag's third confusion is her presumption that while interpretive content represents "the revenge of the intellect on art" by taming art's sensuous liberational power into something "manageable, conformable" (*AI*, 8), form, on the other hand, is neither intellectual nor constraining but simply liberationally erotic. This is obviously false, as the very morphology of the word "conformable" makes clear. Indeed, since the time of Plato and Aristotle, who essentially formed our notion of form, we regard form as something paradigmatically intellectual and constraining. Moreover, as has been emphasized since Kant, the formalistic appreciation of aesthetic objects demands much more intellectual power and repressive austerity than appreciation based on content, which can simply rely on our ordinary feelings associated with and immediately evoked by the content. Formalists like Kant and Clive Bell condemn the more natural, less intellectualized appreciation of content as philistine barbarism.[11] Sontag similarly condemns interpretation of content as philistinism and privileges the appreciation of form. But she mistakenly confuses formal analysis with unintellectual "sensuous immediacy" (*AI*, 9), when it instead requires no less (and usually much more) intellectual mediation than the interpretation of content.

This leads to the fourth crucial error in Sontag's position—her failure to recognize that she is not really sustaining a global rejection of interpretation; for the formalistic analysis she advocates is itself a recognized form of interpretation. It is simply a mistake to think all interpretation is governed by the depth metaphor of uncovering hidden layers or kernels of meaning. Interpretation is also practiced and theorized in terms of formal structure with the aim not so much of exposing hidden meanings but of connecting unconcealed features and surfaces so as to see and present the work as a well-related whole. Recognition of this for-

malist interpretive mode which aims "to grasp the whole design" of the work is what swayed an earlier rejecter of interpretation, T. S. Eliot, from his view that "the work of art cannot be interpreted" to an acceptance of interpretation's ineliminable role and value.[12]

Sontag should similarly recognize that her apparent critique of all interpretation is but a privileging legitimation of one interpretive form above and against all others. She provides no argument that we ever should or could do without interpretation altogether, or that in fact we ever do without it in at least its Nietzschean constitutive sense. Indeed, she does not even consider hermeneutic universalism's arguments for holding that interpretation is necessarily present in any meaningful experience of art, or experience of anything. In short, Sontag's critique is simply normative: that we should not interpret for content. She does not even address the logical issue of whether in fact it is possible not to interpret at all; and her Nietzscheanism and formalism contradictorily suggest it is not. My critique, in contrast, is not primarily normative, since I think that interpretation should and must be practiced on innumerable occasions. What I wish to contest is the view that, logically and necessarily, we are always interpreting whenever we meaningfully experience or understand anything, the view expressed in Gadamer's dictum that "all understanding is interpretation." I must therefore address hermeneutic universalism's powerful arguments for this view.

III

Since our current hermeneutic turn derives in large part from the rejection of foundationalism, it is not surprising that the central arguments for hermeneutic universalism turn on rejecting foundationalist ideas of transparent fact, absolute and univocal truth, and mind-independent objectivity. For such ideas underwrite the possibility of attaining some perfect God's-eye grasp of things as they really are, independent of how we differently perceive them, a seeing or understanding that is free from the corrigibility and perspectival pluralities and prejudices that we willingly recognize as intrinsic to all interpretation.

I think the universalists are right to reject such foundational understanding, but wrong to conclude from this that all understanding is interpretation. Their mistake, a grave but simple one, is to equate the nonfoundational with the interpretive. In other words, what the universalists are successfully arguing is that all understanding is nonfoundational; that it is always corrigible, perspectival, and somehow prejudiced or

prestructured; that no meaningful experience is passively neutral and disinterestedly nonselective. But since, in the traditional foundationalist framework, interpretation is contrasted and designated as *the* form of nonfoundational understanding, the inferior foster home of all corrigible, perspectival perception, it is easy to confuse the view that no understanding is foundational with the view that all understanding is interpretive. Yet this confusion of hermeneutic universalism betrays an unseemly residual bond to the foundationalist framework, in the assumption that what is not foundational must be interpretive. It thus prevents the universalists from adopting a more liberating pragmatist perspective which (I shall argue) can profitably distinguish between understanding and interpretation without thereby endorsing foundationalism. Such pragmatism more radically recognizes uninterpreted realities, experiences, and understandings as already perspectival, prejudiced, and corrigible; in short, as nonfoundationally given.

So much for a general overview of the universalist arguments. I now want to itemize and consider six of them in detail. Though there is some overlap, we can roughly divide them into three groups, respectively based on three ineliminable features of all understanding: (a) corrigibility, (b) perspectival plurality and prejudice, and (c) mental activity and process.

1. What we understand, what we grasp as truth or fact, frequently turns out to be wrong, to require correction, revision, and replacement by a different understanding. Moreover, this new understanding is typically achieved by reinterpreting the former understanding, and can itself be replaced and shown to be not fact but "mere interpretation" by a subsequent understanding reached through interpretive thought. Since any putative fact or true understanding can be revised or replaced by interpretation, it cannot enjoy an epistemological status higher than interpretation; and interpretation is paradigmatically corrigible and inexhaustive. This is sometimes what is meant by the claim that there are no facts or truths but only interpretations.

The inference, then, is that since understanding is epistemologically no better than interpretation, it is altogether no different from interpretation (as if all meaningful differences had to be differences of apodicticness!). The conclusion is reinforced by the further inference that since all interpretation is corrigible, and all understanding is corrigible, then all understanding is interpretation. Once formulated, the inferences are obviously, indeed pathetically, fallacious. But we tend to accept their

conclusion, since we assimilate all corrigible and partial understanding to interpretation, as if genuine understanding itself could never be revised or enlarged, as if understanding had to be interpretive to be corrigible. But why make this rigidly demanding assumption? Traditionally and foundationally, the reason was that understanding (like its cognates truth and fact) was itself defined in contrast to "mere interpretation" as that which *is* incorrigible. But if we abandon foundationalism by denying that any understanding is incorrigible, the idea of corrigible understanding becomes possible and indeed necessary; and once we recognize this idea, there is no need to infer that all understanding must be interpretation simply because it is corrigible. When hermeneutic universalists make this inference, they show an unintended and unbecoming reliance on the foundationalist linkage of uninterpreted understanding with incorrigible, foundational truth.

2. The second argument for hermeneutic universalism derives from understanding's ineliminable perspectival character and the inevitable plurality of perspectives. We already noted how Nehamas builds his argument that all understanding is interpretive on the premise that all understanding, indeed "all our activity," is "partial and perspectival." I think the premise is perfectly acceptable and can be established by an argument that Nehamas does not supply. All understanding must be perspectival or aspectual, since all thought and perception exhibit intentionality (in the phenomenological sense of being about something), and all intentionality is aspectual in grasping its object in a certain way. But the very idea of perspective or aspect implies that there are other possible perspectives or aspects, which lie (in Gadamer's words) outside "the horizon" of a particular perspectival standpoint and thus outside its "range of vision" (*TM*, 269). If all understanding is aspectual and admits of other possible and legitimate perspectives, there can be no univocal and exclusive understanding of any thing, but rather many partial or perspectival ways of seeing it, none of which is wholly and exclusively true.

So much for the premise, but how does it follow that all understanding is interpretive? Again, in the traditional foundationalist framework, interpretation marks the realm of partial, perspectival, and plural ways of human understanding in essential contrast to some ideal understanding that grasps things as they really are univocally, exhaustively, and absolutely. Rejecting the very possibility and intelligibility of such univocal and complete understanding (as Nehamas and Gadamer rightly do),

the universalists infer that all understanding is thereby reduced to interpretation—the foundationalist category for understanding that, although it is not necessarily false and illegitimate (not a *mis*understanding), cannot represent true understanding since it is perspectivally plural and not necessarily and wholly true. However, again we should realize that once we are free of foundationalism's doctrines, there is no need to accept its categorizations. There is thus no need to deny that true understanding can itself be perspectivally partial and plural, and consequently no reason to conclude that since all understanding must be perspectival, it must also be interpretation.[13]

3. In speaking of understanding as perspectival and hence partial, we have so far meant it cannot exclude different perspectives and can in principle always be supplemented. But partiality also has the central sense of bias and prejudice. The third argument why understanding must always be interpretation is that it is always prejudiced and never neutrally transparent. This is a key point in the Nietzschean, Gadamerian, and even pragmatist attacks on foundationalist understanding. Any understanding involves the human element that prestructures understanding in terms (and in service) of our interests, drives, and needs, which significantly overlap but also frequently diverge among different societies and individuals. Moreover, for Nietzsche, Gadamer, and the pragmatists, the fact that understanding is always motivated and prejudiced by our needs and values is a very good thing; it is what allows us to thrive and survive so that we can understand anything at all.

From the premise that "all understanding necessarily involves some prejudice" (*TM*, 239), "that every view depends on and manifests specific values" and "antecedent commitments" (*N*, 67–68), it is but a short step to the view that all understanding and perception is interpretation. But it is a step where the more canny pragmatist fears to tread, and where she parts company from grand continental hermeneuts like Nietzsche and Gadamer. In rejecting the foundationalist idea and ideal of transparent mirroring perception, she recognizes that understanding is always motivated and prejudiced, just like interpretation. But she wonders why this makes understanding always interpretive. It just does not follow, unless we presume that *only* interpretation could be prejudiced, while (preinterpretive) understanding or experience simply could not be. But to her, this inference is as strange and offensive as a sexist argument that all humans are really women because they all are influenced by emotions, while presumably real men are not.

4. The fourth argument for hermeneutic universalism inhabits the overlap between understanding's perspectival partiality and its active process. The argument is basically that since all understanding is selective—focused on some things and features but not others—all understanding must therefore be interpretive. We find an analogous claim in the philosophy of art criticism, where it is argued that we cannot distinguish between describing and interpreting the work; that any description of the work already constitutes an interpretation by its selection of certain features to describe rather than others, because such selection represents an interpretive decision about what is important and meaningful in the work. Moreover, hermeneutic universalists like Fish go on to say that not only every description but every reading or perception of the work is similarly selective, and thus already an interpretation of it. Hence, "interpretation is the only game in town."[14]

The fact that understanding is perspectivally partial (in both senses of incompleteness and purposive bias) implies it is always selective. It always grasps some things rather than others, and what it grasps depends in part on its antecedent purposes. This much seems incontestable. What I challenge is the inference that since understanding (or indeed any intelligent activity) is always selective, it is therefore always interpretive. Such a conclusion needs the further premise that all purposive selection must be the product of interpretive thinking and decision. But this premise is false, an instance of the philosophical fallacy John Dewey dubbed "intellectualism."[15] For most of the selection involved in our ordinary acts of perception and understanding is done automatically and unconsciously (yet still intelligently and not mechanically) on the basis of intelligent habits, without any reflection or deliberation at all.[16] Interpretation, in its standard ordinary usage, certainly implies conscious thought and deliberate reflection; but not all intelligent and purposive selection is conscious or deliberate. Walking down the stairs requires selecting how and where to place one's feet and body, but such selection involves interpreting only in cases of abnormal conditions when descent of the staircase presents a problem (as with an unusually dark or narrow winding staircase, a sprained ankle, or a fit of vertigo).

Just as it wrong to confuse all purposive intelligent choice (some of which may be prereflective) with interpretive decisions requiring ratiocination, so we need not confuse perceptions and understandings that are immediately given to us (albeit only corrigibly and mediated by prior experience) from understandings reached only by interpretive delibera-

tion on the meaning of what is immediately given. When I awake on the beach at Santa Cruz with my eyes pierced by sunlight, I immediately perceive or understand it is daytime; only when I instead awake to a darkish gloom do I need to interpret that it is no longer night but merely another dreary morning in Berlin.

In short, I am arguing that though all understanding is selective, not all selective understanding is interpretive. If understanding's selection is neither conscious nor deliberate but prereflective and immediate, we have no reason to regard that selection or the resultant understanding as interpretation, since interpretation standardly implies some deliberate or at least conscious thinking, whereas understanding does not.[17] We can understand something without thinking about it at all; but to interpret something, we need to think about it. This distinction may recall a conclusion from Wittgenstein's famous discussion of seeing-as, where he distinguishes seeing from interpreting: "To interpret is to think, to do something; seeing is a state."[18]

5. Though insightful, Wittgenstein's remark is also problematic. For it suspiciously suggests that we could see or understand without doing anything; and this suspicion suggests the fifth argument for hermeneutic universalism. Understanding or perceiving, as Nietzscheans, pragmatists, and even Gadamerians insist, is active. It is not a passive mirroring but an active structuring of what it encounters. To hear or see anything, even before we attempt to interpret it, involves the activity of our bodies, certain motor responses and tensions in the muscles and nerves of our organs of sensation. To characterize seeing or understanding in sharp contrast to interpretation as an achieved "state" rather than as "doing something" suggests that understanding is static rather than active; and if passively static, then it should be neutral rather than selective and structuring. The fifth argument for hermeneutic universalism therefore rejects this distinction between understanding as passively neutral and interpretation as actively structuring, and infers that since all understanding is active, all understanding must be interpretive.

My response to this argument should already be clear. As a pragmatist, I fully assent to the premise that all perception and understanding involve doing something; but I deny this entails that they always involve interpretation. The inference relies on an implicit premise that all "doings" that are cognitively valuable or significant for thought are themselves already cases of thinking. Hence any active selection and structuring of perception must already be a thoughtful, deliberate selection,

one involving an interpretive decision. This is the premise I contest, the assimilating conflation of all active, selective, and structuring intelligence with the active, selective, and structuring of the interpreting intellect. Understanding can actively structure and select without engaging in interpretation, just as action can be intelligent without engaging thought or the intellect. When, on my way to the beach, I am told that the surf is up, I immediately understand what is said, prereflectively selecting and structuring the sounds and meanings I respond to. I do not need to interpret what is said or meant. Only if I were unfamiliar with idiomatic English, or unable to hear the words, or in a situation where the utterance would seem out of place, would I have to interpret it. Only if there were some problem in understanding, some puzzle or doubt or incongruity, would I have to thematize the utterance as something that needed interpretation, something to think about and clarify or resolve.

6. But this assertion is precisely what is challenged by the sixth argument for universal hermeneutics, an argument that highlights the intimate link between the hermeneutic turn and the linguistic turn in both continental and Anglo-American philosophy. Briefly and roughly, the argument goes as follows. All understanding is linguistic, because all understanding (as indeed all experience) involves concepts that require language. But linguistic understanding is essentially a matter of decoding or interpreting signs that are arbitrary rather than natural and whose translation into meaningful propositions thus requires interpretation. To understand the meaning of a sentence, we need, on the Quinean-Davidsonian model, to supply a translation or interpretation of it in terms already familiar to us (whether those terms be in the interpreted language itself or in another more familiar "home" language). So Davidson baldly asserts that "all understanding of the speech of another involves radical interpretation" and firmly equates "the power of thought" with "speaking a language."[19] And from the continental tradition, Gadamer concurs by basing the universal scope of hermeneutics on "the essential linguisticality of all human experience of the world" and on a view of language as "itself the game of interpretation that we are all engaged in every day."[20] Hence, not only all understanding but all experience is interpretive, since both are inevitably linguistic—a conclusion endorsed by Richard Rorty, Jacques Derrida, and a legion of hermeneutic universalists.

Though the consensus for this position is powerful, the argument

strikes me as less than persuasive. It warrants challenging on two points at least. First, we can question the idea that linguistic understanding is always the decoding, translation, or interpretation of arbitrary signs in terms of specific rules of meaning and syntax. This is, I think, an overly formalistic and intellectualized picture of linguistic understanding. Certainly, it is not apparent that we always (or ever) interpret, decode, or translate the uncoded and unproblematic utterances we hear in our native tongue simply in order to understand them. That is precisely why ordinary language distinguishes such direct and simple understandings from decodings, translations, and interpretations.

But, the hermeneutic universalists will persist: Mustn't we be interpreting even when we don't know it, since no other model can account for our understanding? No, because an alternative model is available in Wittgenstein, where linguistic understanding is a matter of being able to make the right responses or moves in the relevant language game, and where such ability or language acquisition is first gained by brute training or drill.[21] Language mastery is (at least in part) the mastery of intelligent habits of gesture and response for engaging effectively in a form of life, rather than the mastery of a system of semiotic rules for interpreting signs.

So I think a case can be made for some distinction between understanding and interpreting language, between an unreflective but intelligent trained habit of response and a thoughtful decision about how to understand or respond. I have to interpret or translate most utterances I hear in Italian in order to understand them, but I understand most sentences I hear in English without interpreting them; I interpret only those that seem unclear or insufficiently understood. To defend the conflation of understanding and interpretation by arguing that in simply understanding those alleged uninterpreted utterances, I am in fact already interpreting sounds as words — or, perhaps further, that my nervous system is busy interpreting vibrations into sounds — is not only to stretch the meaning of "interpretation" for no productive purpose, it is also to misrepresent our actual experience. Certainly we can make a distinction between the words and the sounds, and between the sounds and the vibrations that cause them. But this does not mean they are really distinct or distinguishable in experience and that I therefore must interpret the sounds in order to understand them as words. On the contrary, when I hear a language I understand, I typically do not hear the sounds at all but only the understood words or message. If any interpretive

effort is needed, it is to hear the words as sounds or vibrations, not vice versa.

There is, then, good reason to reject the view that linguistic understanding is always and necessarily interpretation. But even granting it, we still need not grant the conclusion that all understanding is interpretive. For that requires the further premise that all understanding and meaningful experience is indeed linguistic. And such a premise, though it be the deepest dogma of the linguistic turn in both analytic philosophy and continental hermeneutics, is neither self-evident nor immune to challenge. Certainly, there seem to be forms of bodily awareness or understanding that are not linguistic in nature and in fact defy adequate linguistic characterization, though they can be somehow referred to through language. As dancers, we understand the sense and rightness of a movement or posture proprioceptively, by feeling it in our spine and muscles, without translating it into conceptual linguistic terms. We can neither learn nor properly understand the movement simply by being talked through it.

Moreover, apart from the nonlinguistic understandings and experiences of which we are aware, there are more basic experiences or understandings of which we are not even conscious, but whose successful transaction provides the necessary background selection and organization of our field that enables consciousness to have a focus and emerge as a foreground. We typically experience our verticality and direction of gaze without being aware of them, but without our experiencing them we could not be conscious of or focused on what we are in fact aware of; our perceptual field would be very different. As Dewey insisted, there is a difference between not knowing an experience and not having it. "Consciousness . . . is only a very small and shifting part of experience" and relies on "a context which is non-cognitive," a "universe of non-reflectional experience."[22]

To all such talk of nonlinguistic experience or understanding the hermeneutic universalists have a ready and seemingly irresistible response. How can I claim any experience is nonlinguistic, when in that very claim I have had to talk about it, refer to it by language? Any attempt to characterize something as nonlinguistic or describe it as linguistically inexpressible self-refutingly renders it linguistic and linguistically expressed. Therefore, whatever can be said to exist, or even is explicitly thought to exist (since explicit thinking can be seen as conceptual and language dependent), is and must be linguistic. Hence Gadamer, for

example, concludes, "Being that can be understood is language" (*TM*, 432), and the likes of Derrida and Rorty similarly deny any "*hors-texte*."

This argument has, I admit, considerable suasive power, and it long swayed me. But now it strikes me more like a sophistic paradox about talking without language than a deep truth about human experience and the world. Surely, once we have to talk about something, even merely to affirm or deny its existence, we must bring it into the game of language, give it a linguistic visa or some conceptual-textual identity— even if the visa be one of alien or inferior linguistic status, like "inexpressible tingle" or "nondiscursive image." But this only means that we can never talk (or explicitly think) about things existing without their being somehow linguistically mediated; it does not mean that we can never experience them nonlinguistically or that they cannot exist for us meaningfully but not in language.

We philosophers fail to see this because, disembodied talking heads that we are, the only form of experience we recognize and legitimate is linguistic: thinking, talking, writing. But neither we nor the language that admittedly helps shape us could survive without the unarticulated background of prereflective, nonlinguistic experience and understanding.[23] Hermeneutic universalism thus fails in its argument that interpretation is the only game in town because language is the only game in town. For there is both uninterpreted linguistic understanding and meaningful experience that is nonlinguistic. We can find them in those darkly somatic and illiterate neighborhoods of town that we philosophers and literary theorists are occupationally accustomed to avoid and ignore, but on which we rely for our nonprofessional sustenance and satisfactions. After the conference papers are over, we go slumming in their bars.[24]

IV

Thus far I have resisted the universalists' arguments that understanding and interpretation cannot possibly be distinguished since all understanding is and must be interpretation. What remains, for the final sections of this chapter, is to show why the distinction is worth making and how it should be made and understood. There are three reasons why I think it important to preserve some distinction between understanding and interpretation.

First and most simply, it provides interpretation with a "contrast-class" to help delimit and thus shape its meaning. Without an activity

to contrast to interpretation, what can interpretation really mean? The possibility of alternatives is a necessary condition of meaningfulness. This principle of choice, endorsed not only in structuralist semantics but in analytic information theory, recognizes that the meaning of a term or proposition is a function of those terms or propositions it opposes or excludes.[25] Notions of unlimited extension, like tautologies that are universally true, tend to evaporate into semantic emptiness. If everything we do or experience is always and must always be interpretation, the notion of interpretation becomes synonymous with all human life and activity, and thus loses any real meaning or specific role of its own. Uninterpreted understandings and experiences provide a relevant contrast-class for interpretations, enabling interpretation to be distinguishable as having some definite meaning of its own, since its meaning is in some way defined and limited by what falls outside it and is contrasted to it.

Second, understanding provides interpretation not only with a meaning-giving contrast but with a meaning-giving ground. It supplies something on which to base and guide our interpretations, and represents something by which we can distinguish between different levels or sequential acts of interpretation. How does understanding ground and guide interpretation? We can find the makings of an answer in Heidegger and Wittgenstein, two revered progenitors of hermeneutic universalism who I think wisely resisted that doctrine. The complexly reciprocal and leveled relationship between understanding and interpretation is suggested in the second dimension of the hermeneutic circle, which Heidegger calls to our attention in his famous remark that "any interpretation which is to contribute understanding must already have understood what is to be interpreted."[26]

Elucidating this idea with respect to a literary text, we can say that before and while we try to interpret its meaning, we must be struck and directed by some sense of what it is we are trying to interpret. At the very least, we need some primitive understanding of what we are individuating as the textual object of interpretation, simply to identify it as such. Moreover, it is our initial understanding or experience of the text as something meaningful and perhaps worth understanding more fully that generates our desire to interpret it. We do not interpret every text we encounter. But our attempt to interpret the given text is not only motivated but guided by this prior understanding, though it be inchoate, vague, and corrigible. For we form our interpretive hypotheses

about the text (and accept or reject alternative interpretations) on the basis of what we already understand as properly belonging to the text rather than falsely foisted onto it.

But how do we determine whether our initial guiding understanding is valid and not a misunderstanding? We cannot appeal to the apodicticness or incorrigibility of understanding, because we have rejected all foundationalist accounts of understanding. Nor can we simply test the validity of our initial understanding by measuring it against the meaning of the text. As the text's meaning is not self-evidently given but is precisely what is in question, we would first have to determine more clearly what this meaning is. Yet to do this we must interpret, and thus we can only test our prior understanding by subsequent interpretation. In other words, though interpretation of the text must be based on some prior understanding of it, this understanding itself requires interpretation of the text for its own clarification and justification, if indeed we wish to pursue this. But that clarificatory and justificatory interpretation depends again on the very understanding it has to sharpen or validate. And so the hermeneutic circle revolves in a cycle of understanding and interpretation.

Considerations of this sort have led Gadamer and other hermeneutic universalists to the radical claim that "all understanding is interpretation" (*TM*, 350). But this claim, I have argued, is not only uncompelling but misleading in suggesting that we can never understand anything without interpreting it. For in many cases we are simply satisfied with our initial understanding and do not go on to interpret; there are always other and usually better things to do.

Moreover, if we could never understand anything without interpreting it, how could we ever understand the interpretation itself? It, too, would have to be interpreted, and so would its interpretation, and so on ad infinitum. As Wittgenstein notes, "Any interpretation still hangs in the air along with what it interprets." Interpretation must ultimately depend on some prior understanding, some "way of grasping . . . which is *not* an interpretation."[27] This seems a basic but crucial point of philosophical grammar about how these notions are related: understanding grounds and guides interpretation, while interpretation enlarges, validates, or corrects understanding. We must remember that the distinction is functional or relational, not ontological.[28] The prior and grounding understanding "which is not an interpretation" may have been the product of prior interpretations, though now it is immediately grasped.

Moreover, it need not be an explicitly formulated or conscious understanding, and the ground it provides is not an *incorrigible* ground.[29]

Though the universalists are wrong to deny that a helpful distinction can be drawn between simply understanding something and interpreting that which was understood, their attempts to deny it have not been unhelpful. For they showed that there is no rigid or absolute dichotomy, but rather an essential continuity and degree of interdependence, between understanding and interpretation. What is now immediately understood may once have been the product of a labored interpretation and may form the basis for further interpretation. Words of a French song I once struggled to interpret are now immediately understood, and this understanding affords me the ground for an interpretation of their deeper poetic meaning. Though frequently what we encounter neither demands nor receives interpretation, many things are felt to be insufficiently understood until they are interpreted by us or for us. We seek an interpretation because we are not satisfied with the understanding we already have—feeling it partial, obscure, shallow, fragmented, or simply dull—and we want to make it fuller or more adequate. Yet the superior interpretation sought must be guided by that prior inadequate understanding. We no longer feel the need to interpret further when the new, fuller understanding that interpretation has supplied is felt to be satisfactory. Criteria of what is satisfactory obviously will vary with context and will depend on the sort of understanding sought. Wittgenstein aptly puts this pragmatic point: "What happens is not that this symbol cannot be further interpreted, but: I do no interpreting. I do not interpret, because I feel at home in the present picture."[30]

The third reason I think it worth distinguishing between understanding and interpretation is to defend the ordinary: not only ordinary usage, which itself draws and endorses the distinction, but ordinary experiences of understanding whose legitimacy and value tend to get discredited by hermeneutic universalism's assimilation of all experience into interpretation. In commonplace discourse not all understanding is interpretation. There are countless contexts where one might justifiably reply to a query of how one interpreted something by denying that one actually interpreted it at all: "I didn't bother interpreting what he said; I just took it at face value." "I didn't pause to interpret her command (or question); I immediately complied with it (or ignored it)."

Even if these direct or immediate understandings are always based on the funded habits and capacities of prior efforts of interpretation, there

is still a difference between such effortless, unthinking acts of under-standing (or experiences of meaning) and acts of interpretation, which call for deliberate, focused thought. In marking a difference between interpretation and the more direct experiences or understandings on which it is based, ordinary language respects the role of the prereflec-tive and nondiscursive background from which the foreground of con-scious thinking emerges and without which it could never arise. In re-jecting this distinction by asserting that all experience is interpretation, hermeneutic universalists deny this very ordinary but very crucial un-thinking dimension of our lives and indeed of our thinking.

We can see a variation of this discrediting denial of the ordinary and unreflective in Stanley Fish's account of reading. As hermeneutic uni-versalist, he asserts that all our activity is essentially interpretive. We cannot simply read or even recognize a text without interpreting it, since the text can only be constituted as such by an act of interpretation. Now since interpretation implies active thinking and discourse, it can-not be a merely mirroring representation of the text but must in some way supplement, shape, or reconstruct it. Hence all our apparent prac-tices of reading are really "not for reading but for writing texts."[31] Hav-ing conflated reading with interpretation, Fish further conflates interpre-tation with the institutionalized interpretation of professional academic criticism, where an interpretation must not only be discursively formu-lated but must provide "something different" or significantly new in or-der to be legitimate and "be given a hearing." Hence he concludes that all reading of a text must not only be interpreting it but also changing it in some professionally meaningful way.[32]

The result is that ordinary, unreflective, nonprofessional modes of reading are discredited and dismissed as foundationalist myth. Yet pre-cisely these unreflective unoriginal readings, which anticipate the at-tempt to interpret, are what in fact provides the basis for professional transformative interpretations by supplying some shared background of meaning which enables us to identify what we agree to call "the same text" so that we can then proceed to interpret it differently. Fish himself must and does appeal to this unformulated "core of agreement" or "gen-eral purpose," which prestructures and constrains interpretive strate-gies. But he simply ascribes it to "the literary institution" or "interpretive community" (another dangerous conflation) and fails to realize that such a community exists only as embodied in the concrete experiences and understandings of readers, just as its most basic constraints are embod-

ied in the prereflective, uncritical habits of reading, habits that precede the attempt to interpret what is read.[33]

Here, as elsewhere, universal hermeneutics' dismissal of the pre-interpretive reflects an intellectualist blindness to the unreflective, nondiscursive dimension of ordinary experience, a bias at once haughtily elitist and parochially uncritical. To defend this ordinary, unassuming, and typically silent dimension, we need to preserve something distinct from interpretive activity, even if it cannot be immune from interpretation and may indeed rest on what was once interpretation.

V

I have argued that we can eschew foundationalism without maintaining that all experience and understanding must be interpretation. We can do so by insisting that understanding should itself be understood nonfoundationally, that is, as corrigible, perspectival, pluralistic, prej-udiced, and engaged in active process. I have further argued that there are at least a few good reasons for admitting some meaningful activity or experience other than interpretation, and thus for allowing or indeed making some distinction between interpretation and understanding. What remains is to suggest how this distinction might best be drawn or understood, largely by recollecting and recasting some of the central points already made in our discussion.

First, the distinction between understanding and interpretation is not a rigid ontological one, where the two categories cannot share the same objects. Second, they cannot be distinguished by epistemological relia-bility, where understanding implies univocal truth while interpretation connotes pluralistic error. Nonetheless, understanding and interpreta-tion are epistemologically different in terms of their functional relations: understanding initially grounds and guides interpretation, while the lat-ter explores, validates, or modifies that initial ground of meaning.

Other differences to be drawn between understanding and inter-pretation are probably more debatable. While understanding, even in-telligent understanding, is often unreflective, unthinking, indeed un-conscious (even if always purposive), interpretation proper involves conscious, deliberate thought: a clarification of something obscure or ambiguous, a deciphering of a symbol, an unraveling of a paradox, an articulation of previously unstated formal or semantic relations between elements. While understanding is frequently a matter of smoothly coor-

dinated, unproblematic handling of what we encounter,[34] interpretation characteristically involves a problematic situation. We only stop to interpret in order to resolve a problem—some question, obscurity, ambiguity, contradiction, or, more recently, the professional academic problem of generating an interpretive problem. The intrinsic problem-solving character of interpretation explains why it involves conscious, deliberate inquiry. Solving a problem demands thinking, seeing the obvious does not.

On this question of consciousness, our ordinary linguistic usage (to which I earlier appealed) does not give unchallengeable support. Although it sounds strange to speak of someone unconsciously interpreting some remark or event, it is not a blatant contradiction or solecism. But that is simply because language aims more at loose flexibility than precision, and because hermeneutic universalism has accustomed us to think loosely of interpretation as subsuming all construals, understandings, or meaningful experiences, some of which are obviously unconscious. If our ordinary speech does not always draw a distinction between interpreting and understanding, it more often makes it and never implies that it is not worth making.

The conscious and problem-solving character of interpretation suggests yet another feature that might help distinguish it from understanding. Though both are inevitably perspectival, interpretive activity seems intrinsically aware that alternative interpretations may be given to resolve a problem, while understanding can be unreflectively blind to the existence or possibility of alternative understandings, since it can be unaware of any problem of understanding that might present alternative solutions.

I conclude with one last suggestion for distinguishing interpretation from more primitive or basic understandings and experiences, one that reaffirms the link I established between hermeneutic universalism and the linguistic turn. Interpretation is characteristically aimed at linguistic formulation, at translating one meaningful expression into another one. A criterion for having an interpretation of some utterance or event would be an ability to express in some explicit, articulated form what that interpretation is. To interpret a text is thus to produce a text.[35] Understanding, on the other hand, does not require linguistic articulation. A proper reaction, a shudder or tingle, may be enough to indicate one has understood. Some of the things we experience and understand are never captured by language, not only because their particular feel

defies adequate linguistic expression but because we are not even aware of them as "things" to describe. They are the felt background we presuppose when we start to articulate or to interpret.

"There are, indeed, things that cannot be put into words. They show themselves. They are the mystical."[36] So said the greatest twentieth-century philosopher of language in his first philosophical masterpiece. What Wittgenstein fails to emphasize here is that the ineffable but manifest is as much ordinary as mystical, and it is mystifying only to those disembodied philosophical minds who recognize no understanding other than interpretation, and no form of meaning and experience beyond or beneath the web of language.

7 |

somaesthetics and the body/media issue

> The human body is the magazine of invention. . . . All the tools
> and engines on earth are only extensions of its limbs and senses.
>
> EMERSON

I

One striking paradox of our new media age is its heightened concentration on the body. As telecommunications render bodily presence unnecessary, while new technologies of mediatic body construction and plastic cyborg-surgery challenge the very presence of a real body, our culture seems increasingly fixated on the soma, serving it with the adoring devotion once bestowed on other worshiped mysteries. In postmodern urban culture, gyms and fitness centers proliferate, largely replacing both church and museum as the preferred site of self-meliorative instruction, where one is obliged to visit in one's leisure as a duty to oneself, even if it involves inconvenience and discomfort. Ever more money, time, and pain is being invested in cosmetics, dieting, and plastic surgery. Despite mediatic dematerialization, bodies seem to matter more.

The media's advertisement of good-looking bodies has partly fueled this interest, but only in part. Much somatic interest, as I have elsewhere explained,[1] is not at all directed at representational beauty but instead at the quality of immediate experience: the endorphin-enhanced glow of high-level cardiovascular functioning, the slow savoring awareness of improved, deeper breathing, the tingling thrill of feeling into new parts of one's spine. Pursuit of such heightened bodily experience is typically portrayed and celebrated as the very antithesis of "couch-potato" media consumption, as an antidote to what it sees as media-induced passivity.

Such revalidation of the active, transformative body is something very different from the vision of the body held by media advocates: the body as dull and inert—a sluggish antithesis to the media's electric flexibility. Yet the opposition of body and media remains. This contrasting vision of the media—not as a passive, pacifying mirror but as an active creator possessing apparently limitless range and power—finds its most extreme and futuristic expression in William Gibson's vision of cyberspace, a fiction that is nonetheless forging real research links be-

tween scientists working in artificial intelligence, telecommunications, and virtual reality.[2] In contrast to cyberspace's dynamic freedom and protean mobility that defy traditional spatiotemporal constraints, the body is opposed as a lifeless, inert prison. "The body was meat," writes Gibson, "the prison of [one's] own flesh."[3]

That both critiques and theodicies of the media portray the body as its antipode renders this opposition an unremarkable commonplace. It nonetheless strikes me as strange, indeed uncanny. For the body was always the primordial *paradigm* of the media—by constituting the most basic medium of human life. In fact, for much of ancient and non-Western culture, the body also constituted an essential site of philosophy, conceived as a critical, self-fashioning life practice, an art of living.

In *Practicing Philosophy*, I tried to revive and reconstruct this notion of embodied philosophy by introducing a field I call *somaesthetics*. This chapter aims to elaborate the structure of this field and to explore how it can be useful in treating crucial issues in the rapidly growing fields of body theory and cultural studies. Since the problematic relationship between soma and media commands so much recent attention and seems so central to our performing arts, I have selected it as my focus.

II

Somaesthetics is devoted to the critical, ameliorative study of one's experience and use of one's body as a locus of sensory-aesthetic appreciation (*aisthesis*) and creative self-fashioning. It is therefore likewise devoted to the knowledge, discourses, practices, and bodily disciplines that structure such somatic care or can improve it. Though modern Western philosophy has largely slighted the body, if we put aside this prejudice and simply recall philosophy's central aims of knowledge, self-knowledge, right action, and quest for the good life, then the crucial philosophical value of somaesthetics becomes clear in several ways.

1. Since knowledge is largely based on sensory perception whose reliability often proves questionable, philosophy has always been concerned with the critique of the senses, exposing their limits and avoiding their misguidance by subjecting them to discursive reason. Philosophy's work here (at least in Western modernity) has been confined to the sort of second-order discursive analysis and critique of sensory propositional judgments that constitutes standard epistemology. The complementary route offered by somaesthetics is instead to correct the

actual functional performance of our senses by an improved direction of one's body, since the senses belong to and are conditioned by the soma.

Philosophy since Socrates has always recognized that physical ill health (through consequent organ malfunctioning or mental fatigue) is a major source of error. But therapies such as Alexander Technique, Feldenkrais Method, and Reichian bioenergetics (like older Asian practices of hatha yoga and Zen meditation) go further by claiming to improve the acuity, health, and control of our mind and senses by cultivating heightened attention and mastery of their somatic functioning, while also freeing us from bodily habits and defects that tend to impair cognitive performance.

2. If self-knowledge is a central aim of philosophy, then knowledge of one's bodily dimension must not be ignored. Somaesthetics, whose concern is not simply with the body's external form or representation but with its lived experience, works toward improved awareness of our feelings, thus providing greater insight into both our passing moods and lasting attitudes. It can therefore reveal and improve somatic malfunctionings that normally go undetected even though they impair our well-being and performance.

Consider two examples. We rarely notice our breathing, but its rhythm and depth provide rapid, reliable evidence of our emotional state. Consciousness of breathing can therefore make us aware that we are angry or anxious when we might otherwise remain unaware of these feelings and thus vulnerable to their misdirection. Similarly, a chronic contraction of certain muscles that not only constrains movement but results in tension and pain may nonetheless go unnoticed because it has become habitual. As unnoticed, this chronic contraction cannot be relieved, nor can its resultant disability and discomfort. Yet once such somatic functioning is brought to clear attention, there is the possibility of modifying it and avoiding its unpleasant consequences.

3. A third central aim of philosophy is right action, for which we need not only knowledge and self-knowledge but also effective will. As embodied creatures, we can act only through the body, hence our power of volition—the ability to act as we will to act—depends on somatic efficacy. By exploring and refining our bodily experience, we can gain a practical grasp of the actual workings of effective volition—a better mastery of the will's concrete application in behavior. Knowing and desiring the right action will not avail if we cannot will our bodies to per-

form it; and our surprising inability to perform the most simple bodily tasks is matched only by our astounding blindness to this inability, these failures resulting from inadequate somaesthetic awareness.

Just think of the typical golfer who tries to keep his head down and his eyes on the ball and who is completely convinced that he is doing so, even though he fails miserably. His conscious will is unsuccessful because deeply ingrained somatic habits override it, and he does not even notice this failure because his habitual sense perception is so inadequate and distorted that it feels as if the action intended is indeed performed as willed. In too much of our action we are like the golfer whose will is at once strong yet impotent, since lacking the somatic sensibility to make it effective. This argument, advanced by body therapists outside the standard discourse of philosophy (such as F. M. Alexander and Moshe Feldenkrais), was long ago asserted by Diogenes the Cynic in advocating rigorous body training as "that whereby, with constant exercise, perceptions are formed such as secure freedom of movement for virtuous deeds."[4]

4. If philosophy is concerned with the pursuit of happiness and better living, then somaesthetics' concern with the body as the locus and medium of our pleasures clearly deserves more philosophical attention. Even the joys and stimulations of pure thought are (for us humans) embodied, and thus can be intensified or more acutely savored through improved somatic awareness and discipline. Nor should we forget that thinking depends on the body's health and requires its muscular contractions.

5. Recognizing (with Wilhelm Reich, Michel Foucault, and Pierre Bourdieu) that the body is a docile, malleable site for inscribing social power, we see the value of somaesthetics for political philosophy.[5] It offers a way of understanding how complex hierarchies of power can be widely exercised and reproduced without any need to make them explicit in laws or have them enforced; entire ideologies of domination can thus be covertly materialized and preserved by encoding them in somatic norms that, as bodily habits, are typically taken for granted and so escape critical consciousness: for example, the norm that women of a given culture should speak softly, eat dainty foods, sit with their knees close together, keep the head and eyes down while walking, and assume the passive role or lower position in copulation. However, just as repressive power relations are encoded in our bodies, so they can be challenged by alternative somatic practices. Foucault joins Reich and other

body therapists in advocating this message, though the recommended somatic methods vary greatly.

6. Beyond these essential epistemological, ethical and sociopolitical issues, recent philosophy reveals the body's crucial role for ontology. Just as Maurice Merleau-Ponty explains the body's ontological centrality as the focal point from which we and our world are reciprocally projected, so analytic philosophy examines the body as a criterion for personal identity and as the ontological ground (through its central nervous system) for explaining mental states.[6]

7. Finally, outside the legitimized realm of academic philosophy, we find the philosophical speculations of body therapists like Reich, Alexander, and Feldenkrais affirming deep reciprocal influences between bodily experience and character development. Somatic malfunctioning can be both a consequence and reinforcing cause of personality problems, which themselves may only be remedied through body work. Similar claims are even made by yogis and by bodybuilders like Arnold Schwarzenegger.[7] Here somatic health and know-how are presented, much in the style of the ancients, as a prerequisite to mental well-being and psychological self-mastery. In short, somatics appears here at the heart of ethics' care for the self.

Although contemporary theory pays increasingly more attention to the body, it tends to lack two important features. The first is a structuring overview or architectonic to integrate its very different, seemingly incommensurable discourses into a more productively systematic field: some comprehensive framework that could fruitfully link the discourse of biopolitics with therapies of bioenergetics, and analytic philosophy's doctrines of psychosomatic supervenience with bodybuilding principles of supersets. The second thing lacking in *philosophical* discourse on the body is a clear pragmatic orientation, something that the individual can directly translate into a discipline of improved somatic practice. The notion of somaesthetics tries to remedy both these lacks.

III

Somaesthetics has three fundamental branches, all of which are present in exemplary somatic philosophers like John Dewey and Michel Foucault. The first, *analytic somaesthetics*, describes the basic nature of our bodily perceptions and practices and their function in our knowledge and construction of reality. This theoretical branch involves standard ontological and epistemological issues of the body, but also includes the

sort of sociopolitical inquiries that Foucault made central: how the body is both shaped by power and employed as an instrument to maintain it, how bodily norms of health and beauty and even the most basic categories of sex and gender are constructions sustained by and serving social forces. Foucault's approach to these somatic issues was typically genealogical, portraying the historical emergence of various doctrines, norms, and disciplines pertaining to the body. This approach can be extended by a comparative form of analytic somaesthetics that contrasts the body views and practices of two or more synchronic cultures. But there is also place for an analytic somaesthetics of a more universalist bent, like that which is found in standard philosophical theorizing of the mind-body relationship in analytic philosophy and in the phenomenology of Merleau-Ponty.

A second branch, *pragmatic somaesthetics*, is concerned with methods of somatic improvement and their comparative critique. Since the viability of any proposed method will depend on certain facts about the body (whether ontological, physiological, or social), this pragmatic branch always presupposes the analytic. But it transcends mere analysis, not simply by evaluating the facts that analysis describes, but by proposing various methods to improve certain facts by remaking the body.

Over the course of history, a vast variety of disciplines have been recommended to improve our experience and use of the body: diverse diets, forms of dress, gymnastic training, dance and martial arts, cosmetics, body piercing or scarification, yoga, massage, aerobics, bodybuilding, S/M, and disciplines of psychosomatic well-being like Alexander Technique, Feldenkrais Method, and bioenergetics. These diverse methodologies of practice can be roughly classified into *representational* and *experiential* forms: representational somaesthetics emphasizes the body's external appearance while experiential disciplines focus not on how the body looks from the outside but on the aesthetic quality of its experience. Such experiential methods aim to make us "feel better" in both senses of this ambiguous phrase (a phrase that reflects the ambiguity of the very notion of aesthetics): they aim to make the quality of experience richer and more satisfying, but also to render our awareness of somatic experience more acute and perceptive. Cosmetic practices (from makeup to plastic surgery) exemplify the representational side of somaesthetics, while practices like Zen meditation or Feldenkrais Method are paradigmatic of the experiential.

The representational/experiential distinction is helpful for showing

that somaesthetics cannot be globally condemned as superficial on the grounds that it is confined to surface appearances. But this distinction should not be taken as rigidly exclusive, since there is an inevitable complementarity of representation and experience, of outer and inner. As advertising constantly reminds us, how we look influences how we feel, but also vice versa. Practices like dieting or bodybuilding that are initially pursued for ends of representation often produce feelings that are then sought for their own sake. The dieter thus becomes an anorexic craving the inner feel of hunger; the bodybuilder turns into an addict of the experiential surge of "the pump." On the other hand, somatic methods aimed at inner experience sometimes employ representational means as cues to achieve the body posture necessary for inducing the desired experience, whether by consulting one's image in a mirror, by focusing one's gaze on a body part like the tip of the nose or the navel, or simply by visualizing a body form in one's imagination. Conversely, representational practices like bodybuilding utilize improved awareness of experiential clues to serve its ends of external form.

The distinction between the experiential and representational forms of pragmatic somaesthetics is also not exhaustive; a third category of *performative* somaesthetics could be introduced to group methodologies that focus primarily on building strength, health, or skill: for instance, weightlifting, athletics, and certain martial arts. But to the extent that such performance-oriented practices aim either at external exhibition or at one's inner feeling of power, they might be assimilated into the representational or experiential categories.

However we classify them, the methodologies of pragmatic somaesthetics need to be distinguished from their actual practice. This third branch I call *practical* somaesthetics. Here it is not a matter of producing texts about the body, not even those offering pragmatic programs of somatic care. Instead, this practical branch is about physically engaging in such care, not by pushing words but by moving limbs, that is, in reflective, disciplined, demanding corporeal practice aimed at somatic self-improvement (whether representational, experiential, or performative). This dimension, not of saying but of doing, is the most neglected by academic body philosophers, whose commitment to the *logos* of discourse typically ends in textualizing the body. About practical somaesthetics, the less said the better, *if* this means the more done. Unfortunately, however, it usually means that actual body work simply gets left altogether out of philosophical practice and its quest for self-knowledge

and self-care. Since, in philosophy, what goes without saying typically goes without doing, the concrete activity of body work *must* be named as the crucial practical branch of somaesthetics, conceived as a comprehensive philosophical discipline concerned with embodied self-care.

Is such a discipline possible? Aren't embodied selves just too distinctively different for philosophy to offer any determinate theory or any concrete recommendations of somatic techniques? As I argue in *Practicing Philosophy*, since philosophy as a lived practice must be contextualized to be effective, and since every self is in some sense the unique product of countless contingent factors (physiological, societal, historical, and the more personal circumstances of family and private experience), each individual needs to fashion her own somaesthetic practice to suit her specific life conditions. But, on the other hand, don't our embodied selves share significant commonalities both of biological makeup and societal conditioning (at least within a given cultural tradition or historical age) that would allow some interesting generalizations about the values and risks of different somatic methods? What could philosophy or social science be without such generalization?

IV

Bracketing these grand metaphilosophical questions, let me now apply somaesthetics to the vexed issue of the body/media relationship, beginning with an all-too-hasty genealogical analysis of how the body escaped its old mediatic identity to become a worshiped end. Part of the explanation, I will argue, is that the media revolution so transformed the notions of medium and reality that our body—formerly declassed as merely a medium of, or means to, the real (hence subordinate, reflective, distortive)—now gets elevated, as our central medium, to the status of constructor and locus of the real. Hence it becomes a real value in itself. Once reality is seen as a construction, the media that construct it can no longer be disdained.

Further, since it is more basic, familiar, and organic than the newer electronic media, the body comes to seem so immediate as to occlude its old mediatic image. Nonetheless, the somatic constructor of reality is itself also continuously constructed through other varieties of media and mediations (including reconstructive surgery). So even if the media revolution emancipates the soma in recognizing its constructing powers and its openness to reconstruction, it also presents the further task of discriminating what, with respect to the body, should be constructed

and how the newer electronic media serve or sabotage our desired constructions (questions for pragmatic somaesthetics). That is the thrust of this chapter, which is caught, like all of us, between conceptual history and futuristic speculation.

We may begin historically by recalling the body's forgotten role as media paradigm, a role that reflects but goes beyond the image of instrumentality through which the somatic terms "organism" and "organ" emerged from the Greek word for tool—*organon*. But we should first ask: What, fundamentally, is a medium or means of communication? As its etymology (*meson, medius, Mittel, moyen*) makes evident, a medium is something that stands in the middle, typically between two other things or terms, between which it mediates. Being in the middle, a medium has two aspects. An interface with two faces, it both connects the mediated terms and separates them by standing between them. This double aspect is also present in the instrumental sense of medium as means to an end. Though it is a way to the end, it stands *in* the way, a distance to be traveled between purpose and its fulfillment.

Plato's seminal account of the body as medium insists on the negative, separative aspect, though the positive, constructive one is always resurfacing, *malgré lui*. His classic attack on the body (in *Phaedo*) reads like the *ur*-formula of contemporary media critique. The body is so poor a means to the truth that it actually constitutes an obstacle. First, it provides "innumerable distractions," "filling us with loves and desires and fears and all sorts of fancies and a great deal of nonsense, with the result that we literally never get a chance to think at all about anything." Second, if we finally find a quiet time to think, it will suddenly "intrude once more into our investigations, interrupting, disturbing, distracting, and preventing us from getting a glimpse of the truth." Third, it distorts our vision of the real so that when we take its reports for truth about the world, we are deceived. Only by keeping ourselves "uncontaminated by its follies" can we hope to get real knowledge.[8]

Plato could be denouncing the time-wasting nonsense of TV entertainment, the disruptive intrusion of incessant phones, faxes, and boom boxes, and the tendentious untruth of media reporting. But his target is the originary mother of all evil media—the body. This single body, however, is already portrayed as a multimedia conglomerate (of different sensory modalities and technologies, e.g., eyes, ears, feeling limbs, etc.), and such plurality and divisibility of parts provide all the more reason for Plato to degrade it by contrast to

the indivisible soul, which seeks the truth despite its confinement in the body's distortive prison.

However, given the conceptual doubleness of media as both obstruction and connection, the soul seeks truth not only despite the body but through it. Not only the soul's jailer, the body (as Plato insists) is also its servant. If the imperfections of bodily senses distract us from the divine Forms, their imperfections are what remind us in the first place that such Forms should exist and be sought.[9] If this means that the soul must be purified from bodily contamination, the only medium for such purification is the body itself, through its control. Indeed Plato's very word for purification here is the somatically evocative notion of catharsis. Purity of soul is not so much an immediate given as a task to be realized through bodily means. Indeed, Socrates' most convincing argument for the soul's immortal privilege over the body is not his abstract doctrines and polemics but his embodied example of calm readiness to face somatic death. If the body proves such a necessary means, it cannot be scornfully neglected without harming the end. Hence Plato later insists (in the *Timaeus*, 88) that we should care for the body, and even protect it from an overly dominant soul.

Christianity exploits the same mediatic doubleness. Though condemned as an obstacle to the soul's purity, the bodily medium still provided a prime instrument of salvation through purification—by serving as an ascetic altar of self-sacrifice. Clearly symbolized in the corporeal incarnation, temptation, and suffering passion of Christ, this ascetic usefulness of the body was even recognized by theologians who most fervently condemned the body's sensuality and urged its transcendence. Thus, Origen, who not only advocated virginal chastity but had himself castrated, still claimed "the body was necessary for the slow healing of the soul" and could provide a site of ascetic worship through which the material soma is transformed into what Origen called a "temple of God." Vividly portraying the baneful body as a purificatory medium, he wrote: "You have coals of fire, you will sit upon them, and they will be of help to you."[10]

This fundamental doubleness, where the very obstruction of the medium is part of its enabling, suggests two conclusions. First, in analyzing any form of media we should expect both obstructive and facilitating dimensions, so our critique should thus consider both constraining and emancipatory effects. Second, if the bodily medium is necessary for achieving (and perhaps even for conceiving) such presumedly ab-

solute realities like "the pure soul," then we can suspect that reality is always constructed through media. Hence we should be suspicious of any claims to absolute immediacy. This point becomes important in assessing contemporary claims for the body as a locus of immediacy.

Underlying Plato's specific attacks on the body as a medium for truth is a more basic dissatisfaction with two of its metaphysical limitations. Since the body is always confined to a particular spatiotemporal location, perception through it is always only from a particular perspective or point of view. For Plato (as later for Descartes) such limitation of perspective is unacceptable for scientific knowledge, which must provide an absolute, God's-eye vision of the real, a view from nowhere. Secondly, the individual body is subject not only to limited location but also to considerable instability, change, and corruption. So if reality is taken to be permanent, unchanging, and independent of perspective, then it can be properly grasped only by an intelligence that is similarly perspectiveless and incorruptibly permanent. The mutable body, then, could only distort the vision of the immutably real.

By the late nineteenth century, this metaphysical vision of an unchanging reality had been abandoned, partly through Darwin's influence but also through the industrial revolution and the great changes wrought by its new means of production and communication: steam engines, railroads, telegraph, and telephone. Both change and perspective could thus be positively revalued, along with the constructive role of physical media, including their original somatic paradigm. We see this most clearly in Nietzsche, where reality is identified as an interpretive construction and the body is privileged as the primary, basic constructor.

In paragraph 492 of *The Will to Power* Nietzsche advocates the body as "the starting point" because it provides not only one's basic, spatiotemporal perspective toward the world but also one's basic drives toward pleasure, power, and life enhancement, which underlie our derivative desire for knowledge. Inverting Plato, Nietzsche argues that the body, as the source of all value, should be master rather than servant. The soul is a distracting, pernicious illusion whose shadowy life depends on the body it imprisons and persecutes. "All virtues" [are] physiological conditions"; moral judgments being but "symptoms . . . of physiological prosperity or failure." "Our most sacred convictions, the unchanging elements in our supreme values, are judgements of our muscles."[11] The soul neither is nor should be the master of bodily activity, since consciousness is but its supervenient product, blind to most somatic behav-

ior and most often a thorn to the rest (*WP*, 674, 676). Recalling but reversing Plato's mediatic image, Nietzsche declares consciousness "is only a means of communication" with no real agency of its own (524, 526). Indeed, it is the body rather than the soul that generates the notion of subject by spatially awakening "the distinction between a deed and a doer" (547). The body should therefore be cherished not only for its life-enhancing pleasures but "as our most personal possession, our most certain being, in short our ego" (659).

In this, if in nothing else, Nietzsche speaks for today's individual, whose surrounding world is mediatically reconstructed and deconstructed at ever increasing speed. While Plato could dismiss the body as too ephemeral to be real and valuable, today the body seems more stable, durable, and real than the rest of the world we experience. It certainly seems much more familiar and easier to grasp, survey, and control. The media's unmanageable overload of unintegrated information is a strongly decentering force, turning consciousness into a flux of swirling, disconnected ephemeral elements. Walter Benjamin complained of this already in the 1930s, long before computers, faxes, and the internet.[12]

The body can now present itself in contrast as an organizing center, where things are brought together and organically conserved. The muscle-memory of bodily habit provides an organic enduring presence that outlasts the fragmentary moments of media bytes and cannot be erased as easily as a data file. Moreover, stressed and baffled by the many changing language games that socially define us and our thoughts, we are tempted to seek the body as a means of escape to a speechless realm of identity and individual autonomy. Influential body therapists like Moshe Feldenkrais, Alexander Lowen, Stanley Keleman, and Thomas Hanna advocate heightened body awareness and gratification of our "private organic life" as a way of coming to know oneself more closely and immediately so as to resist the dominant "trend to uniformity within our society."[13] The body thus emerges as who we most deeply and immediately are; its foundational, privileged status forms part of the implicit common sense of today's secular society, which spends fortunes on the soma's care and adornment.

Nietzsche, however, was perhaps more cautious. For all his privileging of the body as a constructive force, directive value, and basic ground, he avoids erecting it into an entirely unconstructed and immediate foundation. Though grasped as the single, unified thing with which one

so closely identifies, the body is in fact a construction from a vast multi-plicity of different elements and "life-processes"; its image of unity is but a "'whole' constructed by the eye"(*WP*, 547, 674, 676).

But as Merleau-Ponty and Jacques Lacan have emphasized, the eyes do not suffice to provide this whole.[14] For without a mirror or other means of reflection, they can neither see themselves nor the entire head in which they are fixed. The representational perception of our somatic integrity is not an immediate given but a specular media product, re-quiring even more media than our own body parts provide. Here we have the germ of the media's intrinsic control over our external body image, a control that must itself be monitored for techniques and mes-sages that misguide or oppress our sense of bodily self. This is a crucial task for media culture critique.

Recognition of the problematic mediacy of body representations has led body-centered thinkers to locate the body's foundation and immedi-acy not in its external form but in its lived experience, its kinaesthetic sense of itself. William James and John Dewey therefore insist on im-mediate bodily feeling,[15] while Merleau-Ponty has the same goal in cel-ebrating the lived "phenomenal body" as more real and basic than the objective one constructed through science and representations. Provid-ing our originary, permanent, yet always changing perspective on the world, this lived body is claimed as a "primordial presence" that we im-mediately grasp and directly move without any representation, "with-out having to make use of [our] 'symbolic' or 'objectifying' function." From the center of "this immediately given invariant" of inner bodily sense our very identity and world are constructed.[16]

However, as Merleau-Ponty also insists, this foundational presence and world-maker is itself reciprocally conditioned by the world which it structures, for that world (as the horizon or 'other' outside the body) provides the necessary intentional target into which the lived body can project itself so as to realize its perspectival world-organizing func-tion.[17] The world's construction of the experiencing body is more than an abstract argument based on the Hegelian logic of complementarity, where anything is defined by what it is not. Marx's historical materialist insights have been deployed and refined by thinkers like Foucault and Bourdieu to show how the concrete quality of immediate somatic expe-rience can be socially conditioned and transformed.[18] The notion of im-mediate experience (as I argue in Chapters 1 and 6) can still retain a meaning—as experience whose sense or value is directly (perhaps even

nonlinguistically) grasped rather than inferred or deferred. But such immediacy cannot claim an absolute pristine character since it relies on prior constructions, on habits of response formed through the influence of historical and social conditions already in place.

V

If the body, then, is always somehow constructed, the important question becomes what values should guide its construction and what role should be played here by the media, which can, I think, be conceived as extensions of our original bodily medium. I turn now from conceptual history to present proposals.

First, we must encourage two features of today's media scene: its diversity of forms and its new trend toward interactivity. Every medium or technique—radio, television, video, film, newspapers, books—has its advantages and limitations, encouraging certain perceptions, experiences, or constructions and hindering others. We must not let enthusiasms for new media convince us that the old ones can be abandoned as simply *aufgehoben*. Television did not make the radio obsolete, nor will the internet replace the telephone. Even the book, whose imminent death is often declared by media and literary theorists, continues to thrive, and so it should. Its firm, compact tangibility, the look, feel and smell of its pages, presents a special axis or horizon of experience. It is not only the Braille reader who can get something from a tangible text that is lost in a movie.

In short, reducing our choice of media to those that are most technologized, or even those that engage the most sensory modalities, will result in an impoverishment of our experience. Paradoxically, such reducing of diversity will also render our experience less coherent, because the coherence of our experience is not simply a synchronic function of the quantity of media sources but a diachronic, dialogical function of our familiarity with them through entrenched habits of use. Media pluralism and the free flow of information between different modes are just as central for democracy as are political pluralism, freedom of expression, and the effective circulation of information and critique. Such pluralism and interfacing of informational horizons are also crucial to the successful quest for knowledge, a point that pragmatism deploys in making a cognitive justification of democracy.[19]

These democratic and cognitive concerns underscore the importance of interactivity in the media, so that communication is not bifurcated

into a small group of producers and a mass of passive consumers who have no influence on the media products they consume. Though our new interactive media show uncontestable progress and promise, we need to register three qualifications. First, the products of mass media consumption have long been interactive in the sense that the audience often creatively interprets and constructs the message rather than simply and passively receiving the interpretation favored by the message producer. Second, the range of interaction and choice in the new forms of interactive media still remains significantly constrained. Third, encouragement of the new media should not come at the expense of abandoning older forms.

Besides encouraging media pluralism and interactivity, something must be done to discourage the media's tendency to establish oppressive norms of external body form through advertising that systematically suggests that pleasure, success, and happiness belong only to the young, thin, and beautiful of certain races. Anorexia is one documented by-product of this pressure. There is also evidence that fitness videos by movie stars like Jane Fonda can cause significant bodily damage by projecting a uniform, artificially stylized model of what form the exercising body should take, abstracting from varieties of body types and felt dimensions of effort and internal body alignment.[20] Apart from the moral and social problem of causing pain and stigmatizing people whose bodies look different, there is also a potential aesthetic problem: a tedious homogeneity of standardized looks, achieved through surgery if not successfully through cosmetics and bodysculpting exercises.

Media advocates are quick to argue that these problems may be easily enough avoided through new media like the internet, where one's external bodily form is excluded from the communication situation and even one's gender identity can be withheld. But it is only a matter of time before we have visual monitors on the internet. The technology is already there, and so is the ever present motive of profit. Moreover, studies of the literature of virtual reality and of the sociology of its production both suggest that even when we seem freest to dispense with old body identities we seem intent on reproducing them, replete with the social hierarchies encoded in the body's race and gender markings.[21]

If censorship of oppressive body advertising is undemocratic and impractical, the traditional condemnatory style of body-culture critique seems hopelessly ineffective—essentially retrograde, negative naggings. A more positive and radical solution would be to privilege the

experiential forms of somaesthetics. People could be encouraged to transfer their concern from the external shape and attractiveness of the body to an improved qualitative feeling of its lived experience and functioning. Since we are speaking here of an individual's felt improvement, there is no fixed external standard, no stereotypical representation, of what good or improved body feeling must be. Yet one can still talk of real improvement and even of directions of improvement that are not narrowly subjective. While everyone may have a somewhat different optimal rhythm and depth of breathing, certain forms of breathing, which may be habitual for a given person and thus seem initially easier, can nonetheless be shown, through therapy and improved habit, to be less rewarding than others that initially require more effort because they are nonhabitual.

Experiential somaesthetics comprises a wide range of practices and ideologies from the very ancient to the New Age: from Asian practices of hatha yoga, t'ai chi ch'uan, and Zen meditation to Western therapies of Alexander Technique, Feldenkrais Method, and bioenergetics (all three of which will be examined in the next chapter). This somatic domain may strike us as disturbingly nebulous and alien, but part of the reason for this is its gross neglect by modern Western philosophy with its logocentrism and linguocentrism. Even somatic philosophers like Merleau-Ponty seem content with theoretically proving the lived body's primacy and do not seem much concerned with concrete proposals for its improvement. Nietzsche's advocacy of "an ever-greater spiritualization and multiplication of the senses"(WP, 820) remains far too vague, while the concentration by Foucault, Georges Bataille, and Gilles Deleuze on radical, sensationalistic "limit-experiences" seems far too narrow, risky, and unstructured.[22]

Though experiential somaesthetics is not a well-articulated domain, it is essential, inescapable, and therefore deserves greater attention and improvement (in all three of somaesthetics' branches: analytic, pragmatic, and practical). We may substitute computerized holograms or screen images for our external forms, we may even develop machines to punch our keyboards for us and read our screens. But we cannot get away from the experienced body, with its feelings and stimulations, its pleasures, pains, and emotions. In the highest flights of mediatic technology, it is always present. Virtual reality is experienced through our eyes, brain, glands, and nervous system. Even in the mediatic fantasy of Gibson's *Neuromancer*, cyberspace is savored and suffered sensually

through the body (the cyber-cowboy Case emerging physically drained from his escapades in the Matrix). How else could it be? For all affect is somatically grounded. As William James argued, "A purely disembodied human emotion is a nonentity." If we try to abstract from any strong emotion "*all the feelings of its bodily symptoms, we find we have nothing left behind.*"[23]

Cognitive scientists and evolutionists agree that there is good reason for conscious affect to be grounded in the body, since its primordial function was to help the embodied organism survive. The vividness of conscious pleasures and pains usefully directs the organism to what will promote the survival of the species. Moreover, on a more general level, pleasurable feeling has "the most central of biological functions—of insisting that life is worthwhile, which, after all, is the final guarantee of its continuance."[24] Finally, affect is the basis of empathy, which can ground communal living and progressive social action far more firmly and satisfyingly than can mere rational self-interest. If experiential somaesthetics pragmatically provides techniques for the development, refinement, and regulation of affect, it also has a social potential that should not be ignored. Bodily rigidities and blockages are often both the product and a reinforcing support of social intolerance and political repression.

We should therefore reject the intellectualist dogma that condemns the pursuit of somatic improvement as a selfish escape into private narcissism. Disciplines of body care provide instead a promising path toward a better public by creating individuals who are healthier and more flexibly open, perceptive, and effective through heightened somatic sensibility and mastery. We tend to forget, moreover, how much public harm results from the somatic misuse of ourselves that leads to unnecessary fatigue, pain, injury, accident, and the abuses of addiction. The next chapter develops my case for a philosophy of corporeal care by further exploring the meaning of our culture's somatic turn and examining three of the most influential disciplines developed in twentieth-century Western somatics.

the somatic turn: care of the body in contemporary culture

The nonsensuality of philosophy hitherto as the
greatest nonsensicality of man.

<div align="center">NIETZSCHE</div>

I

In a note at the end of *Dialectic of Enlightenment*, Max Horkheimer and Theodor Adorno deplore the body's role in "recent culture": "The body is scorned and rejected as something inferior, and at the same time desired as something forbidden, objectified, and alienated." They then draw the still bleaker conclusion that this somatic disaster can never be undone. "The body cannot be remade into a noble object; it remains the corpse however vigorously it is trained and kept fit."[1]

Today, millions of Americans are zealously working their bodies to prove these philosophers wrong, while Europeans show signs of the same heightened investment. This somatic devotion is expressed not only in the growing number of individuals who ardently pursue programmatic practices for the ameliorative transformation of their bodies, but also in the growing variety of practices that are deployed.

Decoration of the body has always been a form of aesthetic expression, but this ancient art is now increasingly pushed to new limits and, of course, new profits. Beyond the billion-dollar markets of cosmetics, fashion, and hair care, we find a booming business of body-toning tools and videos to be utilized in the comfort of home; there is also a burgeoning diet industry, including comprehensive programs replete with menus, methods, food products, medications, and centers for informational and psychological support. Plastic surgery has drastically increased, spreading from the face to the entire body: breast implants, reduction of the thighs through liposuction, remodeling of the buttocks, thickening of the calves.[2]

Gyms and health clubs are becoming as ubiquitous as corner coffee bars, and increasingly rich in their menus. Though having little to do with traditional gymnastics (e.g., rings, horses, high bars, etc.), today's gyms offer a growing assortment of somatic options: free weights and bodybuilding instruments, diverse machines (from rowing and cycling

to running and climbing) for cardiovascular strength, varieties of massage for muscular relaxation, a miscellany of aerobics and exercise classes that vary with respect to intensity, style of movement, and type of music, and that often concentrate on different body parts. One of my local Manhattan gyms patented a "Brand New Butt" class, which is entirely devoted to the buttocks, and there are analogous offerings for "abs" and thighs. Other classes eclectically exploit the new variety of available somatic practices to produce exotic mixtures like "The Urban Yoga Workout," which, as advertised, "integrates Hatha Yoga with various Western fitness disciplines, hands on alignment and massage, new age music."[3]

Postmodern eclecticism and heightened body consciousness have revived interest in ancient Asian practices of yoga and meditation, which, as the cold war melts into the New Age, are finally receiving as much attention as the more violent martial practices like judo and karate. If the body boom is multicultural, it is also multi-age. Though deeply connected to youth culture and the desire to remain youthful, it draws its votaries from all age groups. Fitness centers and clinics of plastic surgery are places where the young sweat with their elders.

Care of the soul has caught this body fever, deploying somatic disciplines both old and new to achieve mental health and happiness. Even in the traditionally disembodied realm of academic cultural theory, the body has become a hot topic, trumpeted in the titles of so many articles, monographs, and anthologies, even of an entire book series.[4] Much of this academic interest may simply be an interest in finding something new to theorize about; and most of the work merely concerns what they call "writing the cultural body" (that is, describing how the body functions as a symbol or theme in literature or how its conception has been shaped through history) rather than treating real bodies as they actually function in practice and examining how their performance and experience could be improved. Still, the proliferation of body titles remains striking.

Though these diverse phenomena deserve more documentation, there is no question of what they indicate — our culture's deepening preoccupation with the body. But what is its philosophical meaning? What does this body consciousness say about our society, our values, and the evolution of our thinking? Should we view it as a sign of the failure of our civilization, as Horkheimer and Adorno suggest, or does it rather express some sort of success? And what kind of failure or success? Does

the somatic turn represent a postmodern crisis of rejecting modern rationalism, or is it instead the application and expansion of rationality into hitherto neglected and uncolonized domains? If the new somatic turn expresses a rejection of the ideals of rationalism, is this necessarily a bad thing? If it instead extends modernity's rationalist ideal, does the fully rationalized, disciplined body represent a humanist utopia or a cyborg nightmare?

These general questions of the meaning and value of somatics lead to more specific ones about the future role and direction of philosophy. Dedicated to purifying the mind of error, prejudice, and corruptive desire, philosophy saw the body and its senses as a major source of these dangers. Does the new somaticism, then, represent a de facto if not explicit cultural rejection of the enterprise of philosophy? From its earliest beginnings, philosophy claimed the path to wisdom in the art of living. For millennia, people puzzled by the Socratic question of how to live have looked to philosophy as a guide for the perplexed. Today people look elsewhere: to the rapidly growing literature of self-help and pop psychology, which far outsells standard philosophy texts. Much of this literature focuses on somatic issues. How is philosophy to respond to this challenge?

One habitual reaction is simply to ignore it and retreat into academic conservatism, a retrenchment that recalls the bold image of philosophy's glorious past while relying on its institutional power to survive as part of the traditional university system, even if an increasingly diminished part. But there is a more interesting option. Philosophy can engage somatics as a new domain for reconstructive critical theory. Somatic practices, which claim to transform our bodily experience and through it also modify our minds, can be analyzed in terms of their presuppositions, effects, and ideologies; for many somatic disciplines come with a theoretical framework as well as practical exercises.

There is a still more radically embodied and pragmatic option. If we recognize somatic experience as an ineliminable and invaluable dimension of experience and if we see philosophy as ultimately an inquiry into experience and the right way to live, then we can view somatics— with its concrete testing and improving of one's own lived experience through actual bodily exercise—as an essential part of the philosophical life. From his study of Socrates and Diogenes (as well as from his own experiments with the somatic extremes of drugs and sadomasochistic sex), Michel Foucault concluded that philosophy can be a matter not of

texts but of an embodied life-practice: "The *bios philosophicus*," he explains of Diogenes, "is the animality of being human, renewed as a challenge, practiced as an exercise—thrown into the face of others as a scandal."[5]

The scandal, I have argued, is not essential to somatic philosophy per se but rather reflects Foucault's choice of methods and his taste for avant-garde extremism. For other somatic thinkers propound theories and practical methods that aim at an unscandalous wholesome life of embodied inquiry into experience and self-mastery. Of course, in a certain sense, any robustly somatic philosophy may seem scandalous, because it bucks the idealism that still haunts philosophy and is manifest, for example, in the linguistic turn's resolution to exclude from philosophical inquiry anything below the level of language or *logos*. One aim of this chapter is to neutralize this scandal and open philosophy to the promise of somatic disciplines by providing them with philosophical analysis.

There are many different (and even conflicting) reasons for the resurrection of the body as a site of diverse and almost devotional attention in contemporary culture. It can be explained as a product of social conformity (to acquire certain socially endorsed and well-advertised body forms) but also as the result of heightened individualism. It can be seen as the gift of technological freedom but also as a reaction to our technological enslavement and our consequent fear of body atrophy. Loss of religious sentiment is no doubt a major cause of the body boom, but heightened religious interest is also responsible for much of the New Age fascination with somatics, particularly with Asian approaches.

This multiplicity of causes is partly a reflection of the wide variety of phenomena that fall under the category of body practices. It is indeed a very mixed bag—from meditative breathing to breast surgery, from the frenzy of high-impact aerobics and the violent grunting thrusts of weightlifting to the gently silent flow of t'ai chi ch'uan and the inhibitory concentration prescribed in the work of F. M. Alexander. If such diversity of practice renders implausible the idea of a single cause or common set of causes for the body boom, it also makes it hopeless to talk about somatic practices in general as being either rational or irrational, liberational or enslaving, good or bad. Though the philosopher's duty may be to generalize, distinctions among these practices would help make our generalizations more insightful and accurate. Even if the complexity and overlapping of these practices defy precise classification

on the basis of clear distinguishing principles, some rough distinctions may still prove useful.

I I

One way to classify somatic practices is in terms of whether their orientation is holistic or more particularized. Countless practices focus narrowly on particular body parts—stylizing the hair, painting the nails, shortening the nose, enlarging the breasts or biceps, etc. Even if we manage to tan the whole body, we are treating only its skin or surface. In contrast, some practices are emphatically oriented toward the entire body, indeed the entire person, as an integrated whole. Hatha yoga, t'ai chi ch'uan and Feldenkrais Method, for example, include an integrated variety of somatic postures to develop the harmonious functioning and energy of the body as a unified whole. Penetrating beyond skin surfaces and muscle fiber, these postures teach us to realign our bones and better organize the neural pathways through which we move our trunk, head, and limbs. More important, they insist that such somatic harmony is part and parcel of heightened mental awareness and psychic balance, refusing to divide body from mind in seeking the enlightened betterment of the whole person. The names of the two trademark Feldenkrais practices—Awareness Through Movement and Functional Integration—clearly express this aim of improved body-mind holism through coordinated training of our sensorimotor circuit.[6]

Somatic practices also differ in terms of being directed primarily at the individual practitioner herself or instead primarily at others. A masseuse or surgeon standardly works on others, but in doing t'ai chi ch'uan or cross-country training one is working more on one's own body. Clearly the distinction between self-directed and other-directed somatics cannot be rigid, since many practices belong to both. Just as the cosmetic application of makeup can be performed on oneself or on others, so in sexual practices one typically seeks both one's own experiential pleasures and one's partner's by maneuvering the bodies of both self and other. Moreover, even self-directed somatic work often seems motivated by the desire to please others, while other-directed practices (like massage) can have its own self-oriented pleasures. But despite its vagueness (partly due to the interdependence of the very concepts of self and other), the distinction between self-directed and other-directed somatics can at least be useful in combating the common prejudice that to focus attention on the body implies a selfish retreat from the social.

In proposing the discipline of somaesthetics in the previous chapter, I also introduced a central distinction between somatic practices that concentrate more on how the body looks from the outside and those that focus instead on the body as it is felt or sensed from the inside, on its qualitative lived experience. The former, exemplified most clearly by all sorts of cosmetic practices (makeup, hairdressing, tanning, and cosmetic surgery), can be designated as somatic practices of representation; the latter, represented by yoga and other disciplines of body awareness, as the somatics of experience.

In drawing this distinction I am not suggesting any rigid dichotomy of representation/experience or outside/inside. For, given the social construction of self, we know that self-representation and experience are intimately connected, while the logic of complementarity demonstrates that "inside" and "outside" reciprocally constitute and contain each other. On a less abstract level of argument, we noted in the preceding chapter that our inner feeling influences how we look, and vice versa. Moreover, certain practices undertaken primarily for ends of representation (such as aerobics, dieting, or bodybuilding) certainly produce feelings that can be appreciated and sought for their own experiential sake. Finally, practices focusing on inner experience often employ representational means (for example, regarding one's image in the mirror) as cues to effect the right body alignment for the desired experience, just as predominantly representational practices can employ improved awareness of experiential cues to achieve its ends. The bodybuilder needs to know through inner experience the difference between the aching "burn" of effort that builds muscles and other aches which mean injury.

Despite these complexities and borderline cases, it can be useful to distinguish—as we did in the preceding chapter—between representational and experiential somaesthetics, between practices that focus primarily on beautifying our external form and those that instead concentrate on making us "feel better" in both senses we already noted: more satisfying experience and more acute perception. By differentiating experiential from representational practices, we can avoid the most damning attacks on body culture, which focus on the somatics of representation.

Horkheimer and Adorno's critique is a good example of such attacks. All attempts "to bring about a renaissance of the body" must fail, they argue, because all such attempts implicitly reinforce our culture's tragic

"distinction . . . between the body and the spirit," a distinction through which the body is representationally exteriorized as a mere physical object—"the dead thing, the '*corpus*'"—in contrast to the inner living spirit (*DE*, 232, 233). Attention to the body means alienated attention to an external representation, and so inescapably comes to serve the corrupt ends of advertising and propaganda. "The idolizing of the vital phenomena from the 'blond beast' to the South Sea islanders inevitably leads to the 'sarong film' and the advertising posters for vitamin pills and skin creams which simply stand for the immanent aim of publicity: the new, great, beautiful and noble type of man—the Fuhrer and his storm troopers" (233–234).

Body enthusiasts are thus linked to body exterminators by their reduction of the living human soma into a lifeless "physical substance" (234), a mechanical tool whose parts must be sharpened and strengthened so it can more effectively serve the power who controls it or, if no longer in good repair, should be melted down and converted into some other more practical thing.

> Those who extolled the body above all else, the gymnasts and scouts, always had the closest affinity with killing. . . . They see the body as a moving mechanism, with joints as its components and flesh to cushion the skeleton. They use the body and its parts as though they were already separated from it . . . They measure others, without realizing it, with the gaze of a coffin maker . . . [and so call them] tall, short, fat, or heavy . . . Language keeps pace with them. It has transformed a walk into motion and a meal into calories.
>
> *DE*, 235

Although written in the 1940s, Horkheimer and Adorno's critique remains a powerful summary of the major indictments against our culture's heightened attention to the body. Contemporary culture promotes false images of bodily excellence to serve the interests of capitalist advertising and political propaganda. It alienates and reifies the body by treating it as an external mechanism that is anatomized into areas of intensive labor for ostentatiously measurable results (hence our specialized classes devoted to abdomens, thighs, buttocks and the rest, and our preoccupation with body measurements). In reducing the body to an external mechanism, such practices treat the body as merely an instrument for use and not as an aspect of a person's individuality as an end in itself. Indeed they inevitably undermine individuality by urging conformity to

certain standardized measures and models as optimally instrumental or attractive in our society, models which typically reflect and reinforce established social hierarchies (e.g., the North American ideal of lean, tall, tan, blond, blue-eyed bodies has obvious ethnic markings).

Potent as these indictments are, they all depend on conceiving somatics in terms of a reifying exteriorization of the body—the body as a mechanical instrument of atomized parts and measurable surfaces— rather than the body as a living dimension of individual experience and action. Hence such critique cannot condemn somaesthetics *tout court* but only those representational body practices that are based on (and serve) this conception of the body as thing. In contrast, the somaesthetics of experience refuses to exteriorize the body as a thing distinct from the active spirit of human intentionality. It focuses not on the body per se but on bodily consciousness and agency, on embodied spirit. Here, in practices apparently ignored by Horkheimer and Adorno, is where we can perhaps succeed in an ennobling "renaissance of the body" (*DE*, 233).

The blindness of culture critics to experiential somaesthetics is understandable and widespread. For the representational form of body work still dominates our culture, no doubt because its ideology both inherits our entrenched division of body from spirit and also admirably serves the aims of capitalist consumerism. Nonetheless, the somaesthetics of experience has become a growing and promising force in contemporary culture, and, because of its promise and comparative neglect, I shall devote the rest of this chapter to examining the philosophical import of some of its most prominent practices and attendant theories. Guided by philosophy's commitment to reason, I shall use the theme of rationalism to explore three of the most popular and successful forms of experiential somaesthetics practiced in North America, disciplines that combine practical methods with theoretical justification: Alexander Technique, Reichian bioenergetics, and Feldenkrais Method. These different approaches not only display different positions on the scale of rationalism; they also read different meanings into the recent burgeoning of somatic interest. So before treating these three sample schools, we should briefly consider the reasons they offer for the increasing care of the body in twentieth-century Western culture.

III

We can group these reasons around three general issues: the problem of personal identity, the challenge to traditional spiritual authority, and the

need to negotiate a new relationship to nature (including human nature) as a result of rapid modernization and technological change. All three issues clearly intersect with the last chapter's theme of revaluing the body through its status as primary medium in a world that is constantly remade by new media technologies.

1. The somatic turn may express the need to find and cultivate a stable point of personal reference in a rapidly changing and increasingly baffling world. In the postmodern lifeworld of intercontinental commuting and multicultural exchange, the environments and language games through which one's identity is shaped are too diverse and shifting to afford us a firm sense of self. As marriage and family ties prove increasingly vulnerable, our network of personal relationships seems likewise too fragile and fragmented to supply a stable identity. But throughout this confusing postmodern flux, our bodies are always with us, even if we lose a few pounds or some of our hair. By providing a needed ground for our personal identity, the body warrants our care to preserve it. Given this role of self-grounding, it is not surprising that one of the key aims and metaphors of experiential somatics (particularly in bioenergetics) is to *ground* the body, giving it a firm sense of contact and stable support from the earth so that it can afford that same sense of support to one's personality.[7]

Another problem of identity is loss of faith in the unity of the self through psychology's challenges to the unity and reliability of consciousness. We once could identify ourselves with our conscious mind and rely on its transparent introspection to tell us who we are, but, since Freud, this confidence is no longer possible. As the conscious mind loses its singular authority over the self and is seen to be deeply driven by unconscious psychosomatic forces, so the body reemerges as a site of self-definition through which even consciousness can be refashioned.

Moshe Feldenkrais insists on a rather different problem of identity: how to maintain one's individuality despite intense societal pressures for conformity. Though our liberal culture seems distinctly individualistic, Feldenkrais argues (in a way strangely convergent with Foucault) that it effectively neutralizes the private and individual through its pervasive normalizing apparatus, which molds even one's "personal" tastes and values. This "education," says Feldenkrais, "suppresses every nonconformist tendency through penalties of withdrawal of support and simultaneously imbues the individual with values that force him to over-

come and discard spontaneous desires. These conditions cause the majority of adults today to live behind a mask," a social mask which frustrates happiness in "the private organic life and the gratification of needs deriving from strong organic drives." But despite the repressive effects of socialization, our bodies remain a potential source of individual gratification. The somatic turn is thus explained and advocated as a necessary defense reaction against "the trend to uniformity within society."[8]

2. Devotion to the body also reflects the weakening cultural hold of religious views that for many centuries demonized the body as the enemy of the divine immortal soul and hence a threat to true happiness. Secularization prompts us to see our selves and our happiness in more worldly and corporeal terms; hence care of the body assumes a central role in care of the self and comes to be practiced by many with almost religious adoration.

The dialectic of modern thinking has also challenged the spiritual authority of reason itself. Once revered as an autonomous, immutable, truth-assuring principle that defines human essence and value, reason is increasingly recognized as historically variable, shaped by changing social conditions and serving as an equivocal tool of deeper irrational forces. Rather than a God-given, transcendental revealer of eternal truths, it is taken pragmatically as an evolutionary tool for our embodied survival, a tool not primarily for reaching truth but for coping with changing environments. Echoing the old Humean view of reason as the slave of passion, the influential somatic theorist-practitioner Stanley Keleman affirms that "the brain is the servant of the body, not vice versa."[9] If the ultimate aim of reason and truth is to sustain and enhance our corporeal existence, then why not move directly toward that end by working on the body?

The move from idealizing truth for its own sake to valuing it as a tool to improve experience reflects the strong aesthetic turn that pervades our culture, even our philosophy.[10] Hedonism may have always been with us, but it has become more outspoken in secular postmodernity, where "having fun" often seems to be among one's highest duties. Not only a rich source of pleasure, the body is also the medium that conditions all affective experience; so the somatic turn forms part of our culture's aesthetic turn. Improvements in somatic awareness and functioning can render even ordinary bodily experience much more pleasurable. And this new "pleasure from . . . normal and useful activities of life,"

Alexander argues, can give enough satisfaction to free us from "an undue and harmful demand for specific excitements and stimulations" and from the problematic quest of pleasure for its own sake.[11]

3. Deeply influenced by evolutionary theory, our somatic thinkers read the recent growth of body practices as the necessary response to an evolutionary crisis, the need to renegotiate our relationship to ourselves and our environing world. This is the motivating foundation of Alexander's theory: "man is no longer a natural animal" who can rely on his naturally acquired bodily instincts. Rapid changes of modern civilization have rendered old instinctual habits of body use unreliable and inappropriate, thus provoking new epidemic disabilities (like the modern varieties of backache) and stimulating a sense of physical inadequacy whose remedy is sought in the mindless "physical-culture" exercises of Alexander's day and ours. Alexander, however, insists that the somatic method for successful adaptation to our new circumstances cannot be mere physical training; it requires primarily the "mental" mastery of conscious control of the body, since only such control can provide the continuing flexibility to adapt somatic functioning to the rapidly changing and increasingly complex environmental contexts we face. Unable to trust our unconscious and instinctive body mechanisms that were slowly acquired over millions of years of evolutionary adaptation, we must use our evolutionary gift of consciousness to reform and govern our bodily behavior more deliberately, forwarding it in the direction of the evolution of civilization—toward greater consciousness, rationality, and control.[12] Evolutionary adaptation alone will be far too slow to keep pace with our environment's heightened rate of rapid change.

Like F. M. Alexander, the bioenergetic theorists Alexander Lowen and Stanley Keleman recognize that the rapid changes of advanced technological society have created a crisis for our bodies, which demands an increased level of somatic attention. But instead of reading this as a call to escape from nature through new techniques of conscious somatic control, Lowen and Keleman prefer to explain our heightened interest in the body as a yearning to return to the old, beloved rhythms of natural life, still deeply engrained in our physiology by our evolutionary inheritance but frustrated and warped by our rationalized, profit-greedy, technological culture. Heightened care for the body is thus needed as compensation for this "life-denying culture" that is "not geared to the values and rhythms of the living body, but to those

of machines and material productivity"(B, 50,71). For Lowen this reaction reflects a general rule: "In direct proportion to a culture's withdrawal from nature and the life of the body, the need for special activities to engage and mobilize the body increases" (70). This critique of culture as repressing the body's more beneficent natural desires derives from the controversial psychoanalytic prophet who inspired bioenergetics and helped establish contemporary sexology, Wilhelm Reich, whose linkage of sexual repression to political control also influenced Foucault but whose faith in the existence, normativity, and all-purpose healing power of natural rhythms and natural (by which he meant heterosexual, genital) sexuality Foucault found so problematic.

Thomas Hanna, who left a career in academic philosophy to become a somatic practitioner-theorist, adduces the technological revolution to provide yet another interpretation of the body boom. Neither an evolutionary call forward nor a compensatory communion with the constant presence of our evolutionary past, care of the body is simply a means to agreeably pass the increasing burden of free time. We are concentrating more on our bodies now because there is no longer any real need to concentrate on other things in our environment. Writing in 1970 (still on the high of sixties' optimism and before the mid-seventies' energy crisis and more recent famines and ecological disasters), Hanna sanguinely argues that postindustrial society has created a new technological environment so supportive of humanity that there is no longer much need to advance thinking (which can be left to the computers) or to ease the stress of modern living (which should also be technologically filtered out). It follows "that the only responsible adaptation to the sovereign realities of a technological environment is the cultivation of the experience of rich enjoyment [of one's somatic drives] and the learning of playful behavior." "We do not know what [else] to do because there is little left in the environment to do."[13]

From today's hectically troubled perspective, it is easy to ridicule Hanna's blithe optimism and fainéant aestheticism. But that does not refute his view that our culture's increased cultivation of the body is fueled by greater leisure to spend on ourselves. Time-saving technologies have surely helped provide this, but so, perhaps, has the privatist ideology of liberalism with its diminished demands of engagement from the "environments" of social and political life.

IV

From these sketchy reflections on the general meaning of the somatic turn, we move to what seems its prime question for philosophy. Can the new somatic practices be integrated into a revitalized, embodied philosophy? My unequivocal reply is yes; and in proposing somaesthetics as a philosophical discipline of theory and practice, I have tried to show how philosophy's oldest and most crucial goals directly entail a concern for improving our bodily perception and functioning. Rather than retracing all these points, let me simply illustrate four of philosophy's most central goals as exemplified in the work of our chosen theorist-practitioners.

1. Since knowledge is largely based on the input of our senses, whose range is limited and whose reliability is questionable, philosophy has always been concerned with the critique and reeducation of the senses, with exposing their limits and avoiding their misguidance by subjecting them to rational scrutiny. This is precisely the concern of experiential somaesthetics. It seeks to improve the acuity and performance of our senses by cultivating a heightened attention to their bodily functioning and experience and also by freeing us from body habits and defects that impair our sensory performance.

The eye is a biological wonder whose gift of wide-ranging perception through distance vision has long been the prime metaphor for philosophy and knowledge. But our eyes would tell us only little about our environment if we could not raise our head to the horizon and rotate it from side to side. A person unable to turn his head to look behind him because of a stiff neck (typically caused by bad habits of clenching the upper body, which prevents the shoulders and ribs from swiveling) will see less and perceive less reliably. If our hand muscles are too tightly flexed, we cannot make fine perceptual discriminations of the soft or subtle surfaces and textures that we touch.

A central premise of experiential somaesthetics is the epistemological point that even apparently healthy individuals often suffer from such faulty sensory perception—Alexander called it "unreliable sensory appreciation" (*CC*, 36)—as a result of inattention to and the misuse of their bodies. We all have, at one time or another, our unacknowledged stiff necks, clenched muscles, or disequilibrium that misguide our perception. This is true even for the well-trained athletes among us, whose one-sided specialist training often promotes problematic inflexibilities. But though the senses are unreliable, there is no way of circumventing

them so as to know the world purely through reason. The familiarly obvious answer then is to employ reason to correct the input of the senses.

But the interesting feature of somatic approaches like Alexander's is that such rational correction is performed not by the second-order discursive comparison and critique of sensory propositional judgements as in traditional epistemology. The idea instead is to correct the actual functional performance of our senses by a more rational and conscious direction of our bodies, since our senses belong to, move with, and are conditioned by our bodies, forming what Alexander calls a "kinaesthetic system" (*MSI*, 22). Bioenergetics works toward the same end of improved sensory experience but without Alexander's emphasis on conscious control. It attributes sensory malfunctioning not to intrinsic inadequacy but to various somatic rigidities, blockages, and insensitivities resulting from our personal and social experience, and it argues that acute perception will be naturally restored by removing these obstacles through body work.

2. Experiential somaesthetics is likewise devoted to philosophy's goal of self-knowledge. In sharpening our attention to feelings, it exposes aspects of our somatic behavior that normally go undetected even though they may impair our behavior. I already noted how perceptive attention to breathing can make us more quickly aware of our emotional states so that we can regulate them better, and how increased awareness of the tonus of our muscles can reveal habits of chronic contraction that unknowingly cause discomfort and disability but that once recognized can be corrected.

This quest of self-knowledge for self-therapy and self-fulfillment is the existential engine that drives much of the best somaesthetic research. Consider the case of Alexander, who began his career as a struggling actor in Australia. Suffering from recurrent loss of voice when reciting, yet devoid of any anatomical problem of voice apparatus, he could not find solutions from his doctors and thus set out to discover what oddity of behavior was causing his vocal problems. Through the use of mirrors he realized that in reciting he would slightly throw back his head, depress his larynx, and suck his breath through the mouth. After many months of experimentation, he finally learned enough about his psychological and sensorimotor tendencies so that he could reeducate his muscular habits (through a detailed strategy of conscious concentration) and thereby avoid all these undesired actions. His voice problems disappeared forever, but so did his acting career. Alexander

had discovered the key to his system of conscious constructive control, and having conceived this new somatic therapy, he devoted his life to its development and teaching.

Moshe Feldenkrais, who distinguished himself as a nuclear physicist and judo expert before a severe leg injury led him to develop his somatic method for self-care, shares Alexander's view that heightened sensorimotor self-knowledge holds the key to self-improvement: "self-knowledge through awareness is the goal of reeducation. As we become aware of what we are doing in fact, and not what we say or think we are doing, the way to improvement is wide open to us."[14] In short, if we really know what we are doing, we can better do what we want.

3. Philosophy aims at right action, for which we need not only knowledge and self-knowledge, but also effective will. As embodied creatures, we can act only through the body, so our power of volition—the ability to act as we will to act—depends on somatic efficacy.[15] This is not a mere matter of muscular strength but of perceptive orientation and timing. Consider the simple action of drinking a glass of water. You cannot do it without being able to feel where your mouth is oriented in relation to your hand and glass, while also coordinating the lifting and tilting of the glass with the felt position and sipping movement of the mouth. By somaesthetically exploring and refining our bodily experience, we can gain a practical understanding of the actual mechanisms of effective volition and thereby acquire greater mastery of our will so that it can be more successfully employed in right action. Knowing and even desiring the right action will not avail if we cannot will our bodies to perform it; and our surprising inability to perform the most simple bodily tasks is matched only by our astounding blindness to this inability, these failures resulting from inadequate somaesthetic awareness and bad kinaesthetic habits.

Alexander's own story again provides a good example of this point. Early in his self-study and treatment he tried with all his will to keep his head forward, and although he felt he was succeeding in doing this, his voice failed to improve. But subsequent observation with mirrors revealed that he was actually pulling his head back, contrary to his will, just like the golfer who intently tries but fails to keep his eye on the ball. Our conscious will is unsuccessful because deeply ingrained somatic habits override it, and we don't even notice this failure because our habitual body perception is so inadequate and distorted that it feels as if the action is indeed performed as willed.[16] Alexander therefore argued that

somatic work is necessary to reeducate our sensory awareness and submit our bodily mechanisms to more conscious control. Otherwise, right action remains a slave to bad body habits and insensitivity. The great American philosopher John Dewey was so impressed by this argument (and by Alexander's actual work) that he not only applied it in his writings but also became a devoted student and advocate of the Alexander Technique.[17]

4. Philosophy's concerns for knowledge, self-knowledge, and right action are all bound up with its central, overarching quest to live a better life. The pursuit of happiness implies attention to the body both as a locus and medium of pleasure and as a tool for action. Even ascetics who castigate the flesh to seek a higher happiness still make their bodies crucial to their pursuit and still experience their satisfactions somatically. Precisely by heightening somatic discipline and endurance through systematic training in pain or deprivation, ascetics claim to find a happiness impervious to adversity.

But the experiential methods of Feldenkrais and Alexander promote well-being by heightening somatic control in a far less painful but no less disciplined way. Since life is movement, Feldenkrais argued, if we improve the quality and appreciation of our movement, we will improve the quality and appreciation of our lives. And the goal of happiness through the recovery of repressed pleasures surely lies at the core of Reichian somatics. For him "the loss of the organic capacity for pleasure," particularly through the repression of full genital gratification, is the prime source of our neuroses and failure to realize our goals of "pleasurable work and . . . earthly happiness in love."[18]

But besides sharing some aims with philosophy, do these experiential disciplines share philosophy's commitment to rationality? None of the three methods seems irrational, though they differ strongly with respect to their commitment to rationalism, understood as the privileging of reason over all other factors. As my summary discussion will make clear, Alexander represents the pole of rationalism, while bioenergetics presents an antirationalist position. Feldenkrais, though much closer to Alexander, lies somewhere between these poles. I have space for only the briefest profile of these different approaches, and, in any case, the limitations of the print medium preclude an adequate account of their actual practical work. These limitations are worth mentioning because our intellectual culture's privileging of the printed word reinforces the traditional devalorization of somatic practices and presents a continuing

obstacle to the incorporation of the soma into philosophical work, an obstacle paradoxically reinforced in the very writing of this essay as a plea to overcome it. What is quickly and easily said in words may take months and years of practice to achieve in our bodies. As I know from my own still clumsy steps in these disciplines, true somaesthetic understanding means an ability to walk the walk, not just talk the talk.

V

Alexander Technique, bioenergetics, and Feldenkrais Method are all deeply steeped in evolutionary thought and deeply melioristic in purpose, sharing an optimism about the limitless potential of human progress that is so strong and outspoken as to appear almost suspiciously naive to today's critical intellectuals. Alexander portrays his method of conscious somatic control as the necessary means to continue the evolution of humanity to a higher, more perfect mode of life. The development of human consciousness and language brought us beyond brute physical existence and enabled us to improve our conditions of life. But since these conditions are now too complex and changing to be served by established instincts and habits, we need still greater use of consciousness in directing our lives, not merely in creating ideas and tools but in improving the use of our bodily selves. In short, "the all important duty of the human creature, in our present stage of evolutionary vicissitudes, is that of the continuous individual cultivation of fundamental, constructive conscious control of the psychophysical organism and its potentialities" (CC, 311). "By the application of this principle of conscious control," Alexander argued, "there may in time be evolved a complete mastery over the body which will result in the elimination of all physical defects" (MSI, 56).

This principle of conscious control is identified with reason. Rejecting not only unconscious control by habit and instinct but also the conscious control of brute will power and desire, Alexander insists on "an increasing use of the process of reasoning" and the application of "man's conscious reasoning processes" to direct the embodied self (CC, 64, 243). Since reason's conscious control is what distinguishes advanced humanity not only from animals but from primitives,[19] the goal of somatics is not to give us merely better bodies but to put our bodies in "communication with their reason" (MSI, 67). Even in somatic therapy, having the right "mental attitude must precede the performance of the [bodily] act" (74). Reason's conscious control works in three major

ways: in inhibition, in the discovery of the means toward one's ends, and in disciplined methodical concentration on these means rather than "direct end-gaining."

According to Alexander, humanity advanced only by applying "a reasoning inhibition" that allowed us to interrupt and thus control our instincts and habits of action, so paving the way to an alternative, more conscious and reasonable control (CC, 44). And Alexander makes such inhibition the hallmark of his therapeutic technique. If our kinaesthetic system is defective, little good will be achieved by simply trying to move our bodies in compliance with the therapist's instructions, even if these are carefully detailed (for example: stand up from your chair without contracting your shoulders and pulling back your head). We will probably fail to do the action properly and not even notice our failure, since our kinesthetic perception is flawed. Nor can the teacher give us a better sense of movement if we continue to act and feel with our bad habits. The vicious cycle of habitual action and experience must therefore be inhibited. "The inhibitory process," Alexander writes, "must take first place and remain the primary factor in each and every new experience which is to be gained and become established during the cultivation and development of reliable sensory appreciation upon which a satisfactory standard of [psychophysical] coordination depends" (CC, 152).

In this inhibitional method, the therapist as teacher

> tells the pupil that, on receiving the directions or guiding orders, he must not attempt to carry them out; that, on the contrary, he must inhibit the desire to do so in the case of each and every order which is given to him. He must instead project the guiding orders as given to him whilst his teacher at the same time, by means of manipulation, will make the required readjustments and bring about the necessary coordinations, in this way performing for the pupil the particular movement or movements required, and giving him the new reliable sensory appreciation and the very best opportunity possible to connect the different guiding orders before attempting to put them into practice.
>
> CC, 152–153

By this practice the pupil is also given the bodily "experience . . . of being dominated by reason" rather than habitual reaction (US, 18). This helps him to comply correctly to a subsequent set of bodily orders, de-

signed by the teacher as the best means to effect proper movement, which he is this time actually supposed to perform as he continuously repeats them mentally to himself. Yet even while one is projecting and performing these positive orders, one must continue to remind oneself of the needed preventive inhibitions (*CC*, 161–167; *US*, 18–19). To counter the charge that emphasis on inhibition results in slavish suppression of individual expression, Alexander argues that such inhibition actually works to serve the individual's desire and is imposed only by the individual himself through his own reason (*CC*, 186–188), an unwitting echo of Kant's dialectical definition of personal freedom as obedience to the law we give ourselves through reason. But Alexander's ideal of reasoned control is clearly opposed to popular notions of freedom as spontaneity, and he provides a vicious critique of educational and cultural trends that encourage free expression (*MSI*, 124–128, 131).[20]

Besides its use in inhibition, reason helps find and implement the proper positive directives whose compliance results in coordinated movement (*CC*, 67). Alexander designates these directive orders as "the means whereby"; and his demand to focus only on these means rather than on the particular somatic end for which they are undertaken is another trademark of his technique. Not that the ends are not worthwhile, but they are best achieved by eschewing direct attempts to gain them. The logic of such indirection is clear. First, if the pupil pursues his end directly, "he will follow his habitual procedure in regard to it"; and since his bad somatic habits are the reason for his being in therapy, such end-gaining will only reinforce such harmful habits and defective kinaesthesia (154). Second, focusing on the means rather than the desired end should greatly reduce the patient's performance anxiety, especially if these ends already represent actions about which the patient feels anxious or inept (210–212). Third, rationally devised and disciplined somatic means are more general than specific ends. They expand consciousness and psychophysical functioning beyond particular desires, and, once learned, they can be profitably applied to many other ends and indeed suggest new ends (214–215, 308–310). Keeping your head down has wider applicability than driving a golf ball (or hitting a billiard ball or indeed doing anything with a ball) for which it is a means. Alexander therefore demands that the pupil *"must refuse to work directly for his 'end' and keep his attention entirely on the means whereby this end can be secured"* (155).

Alexander's emphasis on reason is radical in its sharp critique of emotionally directed behavior and of all that excites the embodied self to be distracted from rational control (*MSI*, 26,90; *CC*, 207–208). Unlike most body gurus (including his own followers) who have strong ties to dance and music, Alexander severely condemns these arts for their power to overwhelm reasoned control by "excitements" producing an "overexaltation of the whole kinaesthetic system" that is likened to drunken "madness" (*MSI*, 124–125). One would expect a similar attack on sexuality, but we find instead a total silence on this topic, which seems equally damning. Yet what could Alexander see in sexuality but the inherited instinctive means of reproduction that has so far been necessary for evolution toward greater rationality but might well give way to more rational means through biogenetic engineering?

Alexander's rationalist, evolutionary ideology finds striking expression in his anatomy of the body and his concrete practice of working with it. He sees the body as unified through a single pyramidal hierarchy crowned with the dominating central mechanism he calls "the primary control." This point of control, the key to his somatic work of establishing kinaesthetic mastery, he firmly locates in the head and neck area. The focus of somatic attention and governance is thus at the highest part of the human body—highest not only physically but functionally and symbolically: in the vicinity of the brain, the locus of human reason and of our evolutionary advance and advantage.

The evolutionary metaphor of ascent even pervades Alexander's practical directions and exercises for better somatic coordination, which aim at lengthening the spine to elevate the head and realign its gravity so as to give us a feeling of better coordination and control (most often experienced as a feeling of uplifting lightness). One is constantly implored to lengthen, to bring "the head forward and up"; the paradigm somatic sin for Alexander is "pulling down."[21] His is a somatics of verticality oriented toward ascent.

Though today's Alexander practitioners sometimes work on the pupil while she is lying on a table (a position which avoids certain problems of ordinary gravitational pressures and of bad habits), Alexander himself shunned work on the reclining body because it smacked too much of the unconscious surrender of hypnotism and psychoanalysis. His most famous and characteristic exercise was to have the pupil raise herself from a chair. If performed correctly, either independ-

ently or with the light manipulative touch of the teacher, this ascent (described as "thinking one's way out of a chair") would seem astonishingly effortless, almost like defying the weight of gravity through conscious somatic direction (*J*, 71, 76).

Given the rationalist ideal, manipulation by the instructor should be minimal and extremely gentle, since its goal is only to give the pupil the new experience of better somatic coordination (*CC*, 176). True somatic reform can in the end be achieved only through the pupil's own reasoned control (her repetition and mastery of the means-whereby), not through physical manipulation by others. To foster such control, Alexander's method insists on calmness, including calm and slow body movements, for this allows reason and its inhibitory mechanisms to function more effectively. Violent movements, shocking, and shaking are strictly shunned (see *J*, 14).

These turbulent motions, however, are popular strategies in bioenergetics, which provides the strongest contrast to Alexander's rationalism. Though founded officially by Alexander Lowen, this somatic school derives its essential orientation of theory and practice from the work of Wilhelm Reich, the famously eccentric Freudian psychologist and radical sexologist, who taught and treated Lowen before being arrested and left to die in a U.S. prison.[22] If Alexander's central notion is conscious control, the key concept and goal of bioenergetics is flow of energy. Though inspired by Reich's notorious claim of a new energy called orgone which could be accumulated by specially built machines for purposes of therapy, Lowen lacked Reich's scientific training and ambition, so his own model of energy flow is far more vague and metaphorical, and thus may seem more reasonable. It is "best exemplified by the flow of blood," "the energetically charged fluid of the body. Its arrival at any point in the body adds life, warmth, and excitement to that part. It is the representative and carrier of Eros" (*B*, 51).

There are also other somatic flows charged with energy or excitement and thus capable of intensifying and enriching our experience of living. "Sensations, feelings, and emotions are the perceptions of internal movements within the relatively fluid body," 99 percent of which, Lowen claims, is composed of water. "A person's emotional life depends on the motility of his body which in turn is a function of the flow of excitation throughout it. . . . Since the body is an energetic system, it is in constant interaction energetically with its environment," getting

"excited or charged by contact with positive forces" (like "a bright and clear day, a beautiful scene, a happy person") and in turn discharging such energy (52–53).

In sharp contrast to Alexander's rationalism, bioenergetics presents a *Lebensphilosophie* that sees life as movement of feeling ("the pulsatory rise and fall of excitement within the body") and hence advocates the aim of heightened living through "greater flow of feeling" or energy (*B*, 224, 240). It follows that while Alexander privileges reason and the head, Lowen highlights emotion and the heart, the energetic core which stimulates the flow of feeling: "the goal of all therapy is to help a person . . . to expand his heart, not just his mind; "the heart is king or should be . . . [since it] is the center or core of life" (89, 114) and the symbolic source of feelings which link one to the world.[23] If Alexander demands the strict control of emotions, Lowen urges their free flow as a means of heightening energy and contact with one's energy-giving environment. Emotional release "entails a flow of feeling, excitation of energy from the core or heart of the person to the peripheral structures and organs . . . and then . . . with the outside world"; and such free flow makes us feel more pleasurably alive and at home in the world (139).

Thus while Alexander advocates systematic inhibition, Lowen deplores it as unhealthily "blocking the free flow of excitation and feeling," which eventually results in the diminishing of somatic energy through frustrated withdrawal (88, 144). Though conscious inhibition is sometimes necessary, Lowen argues (after Reich) that its excessive use in our culture results in muscular contractions that become so habitual and unconsciously maintained that they develop into permanent spasms or blockages. Such protracted muscular tensions not only cause back pain and other ailments, but by blocking the flow of feeling and energy, they more generally lead to a lowering of the quality of life that will tend to weaken even the power of thought, since thought too is dependent on somatic and emotional energies (65).

As Alexander identified man's superior evolution with the development of reason, so bioenergetics explains our evolutionary advantage as that of "a more highly charged energy system"; "the development of the large brain, the increased sexual interest and activity of the human animal and the erect posture are a result of the increased energy charge in the human organism" (*B*, 227). But while Alexander sees progress as moving further beyond animal nature to greater rational control and

inhibition, Lowen insists that true progress would be a backward return to one's natural "life of the body"; a retreat from the overly inhibited and blocked "second nature" of "life-denying" modern civilization to our more animal "first nature," "a nature that retains the beauty and grace that all animals are normally endowed with at birth" (71, 104).

In contrast to Alexander's somatics of ascent—with its aim of higher evolution through more rational control and its pyramidal somatic hierarchy whose directive focus is the head, Lowen presents what could be called a somatics of descent. To help us get back to more natural living and more flowing feeling, to overcome the blockages and painful muscular contractions resulting from inhibitions that often stem from overly high ideals imposed on the self, Lowen offers the idea and therapeutic practice of "grounding" to make us more comfortably in touch with our earthly, animal nature. "Grounding, or getting a patient in touch with reality, the ground he stands on, his body and his sexuality, has become one of the cornerstones of bioenergetics"; "the major thrust of the work is downward—that is to get the person *into* his legs and feet" (B, 40, 196).[24] This downward path lies fruitfully through the pelvic area of genital sex.

Like Reich, Lowen sees sexuality and orgasm as "critically important" for restoring and maintaining the free and heightened flow of energy, for overcoming muscular and emotional blockages by the overwhelming power of orgasmic release. Part of the work of grounding is to improve our sexual self-acceptance and expression by making us feel more comfortably at home with the lower part of our bodies, where sexuality is most powerfully expressed, and by overcoming our fear to surrender conscious control to the body's involuntary rhythms, as exemplified in "orgastic convulsions." "Deep pelvic feelings of sexuality" are "very frightening to many people" because they evoke "this surrender" and "loss of control" (B, 197). But shouldn't we fear this loss of conscious control as a loss of self-control, even a shameful loss of self, as Saint Augustine viewed orgasm? Is the free flow of bioenergetics not the enslavement of self by unconscious, involuntary forces, as Kant and Alexander would complain?

Such discouraging conclusions follow only if we identify the self and self-control with the conscious ego and its will, but Lowen instead follows Reich in seeing the unconscious as an integral dimension of the self that demands and deserves expression and that provides a needed back-

ground and balance to consciousness.[25] For bioenergetics, "each person is his body" in its unconscious as well as conscious functionings, and a major aim and value of somatic work is to enhance appreciation and access to our unconscious embodied selves (B, 54, 319–20).

This somatics of descent leads to an astounding valorization of the body's most involuntary movements as "the essence of its life" and so "the most meaningful." Because laughter, sobs, tears, and trembling "are spontaneous, unwilled, or involuntary actions, they *move* us in a deep, meaningful way. And most fulfilling, most satisfying, and most meaningful of these involuntary responses is the orgasm in which the pelvis moves spontaneously and the whole body convulses with the ecstasy of release" (B, 243–244). The motivating ideal is not the rationalism of conscious control but the hedonism of powerful experience.

The bioenergetic ideology of flow and descent is expressed in its actual somatic practice. Instead of Alexander's emphasis on lengthening and erectness, bioenergetics works largely with a bent or prostate body. Its grounding exercises include not only body bendings to enable both hands and feet to have firm contact with the floor, but also the repeated experience of falling from positions that are muscularly impossible to maintain for very long. This experience of falling makes us aware that there are real limits to conscious somatic control yet also reassures us that neither surrender of control nor resultant contact with the ground is necessarily painful or dangerous. Other exercises aim at making parts of the body (particularly the legs and pelvis) shake or vibrate uncontrollably. Apart from its help in loosening habitual muscular spasms and "releasing tension," such "vibration of the body . . . allows a person to experience and enjoy the body's involuntary movements" as "an expression of its life, of its vibrant force. If a person is afraid of them, feeling he must be in full control of himself at all times, he will lose his spontaneity and end up as a rigidly bound, automatized person" (B, 243).

Anger, shock, and other strong emotional provocations are likewise used to overcome the patient's entrenched blockages or "holding patterns," while vigorous, at times even painful, physical pressure will be applied by the therapist to loosen fixed contractions or muscle spasms, thus providing for a freer flow of energy. Before the patient can surrender to her psychophysical spontaneity she must be willing to surrender mind and body to violent manipulation by someone else. We are clearly very far from Alexander's method of calm, controlled, unemotional

concentration, where the therapist's touch is so minimal and gentle as to almost efface itself.

Moshe Feldenkrais built on his scientific career as an engineer and nuclear physicist to develop an ingenious somatics of experience that lies between the rationalist voluntarism of Alexander and the emotional involuntarism of bioenergetics. Because it is far closer to the former, I shall abridge its presentation here by concentrating on how Feldenkrais agrees with and differs from Alexander, and by noting only most briefly his critique of bioenergetic theories of energy and human instinct that are neither supported by nor consistent with established scientific evidence.[26]

Feldenkrais shares Alexander's commitment to heightened awareness and conscious control of the body. Such mastery would represent a great and desirable evolutionary advance, especially because it would ensure greater psychophysical flexibility in a complex, rapidly changing world (ATM, 47–48; PS, 91, 238). But Alexander narrowly identifies this control with reason, while Feldenkrais sees it in more global and scientific terms as a function of the entire sensorimotor nervous system, where muscle feelings reeducate the reasoning mind as much as the mind directs the muscles. Similarly, although both theorists demand a retraining of the kinaesthetic system for more acute somatic awareness and more effective action, Feldenkrais does not see the key to this reeducation in Alexander's mechanism of primary control. Rather than one central pyramid to direct movement, Feldenkrais insists on the variety of somatic patterns of control, and he aims at increasing that variety through his practical work. This work focuses on diverse articulations in the pelvis, legs, arms, ribs, abdomen, hands, and feet, as well as on the head-neck area; and it seeks to make one aware of the plurality of ways certain actions can be performed, allowing one to sense their qualitative differences and learn to choose the most effective ways.

The variety of Feldenkrais work in fact comprises two rather different, though related, practices. The first is a set of slow and gentle exercises involving different alignments and movements of trunk and limbs (some of them slightly resembling yoga) aimed at heightening somatic awareness. These exercises, called Awareness Through Movement (or ATM, for short), are properly given by a teacher to a group of students (though they can be practiced alone with tapes or even simply by mem-

ory). The teacher gives verbal instructions to guide the movement and awareness but does not manipulate the body.

There is, however, a second Feldenkrais practice that does involve hands-on treatment by the teacher who, by observing and manipulating the student's body (typically reclined on a padded table), discovers the problematic peculiarities of the student's neuromotor functioning and then makes the student aware of them, "along with *alternative* ways of controlling the motor functions."[27] The manipulation is often more vigorous than the minimal touch Alexander recommended; but it is far more gentle than bioenergetic handling. For the aim is not to overcome blockage by shock, but to communicate very subtle sensory information. It is not so much therapy as teaching, and the sessions of Functional Integration (like those of ATM) are called "lessons." In contrast to classic Alexander Technique, both forms of Feldenkrais work are most often done in a prostrate position (and more often lying on the back than on the side or the belly). This is not simply to counteract the habitual effects of gravity that guide our usual movement (which is not done lying down) but also to disorient the individual so as to make him more aware of his movement and its different possibilities.

Inhibition is as central to Feldenkrais as to Alexander, even if somewhat differently expressed. Less emphasis is placed on the method of explicitly inhibiting compliance with instructions (though one is still often told to think through the movement a few times before doing it). But besides recognizing the value of inhibition in breaking bad habits of use in neuromotor functioning, Feldenkrais supplies a compelling scientific account of why inhibition is essential to all effective action. Since excitation in the motor cortex tends to spread, inhibition is needed to prevent the stimulation of peripheral "unwanted contractions of muscles" that may get excited in our desire to act but actually would interfere in our action. "The sensation of difficulty or resistance to action is indirectly due to imperfect inhibition of the cells commanding the antagonists of muscles that are indispensable in forming the desired pattern" of muscle contraction (*PS*, 85). Moreover, recognition of our antagonistic or reciprocal somatic functioning shows that by inhibiting excitement in one area we can heighten it and its efficacy in another (136). This would refute the bioenergetic complaint that inhibition inevitably leads to a lowering of excitement, vitality, and performance.[28]

Like Alexander, Feldenkrais criticizes our narrowing habit of direct end-gaining. More important than any specific achievement is the

primary goal of acquiring the general means for better self-knowledge and self-mastery, especially by "learning how to learn" (*PS*, 152, 238). Through his neurological accounts of inhibition and induction, Feldenkrais supplies a more substantial scientific explanation of why indirection is necessary for achieving certain somatic ends, particularly those relating to our involuntary actions and autonomic system.[29] By mastering such indirect means, Feldenkrais claims, "man's potential control of self is virtually absolute" (93), thus echoing Alexander's boundless faith in human growth and perfectibility. While bioenergetics displays a similar optimism for continuous "growth" in which "a healthy individual has no limitation" (*B*, 15, 33, 104), such growth, we saw, lies in a very different direction—toward less conscious, more involuntary control.

In one major dimension, Feldenkrais departs sharply from Alexander and approaches bioenergetics: his emphasis on the deep value of affect and sexuality. Though identifying our emotions, particularly those of dependence, as a major cause of our faulty kinaesthesia and compulsive behavior (when, for example, the desire to satisfy one's mother leads to a habit of overeating and the false sensation of not being full until one is overstuffed), Feldenkrais never suggests that affect is an inferior, pernicious animal vestige that we would do better to transcend. Recognizing the crucial contribution of emotions to the richness of life, he merely urges that one learn to free one's action from dependence on compulsive patterns stimulated by emotions. And this, he argues, through the reciprocity of body and mind, will conversely also free one's range of emotion by dissociating it from those same compulsive, muscularly and emotionally entrenched patterns, thus enabling "the person . . . to direct his affective drives toward objects of his choice" (*PS*, 100–103).

In stark contrast to Alexander, Feldenkrais shares bioenergetics' emphasis on the crucial importance of sex for proper psychophysical functioning. "Full orgasm accompanied by intense gratification is a physiological necessity for the smooth running of the protective, self-assertive, and recuperative functions" (*PS*, viii). It gives us a needed release from accumulated tensions including those arising from the effort of conscious control. Thus, "it is impossible to correct and reform adequately the general use of oneself without recovering sexual spontaneity" (173). This is why much of *The Potent Self* is devoted to overcoming problems that hamper our sexual behavior, and it is also one reason why much Feldenkrais work focuses on the lower part of the body, on "establishing the full range and control of the pelvic region" (176). Another reason is

that Feldenkrais regards the pelvis as the body's central source of power and control, since it carries the spine, which in turn supports the head and the ribs.[30]

VI

The somatic turn that I hope to promote in philosophy surely needs much more detailed analysis (and testing) of these and other body-mind disciplines.[31] But let me venture a brief and provisional conclusion. If the somaesthetics of experience should be incorporated into philosophy, conceived as a rationally disciplined quest for better living through greater knowledge, self-knowledge, and right action, then the more rational disciplines of Alexander and Feldenkrais seem much better candidates for incorporation than the Reichian varieties of bioenergetics. The former share philosophy's stress on rational, conscious control and autonomy in contrast to bioenergetics' strong emotionality and surrender to impulse and involuntary control, coupled with its use of shock and forceful manipulation by others. Between Alexander Technique and Feldenkrais Method, the latter seems the more promising, even though it is the less traditionally rationalistic. By recognizing the importance of affect, sexuality, and diverse centers of our sensorimotor system (rather than urging only reason and the head's primary control), Feldenkrais seems better able to listen to the body and not just command it. He offers a more dialogical, distributed, and sensitive somatic rationality, while Alexander often sounds too much like the harsh and haughty voice of a self-centered, dictatorial reason, the negative white male voice of one-sided, willful control. Though this may be the traditional voice of philosophy, can we still take it as the true one?

multiculturalism and the art of living

Life is a boundless privilege, and when you pay for your ticket and get into
the car, you have no guess what good company you will find there.

EMERSON

I

As the new media of cyberspace command our technological imagina-
tion, so multiculturalism seems to have captured our cultural concerns.
One of the noisiest buzzwords of recent times, it expresses (almost
in the cybernetic sense of noise) less a clear message than a confusing,
if positive, disturbance. Like its sister notion of globalization, multi-
culturalism is ambiguous and contested. Both notions are widely ex-
alted as the twin keys to a new, rainbow-rich world community, but
they are also frequently deplored as a virulent threat to the very roots
and life of true community and culture.

In bringing a wealth of new consumers and inexpensive goods from
foreign markets, globalization threatens the stability of our own econ-
omy, inflicting not only chronic social anxiety but frequent tremors in
our labor force through factory closures and mass layoffs. Reciprocal
fears of losing sales to cheaper foreign manufacture have eroded some
of the hard-earned, state-protected social benefits of workers in the na-
tions of the still imperfectly unified European Union. Celebrated as an
end to cruel centuries of nationalist wars of imperialism, globalization
is now brandished to promote the imperialist aims of multinational
conglomerates by undermining the protective statutes of national wel-
fare states (that are accused, in turn, as obsolete vestiges of narrow
chauvinism).

Nonetheless, right-wing nationalists conversely wield the motto of
globalization to inspire a racist hate of foreign workers and resident im-
migrants.[1] In bringing Western contract law and business practices to
the farthest corners of the world, globalization claims to be redeeming
human rights and individual freedom from the tyranny of traditional
social bonds. But it often seems that it is simply destroying these tradi-
tional cultures (with their difference of values) in order to erect the
universal tyranny of the dollar. Is globalization really establishing the in-
trinsic value of the Person or simply the market function of the Con-

sumer? If anything is clear about globalization, it is its complexity, ambiguity, and conflicting valuations.

Multiculturalism, as I experience it, incorporates the same perplexities and mixed emotions. As a binational whose philosophical career spans three continents and four languages, I am sometimes urged to take pride in my multicultural education. But just as often I am made to feel anxious and ashamed of therefore having no consistent cultural training at all; of constituting precisely the sort of rootless Jewish intellectual that T. S. Eliot once condemned as a menace to Western civilization. And when a beauty of Japanese extraction first became the great love of my life, I did not know whether to congratulate myself on being open to an interracial relationship or instead to despise myself as a postcolonial white predator exploiting the erotic fascination for the exotic other. Was it perhaps wrong to think of her in ethnic terms at all? Most readers, I expect, have their own anecdotes of multicultural malaise. And whatever our specific "subject-positions" and personal partisanship in the culture wars, we cannot fail to see that multiculturalism evokes a confusing tangle of ambiguities and ambivalence. Its different meanings and shifting uses (perhaps too diverse and conflicted to make the concept entirely satisfactory) engender a host of controversies. Just consider the following five points of contention.

1. Praised for promoting the expression of difference in the face of society's strong homogenizing pressures, multiculturalism affirms the rights of cultural otherness against the established privilege of dominant ethnic identities. But its radical emphasis on diversity, critics allege, spawns an unhealthy fragmentation of the social body into opposing fractions, thus robbing our country of a wider sense of national identity whose unifying power is required for effective political action, even for insuring the advancement of multiculturalism's own aims of achieving fuller freedom and flourishing for all.

2. Affirmed for boosting the self-respect of ethnic minorities by recognizing the legitimacy of the culture to which they belong, multiculturalism is condemned for distracting public attention from deeper problems of poverty and political injustice that frame the issues of cultural recognition but which cannot be resolved through merely cultural means. I, too, have had to face this charge. My case for the artistic legitimacy of rap music has sometimes been accused of assuming that aesthetic recognition somehow assures (or compensates for) economic and political freedom, that rap's artistic value somehow dissolves or indem-

nifies the evils of ghetto crime and poverty. Though I plead not guilty,
I recognize the dangers of confusing cultural acceptance with social em-
powerment, even if I also insist on the limited (but still valuable) power
of aesthetics for politics.

3. Vaunted for respecting the established cultural traditions of differ-
ent ethnic groups and for protecting their survival from erosion by the
assimilating pressures of more powerful cultures, multiculturalism is
conversely condemned for violating the individual's most basic rights to
freedom. While some extol the multicultural ideal of cherishing French
Quebecker culture by requiring its natives and new immigrants to be
educated in French-speaking schools, others denounce it as a repressive
violation of personal liberty and a reactionary refusal of a wider, more
progressive multiculturalism through new cultural affiliations and pro-
ductive mixing.

4. Touted for bringing new cultural richness by introducing the di-
versity of non-European aesthetic traditions, multiculturalism is con-
trastingly chided for impoverishing our culture through loss of peda-
gogic focus rooted in a coherent canon. More means less, say the critics,
when it is mere dilettante dipping in the cultural inkwells of ethnic oth-
erness. Still worse, it seems a disrespectful plundering of the cultural
goods of disadvantaged others. For champions of the traditional canon,
multicultural eclecticism also presents a threat. By ushering in so many
new works, new styles, and new standards in such wholesale fashion,
it radically reshapes our artistic tradition, threatening the value of what
we already have by challenging the integrity of the structure of tradition
through which artworks acquire their meaning. Moreover, by introduc-
ing its new works and styles more on the basis of universal claims of
ethical fairness than through concrete aesthetic justification, multicul-
turalism sometimes seems to challenge the very legitimacy of aesthetic
discriminations of good and bad. Nothing could be worse for the cause
of culture and the appreciation of difference.

5. Finally, while multiculturalism claims to underline the diversity of
cultures, critics argue that it in fact obscures real cultural diversity by
confusing culture with the fictions of race and individuating cultures by
the surface criterion of skin color. In affirming the multicultural rights
of Native Americans, there seems to be less respect for the specific dif-
ferences between Navaho, Seminole, Cherokee, and Apache cultures
than a general concern to assimilate them all as common victims of po-
litical injustice who need to be helped through policies of affirmative

action. The same might be said for the differing African-rooted cultures that exist in American diaspora and that are grossly lumped together under the concept of African-American. The monocultural blurring of multiculturalist concepts is still more evident in the category of Asian-American, which ignores the enormous differences between Japanese, Chinese, Korean, Indian, and other Asian cultures. All this suggests that today's idea of multiculturalism is not really based on respect for coherent cultures at all, but rather based on a sad recognition of grave social injustices that Americans (and Europeans) have systematically committed along racial lines, the term "culture" euphemistically substituting for "race."

Indeed, if terms get their meaning through contrast, one wonders what is the defining contrast of multiculturalism. Rather than "mono-culturalism" (a term rarely used or defended), its usual opposite is "Eurocentrism"; yet this term belies the great cultural diversity in Europe itself, which is surely richer and deeper than the five ethno-racial categories that make up the familiar American multicultural pentagon.

That multiculturalism is a confused and contested concept does not mean it is a useless one. Vague terms still signify; they even serve better as political rallying calls precisely because of their encompassing vagueness. But in deploying the concept for philosophical work, we need to recognize how its precise meaning shifts according to the specific contexts of multicultural debate, from nation to nation, discipline to discipline, age to age.

In the United States—a country with a nonethnic ideology that separates church from state and that prides itself as a country of immigration from different cultures and races yet has a history marked by a dominant Anglo culture—the pressing issues of multicultural debate will differ from those in a country like Germany. For German national ideology still maintains (despite demographic facts and recent legislature to the contrary) that it "is not a land of immigration" and instead insists on linking its national identity to the romantic idea of a special *Kulturnation* based on a deeply shared language, tradition, and ancestry. Germany is also the place where an enlightened postwar population still struggles with the living Nazi memory of state-orchestrated genocide of foreign ethnicities.[2]

So while German multicultural debate has focused on the problem of citizenship, social integration, and safety from violence for the vast population of (primarily Turkish) foreign workers and their families,

multiculturalism in the United States concentrates on other issues: How much distinctive cultural recognition and compensatory advantages should be given to the different minority cultures resulting from immigration (including the culture of Native Americans, who became a minority through the immigration of others)? How can a unified core American culture be sustained in this diversity? And if this country is just a container for the multiple, hyphenated identities of African-American, Asian-American, Hispanic-American, Jewish-American, Polish-American, etc., how can we maintain sufficient unity to guarantee effective political process for our national interests? Countries (like Canada or Finland) that have rival linguistic communities and more than one official language face their own special multicultural issues. In France—which combines a large immigrant population from its colonial past with an ideology of republican egalitarianism through French acculturation orchestrated by a powerfully centralized education system—multicultural battles have recently focused most prominently on the dress-code infraction of the Muslim schoolgirl's *foulard* and on the violation of personal rights in religiously motivated rituals of clitoridectomy.

Even in the same country, the precise meaning of multiculturalism can differ from one historical age to another, often because of changes in ways the different cultures are individuated. Thus the "cultural pluralism" that Horace Kallen advocated for America in the 1910s and 1920s was far more concerned with different European cultures of minority immigrants facing the established hegemony of Anglo culture. Like later pluralist movements before the present multicultural boom, it also gave far more weight to religious factors than multiculturalism does today.[3]

Finally, the meaning of multicultural discourse shifts greatly from discipline to discipline. If literature departments treat multiculturalism as a question of revising the artistic canon to redress the oppressive blindness of cultural hegemony, constitutional theory and political philosophy see the issue in very different terms—as a conflict between group rights and individual rights, or in terms of the familiar paradoxes of toleration endemic to liberal democracy: Does freedom of speech entail the right to hate-speech? To what extent should we tolerate views and practices that themselves seem intolerant?

In emphasizing the multiple meanings of multicultural discourse, my aim is not to deny that this diversity is rooted in a community of over-

lapping problems, but simply to insist that when exploring the idea of multiculturalism, we should be clear about the sort of philosophical issue that shapes the context of our concern. Neither the constitutional issue of group versus individual rights nor the paradoxes of liberal tolerance is what motivates me here. My prime concern is how the idea of multicultural understanding can be integrated into the project of self-fashioning, when the aesthetic impulse is directed into the conduct of life and philosophy is conceived and practiced as a critical, meliorative art of living.

II

Charles Taylor has influentially argued that multiculturalism's political issues of group rights, tolerance, and recognition of difference all grow out of the deeper problem of the individual's need for distinctive self-expression and self-fashioning.[4] With the collapse of traditional social hierarchies of honor based on inequalities of distinction, modernity developed a universalist and egalitarian sense of dignity rooted in human personhood. But by the end of the eighteenth century, and stimulated by Rousseau's notion that moral judgments were properly rooted in the intuitions of our sentiments, the idea of realizing one's personhood took a less abstract, more individualized turn. And then, in Taylor's view, Johann Herder's notion that "every person has his own measure and mood" finally introduces original self-expression as "the modern ideal of authenticity." Taylor explains: "There is a certain way of being human that is *my* way. I am called upon to live my life in this way, and not in imitation of anyone else's life." To live a full and authentic life, Taylor argues, has thus come to mean expressing one's individuality.

But authenticity's "goals of self-fulfillment and self-realization" require more than the individual's own resources. For the self is essentially social and dialogical in character, constructed from our interaction with other selves, who give us a sense of our own qualities, roles, limits, and worth. Even the meaning of our most private thoughts derives from a language that depends on, and is acquired through, dialogue with others. So if we fail to gain the recognition of others for what we are, our own sense of self is somehow diminished and impaired. These others who help constitute our identity and whose recognition is crucial for our own self-affirmation include not only those intimates whom we care most about, those "significant others" (in George Herbert Mead's phrase) who introduce us to our values and set our models, expecta-

tions, and horizons for self-realization. Beyond this crucial intimate level, we need recognition from wider social groups with which we interact and against which we measure ourselves.

If the modern self demands expression not of a universal human essence but of its own particular authentic identity, then we need more than simple recognition of our basic, equal dignity as human beings; we need a recognition of the *distinctive* people we are. But since part of our distinctiveness depends on the distinct ethnic, gender, or social group of which we are members (groups whose cultural resources form the individual's tools for self-fashioning), then our right to distinctive dignity of self seems to require a right for the distinctive dignity of these groups to which we belong. Particularly with groups that have suffered humiliating oppression, self-dignity requires a recognition of the special worth and dignity of one's group, not just the consolation of being recognized, at bottom, as sharing personhood with individuals of more dignified social categories.

In this way, "the politics of difference grows organically out of the politics of universal dignity," while opposing its universalizing tendency to level cultural differences (39). Taylor therefore argues for the rights of distinctive cultural groups to sustain and protect their distinctive identities, even to the point of imposing limits on the freedom of their members (as, for example, in requiring French Quebeckers to educate their children in Francophone schools). Such group rights, he maintains, paradoxically grow out of the individual's rights to express her distinctive identity and to preserve the distinctive cultural resources for continuing to express this distinctiveness. For the individual's "rights to cultural membership"[5] cannot mean much when that culture lacks the political means to preserve itself. Hence Taylor accepts the legitimacy, in certain circumstances, of collective goals overriding one's individual freedoms in order to insure the survival of an endangered cultural species (such as, presumably, the French Quebeckers).

Defenders of our dominant, procedural liberalism retort that individual rights always come first and have "absolute precedence over collective goods," unless those collective goals are themselves adequately justified by more important, fundamental rights of individuals. These liberal critics, who doubt whether the rights Taylor alleges are sufficiently fundamental, are also quick to emphasize the political dangers of full respect for cultural otherness. Pointing to the dilemma of tolerating intolerant claims of cultural expression, they cite cases like the funda-

mentalism of the Rushdie death *fatwah* threat and the racism of hate speech.

I now leave these important political issues so as to probe more deeply the basic multicultural issue of expressive self-realization from which they seem to stem. Taylor's helpful account needs to be refined by looking more closely at the intricate dialectics that complicate the assertion of identity through multicultural recognition. It especially needs to be complemented by an altogether different perspective on multicultural identity that Taylor and other philosophers tend to ignore.

Taylor argues that our demand for distinctive self-expression to realize our identity emerges from two modern phenomena: the loss of a secure (if not always flattering) identity guaranteed by fixed aristocratic social hierarchies, and a new desire for a more *"individualized* identity" (28) than that expressed by something universal like human reason. This desire, which Taylor traces to the late-eighteenth-century advocacy of intuitive moral sense guided by feeling, as against an overly rational ethics of "dry calculation" (28), suggests a third complex reason for the growing demand for individual self-fashioning in the past two centuries. A diminishing faith in traditional moral codes and in the very possibility of deriving any universal ethical principles from a presumed human essence has made the conduct of life increasingly a matter of taste and style.

As ethics melts into aesthetics, so art replaces religion as the most credible core of spiritual value. The artistic genius (a positive power beyond the fixity of traditional laws) replaces the saint and scientist as the hero of our culture. Yet the waxing power of democratic ideology (reinforced no doubt by a profit-hungry economy keen to market life-styles) calls upon all of us to become the artists of our individual lives. "Everyone is special," paradoxically intones the familiar mantra of advertising, as it perplexingly implores us to affirm our distinctive uniqueness through the purchase of mass-produced commodities.

Taylor sees the need for distinctive self-expression as entailing a need for recognition of the distinctive culture of the social group in which our identity was forged; for culture provides us with far greater resources for meaningful self-expression than we could ever achieve on our own. Our lives become larger and more significant when seen as part of the greater group and history to which we belong. But in taking the artist as exemplar of authentic individuality, Taylor unwittingly introduces a problem for his view, since the modern paradigm of the artist's self-

expression involves critical distance and an oppositional stance toward the society which shaped her.[6] Likewise, the most potent moments of artistic creativity more often seem the product of adventures in cultural traveling than narrowly inbred expressions of ethnic patriotism.

There is another puzzling wrinkle in multiculturalism's affirmation of self-expression through advocacy of cultural difference. Taylor and others justify this politics of difference by arguing that the distinctiveness of the minority cultures must be emphasized to counteract the tendency to assimilate them to the dominant culture. This assimilation is often done implicitly by ignoring their specificity and subsuming them under a universal humanism, so that these minority cultures are taken to express the very same core human essence that the dominant culture does, although less clearly or familiarly. Such essentialism, it is claimed, robs the dominated cultures of their specific worth and content.

But the politics of difference courts its own damaging dialectic of essentialism. In denying traditional universal humanism as an oppressive myth disguising Eurocentric-phallocentric hegemony, multiculturalism affirms an anti-essentialist emphasis on cultural difference that recognizes the historical construction and complexities of human identities. But, given the practical stakes of cultural struggle and the problematic way in which our history of oppression has individuated "minority" cultures, the politics of difference quickly falls into its own form of essentialism that often seems especially self-serving. In a competitive society whose ideology of equality demands compensatory favoring of disadvantaged ethnic groups that have been somehow exploited or persecuted, individuals seek to promote themselves by affiliation with such victimized cultures.

A common cultural essence is thus presumed and projected in ways that often seem arbitrary and opportunistic. This presumed common essence obscures the valuable distinctiveness of the different cultures lumped together in terms of this essence and instead perpetuates the same primitive categories of race and color that generated these cultures' history of oppression. The multicultural category of Asian-American (which did not originally include Asians from the Indian subcontinent and still often ignores them in practice) looks more like a racist essentialism of "yellow people" than a politics of recognition of difference; for it brutally homogenizes the important cultural differences between (and within) the Chinese, Japanese, Korean, Thai, Vietnamese, and other Asian-rooted cultures that exist in America.[7]

To insure the distinctiveness or special essence of a culture (especially when that essence seems vulnerable or dubious), its borders must be policed. Insisting that American society should open itself up to include their specific cultures, multicultural advocates often exercise their own separatist strategy of purist exclusion, even when they know the distinctive culture they champion is far from pure and even owes its distinction to its hybrid mixing. Rap culture can provide a good example of this phenomenon. Celebrating the aesthetic of the mix through its signature technique of sampling, rap is the product of blending different cultures of African diaspora with American pop culture in the volatile crucible of urban life. But despite its affirmation of hybridity and its aspiration to embrace a rainbow coalition of hip-hop enthusiasts from all over the world, rap still often needs to affirm itself distinctively, and sometimes even exclusively, as black ghetto music. In a dialectic of exclusion where rejected cultures affirm their intrinsic worth by rejecting those who rejected them, rap separatists repeat the proud but wayward strategy of the Jews: the more that Jews were scorned, persecuted, and excluded in ghettos, the more they insisted on their special status as the "chosen people" and the higher they raised the bar of conversion for those who wanted to identify with their culture.

Such turns toward essentialism and separatist exclusion plague the logic of multicultural difference. In eschewing the notion of a universal human essence so as to insist on the claims of cultural difference, multiculturalism threatens to erect such differences into rigid distinctions between a set of impermeable cultures. In defining one's cultural group by sharply contrasting it to rival groups, one multiplies the barriers to mutual understanding within the multicultural spectrum. Yet isn't the goal of multicultural recognition to have one's self and culture understood, not just stridently asserted as different?

The advocacy of difference seems crucial, however, to resist the cultural imperialism of liberalism's standard formula for recognizing people of other cultures: simply assimilate them to us and ignore their differences. Thus Richard Rorty's neoliberal ideal of multicultural understanding is "to extend our sense of 'we' to people whom we previously thought of as 'they.'"[8] But such an imperially patronizing attitude does not really credit the foreign culture with any integrity or value of its own. If, as Taylor insists, a people's identity is partly shaped by recognition or . . . the *mis*recognition of others" (25), then they need recognition not simply as an assimilated "us" but as a respected "they." By

homogenizing or ignoring their difference in our aim of understanding, we are robbing them of the "external recognition" of their "equal value" that Taylor sensibly sees as necessary for self-respect (64). But if true recognition demands understanding a different culture on its own terms rather than ours, how can this be achieved? How do we get beyond this apparent conflict between recognition of otherness and shared understanding?

Part of the problem, I think, is a one-sided stress on affirming one's culture vis-à-vis the culture of others.[9] This attitude clearly underlies Rorty's presumption that assimilation to our own culture is the only way minorities can gain our recognition. But this self-affirming stance is also evident in Taylor's pluralist counterclaim that minority cultures should proudly demand from mainstream culture an "external recognition" of their distinctive yet equal worth. Beyond this simple logic of self-assertion, I propose a different approach: a self-challenging exploration of the culture of others in order to test, deepen, and enrich our own sense of self.

III

Even when most sincere, the quest for a better understanding of the culturally other often contains the further (sometimes even dominant) desire of better understanding oneself.[10] To seek self-understanding through the medium of others reflects the Delphic injunction "to know oneself" that set the entire course of Western philosophy when Socrates pursued it for himself by engaging others in dialogue.

Exploring the self through comprehension of the other proceeds not simply by confrontational contrast but by way of integrative participation. We learn to understand ourselves better by discovering the cultural others in us. Sometimes these others are already deeply present and just need to be uncovered, but sometimes they lurk more in the margins as potential dimensions waiting to be incorporated into the self. The self can incorporate them because it is neither a fixed universal nor an immutable personal essence. Shaped through change and interaction, it derives its unity not from a permanent core but from its stability and coherence in transformation.

Let us begin, however, by recognizing the productive value of simple contrast expressed in the conceptual interdependence of self and other. In the logic of complementarity—whose importance in Western philosophy can be traced back to Heraclitus and whose greatest modern cham-

pion is surely Hegel—anything and everything is defined by its others.[11] The limits of any entity, hence its individuation, are determined by what lies outside those limits, by what constitutes the environing field in which these limits can be constructed and the entity individuated from the rest of the field. To understand oneself as a self implies a knowledge that there is something outside the self, an other, in contrast to which the self can be defined and distinguished. Since our environing fields are social and cultural as well as spatiotemporal, we need a sense of the culturally other against whose background our own culture and self can be defined.

Beyond the bare logical point that self-understanding requires the other because the very definition of self does, the other provides a medium or dialogical partner through which the self can see and test its limits. Insisted on by many post-Hegelians but already evident in the dialogical and epistolary philosophical traditions of antiquity, this theme of contrast is also prominent in the fictional literature of diverse cultures. In order to find himself, the protagonist must venture into foreign lands or into the wilderness (a *natural* otherness which by differing from one's indigenous culture and requiring quite a different way of life amounts to a *cultural* otherness as well).

Encountering the culturally other not only prompts us to self-assertion and self-awareness but spurs us toward a deeper probing of who we really are. Hans-Georg Gadamer makes this point in his famous discussion of prejudice, which he treats as cognitively enabling because limiting. "It is impossible to make ourselves aware of [our prejudice] while it is constantly operating unnoticed, but only when it is, so to speak, stimulated." An encounter with a culturally other, even through "the encounter with a text from the past, can provide this stimulus" and so "make conscious the prejudices governing our own understanding" and constituting our own culture and self.[12]

But in using other cultures as a contrast to help us better grasp our own, we must not forget the danger of stressing differences rather than shared appreciation and empathetic interchange. How can we avoid erecting such cultural contrasts into a divisive arena of oppositional self-assertion between cultural identities that seek to define themselves by presuming their essential, irremediable difference? This question is extremely difficult to answer, not only because it nests in the tangled dialectic between multicultural difference and shared understanding (which dialectically includes also understanding of difference), but also

because multicultural recognition enfolds a complex web of varied and often conflicting motivations: social acceptance, cultural distinction, economic advantages for disfavored difference, etc. Those who struggle to fit in, sometimes also prefer to stand out.

One strategy to deploy cultural contrast while avoiding the unbridgeable barrier of essentialist difference would be to loosen the fixity of cultural identities by recognizing their contextual character, given their constitution in terms of contrasts in their environing field. Such identities can neither be very precisely nor rigidly defined but must change with the changing elements in the field, the field being as much a construction of its elements and their varying positions as those elements are a function of their place in the field. The result is that one's self-definition and sense of self are differently constructed in different contexts in light of the kind of others who constitute the self's field. One is more conscious of being a white man when one suddenly finds oneself surrounded by a large group of Japanese women. By the same logic of contextual complementarity, a patriotic Breton or Corsican is apt to feel his cultural difference from France more in Paris than in Peking, which provides a far more dramatic range of contrasts.

As an American-Israeli binational, I know the vagaries of cultural identity from personal experience. Since English was my mother tongue, I was defined by Israelis as being an "Anglo-Saxon," while in America I am defined as Jewish in contrast to Anglo-Saxon ethnicity. As an Israeli, one is geographically Asian, though culturally very close to Europe. Hebrew, however, is far from a European language; and Israel has not been admitted to the European Union, though it belongs to European sports associations (having been thrown out of Asian sports!). In the East / West division of culture — a division as false as most binary oppositions, Israeli culture seems to inhabit (and suffer) the punctuating slash.

As a student at Oxford, I would vacillate between seeing myself as an Israeli and as an American, though a close Sikh friend of mind had a third view of my ethnic identity. As my father and all my grandparents came from Eastern Europe, I was neither American nor Israeli but essentially of Eastern European stock. Since the fields that define the self can thus be differently drawn from different historical perspectives, even at the same time, the variety of identity-changing contexts can be greatly multiplied. And in a world where increasing speed of physical transit and information flow makes us shift our contextual fields quite rapidly, it is not surprising that our sense of identity has become more

problematic. If this fuels the postmodern idea of the disintegration of the subject, it also promotes today's passion for multicultural identity politics as a tool to sharpen our vague sense of identity by self-affirming, contradistinctive ethnic affiliations, even though (or perhaps because) our different cultures are becoming more porous and mixed.

Encounter with the culturally other fosters self-understanding in a second way: not by mere contrast but through accretion or absorption. In other words, in defining ourselves by addressing another culture, we can revise and enrich ourselves by assimilating aspects of that other and by integrating the complex consequences of this cultural interchange. Through this process of self-definition and development by self-transformational absorption of the other, an individual (in Nietzsche's phrase) "becomes what one is."[13]

T. S. Eliot provides good testimony of how one's self is defined and transformed through wide reading in alien cultural worlds. To understand the literary works of another culture, one must to some extent accept their structures of meaning and belief. As Eliot describes it, "you have to give yourself up, and then recover yourself"; "but the self recovered is never the same as the self before it was given."[14] When we are immature and read a powerful author, Eliot explains, "what happens is a kind of inundation, of invasion of the underdeveloped personality by the stronger personality" of the author. But the more experience and wider reading we assimilate, the more well-rounded, tempered, and sturdy our belief structures become, and thus the less likely we are to be one-sidedly possessed by any one author or foreign culture.

Moreover, since different cultural views are often in conflict, digesting a variety of them makes us compare them critically. And this stimulates the formation and expression of our selfhood through our comparative assessment of the different views. Wide reading and experience of the culturally other are valuable, therefore, "not as a kind of hoarding" or accumulation of information, but "because in the process of being affected by one powerful . . . [author or culture] after another, we cease to be dominated by any one or by any small number. The very different views of life, cohabiting in our minds, affect each other, and our own personality asserts itself and finds each a place in some arrangement peculiar to ourself." Hence Eliot urges that "we make the effort to enter those worlds of poetry in which we are alien" so that we can better understand the world and culture we identify as most our own, but do so without falling into a parochial cultural chauvinism.

Eliot practiced what he preached. A native of St. Louis, Missouri, he absorbed himself deeply in French and Indian culture before thoroughly projecting himself into the English culture that he eventually made his own, even to the point of naturalization as a British subject and conversion to Anglicanism. Eliot's early fascination with Indian philosophy is particularly instructive on this issue of self-understanding and self-fashioning through projection into the culturally alien. His example suggests there are practical limits beyond which one's understanding and absorption of the other threatens to destroy one's stable, familiar sense of self. Though he originally hoped to make it his prime topic of doctoral research, Eliot confessed to have abandoned his study of Indian philosophy because the task of bringing himself to understand it in its utmost depth would have involved transforming himself into a very different person, which for practical and personal reasons he did not wish to become.

Self-expanding, self-testing encounters with the other are enriching but can be dangerously destabilizing. What seems easy and limitless in theory is often painfully stressful and incapacitating in practice, as we could learn from refugees who are forced to settle in alien cultures. My conclusion is not to reject cultural travel but simply to recognize its risks and limits, so as to make it more fruitful. That is a pragmatic way of putting what can also be aesthetically formulated. We should seek cultural variety for enriching and defining the self but only to the extent that such variety can be held in a satisfying unity. As with other aesthetic questions, no fixed rules can be prescribed for the ideal balance. Taste, if not also a certain measure of genius, will be required to find this optimum.[15]

Besides contrast and assimilation, there is a third way in which understanding the culturally other can promote a better understanding of the self. This is in cases where our cultural selves are in fact actually composed of elements of the culturally other that we have so far failed to recognize and thus have not fully understood. Here, by coming to understand the other we improve our self-understanding by understanding that other in ourselves.

Typically, we take the "selfhood" of our cultural self for granted; we presume the unity and autonomy of our culture, ignoring that our cultural self is often partly constituted by elements from cultures that we all too simplistically regard as radically other. We fail to realize the cultural others in ourselves in two different ways: either by simply failing

to recognize the culturally other dimension of these elements or by failing to reclaim the richness of this dimension even when we recognize its otherness.

Take two examples. Western philosophy tends to distinguish itself sharply from both Asian philosophy and from African philosophy (to the meager extent that it is even ready to acknowledge and respect the latter). Yet it can be argued that Western philosophy is deeply indebted to Asian and African philosophical traditions, and thus has already incorporated these presumed radical philosophical others. We do not need to enter the "Black Athena" debate and engage the more radical Afrocentric claims that Egypt is the prime source of Greek philosophy. For whatever the truth about ultimate origins, it is clear that ancient Greek thought was deeply influenced by Asian and African sources. Even Diogenes Laertius, the patriotic chronicler of the early Greek philosophers, who zealously insists philosophy was a Greek invention, nonetheless is ready to admit that several of the most important Greek thinkers (like Democritus) learned significantly from the Indian "Gymnosophists" and Egyptians.[16] It is also clear that modern continental philosophy (in Schopenhauer and others) has been partly influenced by Asian thought, which has also marked American philosophy through its seminal impact on Emerson. Failure to recognize these cultural others in our own Western philosophical tradition is not just an insult to these others, a failure of external recognition; it also constitutes a failure of self-recognition, a lack in our own cultural understanding.

For an example far outside the realm of philosophical culture, recall the case of American country music from Chapter 4. Frequently expressing the most patriotic and chauvinistic sentiments, it regards itself as an "all-American" music and sharply distinguishes itself from African-American music and other ethnic music. Yet country music is in fact deeply rooted in the black musical tradition of the United States; country's first and most formative stars, like Jimmie Rodgers and Hank Williams, learned their skills and style from black performers. This influence was originally so evident that country music was first classified (in record stores and in the professional music magazines) along with black music. The steel string guitar sound, regarded by fans as characteristic of "pure country," was in fact imported from Hawaii as late as the 1940s.

These foreign ethnic roots have been quickly forgotten by today's country fans who see themselves as the protectors of the country tradi-

tion. They have been erased in popular consciousness not simply by the passage of time but by the drive to sustain a model of authenticity based on an imaginary cultural pureness, rather than pursuing an alternative model of authenticity based on the fruitful facts of cultural mixing. Underlying this drive for pureness is the false assumption that cultural identity is inherently diminished or violated by the inclusion of elements from another culture. Such an assumption must deny the obvious fact that most cultures are hybrid and historically constructed through dialogical exchange with each other and that cultural traditions seem for the most part stronger and richer through their synthesis of multicultural sources.

The English language gained its rich range and power by absorbing both French and German elements. If American culture seems today more potent than the English culture from which it stems, this is largely the product of its integration of many different vibrant cultures through successive waves of immigration (not all of them voluntary or happy). Even Jewish culture, despite its tenaciously separatist ideology of the "chosen people," actually derives its longevity and richness more from its skills of cultural adaptation and importation from the dominant environing cultures: Hellenistic, Arabic, and European. Cultural syncretism is already evident in the Hebrew culture of the Old Testament.

If our self-understanding as Western philosophers (or as country music fans) requires the realization of the foreign roots or elements that helped form our tradition, what does such realization actually amount to? Two levels can be distinguished. Realizing the other in our cultural selves can simply mean recognizing the historical fact of these other elements. Such bare recognition, however, does not seem to me sufficient for a true understanding of the other in ourselves; hence it cannot give us a full self-understanding. More than simply acknowledging that inner other, we need to learn and incorporate it for ourselves, to grasp and reclaim consciously what previously belonged only blindly and implicitly to us. This calls for a personal discipline of cross-cultural study whose limits and rewards seem ever expanding but whose "trans-world" travel risks are far from negligible.

I know this from personal experience, since my own philosophical life has been structured by such a transcultural quest for self-realization, long before I ever thought of it as such. If leaving my native American home to settle in Israel at the age of sixteen gave me a much deeper realization of my Jewish identity through a life of work, study, and mili-

tary service in the Jewish state, it also deeply alienated me from the American culture that had formed me. My Israeli life paradoxically made it more difficult to reintegrate myself into the American Jewish community when I finally returned to the United States.[17] After being back for almost fifteen years, it is still hard to feel that I have entirely come home. Perhaps I never shall. Like most binationals, wherever I go (even if back to Israel), home has also been, will always have been, a very different place. Grateful for the enrichment of my Israeli experience, I am nonetheless sometimes saddened by the loss of an undiluted, unequivocal American identity, particularly when I think of how strongly I identify myself with American pragmatism.

But the same desire to deepen my identity by reclaiming a cultural other buried in myself led me to leave America again and make Berlin my home for eighteen months (whose experience shaped the urban aesthetics of Chapter 5). As a pragmatist philosopher, I recognized how deeply classical American pragmatism drew from German philosophical culture and how closely it relates to the work of the Frankfurt School. As a secular Jewish intellectual, I recognized how profoundly this cultural identity has been informed by German culture. Even my family name bears a German imprint, though I have no known German ancestors. While I long regarded German culture as not only foreign but hostile (hence never studied its language and literature), it had undeniably marked my identity in many ways, even in something as personal as my surname. To give these marks a clearer meaning I needed a fuller knowledge of the culture and language that left them; and knowing the limits of my skills in learning from books, I knew I had to transplant myself to Germany. If to know myself meant learning that culturally other, this in turn meant distancing myself, once again, from the things most dear to me in American life, including American philosophy. Of course, philosophy's quest for self-knowledge has never been perceived as effortless and trouble-free, even if its end is often seen as peace and tranquillity. But, for me in Germany, it was not always easy to distinguish between the healthy asceticism of philosophical self-improvement and the twisted psychological self-torture of pushing oneself beyond where one should go.

In the cosmic economy, our gains seem always to involve some loss. But my experience suggests that philosophers risk losing more by a stolid refusal to recognize and integrate the cultural other in ourselves. This plea for greater openness might be expanded to include the inte-

gration of personal experience and testimony as an "other" in academic philosophical discourse. Though the personal witness of the last two paragraphs makes me uncomfortable, I feel uneasy for stylistic rather than philosophical reasons, worried about the limits of good taste, not logical relevance. We cannot outlaw the use of autobiographical details here by arguing that they are contingent while philosophy should only concern the necessary. That argument may work for certain topics of philosophy but not for those that involve understanding our contingent selves. Even if banished on the level of explicit discourse, the personal will always motivate us beneath the surface. Why philosophize about our understanding of self and other, if not out of the personal experience of its inadequacies and the desire to improve our understanding not only in theory but in our own concrete practice?

genius and the paradox of self-styling

Genius only genius can explain.

WELSH PROVERB

I

Though principally discussed with a focus on the fine arts, the concept of style actually plays a far larger role in our lives. Guiding our choice of the clothes we wear, the food we eat, the environments we inhabit, the company we keep, style can likewise shape our ethical activity and efforts of self-realization. It thus informs what ancient philosophers considered the "most valuable of all arts, the art of living well." Affirming their message for modernity, Montaigne argued in his *Essays* that our most "glorious masterpiece is to live appropriately"; and his own artistic masterpiece of introspective exposition is indeed inseparable from his life.[1]

Montaigne's integration of life and literature was peculiarly intense and intimate. But on the reasonable premise that art is always somehow based on life, one could argue, more generally, that style in the fine arts must in some way depend on lifestyle, that one's style of life will somehow inform the style of one's artistic products. And this in no way negates the converse view that artworks influence our lives, which Plato famously argued in condemning art for corrupting morals. Ancients like Seneca do indeed insist that lifestyles—not only of the individual but of a society or a period—naturally find expression in corresponding literary styles.[2] And moderns like Hippolyte Taine or Pierre Bourdieu stress how an artwork's style is shaped by the stylistic disposition or *habitus* of the author, which is shaped in turn by the wider conditions of the contemporary social milieu, including the specific structure and possible style options of the artistic field.

However, the dominant aesthetic of both antiquity and modernity follows the strategy of separating art from life that Aristotle first shrewdly deployed to disarm Plato's critique of art as ethical corruption. This wedge between art and life is subtly introduced by quite reasonably defining art as *poiesis* or making, and then sharply distinguishing making from real action or doing, as Aristotle does through his firm and famous *praxis/poiesis* distinction (for example, in *Nichomachean Ethics*, Book VI,

1140a1–1140b25). Praxis or action—the domain of life and ethics—depends, says Aristotle, on the agent's character and reciprocally affects it. Action's end is not merely in an external object but in the virtue of its agent, and one cannot separate the value of an act from the character of its agent to which the action in turn contributes. In contrast, the artwork is an external product of skilled making, whose character (or value) is independent of the maker's character and in turn has no reciprocal influence on that character. The maker of the beautiful can be ugly and vile in every way; for his character is in no way ennobled by his beautiful work.

This separation of the artwork from the artist's personality has deeply marked our aesthetic heritage. Reaffirmed in the twentieth century not only by Thomist philosophers like Jacques Maritain, it also formed the core of T. S. Eliot's avant-garde modernism. Eliot's famous "impersonal theory of poetry" (formulated in "Tradition and the Individual Talent" and other essays) influentially argued that the greater the poet, the greater the distance between the man who suffers and the artist who creates. New Criticism's doctrine of the intentional fallacy (that the text's meaning is not the author's) took this logic of separation still further, as did the more radical postmodern idea of the death of the author.[3]

But there is also an alternative tradition in aesthetics that affirms a greater unity of art and life, of making and doing. This book continues my previous efforts to revive this aesthetic tradition: not simply to recall its ancient message and later formulations in moderns like Montaigne, Nietzsche, Dewey, and Foucault, but also to promote its development through newer pragmatist directions. By legitimating an aesthetics of popular art together with an embodied ethics of self-styling, we could forge a wider, more democratic concept of art. If its master genre, the art of living, could be practiced by all, then beauty would express itself much more fully in moral integrity, political fairness, and social harmony—not just in works of art. If the shaping of life and character is not only the highest art but one which all can practice, then aesthetics should pay closer attention to the concept of self-styling.

In this chapter I explore a crucial nest of issues emerging from the very notion of personal style by examining their often puzzling expression in the theories of Emerson, Nietzsche, and Wittgenstein. Influential advocates of the art of living, these writers further insist that style in other artworks is an intimate outgrowth of the artist's fundamental

style of life or character. If the most fundamental issue of self-styling is "what is necessary for an individual to have style?," it immediately prompts further, more specific, questions: To what extent does individual style require singular genius or distinctive character; what in fact is meant by such genius or character; and how are they (and hence style) acquired?

In answering these questions, the theories of Emerson, Nietzsche, and Wittgenstein tangle us in a dark matrix of pregnant ambiguities and inspiring profundities which come to a head in a series of deeply fascinating paradoxes: that the power of individual style lies not in its individuality but in its more-than-individual force; that the secret of acquiring style is that we must be true to ourselves yet also transform ourselves into something different; that the genius of self-styling demands the patient discipline of perfectionist striving yet can come only by letting go, through leaps of self-abandon.

Before broaching these bewitching complexities, any discussion of style should, for clarity's sake, heed the familiar distinction between the generic or taxonomic concept of style and the concept of individual style. In an obvious but perhaps trivial sense, if an individual displays some taxonomic style concept (for example, if she lives in a Stoic or Epicurean style, paints in a baroque style, writes in a seventeenth-century style, dresses in a *petit tailleur* Chanel style), then she exhibits some style. But when we say that an individual has style we mean something more, something much more specific or personal that serves to distinguish the artist from others with whom she may share a general style, something that serves, like a "signature," to single her out as individual. In this sense, exhibiting some general, taxonomic style concept is not a sufficient condition for having style. Nor does it seem to be a necessary condition. We can easily imagine saying of an innovative writer that no traditional taxonomic style concept can fit her particular style and yet, perhaps for that very reason, her style is strong and distinctive.[4] Nonetheless, though neither necessary nor sufficient, taxonomic categories of style may be useful in characterizing an individual's style.

II

What then is needed for an individual to have style? In explaining the sources of individual style, deep thinkers like Emerson, Nietzsche, and

Wittgenstein have often invoked two other concepts: genius and character. Etymologically, character and style are intimately linked: both concepts derive from the arts of engraving and writing, initially denoting pointed implements for carving a distinct sign or mark on a flat surface. One's style or character thus bears the sense of a special imprint engraved on the self. As for the notion of genius, in deriving from the Latin and Greek words (*gignĕre* and γίγνεσθαι) for begetting and being born, it suggests a natural distinction or native-born endowment of the self.

However, the ultimate roots of genius go deeper and further back—to the supernatural, to the Greek notion of *daimon* (δαίμων or δαιμόνιον) denoting "a tutelary god or attendant spirit allotted to every person at his birth, to govern his fortunes and determine his character."[5] "The ancients," as Emerson remarked, "held that a genius or good Daemon presided over every man, leading him, whenever he suffered himself to be led, into good and successful courses; that this genius might even in some cases be preternaturally heard and seen;—when seen, appearing as a star immediately above the head and attached to the head of the person whom it guided." Such a "guardian genius" was, however, more often made manifest only to its human subject as a still, small voice; and so it was with the ancient world's most famous *daimon*, that of Socrates.[6]

Later such guiding, guardian spirits were reinterpreted by a vigilant, jealously monotheistic Church as evil demons. But the old meaning of genius as a personal, quasi-divine spirit to guide or govern the individual was nonetheless retained in our modern concept of genius, though typically absorbed into the inner character of man. We see this not only in Emerson's and Goethe's views on genius and *das Dämonische*, but even in the far less theological Nietzsche, who warns of the utter loss of not heeding the guiding call of one's genius: "There exists no more repulsive and desolate creature than the man who has evaded his genius and now looks furtively to left and right, behind him and all about him." Our singular guardian genius is transfigured from a uniquely personalized external deity to an individualized inherent spirit, but Nietzsche still talks as if it were sometimes outerly visible: "Each of us bears a productive uniqueness within him as the core of his being; and when he becomes aware of it, there appears around him a strange penumbra which is the mark of his singularity." So conceived, genius is also a distinctive

mark (like a style or character) engraved on the individual by a power-ful spirit whether from without or within. "Man's character is his genius [*daimon*]," declared the ancient Heraclitus, while in our day Wittgenstein affirmed the same deep link in conversely claiming "the measure of ge-nius is character."[7]

Besides their ancient etymology, the concepts of character, style, and genius share a systematic ambiguity between neutral and honorific meaning. In the simple sense that everyone has a particular personality or manner of doing things that is characteristic of the individual and somehow (even if only very slightly) different from the personality or manner of others, then *everyone* has a character or style of some sort— even if it is a weak or dull character or a banal, awkward, or tasteless style. But that is not what is normatively meant or praised as having character or style. Something more positive and compelling is needed than just a personal way of being or doing. The same goes for genius, whose plain meaning denotes a person's "characteristic disposition," "inclination," or "natural aptitude, coupled with . . . inclination," but whose honorific sense entails "native intellectual power of an exalted type" or "extraordinary capacity for imaginative creation, original thought, invention or discovery." In the former sense, Samuel Johnson could claim "every man has his genius"; but by the latter meaning (which did not exist when Johnson compiled his famous dictionary of 1755), only a select elite could have true genius. In this sublime, romantic sense, genius is exalted in contrast to mere natural talent rather than simply identified with it.[8]

But what, then, differentiates genius, style, and character in the hon-orific sense of real distinction? Mere singularity is not enough, nor even rule-breaking deviance. For then any oddity could count as style, any monstrosity be claimed as character, and any eccentricity masquerade as genius. Such confusions were dangerously common, Goethe com-plained, making it seem "an easy thing to be a genius" since "any absurd undertaking without aim or use" could meet the oddball criterion. Willful perversity and rule breaking could thus be freely promoted in the name of genius. To avoid such abuses, Kant took pains to define ge-nius as the special "innate mental aptitude (*ingenium*) through which na-ture gives the rule to art." Since these rules demand an originality that cannot be formulated in scientific terms, they derive from natural gifts not mere learning (and here Kant alludes to their inspirational source in

"the peculiar guardian and guiding spirit given to man at his birth"). On the other hand, "since there may also be original nonsense," genius must be distinguished by its standard-setting role as a model of success for emulation or a "rule of estimating."[9]

This exemplarity is what gives style, character, or genius their honorific force. But how can it be guaranteed by mere nature any more than by mere singularity? For there exists also nonsense and monstrosity in nature which cannot function as a rule for emulation. Emerson's solution was to ground the normativity of genius still more deeply in truth, in the spiritual truth that forms the underlying, unifying soul of surface nature's manifold. "Genius," writes Emerson, "is the spontaneous perception and exhibition of truth. Its object is Truth. They err who think Genius converses with fancies and phantoms; has anything in it fantastic and unreal. Genius is the truest soul." And its truth is of the spirit: "not truth of facts, of figures, dates, measures,—which is a poor, low, sensual truth,—but Ideal truth." Emerson was not alone in grounding genius in veracity. Goethe, even while acknowledging the mysterious *Dämonische*, insisted that "the first and last thing required of Genius is the love of truth."[10]

But truth provides its own paradoxes. For aren't lying and deception, as Nietzsche suggests, part of the deepest truth of nature, especially human nature? In a world that "is false, cruel, contradictory, seductive, without meaning," "*we have need of lies* . . . in order to *live*—That lies are necessary in order to live is itself part of the terrifying and questionable character of existence. . . . To solve it, man must be a liar by nature, he must be above all an artist." And aren't the greatest achievements of genius precisely the products of our "*genius in lying*"? Not only art but "metaphysics, religion, morality, science," all seem to stem from our natural and necessary will "to lie, to flight from 'truth,' to *negation* of 'truth.' This ability itself, thanks to which [man] violates reality by means of lies, this artistic ability of man *par excellence*—he has it in common with everything that is. He himself is after all a piece of reality, truth, nature: how should he not also be a piece of *genius in lying*!"[11] If genius rests on the pillars of truth and nature, these paradoxically lie, in turn, on lies.

Other puzzles arise in defining the distinctiveness of exalted genius through the all too capacious values of nature and truth. For all men partake of nature; and shouldn't the truth, in principle, be common to all? If genius implies special distinction, how can it avoid a snobbish elit-

ism? But if, to the contrary, it is truly common to all, how could genius retain its distinctive exemplary status? On the other hand, if individual genius rightly commands the status of model for others, must it not express a more-than-individual power? Rather than dodge this tangle of dilemmas, Emerson, a theorist of genius whom Dewey rightly dubbed "the philosopher of democracy," meets them head on by spiking his solution with yet another paradox: the distinctiveness of individual genius is but the deeper expression of what is most common.

Genius is exceptionally common in two related ways. Its prime function is to reveal the astonishing value, spirit, and divine dignity that lies hidden in the simple events and humble characters of ordinary life, to disclose the wondrous poetry of prosaic everyday existence. "We owe to genius always the same debt," wrote Emerson, "of lifting the curtain from the common, and showing us that divinities are sitting disguised in the seeming gang of gypsies and pedlers." Genius therefore succeeds best when, eschewing ostentatious display, it works from the most common materials and seeks "to clothe [its] fiery thought in simple words." "Genius and virtue, like diamonds, are best plain-set,—set in lead, set in poverty."[12]

But genius is also exceptionally common in being the most perfect expression of the common heart and soul of humankind. Even when it seems lonely in its higher vision, "Genius is always representative" and "communicative" of "the soul of the people." "The man of genius apprises us not of his wealth but of the commonwealth" (G, 81, 83). Genius commands authority neither by snobbish prestige nor marketing wizardry but through the spontaneous perception that "it is a larger imbibing of the common heart," a "profounder sympathy with human nature than ours."[13] And genius remains fresh to please all times and ages because of this commonality, "because that which is spontaneous is not local or individual but flows from that internal soul which is the soul of every man" (77). The same man who belittles and begrudges his neighbor's talent is happy to admire figures of true genius because "to speak somewhat paradoxically, they are more himself than he is. They hold of the Soul, as he also does, but they more." The expression of genius is "the voice of the Soul, of the Soul that made all men, uttered through a particular man; and so, as soon as it is apprehended, it is accepted as a voice proceeding from his own inmost self." "The essence of Genius," Emerson concludes, "is Spontaneity" (70).

That spontaneity which defines genius is shared by the admiring

beholder only because it first belongs to the individual who exercises genius or, to speak more precisely, is seized and exercised by it. For geniuses are not masters of genius, but its servants, envoys, or instruments. Its spontaneity bespeaks a more-than-human energy beneath the individual's conscious will and beyond his powers of control. Genius "is not a knack, a habit, a skill of practice, a working by a rule, nor any empirical skill whatever; it is not anything the man can handle and describe and communicate, can even do or not do, but always a power which overawes himself, always an enthusiasm not subject to his control, which takes him off his feet, draws him this way and that, and is the master, not the slave" (G, 70).[14]

This involuntary aspect of genius is affirmed by many thinkers, though in different ways, as when Nietzsche claims "Genius resides in instinct," in forces far deeper than human rationality and the individual's conscious control. Rather than locating these forces in Emerson's transcendent, theological notion of the Soul, Nietzsche paints a naturalistic picture of their involuntary, more-than-personal source of power. Geniuses "are explosives in which a tremendous force is stored up; their precondition is always, historically and physiologically, that for a long time much has been gathered, stored up, saved up, and conserved for them . . . , then any accidental stimulus suffices to summon into the world the genius," without any need for his consent. An overflowing of stored up energy, genius is an "involuntary fatality, no less than a river's flooding the land."[15] If genius is a power that lies beyond personal, conscious control, we find yet another fold in the paradox that individual genius expresses something more and other than the individual: "the thought most strictly his own is not his own," since he can neither control it nor fully explain its origin.[16]

Emerson makes the same sort of point about style, opposing its common definition as involving deliberate choice between different possibilities of expression. "A man's style is his intellectual Voice only in part under his control"; and like our voice, though we may try to change its characteristic pitch or mimic the speech of others, it will always reassert its distinctive tonality.[17] No arsenal of rhetorical gimmicks can disguise or transform it. "Use what language you will, you can never say anything but what you are"; and what you are, your character (which "is nature in the highest form") is an inimitable, impenetrable "force," "higher than intellect" and "above our wills," like the mysterious genius or dai-

mon alleged to determine character.[18] So one should never seek a distinctive style beyond one's genius, as Petrarch poetically insinuated long before Emerson.[19] If style is foiled by apish affectation and willful posturing, if it requires (because it essentially *is*) free and faithful self-expression, how should the individual seek to style herself?

III

"Trust thyself," Emerson boldly concludes, and you will attain not only a distinctive style but the distinction of true genius. "To believe your own thought, to believe that what is true for you in your private heart, is true for all men,—that is genius." Since nothing is more "sacred" than "the integrity of our own mind," the imitation of others is "suicide" for self and for style. Conformity to conventions and established dogma stifles style, obscures the self. "But do your [own] thing," says Emerson, "and I shall know you" (*SR*, 30, 31, 33, 35).

Inspired by Emerson, Nietzsche offers the same answer in urging the need "to give style to one's character—a great and rare art!" "Be your self!" he counsels. "Every style is good, which actually communicates one's inner state." Styling the self means giving it full and free expression. Conformity to the herd and their conventions is therefore deadly for style, which commands: "keep to one's own way," follow "the fundamental law of your own true self."[20] Wittgenstein likewise argues that style, since it is a matter not of mere technique but of "spirit," should be "freshly grown from deep within oneself." Confirming the link of style and character, he cites with approval the familiar French apothegm of Buffon, "Le style c'est l'homme même."[21]

But if style is simply self-expression, how can it get its normative aesthetic force as a great and difficult achievement, as (in Nietzsche's terms) "a great and rare art" (*GS*, 232)? For don't we all, inevitably, express ourselves, not only by conscious communicative acts but by our unreflective behavior—bodily posture, gait, and gestural mannerisms that also convey an individual's style? To respond by redefining style not as mere self-expression but as *original* self-expression will not evade the difficulty here; because Emerson, Nietzsche, and Wittgenstein likewise define originality in terms of faithful self-expression. "Originality," says Emerson, "is being, being oneself, and reporting accurately what we see and are" (*QO*, 438). As Wittgenstein explains, "the beginnings of any good originality are already there if you do not want to be something

you are not." "Someone who does not lie is already original enough. Because, after all, any originality worth wishing for could not be a sort of clever trick, or a personal peculiarity, be it as distinctive as you like" (*CV*, 60).

Certainly this view expresses fine sentiment, but is it really convincing? However much we appreciate honesty, this hardly seems enough for original style. Think of all the humble, honest, altogether conventional people who don't try to be something they're not, but who still— perhaps precisely for that reason—seem to us entirely unoriginal and without style. Of course, such people may have a personal style of speech or gesture in the neutral sense we identified, according to which everyone has a personal style or character of some sort, just as we all have our own personal pattern of fingerprints. But, however honest, this sort of style cannot be what we praise and strive for; it is as unexemplary as it is inevitable.

Claiming that the idea of original style as truth to oneself has already been "*much* better" presented by others (*CV*, 60), Wittgenstein does not offer arguments for it. But he reinforces the idea by also identifying original genius with being courageously true to one's character. Mere talent is not enough, genius requires that "character itself speaks out" (*sich ausspricht*), expressing the "whole person" (*ganzer Mensch*, *CV*, 65). It is Nietzsche who provides perhaps the clearest arguments to show why simply being oneself will amount to original style. But do they really explain how style's free expression of the self should at the same time be depicted as a difficult, demanding constraint imposed on the self, "the constraint of style" (*GS*, para. 290)? Or do they merely reflect the common confusion of neutral and normative meaning that style shares with character and genius?

Nietzsche's first strategy is bio-ontological. The originality of every individual is ontologically guaranteed, through the uniqueness of the unrepeatable combination of factors that produce him. "In his heart every man knows quite well that, being unique, he will be in the world only once and that no imaginable chance will for a second time gather together into a unity so strangely a variegated an assortment as he is" (*S*, 127). We may agree with the premise that everyone is in some way unique, that is, slightly different, say, in precise genetic makeup, physical features, fingerprints, and biographical data. But it doesn't follow that such uniqueness from trivial differences constitutes originality in a

normative, significant sense. If we are automatically, ontologically unique, why should original style be such an effort, why is it achieved by only a select few?

Nietzsche, however, refuses to dismiss certain dimensions or degrees of uniqueness as too trivial to be relevant for originality of style. Instead he argues (after Emerson) that originality seems so rare and difficult because we typically stifle our uniqueness, our "own true self" by timidly hiding behind society's "customs and opinions." True artists stand out by resisting such conventions so as to reveal "the law that every man is a unique miracle; they dare to show us man as he is, uniquely himself to every last movement of his muscles, more, that in being thus strictly consistent in uniqueness he is beautiful, and worth regarding, and in no way tedious" (S, 127, 129).

Nietzsche's rhetoric, like Emerson's, suggests a sharp dichotomy between the individual's unique "true self" and the external social customs that hide and stifle it. Yet such a dichotomy is clearly problematic, especially if we bring Nietzsche's ontological views into account. First, if we regard the self's uniqueness as the product of the vast and unrepeatable combination of factors that come together in constituting the self, why should we reject social factors and customs from this "variegated assortment" of factors? Individual styles of talking or walking do not simply diverge from, but are developed through, shared social practices of speech and bodily action. Not only language but even the precise style and patterns of our muscular movement are learned in a social context. Since the individual self, even in the expression of his individuality, is socially constituted, we cannot appeal to a "true self" wholly apart from and opposed to social customs and beliefs.

Moreover, Nietzsche's own metaphysics repudiates the very idea of an individual having his "own true self" that is fixed and autonomous, independent of the factors that impinge on it and inviolable to changing circumstances. The very notion of "things that have a constitution in themselves" is, he complains, "a dogmatic idea with which one must break absolutely." "In the actual world . . . everything is bound to and conditioned by everything else"; "no things remain but only dynamic quanta, in a relation of tension to all other dynamic quanta: their essence lies in their relation to all other quanta."[22] The self must therefore likewise be a changing construct from a variety of changing elements that are brought into a dynamic, developing, unity of tension. This idea of

the self, not as a fixed being but as a developing construct, is pithily captured in Nietzsche's injunction to "become what one is," just as it is prefigured in Emerson's dictum "the soul *becomes.*"[23]

IV

The doubling of the self to include not simply what one already is but, more importantly, what one can become is Nietzsche's second strategy for defending style as self-expression. It is crucial. For it makes the expression (indeed the very having) of self something much more than an automatic, already assured, natural given. Instead this becomes a difficult task and distinctive achievement. No longer an already attained presence, the self becomes a path of development toward a higher ideal, and what we normally call our present selves are but completed fractions of our developmental trajectory that opens toward a superior future.

Accordingly, the self's originality consists not of a fixed, ever present essence but of one's new, open-ended path of development toward higher self-achievement . "Each of us bears a productive uniqueness within him as the core of his being," but "a chain of toil and burdens is suspended from this uniqueness," and only by working our way through this developmental chain is originality achieved. "There exists in the world a single path along which no one can go except you: whither does it lead? Do not ask, go along it." The fundamental law of your own true self, "your true nature, lies not concealed deep within you, but immeasurably high above you" (*S*, 129, 143).

But now, distinctive self-stylization can hardly be captured by the ordinary sense of the demand to "be yourself." Self-stylization is original, distinctive, and demanding precisely because we must cease to be our ordinary selves so as to become our higher selves. This demand does not imply a return to one's original nature that has been stifled by culture. On the contrary, this project of self-perfection requires culture. Since one does not find the higher self already present in oneself, one must seek guidance toward constructing it. Examples of higher selves are therefore needed to inspire us and serve as models of emulation, though, of course, not of slavish aping. In this sense, Nietzsche lauds Schopenhauer as an "educator," as an inspiring model, since we can "profit from a philosopher only insofar as he can be an example" (*S*, 136).

Far from the free expression of the self's natural uniqueness, self-styling here involves "constraint," requiring not only the culture of models but the reworking and even the removing of the natural by art-

istry. One must "survey all the strengths and weaknesses of [one's] nature and then fit them into an artistic plan until every one of them appears as art and reason and even weaknesses delight the eye. Here a large mass of second nature has been added; there a piece of original nature has been removed—both times through long practice and daily work at it. Here the ugly that could not be removed is concealed; there it has been reinterpreted and made sublime" (GS, para. 290).

This advocacy of concealment shows how far we have moved from the view that originality means honest self-expression or simply being what one is. The idea of the higher, restyled self seems instead to demand that we disguise and transform what we are so as to become something better. How are we to resolve the apparent contradiction between these injunctions to be what we are and yet also to be what we are not but should strive to become? How do we reconcile the notion of original style as honest self-expression with that of artful self-transformation?

Such questions may seem irrelevant for thinkers like Emerson and Nietzsche; for don't they famously scorn the idea of *consistency*. Remember, however, that it is precisely their insistence on consistency of character or taste that allows them to be free about other (in their view, pettier) forms of consistency. For Emerson, "the integrity" of the individual mind from which action flows guarantees the higher consistency of behavior that may seem capricious and inconsistent. "Fear never but you shall be consistent in whatever variety of actions, so they be each honest and natural in their hour. For of one will the actions will be harmonious, however unlike they seem" (SR, 33, 38). Likewise with Nietzsche. Though he prides himself on his "many stylistic possibilities—the most multifarious art of style that has ever been at the disposal of one man," he insists it must be one art of style, one definitive voice and taste that shapes its diverse expression. In an artistically constructed character it must be "evident how the constraint of a single taste governed and formed everything large and small. Whether this taste was good or bad is less important than one might suppose, if only it was a single taste!" (EH, chap. 3, para. 4; GS, para. 290).[24]

Wittgenstein, who surely is very concerned about logical consistency, nonetheless seems entangled in the same ethical paradox of the double self, with its demand for both honest expression of what one is and of perfectionist striving to make oneself other and better. "Improve yourself," he would often say, "and you will improve the world."[25] "The fact that life is problematic shows that the shape of your life does not fit into

life's mould. So you must change the way you live" (*CV*, 27). Yet, how does one reconcile this ideal of ameliorative self-transformation with his already cited claim that "the beginnings of any good originality are already there if you do not want to be something you are not" (60)?

The most plausible solution, I believe, is to argue that one's attempts at artful self-transformation must begin with a clear recognition and true expression of what one already is. As Wittgenstein himself suggests, "A confession has to be a part of your new life"; for "a man will never be great if he misjudges himself" (*CV*, 18, 49). In short, one must build on one's already existing self—its talents, potential, most promising inclinations, but one must not rest content with them. One can only get to one's higher self through the starting point of one's present self. If one has no real talent for music but only for mathematics, one should seek one's higher self not as a musician but as a mathematician. However much one may admire a revolutionary life "at the edge," one may nonetheless feel that such a life would not suit one's talents and sensibilities. To paraphrase Samuel Johnson (who echoes the sentiments of Montaigne), such radical heroes (whether saints, stoics, or Nietzschean Supermen) should be admired but not imitated, at least not by most of us, whose tastes, talents and circumstances lie elsewhere.

The paradox of "how to become what one is"—of both being true to your self yet becoming another, higher self—could then be resolved by artfully transforming yourself in your own way in terms of your already existing givens and potential. Of course, this reasonable message sounds far less captivating than the paradoxical rhetoric in which Nietzsche envelops it. But it is nonetheless worthy of emphasis—and perhaps more powerfully achieves this emphasis precisely through the fascination of its paradoxical formulation.

One reason to insist on being oneself in transforming oneself is to guard against self-transformation into an already given, standardized model of the higher self. Heroes or esteemed life-models are always already present and influential in social life, and they can stifle new expression by their power of commanding conformist emulation. In advocating ameliorative self-transformation, Emerson, Nietzsche, and Wittgenstein therefore urge that one be oneself in the sense that there is no unique higher self that must be realized by everyone. There is no one style of life that all should adopt; more than one way of life, indeed countless ways, can fit what Wittgenstein calls "life's mould." This synthesis of meliorism with experimental, pluralist individualism expresses

the pragmatist spirit. So does the respect (too often absent in Nietz-sche) for the simpler, ordinary ways we live, coupled nonetheless with a desire to live better.[26]

V

Meliorist notions of style and genius raise one more paradox to unravel. Even when defined in terms of character, style remains (in Nietzsche's words) "a great and rare art" which demands "long practice and daily work at it." Likewise is genius known to rely on prodigious power of will, courage, and patient industry, to require (in Thomas Edison's thermodynamic terms) heavy perspiration more than giddy inspiration. Genius, for Wittgenstein, depends on character's strength of will and persevering courage, since the hurdles it must overcome are "not a dif-ficulty of intellect, but of will." "Courage, not cleverness; not even in-spiration . . . is the grain of mustard that grows into a great tree." "Ge-nius *is talent exercised with courage*." "*Courage* is always original" (*CV*, 17, 36, 38). Emerson and Nietzsche likewise insist on this courageous will for strenuous striving in their perfectionist pursuit of self-styling self-fulfillment.

Notorious for preaching the virtue of selfishness, Nietzsche insists that greatness calls for "resolute" strength of will, not only the "patience" to strive and "to suffer" in self-styling, but "the will to *inflict* great suf-fering"; a "persevering" resolve to ignore the distractions of others so as "to keep to one's own way" in pursuit of self-styling's "goal"—"*to become those we are*," selves "who are new, unique, incomparable, who give themselves laws, who create themselves" (*GS*, para. 283, 290, 325, 335, 338). In advocating self-perfecting "self-reliance," Emerson simi-larly urges an energetic "arduous" striving, a will to pursue one's path and renounce the claims and conventions of others. A man must "trust himself for a task-master" and keep "faithful his will" with "courage and constancy" in order to realize his genius, achieve the fulfillment of "self-culture" (*SR*, 35, 46, 47, 51). He must renounce the seductions of soci-ety, even the natural ties of family when they distract his concentration in "the continual effort to raise himself above himself, to work a pitch above his last height." "Genius," writes Emerson, "is the power to labor better and more availably."[27]

But for all this trumpeting of willed effort and self-motivated striving, have we not heard the tones of spontaneous, involuntary self-abandon reverberating just as strong? Rather than self-regarding, the genius, says

Nietzsche, "squanders himself, that is his greatness. The instinct of self-preservation is suspended." To grow toward greatness and create one-self means to "*live dangerously*" and "lose oneself occasionally, if one wants to learn something from things different from oneself," and thus enrich oneself.[28] "There can be no greatness without abandonment," echoes Emerson. The highest circle of Soul to which our efforts of self-culture reach is precisely "to forget ourselves, to be surprised out of our propriety, . . . to do something without knowing how or why," to be infused and overcome by the spirit of genius as to become its instrument.[29] So genius then means surrendering personal will, pride, and ego to something higher than the self, something that nonetheless gives the self its true distinction beyond any selfish peculiarity.

"Is what I am doing really worth the effort?" asks Wittgenstein, who immediately replies, "Yes, but only if a light shines on it from above. And if that happens—why should I concern myself that the fruits of my labours should not be stolen?" (*CV*, 57–58). For the value of genius goes beyond the petty claims of personal property and ego pride. Empowered by that genial "light from above," one needs no striving will or calculating consciousness. Spontaneity rules; mechanical tools are transformed into inspired instruments of our thinking, as we have become the thinking instruments of a deeper force. "I really do think with my pen," wrote Wittgenstein, "because my head often knows nothing about what my hand is writing" (17).

How do we reconcile the paradox that we must push and discipline ourselves for genius but still need to "let go" and abandon ourselves to finally achieve it? How can genius and style be recommended to the individual as a project of hard work and courageous will, when they are also celebrated as the spontaneous expression of forces beyond the self's willed efforts and power? Spontaneous nature and intentional striving may seem inconsistent, but when coordinated through integrated stages into a higher harmony of action, together they yield the most powerful results. The trick, it seems, is to direct our earnest efforts to the point where spontaneous, involuntary, more-than-personal forces can fruitfully be brought in play.

If this sounds like an empty mantra of mystic hope, it can be demonstrated by the most natural, most mundane phenomena of successful action. "We do not grind corn or lift the loom by our own strength," writes Emerson, "but we build a mill in such position as to set the north wind to play upon our instrument." And the same goes for hand labor;

"we do few things by muscular force, but we place ourselves in such attitudes as to bring the force of gravity, that is, the weight of the planet, to bear upon the spade or the axe we wield." In short, "we seek not to use our own, but to bring a quite infinite force to bear."[30] Yet all our wit, force, and striving may be needed to put ourselves in that pivotal position. Wittgenstein brings this point more clearly home to genius by redeploying its image of creatively potent light. "There is no more light in a genius than in any other honest man—but he has a particular kind of lens to concentrate this light into a burning point" (*CV*, 35).

Elaborating this image in accord with the pluralism embraced by these thinkers, we might also enrich it with a gender inflection typically absent from their prose. To bring one's light to catch the spark of style and make it blaze into genius, each person must reckon with her own color and thickness of lens, her own object and range of focus, her own tilt of terrain, her own azimuth toward the sun. Here is a task for both careful industry and dangerous abandon, for intently pushing on to the limit, and going still further by then letting go. But everyone must find—through trial, courage, honesty—her own proper, changing balance of these elements. And so we close with one last paradox: as with other alleged sublimities, the final formula for genius and style lies in the unformulable details of actual practice.

notes

AESTHETIC RENEWAL FOR THE ENDS OF ART:
AN OVERTURE

1. See G. W. F. Hegel, *Introductory Lectures on Aesthetics* (London: Penguin, 1993), 12–13.

2. See Walter Benjamin, *Illuminations* (New York: Schocken, 1969), especially the essays "The Storyteller" and "The Work of Art in the Age of Mechanical Reproduction"; the quotation is from 222; Gianni Vattimo, *The End of Modernity* (Baltimore: Johns Hopkins University Press, 1988), 52; and Arthur Danto, "The End of Art," in *The Philosophical Disenfranchisement of Art* (New York: Columbia University Press, 1984), and *After the End of Art* (Princeton: Princeton University Press, 1997).

3. I critically analyze this claim in *Pragmatist Aesthetics: Living Beauty, Rethinking Art* (Oxford: Blackwell, 1992), 2d ed. (New York: Rowman & Littlefield, 2000), 47–49; hereafter cited as *PA*.

4. I characterize this crucial attitude as pragmatism's "disjunctive stance" and argue for it in more detail in "Introduction to the Second Edition," *PA*, x–xiii.

5. For more detailed argument of these themes, see *PA* and Chapter 1 of this book, "The End of Aesthetic Experience."

6. The quotation is from Dwight Macdonald, "A Theory of Mass Culture," in B. Rosenberg and D. White, eds., *Mass Culture: The Popular Arts in America* (Glencoe, Ill.: Free Press, 1957), 69. Macdonald uses the pejorative term "Mass Culture" rather than "popular art," which I have substituted for the former in the brackets of this quote.

7. A *Boston Book Review* critic (June 1997, 24–25) attacked me for demanding more embodiment in philosophy than Stanley Cavell's recognition of the need to know "what comfort and discomfort in sitting are" in knowing "what it means 'to sit in a chair.'" This notion of embodied philosophy as armchair reading comfort shows how incredibly weak, stodgy, and reading-oriented is philosophy's current sense of the somatic. A critic in the *Frankfurter Allgemeine Zeitung* (November 28, 1996, 10) shows the same impoverished (and reading-fixated) vision of somatic philosophy when he lampooned my idea of somaesthetics by imagining that it must be "something like self-flagellation while reading Kant, mountain climbing while reading Nietzsche, and breathing exercises while reading Heidegger."

CHAPTER 1. THE END OF AESTHETIC EXPERIENCE

1. One reason for my interest in this concept is its important role in my pragmatist aesthetics. See Richard Shusterman, *Pragmatist Aesthetics* (Oxford: Blackwell, 1992), 2d ed. (New York: Rowman & Littlefield, 2000), especially chap. 2.

2. I also see Joseph Margolis and Richard Rorty as major figures in the aesthetic tradition that shapes my work, but their theories are not so central to the topic of this chapter.

3. See Arthur Danto, *The Philosophical Disenfranchisement of Art* (New York: Columbia University Press, 1986), 13; hereafter cited as *PD*. I shall also be using the following abbreviations in referring to other works of Danto, Beardsley, Dewey, and Goodman: Arthur Danto, *The Transfiguration of the Commonplace* (Cambridge: Harvard University Press, 1981): *TC*; Monroe C. Beardsley, *Aesthetics: Problems in the Philosophy of Criticism* (New York: Harcourt Brace, 1958): *A*; Beardsley, *The Aesthetic Point of View* (Ithaca: Cornell University Press, 1982): *APV*; John Dewey, *Art as Experience* (Carbondale: Southern Illinois University Press, 1987): *AE*; Nelson Goodman, *Languages of Art* (Oxford: Oxford University Press, 1968): *LA*; Goodman, *Ways of Worldmaking* (Indianapolis: Hackett, 1978): *WW*; and Goodman, *Of Mind and Other Matters* (Cambridge: Harvard University Press, 1984): *OMM*.

4. See, for example, the account by the renowned Polish historian of aesthetics W. Tatarkiewicz in his *A History of Six Ideas* (The Hague: Nijhoff, 1980), 310–338.

5. See David Hume, "Of the Standard of Taste," in *Essays Moral, Political, and Literary* (Oxford: Oxford University Press, 1963), 234; and Immanuel Kant, *The Critique of Judgement* (Oxford: Oxford University Press, 1957), 41–42.

6. See George Dickie, "Beardsley's Phantom Aesthetic Experience," *Journal of Philosophy* 62 (1965): 129–136. Eddy Zemach also argues that there is no such thing as the aesthetic experience in his (Hebrew) book, *Aesthetics* (Tel Aviv: Tel Aviv University Press, 1976), 42–53.

7. Theodor Adorno, *Aesthetic Theory* (London: Routledge, 1984), 474, 476; hereafter cited as *AT*.

8. Though he advocates *Erfahrung* over *Erlebnis*, Benjamin is critical of the neo-Kantian and positivist notion of *Erfahrung* as being too narrowly rationalistic and thin. My compressed account of Benjamin is based on his essays "The Storyteller," "On Some Motifs in Baudelaire," and "The Work of Art in the Age of Mechanical Reproduction." All these texts are found in Walter Benjamin, *Illuminations* (New York: Schocken, 1968). Fuller discussions of Benjamin's theme of experience can be found in Richard Wolin, *Walter Benjamin: An Aesthetic of Redemption* (New York: Columbia University Press, 1982), and in Martin Jay,

"Experience without a Subject: Walter Benjamin and the Novel," *New Formations* 20 (1993): 145–155.

9. Challenging the idea that art is something for detached, immediate "appreciation and enjoyment," Heidegger insists that "art is by nature . . . a distinctive way in which truth comes into being, that is, becomes historical." It therefore cannot be separated from the world of its truth-disclosure simply for the narrow goal of experienced pleasure. In this sense, Heidegger warns, "perhaps experience is the element in which art dies." See Martin Heidegger, "The Origin of the Work of Art," in *Poetry, Language, Thought* (New York: Harper & Row, 1975), 78, 79.

10. Hans-Georg Gadamer, *Truth and Method* (New York: Crossroad, 1982), 86–87; hereafter cited as *TM*.

11. In highlighting the cognitive dimension of aesthetic experience, Gadamer writes: "What one experiences in a work of art and what one is directed towards is rather how true it is, i.e., to what extent one knows and recognizes something and oneself." The joy of aesthetic experience "is the joy of knowledge" (*TM*, 101, 102).

12. See Pierre Bourdieu, "The Historical Genesis of a Pure Aesthetic," in Richard Shusterman, ed., *Analytic Aesthetics* (Oxford: Blackwell, 1989), 147–160; the citations are from 148, 150.

13. For more detailed argument of this point, see "Beneath Interpretation," Chapter 6 of this book. I develop the arguments further in *Sous l'interprétation* (Paris: L'éclat, 1994), and *Practicing Philosophy: Pragmatism and the Philosophical Life* (New York: Routledge, 1997).

14. Dewey thus sees aesthetic experience as central not only to art but to the philosophy of experience in general. "To esthetic experience," he therefore claims, "the philosopher must go to understand what experience is" (*AE*, 11).

15. Although I think this is obvious, there is an argument that denies it, asserting that our appreciation of natural beauty is entirely dependent on and constrained by our modern concept of fine art, as indeed is all our aesthetic experience. For a critique of this argument and a fuller discussion of Dewey's views, see *Pragmatist Aesthetics*, chaps. 1 and 2.

16. As Dewey later adds, "The experience is marked by a greater inclusiveness of all psychological factors than occurs in ordinary experiences, not by reduction of them to a single response" (*AE*, 259).

17. Even if we could effect this reclassification, Dewey's definition of art as aesthetic experience would remain problematic. One problem is that this experience is itself never clearly defined by Dewey, but instead asserted to be ultimately indefinable because of its essential immediacy; "it can," he says, "only be felt, that is, immediately experienced" (*AE*, 196). For more detailed cri-

tique of Dewey's definition of art as experience, see *Pragmatist Aesthetics*, chaps. 1 and 2.

18. Beardsley's precise list of defining characteristics of aesthetic experience changes slightly over the years, but almost all his accounts insist on the features I mention. Apart from his book *Aesthetics*, his most detailed treatments of aesthetic experience can be found in "Aesthetic Experience Regained" and "Aesthetic Experience" (reprinted in *APV*, 77–92, 285–297).

19. See Dickie's "Beardsley's Phantom Aesthetic Experience" and his *Art and the Aesthetic: An Institutional Analysis* (Ithaca: Cornell University Press, 1974).

20. Beardsley himself cites Maslow's psychological research into peak experiences (*APV*, 85). See A. H. Maslow, *Toward a Psychology of Being* (Princeton: Princeton University Press, 1962). Use of the notion of experience, and its characterization in terms of coherence and intensity, are also found in more contemporary experimental psychology. For one example, see the influential work of Daniel Stern, *The Interpersonal World of the Infant* (New York: Basic Books, 1985).

21. For a vigorous defense of the centrality of consciousness, see John Searle, *The Rediscovery of the Mind* (Cambridge: MIT Press, 1992). More specifically, I defend the notion of immediate experience against charges that it is cognitively empty and entails commitment to foundationalism's myth of the given; see Richard Shusterman, *Practicing Philosophy*, chap. 6.

22. See Joel Kupperman, "Art and Aesthetic Experience," *The British Journal of Aesthetics* 15 (1975), and Beardsley's response in *APV*, 296.

23. There is also the problem that aesthetic experience in itself is too elusive, ineffable, subjectively variable, and immeasurable in magnitude to provide sufficient grounds for justifying particular evaluative verdicts. Thus, when it came to actual critical practice, Beardsley recognized that one had to demonstrate the unity, complexity, and intensity of the actual work, not of its experience. However, he held that demonstration of the former could allow inference of capacity for the latter, and it was the latter (i.e., experience) that constituted actual aesthetic value.

24. Since these characteristics make no reference to phenomenological consciousness, Goodman's concept of aesthetic experience can be characterized as semantic rather than phenomenological. Like Dewey and Beardsley, Goodman insists on the dynamic nature of aesthetic experience, but he does not emphasize, as they do, the passive aspect in which one surrenders oneself to the work. This idea may be too suggestive of subjectivity and affect for Goodman. But the etymology of "experience" does suggest the peril of undergoing something, and it is perhaps not too fanciful to note that some notion of submission is even hinted at by the "under" in the word "understanding." For more on this, see note 29.

25. T. S. Eliot, "The Frontiers of Poetry," in *Of Poetry and Poets* (London: Faber, 1957), 115. Eliot adds that this means "enjoying it to the right degree and in the right way, relative to other poems. . . . It should hardly be necessary to add that this implies one *shouldn't* enjoy bad poems—unless their badness is of a sort that appeals to our sense of humour." For a detailed account of Eliot's theory of literary understanding, see Richard Shusterman, *T. S. Eliot and the Philosophy of Criticism* (New York: Columbia University Press, 1988), chaps. 5 and 6.

26. A growing number of sociobiologists further maintain that the gratifications of aesthetic experience not only explain art's emergence and staying power but also help account for the survival of humanity itself. Such experiences, says the Oxford anatomist J. Z. Young, "have the most central of biological functions—of insisting that life be worthwhile, which, after all, is the final guarantee of its continuance." J. Z. Young, *An Introduction to the Study of Man* (Oxford: Oxford University Press, 1971), 38. A more recent and detailed case for the evolutionary value of art and its affective experience can be found in Ellen Dissanayake, *Homo Aestheticus: Where Art Comes From and Why* (New York: Free Press, 1992). See also Nathan Kogan, "Aesthetics and Its Origins: Some Psychobiological and Evolutionary Considerations," *Social Research* 61 (1994): 139–165.

27. The idea that aesthetic experience fails miserably at formally defining art's extension but nonetheless is essential for understanding art's point and value is developed in more detail in my *Pragmatist Aesthetics*, chaps. 1 and 2. I emphasize there (and the point bears repeating) that art's valuable uses go far beyond the creation of aesthetic experience. I should also note that Richard Wollheim draws a somewhat similar distinction between a concept's "conditions of application" and its background "assumptions of applicability" in "Danto's Gallery of Indiscernibles," in Mark Rollins, ed., *Danto and His Critics* (Oxford: Blackwell, 1993), 28–38.

28. See "Painting by Numbers: The Search for a People's Art," in *The Nation*, March 14, 1994, 334–348, particularly questions 68 and 70, which relate to art's coherence and ability to "make us happy."

29. These values include not only heightened, positive affect but an enhanced appreciation of the nonconceptual and the sensual. Another possible value of aesthetic experience comes from its making us aware, through its power to transport us, of the benefits that can be derived by opening or submitting oneself to things typically seen as mere objects of our domination and use. This holds, of course, as much for the experience of nature as well as art, and it expresses the transformational role of experience in which, as Dewey insisted, we are subjects as well as agents, undergoing as well as acting. Heidegger makes a similar point: "To undergo an experience of something . . . means

that this something befalls us, strikes us, comes over us, overwhelms and transforms us." Martin Heidegger, *On the Way to Language* (New York: Harper & Row, 1971), 57.

30. Fredric Jameson, *Postmodernism, or the Cultural Logic of Late Capitalism* (Durham, N.C.: Duke University Press, 1991), 10–16. For a specific study of the problematics of embodied, affective aesthetic experience and the new media, see Richard Shusterman, "Soma und Medien," *Kunstforum International* 132 (1996): 210–215, and Chapter 8 of this book.

31. See Philip K. Dick, *Blade Runner* (originally, *Do Androids Dream of Electric Sheep?*) (New York: Ballantine, 1982).

32. Ludwig Wittgenstein, *Philosophical Investigations* (Oxford: Blackwell, 1956), sec. 127.

33. For a provocative critique of the arguments of this chapter, and particularly of my concern for pleasure, see Alexander Nehamas, "Richard Shusterman on Pleasure and Aesthetic Experience," *Journal of Aesthetics and Art Criticism* 56 (1998): 49–51; and Wolfgang Welsch, "Rettung Durch Halbierung? Zu Richard Shustermans Rehabilitierung ästhetischer Erfahrung," *Deutsche Zeitschrift für Philosophie* 47 (1999): 111–126. I reply to their critique in "Interpretation, Pleasure, and Value in Aesthetic Experience," *Journal of Aesthetics and Art Criticism* 56 (1998): 51–53; and "Provokation und Erinnerung," *Deutsche Zeitschrift für Philosophie* 47 (1999): 127–137.

CHAPTER 2. DON'T BELIEVE THE HYPE

1. See, for example, Mikhail Bakhtin, *Rabelais and His World* (Bloomington: Indiana University Press, 1984), and Antonio Gramsci, *Selections from Cultural Writings* (Cambridge: Harvard University Press, 1991).

2. The term "popular" has a much more positive connotation, while "mass" suggests an undifferentiated and typically inhuman aggregate. For more on this terminological debate, see Herbert J. Gans, *Popular Culture and High Culture: An Analysis and Evaluation of Taste* (New York: Basic Books, 1974), 10. In *Pragmatist Aesthetics: Living Beauty, Rethinking Art* (Oxford: Blackwell, 1992), 2d ed. (Rowman & Littlefield, 2000), I clearly show my preference for the term "popular art," not only because of its more positive connotations but because the term "mass" veils the complexities of the popular art audience. Nonetheless, Noel Carroll, who proposes a value-neutral definition of *mass* art, feels comfortable in enlisting my arguments to defend such art. For Carroll's interesting theory of mass art (which he defines essentially in terms of maximal reproducibility and accessibility of immediate understanding), see Noel Carroll, *A Philosophy of Mass Art* (New York: Oxford University Press, 1998), and also my critical review of it in *Metaphilosophy* 30 (1999): 251–255.

3. See Lawrence W. Levine, *Highbrow/Lowbrow: The Emergence of Cultural Hierarchy in America* (Cambridge: Harvard University Press, 1988).

4. Since the most bitter and damaging indictments of popular art are directed not at its aesthetic content but at its pernicious sociocultural and political influence, one might object that an aesthetic defense could do very little indeed to legitimate popular art. The objection can be met by showing that the extra-aesthetic dangers of popular art are directly linked to and largely dependent on its presumed aesthetic faults. For a detailed demonstration, see Shusterman, *Pragmatist Aesthetics*, 173–177. This, however, is not a formalist reduction of the sociopolitical to the aesthetic, since aesthetic taste, as a cultural product, is itself socially and politically inflected.

5. Dwight Macdonald, "A Theory of Mass Culture," in Bernard Rosenberg and David M. White, eds., *Mass Culture: The Popular Arts in America* (Glencoe, Ill.: Free Press, 1957), 69.

6. Leo Lowenthal, "Historical Perspectives of Popular Culture," in Rosenberg and White, *Mass Culture*, 51; and Clement Greenberg, "Avant-Garde and Kitsch," in ibid., 102.

7. See Theodor Adorno, *Minima Moralia* (London: Verso, 1978), 202; and *Aesthetic Theory* (London: Routledge & Kegan Paul, 1984), 340; hereafter cited as *AT*.

8. Bernard Rosenberg, "Mass Culture in America," in Rosenberg and White, *Mass Culture*; and Ernest Van den Haag, "Of Happiness and of Despair We Have No Measure," in ibid., 533–534.

9. See van den Haag, "Of Happiness and of Despair," 533–534.

10. See Allan Bloom, *The Closing of the American Mind* (New York: Simon and Schuster, 1987), 76, 79.

11. The citations are respectively from van den Haag, "Of Happiness and of Despair," 534; and Rosenberg, "Mass Culture in America," 9–10.

12. See Bernard Bosanquet, *Three Lectures on Aesthetics* (Indianapolis: Bobbs-Merrill, 1963), 6, who tells us that aesthetic pleasure "does not of itself pass into satiety," just as aesthetic desire is not something "which ceases in proportion as it is gratified." Dewey, of course, purveys the same message that aesthetic experience at once satisfies and stimulates.

13. T. W. Adorno, "On the Fetish Character in Music and the Regression of Listening," in Andrew Arato and Eike Gebhardt, eds., *The Essential Frankfurt School Reader* (New York: Continuum, 1987), 292. The same fundamental argument of coercive conditioning is given by Dwight Macdonald in "Mass Cult and Midcult," in his *Against the American Grain* (New York: Random House, 1962), 9–10; and by Donald Lazere's "Media and Manipulation," in Lazere, ed., *American Media and Mass Culture: Left Perspectives* (Berkeley: University of California Press, 1987), 31.

14. See van den Haag, "Of Happiness and of Despair," 533, 534; and Bloom, *Closing of the American Mind*, 77, 80.

15. Van den Haag, "Of Happiness and of Despair," 536.

16. The quotations for the first point come from Rosenberg, "Mass Culture in America," 9; for the second, from van den Haag, "Of Happiness and of Despair," 534.

17. See Pierre Bourdieu, *Distinction: A Social Critique of the Judgement of Taste* (Cambridge: Harvard University Press, 1984), 386; hereafter cited as *D*.

18. Adorno, for example, argues that works of popular music "do not permit concentrated listening without becoming unbearable to the listeners," *Essential Frankfurt*, 288. See Rosenberg, "Mass Culture in America," 5; Macdonald, "Theory of Mass Culture," 60; and Gilbert Seldes, "The People and the Arts," in Rosenberg and White, *Mass Culture*, 85.

19. Max Horkheimer and T. W. Adorno, *Dialectic of Enlightenment* (New York: Continuum, 1986), 137.

20. John Dewey, *Art as Experience* (1934; Carbondale: Southern Illinois University Press, 1987), 162. This is not to deny that rock is often consumed in a rather passive immobility, and its increased television and video consumption may strengthen this tendency.

21. The African word, from the Ki-Kongo language, is *lu-fuki*. See Robert Farris Thompson, *Flash of the Spirit* (New York: Vintage, 1984), 104–105; and Michael Ventura, *Shadow Dancing in the U.S.A.* (Los Angeles: Tarcher, 1986), 106. This African source contrasts with a possible English deviation from "funk"—a slang term denoting "to smoke or shake with fear." For more details on these matters, see *Pragmatist Aesthetics*, 316.

22. The quotations are from Bloom, *Closing of the American Mind*, 71,73; and Mark Crispin Miller, *Boxed In: The Culture of TV* (Evanston, Ill.: Northwestern University Press, 1989), 175, 181. James Miller's much more thorough, nuanced, and informed history of rock music ends with similar and sadly one-sided conclusions. Rock "has become the Muzak of the Millennium" and marks "the triumph of the psychopathic adolescent." James Miller, *Flowers in the Dustbin: The Rise of Rock and Roll, 1947–1977* (New York: Simon and Schuster, 1999), 349, 352.

23. See Harry Broudy, *Enlightened Cherishing: An Essay on Aesthetic Education* (Urbana, Ill: University of Illinois Press, 1972), 11; and van den Haag, "Of Happiness and of Despair," 533, 536.

24. James T. Farrell, quoted in Seldes, "People and the Arts," 81.

25. Macdonald, "Theory of Mass Culture," in Rosenberg and White, *Mass Culture*, 72.

26. Van den Haag, "Of Happiness and of Despair," 516–517.

27. See, for example, the studies on *Dallas* and *Dynasty* discussed in John Fiske, *Television Culture* (London: Methuen, 1987).

28. Pierre Bourdieu, "The Production of Belief," in R. Collins et al., *Media, Culture, and Society: A Critical Reader* (London: Sage, 1986), 154–155.

29. From Bruce Springsteen's "Spare Parts." Finally, apart from these logical fallacies, van den Haag's argument has a questionable empirical basis. If we look at the history of high art before its romantic and modernist phase, we do not find that experiential novelty and difficulty of comprehension were necessary conditions of aesthetic legitimacy.

30. The citations here are from Broudy, *Enlightened Cherishing*, 111; and Gans, *Popular Culture and High Culture*, 77.

31. See Horkheimer and Adorno, *Dialectic of Enlightenment*, 121.

32. See T. W. Adorno, "Television and the Patterns of Mass Culture," in Rosenberg and White, *Mass Culture*, 79.

33. See Fiske, *Television Culture*, 84, 94.

34. Cited in Ventura, *Shadow Dancing*, 159.

35. Rap's thematization of noise and linguistic deviance can even be seen from the titles of its songs, e.g., Public Enemy's "Bring the Noise," BDP's "Gimme Dat (Woy)."

36. T. S. Eliot, "Tradition and the Individual Talent," in *Selected Essays* (London: Faber, 1976), 15.

37. See Horkheimer and Adorno, *Dialectic of Enlightenment*, 125; and Ernest van den Haag, "A Dissent from the Consensual Society," in Norman Jacobs, ed., *Culture for the Millions* (Princeton: Van Nostrand, 1961), 59.

38. See Leo Lowenthal, "Historical Perspectives of Popular Culture," 55.

39. Bernard Rosenberg, in "Mass Culture in America," 12, blames "modern technology" as "the necessary and sufficient cause of mass culture" and its cultural barbarism. Leo Lowenthal, in "Historical Perspectives of Popular Culture," 55; similarly cites "the decline of the individual in the mechanized working process" of modern technological society.

40. See Macdonald, "Theory of Mass Culture," 65.

41. See Greenberg, "Avant-Garde and Kitsch," 98.

42. See van den Haag,"Of Happiness and of Despair," 517, 529. We find this argument also in Ariel Dorfman's complaint that "the cultural industry, tailored to answer the simultaneous needs of immense groups of people, levels off its messages at the so-called lowest common denominator, creating only that which everybody can understand effortlessly. This common denominator (as has also been pointed out frequently) is based on a construct of—what else?—the median quintessential North American common man, who has undergone secular canonization as the universal measure for humanity." Ariel

Dorfman, *The Empire's Old Clothes: What the Lone Ranger, Babar, and Other Innocent Heroes Do to Our Minds* (New York: Pantheon Books, 1983), 199.

43. See Fiske, *Television Culture*, 71–72, 163–164, 320. The need for simplistic homogeneous fare to appeal to the lowest common denominator makes sense only when it is assumed that the work's meaning and mode of reception are fixed and uniform for its readers, that its sense is firmly controlled by its author rather than being a dialogical and changing product of its interaction with other texts and sociohistorically situated readers.

44. T. S. Eliot, *The Use of Poetry and the Use of Criticism* (London: Faber, 1964), 152–153.

45. See Stuart Hall, "The Rediscovery of Ideology: The Return of the Repressed," in M. Gurevitch et al., eds., *Culture, Society and Media* (London: Methuen, 1982), 56–90.

46. Popular art audiences are also clearly capable of the disengaged engagement necessary for appreciating essentially ambiguous "open works." The confusing exigencies of postmodern life, where even beliefs must be embraced with a cautionary degree of disbelief and noncommitment, make such complexity of attitude not an aesthetic luxury for the privileged but a necessity for everyday coping.

47. More than most others, Bourdieu recognizes the deep bodily dimension of the aesthetic: "art is never entirely the *cosa mentale* . . . which the intellectualist view makes of it. . . . Art is also a bodily thing," relating to basic "organic rhythms: quickening and slowing, crescendo and decrescendo, tension and relaxation" (*D*, 80). The high aesthetic's spiritualization of form to exclude somatics and sensuality is simply the continuation of a long philosophico-theological disenfranchisement of the body. In this tradition of intellectualist formalism, which can be traced past Kant to Plato, the sensory is aesthetically legitimated only as a means toward intellectual form; as Adorno puts it: "only as the bearer of something intellectual which shows itself in the whole." See T. W. Adorno, "On the Fetish Character in Music and the Regression of Listening," *Essential Frankfurt*, 274. For more on the somatic dimension of aesthetics, see Chapters 7–8 below.

48. For more on these questions, see Dewey's *Art as Experience* and my *Pragmatist Aesthetics*.

49. This argument is different but perhaps related to the more common complaint that popular culture borrows its material from high culture but simply waters it down. That complaint may be answered by noting that high culture has always borrowed much of its material from more popular culture. Think of how the Impressionist and Postimpressionist painters were fond of depicting popular culture: cabarets, carnivals, dancing, etc. Even as austere a modernist

as Mondrian insists on his low culture borrowing in such works as *Broadway Boogie*. In fact, it can be argued that the modernist avant-garde heavily relied on popular culture to distance itself from academicism. See Thomas Crow, "Modernism and Mass Culture in the Visual Arts," in B. Buchloh, S. Guilbaut and D. Solkin, eds., *Modernism and Modernity* (Halifax: Press of the Nova Scotia College of Art and Design, 1983), 215–264.

50. Historical evidence for some of these points, particularly with respect to the American public's protest against the aristocracy, intellectualism, and European-styled elitism of high culture in America, can be found in Levine, *Highbrow/Lowbrow*.

51. See Roger Taylor, *Art, an Enemy of the People* (Atlantic Highlands, N.J.: Humanities Press, 1978), 43; and Bourdieu, who speaks of an "aristocracy of culture," a phrase he uses for the title of the first chapter of his *Distinction*.

52. This, again, is not to say that such resistance was strong enough to prevent the creation in America of a culturally aristocratic and politically influential high art establishment, whose formation is well described by Levine. The point is rather that the resistance was (and remains) strong enough to undermine high art's unquestioned monopoly of aesthetic and cultural legitimacy.

CHAPTER 3. THE FINE ART OF RAP

1. See Jon Pareles, "How Rap Moves to Television's Beat," *New York Times*, January 14, 1990, Arts and Leisure section, 1, 28. Since the original publication of this chapter as an essay in 1991, my study of rap has been significantly extended and updated. Besides the more detailed discussion in *Pragmatist Aesthetics: Living Beauty, Rethinking Art* (Oxford: Blackwell, 1992), 2d ed. (New York: Rowman & Littlefield, 2000), see my treatment of hip hop in *Practicing Philosophy: Pragmatism and the Philosophical Life* (New York: Routledge, 1977), chap. 5; "Rap Remix: Pragmatism, Postmodernism, and Other Issues in the House," *Critical Inquiry* 22 (1995): 150–158; and "Pragmatism, Art, and Violence: The Case of Rap," in T. Yamamoto, ed., *Philosophical Designs for Sociocultural Transformation* (New York: Rowman & Littlefield, 1998), 667–774. I also spent a couple years (1992–1993) writing rap criticism for a North Philadelphia rap fanzine, *JOR Quarterly*, and some of these fugitive pieces can be found on my web page: www.temple.edu/aesthetics.

2. Rap's censorship became national news when Two Live Crew were banned and arrested in Florida in the summer of 1990. For details on earlier attempts to repress rap, see the pamphlet *You Got a Right to Rock, Don't Let Them Take It Away* (New York: Duke and Duchess Ventures, 1989), written by the editors of *Rock & Roll Confidential*; and Dave Marsh and Phyllis Pollack, "Wanted for Attitude," *Village Voice*, October 10, 1989, 33–37. The censorship of concerts

and the "parental" blacklisting of records, vigorously pursued by the Parents Musical Resource Center (PMRC), are sometimes thematized in rap lyrics and related to issues of aesthetic and political freedom of expression, as for instance in Ice-T's "Freedom of Speech."

3. We see this in Spike Lee's provocative film about the black ghetto, *Do The Right Thing* (Forty Acres and a Mule Productions, 1989). The film's climactic race riot, which destroys the local pizzeria (owned and run by a lower-middle-class Italian family and employing one of the neighborhood blacks), is set off by the proprietor's violent refusal to allow rap music to be played in his shop "because of the noise." Rap's typical loudness, one of its most offensive and criticized features for bourgeois sensibility, is a consciously calculated and thematized feature of its aesthetic, as we can see in Public Enemy's song "Bring the Noise," a slogan adopted by many other rappers.

4. I have taken the title from the lyrics of Ice-T's "Hit the Deck," which aims to "demonstrate rappin' as a fine art." There are countless other raps which emphatically declare rap's poetic and artistic status; among the more forceful are: Stetsasonic's "Talkin' All That Jazz"; BDP's "I'm Still #1," "Ya Slippin'," "Ghetto Music," "Hip Hop Rules"; and Kool Moe Dee's "The Best."

5. Hip hop actually designates an organic cultural complex wider than rap. It includes break dancing and graffiti and also a stylized but casual style of dress, where high-top sneakers became high fashion. Rap music supplied the beats for the break-dancers; some rappers testify to having practiced graffiti; and hip-hop fashion is celebrated in many raps, one example being Run DMC's "My Adidas."

6. I explore the aesthetic dimension of postmodernism in much greater detail in Richard Shusterman, "Postmodernism and the Aesthetic Turn," *Poetics Today* 10 (1989): 605–622.

7. Postmodernism is not, of course, the only useful framework for understanding rap. The philosophy of pragmatism also serves well to illuminate some of rap's core features. For more details on the pragmatist dimension of rap, see my "Rap Remix: Pragmatism, Postmodernism, and Other Issues in the House," and *Practicing Philosophy*, chap. 5 ("Art in Action, Art Infraction: Goodman, Rap, Pragmatism").

8. See, e.g., Roger Abrahams, *Deep Down in the Jungle* (Chicago: Aldine Press, 1970), whose study of a Philadelphia ghetto revealed that speaking skills "confer high social status" (39) and that even among young males "ability with words is as highly valued as physical strength" (59). Studies of Washington and Chicago ghettos have confirmed this. See Ulf Hannerz, who notes in *Soulside* (New York: Columbia University Press, 1969) that verbal skill was "widely appreciated among ghetto men" not only for competitive practical purposes

but for "entertainment value" (84–85); and Thomas Kochman, "Toward an Ethnography of Black American Speech Behavior," in Thomas Kochman, ed. *Rappin' and Stylin' Out* (Urbana: University of Illinois Press, 1972), 241–264. Along with its narrower use to designate the traditional and stylized practice of verbal insult, black "signifying" has a more general sense of encoded or indirect communication, which relies heavily on the special background knowledge and particular context of the communicants. For an analysis of "signifying" as a generic trope and its use "in black texts as explicit theme, as implicit rhetorical strategy, and as a principle of literary history," see Henry Louis Gates, Jr., *The Signifying Monkey: A Theory of Afro-American Literary Criticism* (Oxford: Oxford University Press, 1989), citation from 89.

9. Such linguistic strategies of evasion and indirection (which include inversion, "shucking", "tomming", "marking", and "loud-talking", as well as the more generic notion of signifying) are discussed at length in Grace Simms Holt, "'Inversion' in Black Communication," and Claudia Mitchell-Kernan, "Signifying, Loud-Talking, and Marking," both in Kochman, *Rappin' and Stylin' Out*.

10. I demonstrate some of this rich complexity by a close reading of Stetsasonic's "Talkin' All That Jazz," in *Pragmatist Aesthetics*, chap. 8.

11. David Toop, *The Rap Attack: African Jive to New York Hip Hop* (Boston: South End Press, 1984), 14, hereafter cited as *RA*.

12. See, e.g., Ice-T's "Rhyme Pays," Public Enemy's "Bring the Noise," Run DMC's "Jam-master Jammin'," and BDP's "Ya Slippin'."

13. It is called scratch mixing, not only because this manual placement of the needle on particular tracks scratches the records, but because the DJ hears the scratch in his ear when he cues the needle on the track to be sampled before actually adding it to the sound of the other record already being sent out on the sound system.

14. See, e.g., Public Enemy's "Caught, Can I Get a Witness," Stetsasonic's "Talkin' All That Jazz," and BDP's "I'm Still #1," "Ya Slippin'," and "The Blueprint." The motivating image of this last rap highlights the complex notion of hip-hop originality. In privileging their underground style as original and superior to "the soft commercial sound" of other rap, BDP connects its greater originality with its greater closeness to rap's ghetto origins. "You got a copy, I read from the blueprint." But a blueprint is itself a copy, not an original; indeed it is a simulacrum or representation of a designed object which typically does not yet (if ever) exist as a concrete original object.

15. See Fredric Jameson, "Postmodernism, or the Cultural Logic of Late Capitalism," *New Left Review* 146 (1984): 53–92, 73, 75, hereafter cited as *NLR*.

16. For a critique of this early view of Eliot's and for an explanation of the reasons why Eliot himself abandoned it in formulating his later theory of tradi-

tion, see Richard Shusterman, *T. S. Eliot and the Philosophy of Criticism* (New York: Columbia University Press, 1988), 156–167.

17. See, respectively, "My Philosophy" and "Ghetto Music." The lyrics of "Ya Slippin'" and "Hip Hop Rules" respectively date themselves as 1987 and 1989. Public Enemy's "Don't Believe the Hype" has a 1988 time tag, and similar time tags can be found in raps by Ice-T, Kool Moe Dee, and many others.

18. Conversely, the central ideas of this essay are not rendered worthless by the mere fact that rap's continuing development is outdating some of my specific points and examples.

19. There are rap records from white groups like Blondie, Tom Tom Club, Beastie Boys, Third Bass, and from the white solo rapper Vanilla Ice. The notorious punk rock manager Malcolm McLaren has also recorded in this genre.

20. See, e.g., the French rap album *Rapattitudes*, in which the rappers refer to their specific neighborhoods in Paris and their problems of housing and social acceptance.

21. If not for several high-profile rap shootings, after gangsta rap in the mid-1990s became hip hop's most lucrative genre, one could make a very strong argument that hip hop provides an aesthetic field where violence and aggression get translated into symbolic form. Certainly, fierce rivalry and aggressive competition are essential to the aesthetic of rap. Perhaps the most common theme in rap lyrics is how the rapper is superior to others in the power of his rhymes and ability to "rock" the audience, how he can take on the challenge of other rappers (who criticize or "dis" him) and make them look weak and foolish when they duel with him in rap. This dueling is often described in extremely violent terms, as it is in the traditional verbal insult contests of "the dozens" and "signifying" (see the sources cited above in note 8). However, together with this uncompromising competitive assertion to be "the best," rappers also express in their lyrics their underlying solidarity with other rap artists who share the same artistic and political agenda. I provide a more detailed study of rap's relation to violence in *Practicing Philosophy*, chap. 5; and "Pragmatism, Art, and Violence."

22. Public Enemy, "Bring the Noise."

23. See Ice-T's "Heartbeat" and Public Enemy's "Don't Believe the Hype."

24. Public Enemy, "Don't Believe the Hype."

25. See BDP's "Ghetto Music," Public Enemy's "Rebel Without a Pause," and Ice-T's "Radio Suckers." However, as these rappers admit, some stations on some occasions (usually late at night) will play the raw reality sound.

26. Ice-T, "Radio Suckers."

27. Public Enemy, "Black Steel in the Hour of Chaos." On this theme of black

exploitation by white society see also BDP's "Who Protects Us From You?" and Ice-T's "Squeeze the Trigger."

28. For examples of the former tension, see Ice-T's "High Rollers," "Drama," "6 'n the Morning," "Somebody's Gotta Do It (Pimpin' Ain't Easy)," and Big Daddy Kane's "Another Victory"; for the latter, see Ice-T's "Radio Suckers" and BDP's "The Blueprint." A still more troubling contradiction is that despite rap's condemnation of minority oppression and exploitation, it frequently adopts the "pimpin' style," which consists of horribly macho celebrations of the (often violent) exploitation of women.

29. Pierre Bourdieu's *Distinction: A Social Critique of the Judgement of Taste* (Cambridge: Harvard University Press, 1984) exposes the hidden logic of the material, commercial, and class interests and mechanisms that allow for the workings of so-called pure, noncommercial art, and for its effective misprision as pure and noncommercial.

30. Houston A. Baker, Jr., *Blues, Ideology, and Afro-American Literature: A Vernacular Theory* (Chicago: University of Chicago Press, 1984), 34–63.

31. Baker, *Blues, Ideology*, 57.

32. See, e.g., Ice-T's "Rhyme Pays" and Kool Moe Dee's "They Want Money" and "The Avenue."

33. Jameson connects this eclecticism, use of stereotypes, and effacement of history with the common charge that postmodern art is depthless and superficial. But much of its perceived superficiality, I believe, results from judging it in terms of modernist conventions of depth rather than in terms of its oppositional and dialectical relationship to those conceptions, a relationship which can give its superficiality a reflected depth by contextual, ironic contrast.

34. This possible pun of "*his*-story" is recognized and employed by BDP in "Part Time Suckers": "These people make me laugh / The way they like to change up the past / So when you're there in class learnin' His-story / Learn a little your story, the real story." For discussion of "The Man," see Claude Brown, "The Language of Soul"; Ken Johnson, "The Vocabulary of Race"; and Grace Sims Holt, "'Inversion' in Black Communication," all in Kochman, *Rappin' and Stylin' Out*.

35. See BDP's "Why is That?" "You Must Learn," and "Hip Hop Rules."

36. See, e.g., Jürgen Habermas, *The Philosophical Discourse of Modernity* (Cambridge, Mass.: MIT Press, 1987), 1–22.

37. See Friedrich Schiller, *On the Aesthetic Education of Man* (Oxford: Oxford University Press, 1982).

38. See BDP, "My Philosophy" and "Gimme Dat, (Woy)." The lyrics of their knowledge rap "Who Protects Us From You?" describes it as "a public service announcement brought to you by the scientists of Boogie Down Productions."

39. See BDP, "I'm Still #1." For BDP's attack on establishment history and media and its stereotypes, see especially "My Philosophy," "You Must Learn," and "Why is That?"

40. This phrase and notion, for example, provides the central theme of Kool Moe Dee's "Do You Know What Time It Is?" and appears in many other raps. Hip hop's heightened sense of temporality is expressed in other striking ways. For example, Flavor Flav of Public Enemy always appears with a large clock hanging from around his neck.

41. I make a case for the contemporary relevance of Dewey's aesthetics in *Pragmatist Aesthetics*, chaps. 1 and 2.

42. The best example of this is Gary Byrd, a New York radio DJ who developed a literacy program based on rap. For more details on this, see Toop, *RA*, 45–46.

43. T. W. Adorno, *Aesthetic Theory* (London: Routledge, 1984), 322.

44. See, e.g., Ice-T's "409" and BDP's "Nervous." It is noteworthy that even these artists who identify themselves as noncommercial bear names that suggest the commercial business world. Ice-T's group or "crew" is called "Rhyme Syndicate Productions" and BDP stands for "Boogie Down Productions."

45. Grandmaster Flash complained when, at the novelty and virtuosity of his cutting, "the crowd would stop dancing and just gather round like a seminar. This is what I didn't want. This wasn't school, it was time to shake your ass." See Toop, *RA*, 72.

46. See Queen Latifah's "Dance for Me" and Ice-T's "Hit the Deck." For a similar emphasis on rap's mesmerizing power of possession that physically and spiritually moves both performer and audience, see Kool Moe Dee's "Rock Steady" and "The Best."

47. The point is made most explicitly in Plato's *Ion*.

48. See, e.g., Michael Ventura, *Shadow Dancing in the U.S.A.* (Los Angeles: Tarcher, 1986); and Robert Farris Thompson, *Flash of the Spirit* (New York: Vintage, 1984).

CHAPTER 4. AFFECT AND AUTHENTICITY
IN COUNTRY MUSICALS

1. See William James, "On a Certain Blindness in Human Beings," in J. McDermott, ed., *The Writings of William James* (Chicago: University of Chicago Press, 1977), 630–631.

2. While speaking of country music as a genre, I should immediately insist that it, historically, includes a very diverse range of subgenres with often very different styles: old-time music, bluegrass, country gospel, country boogie, country rock, western swing, rockabilly, honky-tonk, etc. These different

forms sometimes have their own particular issues of authenticity and affect, but to make my philosophical arguments clearer and more succinct, I shall have to use the philosophical abstraction of speaking about country music in general. I am, of course, especially concerned with the newer country music that began to be institutionalized and explicitly labeled as "country music" in the second half of the twentieth century and that rose to unprecedented popularity in the 1990s. Already in the March 2, 1992 issue of *Forbes* magazine, an article by Lisa Guberick and Peter Newcomb ("The Wal-Mart School of Music") took note of country's commercial ascendance, not only in albums sold but also in live concerts, "pay-per-view" televised concerts, and, of course, radio. There are far more country radio stations than any other kind, so "in any given week, according to industry figures [from the mid-nineties], 72 percent of the American public listens to country music on the radio." See Cecilia Tichi, "Editorial," *South Atlantic Quarterly* 94 (1995): 4. For more on the institutionalization of country music, see Richard Peterson, *Creating Country Music: Fabricating Authenticity* (Chicago: University of Chicago Press, 1997).

3. See, for example, R. A. Peterson and R. B. Davis, "The Contemporary American Radio Audience," *Popular Music and Society* 3 (1974): 308; and R. A. Peterson and Paul DiMaggio, "From Region to Class, The Changing Locus of Country Music: A Test of the Massification Hypothesis," *Social Forces* 53 (1975): 497–506. For a later, more nuanced study, see R. A. Peterson and A. Simkus, "How Musical Tastes Mark Occupational Status Groups," in M. Lamont and M. Fournier, eds., *Cultivating Differences: Symbolic Boundaries and the Making of Inequality* (Chicago: University of Chicago Press, 1992), 152–186.

4. In contrast to the "singing cowboy" films, the new country musicals are stories not about cowboys but about people deeply involved in contemporary country music culture, either as established or aspiring performers or songwriters or as consumers. These films include the country star biographies of Hank Williams, Loretta Lynn, and Patsy Cline in, respectively, *Your Cheatin' Heart* (MGM, dir. Gene Nelson, 1964), *Coal Miner's Daughter* (Universal, dir. Michael Apted, 1980), and *Sweet Dreams* (HBO, dir. Karel Reisz, 1985). But just as central to the genre are the fictional narratives of imaginary country performers in films such as *Payday* (Zaentz, dir. Daryl Duke, 1973), *Nashville* (Paramount, dir. Robert Altman, 1975), *Honeysuckle Rose*, also known as *On the Road Again* (Warner Bros., dir. Jerry Schatzberg, 1980), *Honky Tonk Man* (Warner Bros., dir. Clint Eastwood, 1982), *Sweet Country Music* (dir. Jack McCallum, 1983), *Tender Mercies* (Universal, dir. Bruce Beresford, 1983), and *Pure Country* (Warner Bros., dir. Christopher Cain, 1992). These fictional stories and characters, however, borrow very heavily from real-life country histories. In *Payday*, for example, the hero's death through a drink-related heart

attack while being driven in his car echoes the death of Hank Williams, while in *Honky Tonk Man* the hero's death from tuberculosis after a strenuous recording session in New York clearly appropriates Jimmie Rodgers's famous death. Less central but still within the ambit of country musicals are films like *Urban Cowboy* (Paramount, dir. James Bridges, 1980), whose hero is not a performer but an avid fan who devotes his life to country music nightclub culture. On the borders of the genre, we might even consider a film like *True Stories* (Warner Bros., 1986), directed by the rock star David Byrne of the Talking Heads. The film's hero is an amateur country singer-songwriter from a small Texas town, and the film's climax is his performance at the town's sesquicentennial show, a performance that finally wins him the love he's been searching for throughout the film.

5. This information is based on figures drawn from Richard Peterson, "The Production of Cultural Change: The Case of Contemporary Country Music," *Social Research* 45 (1978): 292–314; Curtis W. Ellison, *Country Music Culture: From Hard Times to Heaven* (Jackson: University of Mississippi Press, 1995), 224; Clark Parsons, "Taking Stock of the Nineties Boom," *Journal of Country Music* 16, no. 2 (1994): 10–11; Don Cusic, "Country Green: The Money in Country Music," *South Atlantic Quarterly* 94 (1995): 231–241; and Peter Applebome, "Hank Williams. Garth Brooks. BR5-49?" *New York Times Magazine*, October 27, 1996, 38–43. By 1998, the number of country stations had declined to 2,368, but this was still far ahead of all other radio formats: more than double the number of stations of country's closest rival (i.e., news/talk/ business) and over two and half times more than its closest musical rival (adult contemporary). This information is based on a 1998 M Street Survey that is posted by the National Association of Broadcasters.

6. Heavy metal, though typically white, can hardly claim a distinctively ethnic American character. Moreover, its sound and lifestyle remains too brash, young, and excessive for most young adults.

7. A similar strategy of appealing to the oppositional, nonconformist character of country traditionalism, while performing a very untraditional crossover song, can be seen in Barbara Mandrell's commercial hit "I Was Country When Country Wasn't Cool." Described by country music historian Bill Malone as having "a style that possessed no country flavor at all" (Bill C. Malone, *Country Music U.S.A.*, rev. ed. [Austin: University of Texas Press, 1985], 376), the song exploits a cameo appearance by authentic country icon George Jones and the general knowledge that Mandrell had deep family roots in country.

8. See Peter Applebome, "Country Graybeards Get the Boot," *The New York Times*, August 21, 1994, sec. H, pp. 27–28. As one Nashville music publisher and disk jockey explains, "The best thing that ever happened to country music was rap," because it pushed pop music toward a radical direction its main-

stream audience could not follow. "I think you've got a young adult group that would have listened to pop music if they could have identified with it" (28).

9. See Skip Hollandsworth, "Garth Brooks: A Megastar's Last Stand (For Now)," *TV Guide*, April 30, 1994, 14.

10. Newton-John even won the Country Music Association's Female Singer of the Year award in 1974, though not without angering many country traditionalists.

11. On the new focus on music videos and their young "hunks," see Applebome, "Country Greybeards," and Parsons, "Taking Stock."

12. At the 1996 Country Music Association Awards, the then forty-four-year-old Strait (described as "keeper of the country flame" and "country purist") proved the biggest winner, taking the major prizes of best single, best album, and male vocalist of the year. The descriptions are cited from *USA Today*, October 3, 1996, sec. D, p. 1; and *The Philadelphia Inquirer*, October 3, 1996, sec. C, p. 1. In 1997 George Strait continued to be a big CMA prize winner, capturing the best male vocalist and best album awards, while in 1998 he won the best male vocalist for the third straight year and became the most nominated performer in CMA history. See the reports in *The New York Times*, September 25, 1997, sec. A, p. 22, col. 1; and *The Washington Post*, September 24, 1998, sec. B, p. 10. In 1999 Strait was nominated for another three major CMA awards.

13. See Malone, *Country Music U.S.A.*, 409.

14. See Peterson, *Creating Country Music*, 59, 64.

15. Malone, *Country Music U.S.A.*, 127, 181.

16. Ibid., 137–141, 152. Malone relates how the famous singing cowboys Gene Autry, Roy Rogers, and Tex Ritter were far from authentic cowboys who took up singing, but rather professional musicians who only turned to the cowboy image when it proved fruitful for their careers. Anyone well acquainted with country music knew that the cowboy image of country authenticity was a hoax. Thus, to project real authenticity, The Grand Old Opry's Roy Acuff (known as the King of Country Music) vehemently refused to wear the cowboy clothes assigned to him and his band by Republic Studio in their film *The Grand Old Opry*, insisting that his mountaineer work clothes of check shirts and jeans or overalls were far more authentic. See Richard Peterson, "The Dialectic of Hard-Core and Soft-Shell Country Music," *South Atlantic Quarterly* 94 (1995): 279–280, and *Creating Country Music*, chap. 9.

17. Malone, *Country Music U.S.A.*, 5. The historical facts in this paragraph and the previous one are mostly drawn from Malone and from Ellison, *Country Music Culture*.

18. William James, *Principles of Psychology* (1890; Harvard University Press, 1983), 924, 936 (James's italics). "Coerciveness [over our attention—another

common way of construing reality] is the result of liveliness or emotional interest" (929).

19. Country musicals often thematize the notion that the real or authentic is a gradational and contextual category. In *Urban Cowboy*, the hero is accosted by a woman in a honky-tonk with the question: "Are you a real cowboy?" to which he responds, "Depends on what you think a real cowboy is." Her criterion of real is to "know how to dance a two-step." But the film goes on to suggest other criteria of cowboy authenticity: the ability to ride a mechanical imitation rodeo bull, to show stubborn grit and pride, and to perform well in bed. The last, with its metaphor of riding, is a frequent criterion for being a "real" cowboy in contemporary country music lyrics.

20. This is because our dominant highbrow aesthetic (from Kant to T. S. Eliot) rejects raw emotional appeals as aesthetic vulgarity. For details see Richard Shusterman, "Of the Scandal of Taste: Social Privilege as Nature in the Aesthetic Theories of Hume and Kant," in Paul Mattick, ed., *Eighteenth-Century Aesthetics and the Reconstruction of Art* (New York: Cambridge University Press, 1993), 96–119; and *T. S. Eliot and the Philosophy of Criticism* (New York: Columbia University Press, 1988), 64–67.

21. For these details and citations, see Malone, *Country Music U.S.A.*, 242, 301; Paul Kingsbury and Alan Axelrod, eds., *Country: The Music and the Musicians* (New York: Abbeville Press, 1988), 49; Nolan Porterfield, *Jimmie Rodgers: The Life and Times of America's Blue Yodeler* (Champaign: University of Illinois Press, 1979), 75–76; Peterson, "The Dialectic of Soft Shell and Hard Core," 278–279; and Ellison, *Country Music Culture*, 38, 40, 105, 261. The quotation about Southern pietism (cited in Ellison, 105) comes originally from the religion historian Peter Williams, *America's Religions: Traditions and Cultures* (New York: Macmillan, 1990), 233. Ellison also cites the contemporary country singer Colin Raye, "I go for the songs that sound like the writer cut a hole in his heart and just let it pour out" (256).

22. See William James, *The Varieties of Religious Experience* (New York: Penguin, 1985), 112, 261.

23. Yet in certain moods, at certain moments, or because of certain pressures that decenter the habitual self, the intellectual's inhibitory habits can be overcome and country music's emotionality can be deeply shared and not simply discriminated. This chapter's appreciation of country is, of course, partly a result of my own rewarding moments of surrender to its sentiment, suggesting that we intellectuals may sometimes learn from releasing ourselves, even if only occasionally and momentarily, from our cherished critical inhibitions.

24. Walter Benjamin, *Illuminations*, ed. Hannah Arendt (New York: Schocken, 1969), 83–84, 87, 89, 97, 108.

25. Ibid., 108–109.

26. See Richard Peterson and Melton McLaurin, "Introduction: Country Music Tells Stories," in Melton McLaurin and Richard Peterson, eds., *You Wrote My Life: Lyrical Themes in Country Music* (Philadelphia: Gordon and Breach, 1992), 2.

27. See Nat Hentoff, *Listen to the Stories: Nat Hentoff on Jazz and Country Music* (New York: HarperCollins, 1995), 168.

28. Dusty's show is here compared to a phony "dancin' chicken" act they saw as kids: the stage chicken did not dance of its own free will but was controlled by the director, who both played the music and secretly stoked the stove under the stage whose heat kept the chicken hopping. Earle's question, "Why didn't that chicken just run off the stage?" prompts Dusty's decision to run off.

29. Similarly, in *True Stories*, the amateur country singer hero is so powerfully emotive in his televised song pleading for "someone to love" that he immediately receives a phoned-in marriage proposal. The next shot shows the subsequent marriage, whose success is intimated by the heartfelt approving joy of the wedding guests.

30. In *Honeysuckle Rose* such stereotypes include the strong, faithful wife of the adventurous voyager (a topos dating back to the *Odyssey* and suggested in the film's hit song "A Goodhearted Woman in Love with a Goodtimin' Man"), the tender young temptress of the idolized older star, the duet as a model and means for love making, the hero's disappearance into the wilderness to find himself, and the concluding public confession of sin and atonement, reminiscent of popular Christian evangelism. Country music's stereotypes and clichés can thus be seen as expressions of typical truths that are no less real or authentic for being common, and perhaps are particularly real for its audience of common people who cannot afford to imagine their lives as distinctively above the commonplace. For a perceptive study of country music's use of stereotypes and clichés, arguing that they should be understood as neither critically oppositional nor devoid of cognitive import, see Astrid Franke, "'The Broken Heart' and 'The Trouble with Truth': Understanding Clichés in Country Music," *Poetics Today* 18 (1997): 397–412.

31. For James's justification of this right to believe before having sufficient evidence, see "The Will to Believe," in *Pragmatism and Other Essays* (New York: Simon and Schuster, 1963), 209. James identifies this attitude with empiricism's strategy of learning from experience (205).

CHAPTER 5. THE URBAN AESTHETICS OF ABSENCE
1. For a fuller account of my pragmatism, see Richard Shusterman, *Pragmatist Aesthetics: Living Beauty, Rethinking Art* (Oxford: Blackwell, 1992), 2d ed. (New York: Rowman & Littlefield, 2000), and *Practicing Philosophy: Pragmatism and the Philosophical Life* (New York: Routledge, 1997).

2. In 1995–96, I spent eighteen months in Berlin as a Guest Professor and then Fulbright Professor at the Freie Universität, hosted by the Institut für Philosophie and the John F. Kennedy Institute for American Studies. I am especially grateful to Professors Albrecht Wellmer and Hans Joas for their hospitality and help. Astrid Franke and Mika Hannula also deserve thanks for assisting me with some research and fieldwork, as does Professor Heinz Paetzold of the Jan van Eyck Akademie in Maastricht, whose conference on "The Politics of the Visual Culture of Contemporary Cities" provided me a lively audience for an earlier draft of this chapter.

3. Kurt Tucholsky, "Die Flecken" (1919), in *Germany? Germany!* (London: Carcanet, 1990). The story seems even more poignant today, since the whole military academy and its granite walls are now gone, while Dorotheenstrasse was itself long absent from Mitte, since it was renamed as Clara Zetkin Strasse by East German officials and reverted back to Dorotheenstrasse only in 1995 after the reunification of Berlin. This systematic strategy of changing the names of streets and public squares to obliterate the ideologies they reflect creates a fascinating play of absences, where history is recalled by the very attempt to efface it by erasing its names.

4. Two years after this essay was first published as an article, the German Bundestag finally decided on June 25, 1999, to erect an official holocaust memorial for Jewish victims in Berlin, ending almost a decade of debate about what precise form the memorial would take. Designed by Peter Eisenman, it will be located near the Brandenburg Gate and will consist of a field of 2,700 concrete pillars, complemented by an information center. Construction of the monument is planned to begin in January 2000.

5. I should also note here a distinctive absence in Berlin's structure as city: the emptiness of its center. In contrast to most cities whose center is one of density (a greater concentration of buildings, people, power, and activity), Berlin's geographical center is a large wooded park, the Tiergarten, with some thirty kilometers of zigzagging empty paths and (in its southwest corner) the city zoo.

Roland Barthes, in his *Empire of Signs* (New York: Farrar Strauss, 1982, 30), made a similar point about the empty center of Tokyo, contrasting it to all Western cities (Berlin apparently included) and linking this contrast to deep metaphysical differences between the Occident and Orient concerning the primacy of Being's presence over nothingness or emptiness: "In accord with the very movement of Western metaphysics, for which every center is the site of truth, the center of cities is always *full*: a marked site, it is here that the values of civilization are gathered and condensed: spirituality (churches), power (offices), money (banks), merchandise (department stores), language (agoras: cafes and promenades)."

Did Barthes ignore Berlin? Writing during its cold war division, he perhaps viewed it instead as centered by its wall's prime point of passage (Checkpoint Charlie). Could he instead have cynically regarded Tiergarten as Berlin's true center, its woods and caged beasts presenting the condensed truth of German civilization? Or did Barthes simply (and justifiably) regard divided Berlin as two different cities, each having its own center? In any case, long before Berlin's political division, its empty center of Tiergarten divided its two prime foci of power and activity: the commercial hub in the west balanced by the center of culture and political power in the east.

6. This is certainly most evident in Asian philosophy, as exemplified in the central Buddhist concept of *sunyata* and as suggested in my Tao epigraph for this chapter. But the ontological centrality of absence also appears in Western thought, for example in the tradition that develops from late Heidegger's notion of *An-/Abwesen* and is further expressed in the notion of "the trace" (the presence of an absence) employed by Derrida and Levinas.

7. See Blake's "London" and Wordsworth's "London, 1802" and "Written in London, September, 1802." In "Composed upon Westminster Bridge, September 3, 1802," Wordsworth finds some beauty in London, but only that of a city still "asleep," "lying still," "silent, bare," graced by nature's sun and "open unto the fields, and to the sky."

8. George Simmel, "The Metropolis and Mental Life," in *The Sociology of George Simmel* (New York: Free Press, 1950), 419; hereafter cited as *S*.

9. I go further into rap's urban philosophical themes in *Pragmatist Aesthetics*, chap. 8; *Practicing Philosophy*, chap. 5; and in "Rap Remix: Pragmatism, Postmodernism, and Other Issues in the House," *Critical Inquiry* 22 (1995): 150–158. More detailed studies of rap's relation to American cities can be found in Houston Baker, *Black Studies, Rap, and the Academy* (Chicago: University of Chicago Press, 1993), and Tricia Rose, *Black Noise: Rap Music and Black Culture in Contemporary America* (Hanover: University of New Hampshire Press, 1994).

10. Friedrich Engels, *The Conditions of the Working Class in England*, cited in Walter Benjamin, "On Some Motifs in Baudelaire," in *Illuminations* (New York: Schocken, 1988), 167.

11. Lewis Mumford, *The Culture of Cities* (New York: Harcourt Brace, 1971); hereafter cited as *M*.

12. Richard Sennett, *The Conscience of the Eye: The Design and Social Life of Cities* (New York: Knopf, 1990), 225.

13. Another crucial use of absence as a tool of order for coping with urban complexities should be mentioned: the use of empty forms or matrices as a way of organizing, rationalizing, and so better managing the city's variety and

complex flux. The rectangular street grid is one such empty form for ordering; so is the individual street format, so salient in Berlin, of parallel strips respectively devoted to the pedestrian, the cyclist, the dog in need of a line of trees to do his business, and the motorist in need of lanes for parking and travel. This format of empty, parallel ordering strips for defining the types of movement and their limits can also be seen in the layout of concentration camps like Sachsenhausen with the distinctions between the prisoners' walking space (including a lane marked for the work of testing shoe durability through ceaseless walking), the no-man's-land danger strip, and the wall and patrol areas.

Richard Sennett, who notes the city grid's "logic of emptiness," relates it to the temporal emptiness of mechanical time, "an empty volume" through which time could be made objective and visual, thus allowing diverse activities to be more easily ordered. Like Simmel, Sennett sees the Renaissance invention of the mechanical clock as central to the emergence of the modern metropolis, and he remarks that old buildings were often torn down to permit clear vision of the city's central clocks from distant locations (Sennett, *Conscience of the Eye*, 176–180). Here we see how an abstract form of absence—the empty grid of mechanical time—creates a concrete spatial absence of missing, demolished buildings.

This seems a good occasion to repeat that in exploring the varieties of absence and its uses in urban life, I am not assuming that there is any substantive essence common to them all or that there must be a fixed meaning to the concept of absence for it to be usefully employed in theoretical discourse.

14. Benjamin, "On Some Motifs in Baudelaire," 162, 172–173; hereafter cited as *B*; and Walter Benjamin, *The Arcades Project*, trans. H. Eiland and K. McLaughlin (Cambridge: Harvard University Press, 1999), 423, hereafter cited as *AP*. This is a translation of Benjamin's *Das Passagen-Werk* (Frankfurt: Suhrkamp, 1983), 1:525.

15. I cite from *Das Passagen-Werk*, 1:525, in my translation; cf. *AP*, 417.

16. One should not forget that in earlier centuries Berlin was sometimes a welcoming refuge for European foreigners. But since the 1930s the city has been notably hostile to its "foreign" residents, particularly those of non-Christian or non-European ethnicity.

17. The lines are cited in the English translation of Benjamin's essay with a translation whose clumsiness makes me prefer to give my own (still awkward) English rendering. The translation of the passage from "A Une Passante" cited below is also my own.

18. Benjamin stresses the distinctively central use of eyes in city life, citing Simmel's insistence on the urban primacy of the sense of vision. "This can be

attributed chiefly to the institution of public conveyances. Before buses, rail-roads, and streetcars became fully established in the nineteenth century, people were never put in a position of having to stare at one another for minutes or even hours without exchanging a word" (Benjamin, *B*, 191). But does one have to stare? The use of eyes in different cities is instructive. If one stared in the New York subway as one does in Berlin, one would be sure to provoke sharp words, if not something more violent. The delicious eros of Parisian eye-play is not achieved through prolonged, direct staring (which, as its French word *dévisager* suggests, disfigures or undoes the face); it instead works through a game of brief glances with intermittent gaps, again an aesthetic that exploits the play of presence and absence.

CHAPTER 6. BENEATH INTERPRETATION
1. In an earlier version of this chapter I was tempted, by alliteration, to de-scribe this position as "hermeneutic holism" (see Richard Shusterman, "Be-neath Interpretation, against Hermeneutic Holism," *Monist* 73 [1990]: 181–204). Though the term "hermeneutic universalism" is longer and more plod-ding, it has the advantage of more clearly distinguishing the position I attack from another position that the term "hermeneutic holism" might suggest. This second view maintains that the meaning of a word or statement, or the justifi-cation of a knowledge claim, is not an affair of simple atomistic reference to foundational objects or atomistic correspondence to privileged representa-tions, but instead always depends on a larger context of words, statements, beliefs, and so forth—a whole background of social practice, and one that is not immune to change. The nonfoundationalist pragmatism I advocate in this chapter is not at all opposed to this second sense of interpretive holism; what I challenge is the idea that interpretation constitutes the whole of understand-ing and meaningful experience. Since several readers found the term "herme-neutic holism" confusingly ambiguous with respect to these issues, it is here re-placed by "hermeneutic universalism" or occasionally "universal hermeneutics."
2. Friedrich Nietzsche, *The Will to Power* (New York: Vintage, 1968), para. 481.
3. See Alexander Nehamas, *Nietzsche: Life as Literature* (Cambridge: Harvard University Press, 1985), 66, 70, 72; hereafter cited as *N*. In challenging my own view of aesthetic experience, Nehamas, however, makes very strong de-mands on what can count as an interpretation of art. See his article, "Richard Shusterman on Pleasure and Aesthetic Experience," *Journal of Aesthetics and Art Criticism* 56 (1998): 49–51; and my response, "Interpretation, Pleasure, and Value in Aesthetic Experience," ibid.: 51–53.
4. Stanley Fish, *Is There a Text in This Class?* (Cambridge: Harvard University Press 1980), 350, 352.

5. Stanley Fish, "Working on the Chain Gang; Interpretation in the Law and in Literary Criticism," *Critical Inquiry* 8 (1982): 204.

6. Hans-Georg Gadamer, *Truth and Method* (New York: Crossroad, 1982), 350; hereafter cited as *TM*.

7. This chapter is dedicated to the spirit of that Santa Cruz encounter, which eventually issued in a collection of papers on interpretation, *The Interpretive Turn: Philosophy, Science, Culture* (Ithaca: Cornell University Press, 1991), which I edited with James Bohman and David Hiley.

8. Susan Sontag, "Against Interpretation," in *Against Interpretation and Other Essays* (New York: Dell, 1966); hereafter cited as *AI*.

9. Arthur Danto, *The Philosophical Disenfranchisement of Art* (New York: Columbia University Press, 1986), 45.

10. See Nietzsche, *Will to Power*, para. 556, 557, 559, 560. I examine Nietzsche's alternative account of objects (viz., as interpreted unities) in "Nietzsche and Nehamas on Organic Unity," *Southern Journal of Philosophy* 26 (1988): 379–392.

11. I discuss the intellectual demands and social preconditions of formalist appreciation in "Of the Scandal of Taste: Social Privilege as Nature in the Aesthetic Theories of Hume and Kant," in Paul Mattick, ed., *Eighteenth-Century Aesthetics and the Reconstruction of Art* (New York: Cambridge University Press, 1993), 96–119. Pierre Bourdieu's empirical treatment of this topic in his *Distinction: A Social Critique of the Judgement of Taste* (Cambridge: Harvard University Press, 1984) is very illuminating. However I reject his radical conclusion that the presence and appreciation of form are therefore precluded in popular art. See my discussion in Chapter 2.

12. T. S. Eliot, "Hamlet," in *Selected Essays* (London: Faber, 1976), 142; and his introduction to G. W. Knight, *The Wheel of Fire* (London: Methuen, 1962), xix. For a detailed account of the arguments motivating Eliot's hermeneutic turn and for a critical analysis of his mature theory of interpretation, see Richard Shusterman, *T. S. Eliot and the Philosophy of Criticism* (New York: Columbia University Press, 1988), 107–155.

13. I have elsewhere argued that in pragmatic terms we can indeed have complete (albeit perspectival) understanding, and that only in pragmatic, contextual terms is the idea of complete understanding at all intelligible. The idea of completeness always presupposes a particular and limited context or purpose of fulfillment, so the foundationalist idea of completeness in and for itself, without aspects or horizons or purpose, is simply a meaningless notion, not a regrettably unreachable ideal. For more on this, see my *T. S. Eliot and the Philosophy of Criticism*, 126–128.

I should also suggest that a radical break with foundationalism allows us to regard things themselves (in the nonfoundational sense of objects we

experience) as perspectival. The keyboard I press is (and is not simply interpreted as) a writing tool, though I can also treat it as a paperweight or a book prop.

14. For more detailed discussion of the problematic (but still functional) distinction between description and interpretation in literary criticism, see Richard Shusterman, *Pragmatist Aesthetics: Living Beauty, Rethinking Art* (Oxford: Blackwell, 1992), 2d ed. (New York: Rowman & Littlefield, 2000), chap. 4.

15. John Dewey, *Experience and Nature* (LaSalle, Ill.: Open Court, 1929), 21–24.

16. See Dewey's remark that "primary non-reflectional experience . . . has its own organization of a direct, non-logical character"; in John Dewey, *Essays in Experimental Logic* (Chicago: University of Chicago Press, 1916), 6.

17. Of course, the hermeneutic universalists would contest such a view of standard usage and insist that even unconscious actions and immediate perceptions are and must be interpretive, and indeed that they may be so described without gross violation of diction. My point is that the universalists give no compelling reason to extend the use of interpretation this way, and that in recommending linguistic revision or the denial of a useful distinction, the burden of proof lies heavily with them. As should already be clear, the appeal of their case derives from the hasty presumption that uninterpreted understanding is impossible because it must be conceived foundationally.

18. Ludwig Wittgenstein, *Philosophical Investigations* (Oxford: Basil Blackwell, 1968), 212. Wittgenstein quickly goes on to specify the sort of thinking we do in interpretation: "When we interpret we form hypotheses, which may prove false" (ibid.).

19. Donald Davidson, "Radical Interpretation" and "The Very Idea of a Conceptual Scheme," in *Inquiries into Truth and Interpretation* (Oxford: Oxford University Press, 1984), 125, 184.

20. Hans-Georg Gadamer, "On the Scope and Function of Hermeneutical Reflection," in *Philosophical Hermeneutics* (Berkeley: University of California Press, 1989), 19, 32. Gadamer, however, does not always seem perfectly consistent on this last matter. At one point in *Truth and Method* he speaks of "an understanding of language," which "is not yet of itself a real understanding and does not include an interpretive process but it is an accomplishment of life. For you understand a language by living in it" (346). Could Gadamer here be acknowledging, albeit in a rather odd and contorted manner, the point I wish to make that interpretation does not go all the way down, but always relies on some more primitive linguistic understanding? In any case, this is not Gadamer's standard view.

21. See, for example, Ludwig Wittgenstein, *Zettel* (Oxford: Basil Blackwell, 1967), para. 419, and *Philosophical Investigations*, para. 4–6, 9, 86.

22. See Dewey, *Essays in Experimental Logic*, 4, 6, 9.

23. Moreover, there is good evidence that many of our linguistic structures and meanings (including some of our more abstract logical principles) reflect more basic preconceptual and prelinguistic patterns of bodily experience. See Mark Johnson, *The Body in the Mind* (Chicago: University of Chicago Press, 1987).

24. But such uninterpreted experiences and understandings can, of course, also be found in our professional activities, as underlying more deliberative, reflective thought.

25. See John Lyons, *Semantics* (Cambridge: Cambridge University Press, 1977), 1:33—50.

26. Martin Heidegger, *Being and Time* (New York: Harper & Row, 1962), 194.

27. Wittgenstein, *Philosophical Investigations*, para. 198, 201.

28. The same can be said for another problematic distinction that much contemporary philosophy seems bent on confusing and then denying—the conventional versus the natural. Convention is always more superficial than the natural which grounds it; but what we regard in one context as conventional in contrast to its more natural background can itself be regarded as natural in relation to something still more superficial or artificial. For a more detailed argument of this thesis, see Richard Shusterman, "Convention: Variations on a Theme," *Philosophical Investigations* 9 (1986): 36—55.

29. This is one reason why my rehabilitation of uninterpreted understanding should not be seen as simply resurrecting what Sellars called "the myth of the given." See Wilfrid Sellars, "Empiricism and the Philosophy of Mind," in *Science, Perception, and Reality* (London: Routledge & Kegan Paul, 1963); and Richard Rorty's supportive elaboration in *Philosophy and the Mirror of Nature* (Princeton: Princeton University Press, 1979), 182—192. I agree with Rorty and Sellars that any understanding that functions as epistemological grounding for another understanding must always exist within "the logical space of reasons" and hence must be conceptual. But I maintain, first, that such conceptual understandings can still be immediately (though not apodictically) given; they need not be interpretations. Moreover, I would hold that nonconceptual (e.g., kinaesthetic) experiences, though they be beneath the logical space of reasons, may nonetheless be meaningful and constitute a form of understanding. Finally, though I agree with Rorty and Sellars that such experiences cannot provide epistemological grounding or justification for further understanding unless they get conceptualized, they can still provide the practical ground and orienting background for such understanding.

In other words, I am here urging recognition of a category of embodied, experienced practice that grounds and guides intelligent activity but that is neither at the discursive and epistemological level of the logical space of reasons nor simply reducible to the physical conditions and causes described by

natural science. Nor should this category be seen as *epistemologically* grounding the categories of reasons and physical causes. Sellars and Rorty would no doubt retort that all forms of grounding necessarily fall into the logical space of reasons or otherwise enter the physical space of causes, spaces that must not be confused and whose dichotomy exhausts the ways of understanding human experience. They are surely right not to confuse logical reasons with physical causes, and also right to criticize traditional epistemological notions of "the given" for such confusion. But to regard these two categories as an exhaustive dichotomy seems an unnecessary limitation on understanding human being-in-the-world and an unfortunate vestige of Cartesianism, with its rigid and exhaustive dualism of mind and body, thought and physical extension. All these points are developed in greater detail in my *Practicing Philosophy: Pragmatism and the Philosophical Life* (New York: Routledge, 1997), chap. 6.

30. Wittgenstein, *Zettel*, para. 234. The imagery of this remark makes me hazard the suggestion that we are today so preoccupied with interpretation largely because we so rarely feel comfortably at home in the often conflicting worlds of our understanding, that our age is an age of interpretation because it is one of alienation and fragmentation. We need not mourn this nostalgically as the loss of unity and certainty, but can rather recognize it as the price of our greater freedom and pluralistic possibilities.

31. Fish, *Is There a Text?* 14.

32. See Stanley Fish, "No Bias, No Merit: The Case against Blind Submission," *PMLA* 103 (1988): 739; "Working on the Chain Gang," 211; "Profession Despise Thyself: Fear and Self Loathing in Literary Studies," *Critical Inquiry* 10 (1983); and "Change," *South Atlantic Quarterly* 86 (1987).

33. Fish, *Is There a Text?* 342; and "Change," 432. The multiple confusions of Fish's theory of interpretation and its totalizing professionalism are treated in much greater detail in *Pragmatist Aesthetics*, chap. 4.

34. In glossing Heidegger's notions of "circumspection" and the "ready-to-hand," Hubert Dreyfus aptly describes this smoothly coordinated understanding as "everyday skillful coping" or "absorbed coping." See Hubert Dreyfus, *Being-in-the-World: A Commentary on Being and Time, Division I* (Cambridge: MIT Press, 1991), chap. 4. The idea is also central to Dewey's concept of unreflective intelligent behavior versus conscious inquiry. See, for example, John Dewey, "The Practical Character of Reality" and "The Unit of Behavior," in *Philosophy and Civilization* (New York: Minton, Balch, 1931), 36–55, 233–248.

35. It might seem that artistic interpretation, i.e., interpretive performance, would constitute a refutation of this claim, since Rubinstein's interpretation of Beethoven's *Moonlight Sonata* is not a linguistic text. One need not meet this objection by arguing that "interpretation" is used here in a different, derivative sense. For again we have the translation of one articulated text (the score) into

another articulated form (the actual sonic performance); and the criterion for having an artistic interpretation is expressing it in such an articulated performance or in explicit instructions for one.

36. Ludwig Wittgenstein, *Tractatus Logico-Philosophicus* (London: Routledge & Kegan Paul, 1961), 6.522 (I depart from the translation of David Pears and Brian McGuinness by more simply rendering *zeigt* as "show" rather than "make manifest" and *das Mystiche* as "the mystical" rather than "what is mystical"). I examine Wittgenstein's relation to the nonlinguistic and the somatic in *Practicing Philosophy*, chap. 1.

CHAPTER 7. SOMAESTHETICS AND THE BODY/MEDIA ISSUE

1. See Richard Shusterman, "Die Sorge um den Korper in der heutigen Kultur," in Andreas Kuhlmann, ed., *Philosophische Ansichten der Kultur der Moderne* (Frankfurt: Fischer, 1994), 244–277; and in "Somaesthetics: A Disciplinary Proposal", in *Pragmatist Aesthetics,* 2d ed. (New York: Rowman & Littlefield, 2000), chap. 10.

2. See the collection *Cyberspace: First Steps*, edited by Michael Benedikt (Cambridge: MIT Press, 1991), and the special double issue of *Body and Society* (1995) entitled "Cyberspace Cyberbodies Cyberpunk: Cultures of Technological Embodiment."

3. William Gibson, *Neuromancer* (New York: Ace, 1984), 6.

4. Diogenes Laertius, *Lives of the Eminent Philosophers*, vol. 2 (Cambridge: Harvard University Press, 1931), 71.

5. See Wilhelm Reich, *The Function of the Orgasm* (New York: Noonday, 1973); Michel Foucault, *Discipline and Punish* (New York: Vintage, 1979); and Pierre Bordieu, *The Logic of Practice* (Stanford: Stanford University Press, 1990), chap. 4.

6. See Owen Flanagan, *The Science of the Mind*, 2d ed. (Cambridge: MIT Press, 1984), and B. A. O. Williams, *Problems of the Self* (Cambridge: Cambridge University Press, 1973).

7. See Pandit Usharbudh Arya, *Philosophy of Hatha Yoga*, 2d ed. (Honesdale, Pa.: Himalayan International Institute of Yoga, 1985), and Arnold Schwarzenegger, *Encyclopedia of Modern Body Building* (New York: Simon and Schuster, 1985), 201–215.

8. See Plato's *Phaedo*, 65C–67A, in H. Tredenick, trans., *The Last Days of Socrates* (London: Penguin, 1969), 111–113.

9. Plato later asserts in the *Timaeus* that philosophy itself is derived from the sense of sight. See B. Jowett, trans., *The Dialogues of Plato* (New York: Random House, 1937), 27.

10. Peter Brown, *The Body and Society: Men, Women, and Sexual Renunciation in Early Christianity* (New York: Columbia University Press, 1988), 164–165.

11. Friedrich Nietzsche, *The Will to Power* (New York: Vintage, 1968), para. 255, 258, 314; hereafter cited as *WP*.

12. Walter Benjamin, *Illuminations*, ed. Hannah Arendt (New York: Schocken, 1968).

13. Moshe Feldenkrais, *Awareness Through Movement* (New York: HarperCollins, 1977), 6–7. For more details on the theories and practice of these somaticists, see Shusterman, "Die Sorge um den Korper," and Chapter 8 below.

14. See Jacques Lacan, "The Mirror Stage as Formative of the Function of the I as Revealed in Psychoanalytic Experience," in Alan Sheridan, trans., *Ecrits: A Selection* (London: Tavistock, 1977); and Maurice Merleau-Ponty, *The Phenomenology of Perception*, trans. Colin Smith (London: Routledge, 1962).

15. See William James, *The Principles of Psychology* (Cambridge: Harvard University Press, 1983), 378; and John Dewey, *Experience and Nature* (Carbondale: Southern Illinois University Press, 1988), 227–232.

16. Merleau-Ponty, *Phenomenology of Perception*, 92, 94, 140–141.

17. Merleau-Ponty writes that "the body is the general medium for having a world" and "our means of communication with it," but the world itself is "the horizon latent in all our experience and itself ever-present and anterior to every determining thought" (ibid., 92, 146).

18. See K. Marx and F. Engels, *The German Ideology*, in David McLellan, ed., *Karl Marx: Selected Writing* (Oxford: Oxford University Press, 1977); Foucault, *Discipline and Punish*, and *The History of Sexuality*, 3 vols. (New York: Random House, 1978, 1985, 1986); Pierre Bourdieu, *Distinction: A Social Critique of the Judgement of Taste* (Cambridge: Harvard University Press, 1984), and *The Logic of Practice*.

19. See Shusterman, *Practicing Philosophy: Pragmatism and the Philosophical Life* (New York: Routledge, 1997), chap. 3.

20. See, for example, Susan Bordo, *Unbearable Weight: Feminism, Western Culture, and the Body* (Berkeley: University of California Press, 1993); and on the Jane Fonda fitness videos, Elizabeth Kagan and Margaret Morse, "The Body Electronic, Aerobic Exercise on Video: Women's Search for Empowerment and Self-Transformation," *Drama Review* 32 (1988): 164–180.

21. See, for instance, Ann Balsamo, "Will the Real Body Please Stand Up? Boundary Stories about Virtual Cultures," in Benedikt, ed. *Cyberspace: First Steps.* "Bodies in cyberspace are also constituted by descriptive codes that 'embody' expectations of appearance. Many of the engineers currently debating the form and nature of cyberspace are the Young Turks of computer engineering, men in their late teens and twenties, and they are preoccupied with the things with which postpubescent men have always been preoccupied. This rather steamy group will generate the codes and descriptors by which bodies in cyberspace are represented" (103–104).

22. For more detailed arguments on these points, see *Practicing Philosophy*, chaps. 1, 4, 6.

23. William James, *The Principles of Psychology* (Cambridge, Mass: Harvard University Press, 1983), 1067–1068.

24. J. Z. Young, *An Introduction to the Study of Man* (Oxford: Oxford University Press, 1971), 38.

CHAPTER 8. THE SOMATIC TURN

1. Max Horkheimer and Theodor Adorno, *Dialectic of Enlightenment* (New York: Continuum, 1986), 232, 234; hereafter cited as *DE*. The original German text [*Dialektik der Aufklärung* (Frankfurt: Fischer, 1988), 248] deploys a useful distinction between two German words for body—*Körper and Leib*. The English translation, by John Cumming, renders *Leib* (somewhat problematically) as "noble object," for want of a clear English term to capture the contrast to *Körper* that the German text wants to make. (Perhaps "living core" would be a more neutrally accurate way of translating *Leib* in this context.) Some German readers of my work on somaesthetics have suggested that the term "soma," if construed in the sense of lived bodily experience, could serve as a useful term to render the notion of *Leib* and mark a contrast to the objectified body. At this stage, however, my use of the terms "soma" and "somatic" remains more general; partly because somaesthetics also includes issues relating to body representations and objectifications, and partly because using these general terms in a special, restricted sense could introduce as much confusion as clarity.

2. The cosmetic surgery industry was already grossing $300 million a year and growing annually by 10 percent in the early 1990s. By 1996 the yearly total of procedures was 1.9 million, six hundred thousand more than in 1994 and more than two and a half times the amount of 1989. For more details and critique of the boom in cosmetic surgery and of the ideology that drives it, see Naomi Wolf, *The Beauty Myth: How Images of Beauty Are Used against Women* (New York: Anchor, 1991); Susan Bordo, *Unbearable Weight: Feminism, Western Culture, and the Body* (Berkeley: University of California Press, 1993); and Sander Gilman, *Making the Body Beautiful: A Cultural History of Aesthetic Surgery* (Princeton: Princeton University Press, 1999).

3. I quote from the July 1993 exercise schedule of Crunch (54 East Thirteenth Street).

4. See, for example, the series of the State University of New York Press entitled "The Body in Culture, History, and Religion."

5. This citation is from the conclusion of Michel Foucault's Collège de France Lecture of March 14, 1984. For a critical analysis of how Foucault's somatic views and practices relate to the idea of somaesthetics, see Richard Shusterman, *Practicing Philosophy: Pragmatism and the Philosophical Life* (New York: Rout-

ledge, 1997), chaps. 1, 6; and "Somaesthetics and Care of the Self: The Case of Foucault," *The Monist* 83 (2000): 530–551.

6. Feldenkrais stresses that awareness becomes clearer through *movement* and uses this idea to distinguish his practice from the Asian practices of yoga and zazen, which are far more stationary (in contrast to t'ai chi ch'uan, which like Feldenkrais uses movement to heighten awareness). However, one could argue that movement—in particular the properly controlled movement of the breath (which should entail movement of the diaphragm, ribs, etc.) — is central to the stillness of the more stationary meditative disciplines of yoga and zazen. Movement of some sort seems common to all body disciplines.

7. See Alexander Lowen, *Bioenergetics* (New York: Penguin, 1975), 196–197, who explains that grounding is especially necessary for stabilizing the individual in times of heightened agitation, providing "a safety valve for the discharge of excess agitation. In the human personality, the build up of [such] a charge could also be dangerous if the person were not grounded. The individual could split off, become hysterical, experience anxiety, or go into a slump. . . . This makes grounding a prime objective in bioenergetic work." Hereafter cited as *B*.

8. See Moshe Feldenkrais, *Awareness Through Movement* (New York: Harper-Collins, 1977), 6–7; hereafter cited as *ATM*.

9. Stanley Keleman, *Your Body Speaks Its Mind* (Berkeley: Center Press, 1981), 119.

10. On this point see Richard Shusterman, "Postmodernism and the Aesthetic Turn," *Poetics Today* 10 (1989): 605–622.

11. F. M. Alexander, *Constructive Conscious Control of the Individual* (New York: Dutton, 1924), 307; hereafter cited as *CC*.

12. F. M. Alexander, *Man's Supreme Inheritance* (New York: Dutton, 1918), 311, 5–39; hereafter cited as *MSI*. See also *The Use of the Self* (New York: Dutton, 1932), 12–16; hereafter cited as *US*. "In our present state of civilization which calls for continuous and rapid adaptation to a quickly changing environment, the unreasoned, instinctive direction of use such as meets the needs of the cat or dog was no longer sufficient to meet human needs" (*US*, 13).

13. Thomas Hanna, *Bodies in Revolt* (New York: Dell, 1970), 7, 9, 212, 216, 297. Hanna's later work is more sober and more closely related to Feldenkrais theory and practice, whose work Hanna helped develop by sponsoring and directing the first Feldenkrais training course in the United States. See, for example, Hanna, *The Body of Life* (New York: Knopf, 1980) and *Somatics* (New York: Addison Wesley, 1988).

14. Moshe Feldenkrais, "Mind and Body," in Gerald Kogan, ed., *Your Body Works* (Berkeley: Transformations, 1980), 80.

15. Philosophers often further claim that acts of volition cannot even be individuated apart from bodily action. For a brief discussion of these issues, see

G. Vesey, "Volition," in Paul Edwards, ed., *The Encyclopedia of Philosophy*, vol. 7–8 (New York: Macmillan, 1967), 258–260.

16. See *CC*, 208–209: "In cases where there is an imperfect functioning of the organism, *an individual cannot always do as he is told correctly*"; and *US*, 10: "*The belief is very generally held that if only we are told what to do in order to correct a wrong way of doing something, we can do it, and that if we feel we are doing it, all is well. All my experience, however, goes to show that this belief is a delusion.*"

17. See John Dewey, *Experience and Nature* (1922; Carbondale: Southern Illinois University Press, 1983), 23–24. Dewey spent over twenty years of his later life in Alexander treatment and wrote introductions to three of Alexander's books. Aldous Huxley, also a devoted student, described Alexander as a "uniquely important, because uniquely practical, philosopher"; see the title page to *MSI*.

18. See Wilhelm Reich, *The Function of the Orgasm* (New York: Farrar, Straus & Giroux, 1973), 12, 256.

19. Alexander's evolutionism is mixed with the most disagreeable elements of racism and chauvinism. He writes: "The controlling and guiding forces in savage four-footed animals and in the savage black races are practically the same; and this serves to show that from the evolutionary standpoint the mental progress of these races has not kept pace with their physical evolution" (*MSI*, 72). In a similar way he blames the war of 1914 on the irrational, unconscious self-hypnotism and "madness" of German mentality (161–175).

20. Alexander would argue, however, that advocates of spontaneous freedom can never achieve it, since without "the reasoned control of his physical being" one can never really act freely, ensuring that one's body obeys one's free will rather than entrenched habits (*MSI*, 136–137).

21. See *CC*, 180; and F. P. Jones, *Body Awareness in Action: A Study of the Alexander Technique* (New York: Schocken, 1979), 76; hereafter cited as *J*.

22. Lowen himself has been an influential teacher, among whose students we find the popular somatician Stanley Keleman, who has developed his own variety of "energetic studies."

23. In shifting the bioenergetic focus from Reich's emphasis on sexual energy and the genitals to love and the heart, Lowen shrewdly tried to make Reich's approach more palatable to the mainstream American audience.

24. This, however, does not imply a reversed somatic pyramid where the feet become the primary control; for in contrast to Alexander's centralizing hierarchical focus, bioenergetics insists on six different body areas essential to energetic interaction with the world: the face, the two hands, the two feet, and the genital area (*B*, 139).

25. "Self-expression describes the free, natural, and spontaneous activities of the body, and is not usually a conscious activity" (*B*, 261–262).

26. For his critique of theories of "dammed-up" energy and the powers of instinct, see Moshe Feldenkrais, *The Potent Self* (New York: HarperCollins, 1992), xiii–xvi, 37, 63–81; hereafter cited as *PS*.

27. Yochanan Rywerant, *The Feldenkrais Method: Teaching by Handling* (New York: Harper and Row, 1983), xix.

28. The physiological phenomenon of induction in reciprocal or antagonistic functional systems also shows the complementarity of inhibition and excitement. In this phenomenon of antagonists "the longer one is excited and consequently the other inhibited, the greater is the outburst of excitation once the inhibition is lifted" (*PS*, 167).

29. See for example *PS*, 166–178, with respect to the parasympathetic system and sexuality; or 119–122, with respect to posture: Since "all voluntary direction for using oneself contracts the muscles" to achieve a desired lengthening we must either inhibit habitual contractions or impose new contractions of antagonistic muscles which would induce the lengthening. Since these contractions will also tend to distort or rigidify the body, Feldenkrais concludes that "the ideal standing posture is obtained not by doing something to oneself, but by literally doing nothing, that is, by eliminating all acts of [interfering] voluntary" contraction; "no voluntary direction can correct bad posture . . . [even if] it does change the appearance of the body—not by lifting the contraction that needs lifting, but by enacting a compensatory one" (119, 120, 122).

30. "No proper action is possible without good control of the pelvic joints. The strongest muscles of the body articulate the pelvic joints. . . . In short, the power of a body is determined by the power of the lower abdomen and more generally by the pelvic region" (*PS*, 189). "All correct action starts with the movement of the pelvic bone" (139).

31. I should note that this opinion and my preceding accounts of Alexander Technique, bioenergetics, and Feldenkrais Method are based not only on their respective texts, but on my own bodily experimentation with their actual practice. Such comparative testing also resulted in my decision to become a certified Feldenkrais practitioner, which involves a four-year training program.

CHAPTER 9. MULTICULTURALISM AND THE ART OF LIVING

1. For a hard-hitting critique of globalization from the European perspective, see Pierre Bourdieu, *Acts of Resistance: Against the Tyranny of the Market* (New York: New Press, 1999).

2. See Jürgen Habermas, "Struggles for Recognition in the Democratic Constitutional State," in Amy Gutmann, ed., *Multiculturalism: Examining the Politics of Recognition* (Princeton: Princeton University Press, 1994), 144–146. As the result of a much debated new citizenship law enacted May 1999, only

in January 1, 2000 will citizenship begin to be granted to people born in Germany whose parents were not considered German in terms of cultural ancestry and blood links. But even here there remain strong restrictions: for example, at least one of the parents must have already been legally resident in Germany for eight years and possess the proper long-term residence certificates.

3. On this point, see historian David Hollinger, *Postethnic America: Beyond Multiculturalism* (New York: Basic Books, 1995).

4. Charles Taylor, "The Politics of Recognition," in Gutmann, *Multiculturalism*; citations in this paragraph and the next are from pages 30, 31, and 32. Further page references to this article will appear parenthetically.

5. The phrase is that of Will Kymlicka, *Liberalism, Community, and Culture* (Oxford: Oxford University Press, 1991).

6. Like artists, philosophers are often thought to have and need a critical distance from a culture's common ways of thought in order to express themselves authentically. We see this not only in defiant iconoclasts like Nietzsche but even in someone like Ludwig Wittgenstein, who was deeply appreciative of the commonalities of language and culture. "The philosopher is not a citizen of any community of ideas. That is what makes him a philosopher." *Zettel* (Oxford: Blackwell, 1967), para. 455.

7. Until the mid-1970s, Indians were classified in the United States as Caucasian. They then successfully petitioned to be reclassified as a minority and are now categorized (e.g., in the 2000 Census) as Asian Indians. However, in *de facto* affirmative action practice and in other multicultural contexts, their Asian-American status is still often neglected.

8. Richard Rorty, *Contingency, Irony, and Solidarity* (Cambridge: Cambridge University Press, 1989), 192.

9. Another part of the problem is the failure to recognize how porous and interpenetrating different cultures often are.

10. Though I shall concentrate on understanding the culturally other as a crucial means for understanding and enriching oneself, I think it could also be argued that some knowledge of oneself is necessary for a good understanding of the other. We need to know something of our own beliefs and point of view in order to appreciate the other more accurately and better assess both her similarity to and difference from ourselves. We understand anything in terms of a field, and the self is as much the background field of the other as the other is that of the self.

11. For more details on the genealogy of this logic, its deployment by Nietzsche and deconstruction, and its link to the crucial aesthetic idea of organic unity, see Richard Shusterman, "Organic Unity: Analysis and Deconstruction,"

in *Pragmatist Aesthetics: Living Beauty, Rethinking Art* (Oxford: Blackwell, 1992), 2d ed. (New York: Rowman & Littlefield, 2000), chap. 3.

12. H. G. Gadamer, *Truth and Method* (New York: Crossroad, 1982), 266.

13. This phrase, which forms the subtitle of Nietzsche's book *Ecce Homo*, will be discussed more fully in the following chapter.

14. The quotations from Eliot come from Stephen Spender's "Remembering Eliot," in A. Tate, ed., *T. S. Eliot: The Man and His Work* (New York: Delacorte Press, 1966), 56; and from T. S. Eliot, *Essays Ancient and Modern* (London: Faber, 1936), 102–103; and "Poetry and Propaganda," *Bookman* 70 (1930): 602. For a full discussion of Eliot's views on reading and culture, see Richard Shusterman, *T. S. Eliot and the Philosophy of Criticism* (New York: Columbia University Press, 1988) and "Eliot and Adorno on the Critique of Culture," *Theory, Culture, & Society* 19 (1993): 25–52.

15. On this problem of balancing unity and richness of self, see Shusterman, *Pragmatist Aesthetics*, chap. 9; and Richard Shusterman, *Practicing Philosophy: Pragmatism and the Philosophical Life* (New York: Routledge, 1997), chaps. 1, 2, 5, 7.

16. Diogenes Laertius, *Lives of Eminent Philosophers*, vol. 1 (Cambridge: Harvard University Press, 1931), 445.

17. See Shusterman, *Practicing Philosophy*, chap. 7.

CHAPTER 10. GENIUS AND THE PARADOX OF SELF-STYLING

1. See Michel de Montaigne, *The Complete Essays of Montaigne*, trans. Donald Frame (Stanford: Stanford University Press, 1965), 124 (where he is quoting Cicero), 850–851.

2. See Seneca, Letter to Lucillus, no. 114, in *Letters from a Stoic* (London: Penguin, 1969), 212–220.

3. For a detailed account of Eliot's theory of impersonality and his reasons for later abandoning it, see Richard Shusterman, *T. S. Eliot and the Philosophy of Criticism* (New York: Columbia University Press, 1988).

4. It may be so strong and influential as to establish a sort of taxonomic style of its own, so that we can recognize a Van Gogh style, a Hemingway style, or a Chanel style displayed in the work of other artists. It goes without saying that generic styles can be differently carved out depending on context: we can speak of an abstract style or, more specifically, of an abstract expressionist style, an abstract minimalist style, etc.

5. *Oxford English Dictionary*, 2d edition, s.v. "demon" and "genius."

6. See Ralph Waldo Emerson, "Demonology," in *The Early Lectures of Ralph Waldo Emerson*, vol. 3 (Cambridge: Harvard University Press, 1972), 160. See also the later version of this lecture in Emerson, *Lectures and Biographical*

Sketches (New York: Houghton and Mifflin, 1911). In these texts Emerson cites but opposes Goethe's account of the daemonic.

7. See Friedrich Nietzsche, "Schopenhauer as Educator," in *Untimely Meditations*, trans. R. J. Hollingdale (Cambridge: Cambridge University Press, 1983), 128, 143; hereafter cited as *S*; Heraclitus, frag. 119, cited in G. S. Kirk and J. E. Raven, *The Presocratic Philosophers* (Cambridge: Cambridge University Press, 1966), 213; Ludwig Wittgenstein, *Culture and Value* (Oxford: Blackwell, 1980), 35; hereafter cited as *CV*.

8. The Samuel Johnson quote (which continues "my genius is always in extremes") comes from a 1780 letter cited in the *Oxford English Dictionary*, 2d ed., s.v. "genius," which is also the source of the other citations in this paragraph.

9. J. W. von Goethe, *Aus Meinem Leben: Dichtung und Wahrheit, Goethes Werke*, vol. 10 (Hamburg: Christian Wegner, 1959), 161 (my translation); Immanuel Kant, *Critique of Judgement*, trans. J. C. Meredith (Oxford: Oxford University Press, 1986), 168–169.

10. See Ralph Waldo Emerson, "Genius," in *Early Lectures of Ralph Waldo Emerson*, 71, 73 (hereafter cited as *G*); and Goethe, *Maximen und Reflexionen*, in *Goethes Werke*, vol. 12 (Hamburg: Christian Wegner, 1967), 472.

11. Friedrich Nietzsche, *The Will to Power* (New York: Vintage, 1968), para. 853.

12. Ralph Waldo Emerson, "Works and Days," in *Society and Solitude* (New York: Houghton Mifflin, 1912), 176; "Poet," in Ralph Waldo Emerson, *Collected Poems and Translations* (New York: Library of America, 1994), 207; "Domestic Life," in *Society and Solitude*, 115; and "The American Scholar," in R. Poirier, ed., *Ralph Waldo Emerson* (Oxford: Oxford University Press, 1990), 145.

13. Ralph Waldo Emerson, "The Oversoul," in Poirier, *Ralph Waldo Emerson*, 162; and *G*, 82.

14. These ideas are confirmed much later in Emerson's career, in his essay "Art," in *Society and Solitude*, 48–49. To produce a work that is admired not simply by his peers "but by all men," the artist "must disindividualize himself, and be a man of no party and no manner and no age, but one through whom the soul of all men circulates as the common air through his lungs. He must work in the spirit in which we conceive a prophet to speak . . . ; that is, he is not to speak his own words, or do his own works, or think his own thoughts, but he is to be an organ through which the universal mind acts."

15. Friedrich Nietzsche, *Twilight of the Idols*, in Walter Kaufmann, ed., *The Portable Nietzsche* (New York: Vintage, 1968), para. 44, pp. 547–548.

16. Ralph Waldo Emerson, "Quotation and Originality," in Poirier, *Ralph Waldo Emerson*, 438; hereafter cited as *QO*.

17. See W. Gillman et al., eds., *The Journals and Miscellaneous Notebooks of Ralph*

Waldo Emerson (Cambridge: Harvard University Press, 1960), 3:26. In contemporary aesthetics, Nelson Goodman has likewise rejected the idea of style as a function of "conscious choice among alternatives" and offers instead the idea of style as signature, something roughly analogous to the individual's particular "voice" that Emerson describes. See Nelson Goodman, "The Status of Style," in *Ways of Worldmaking* (Indianapolis: Hackett, 1978), 35.

18. See Ralph Waldo Emerson, "Worship," in *The Conduct of Life* (New York: Houghton Mifflin, 1904), 226; "Character," in *Essays* (New York: Dutton, 1942), 253, 261; "Self-Reliance," in *Essays*, 38 (hereafter cited as *SR*); and "The American Scholar," in Poirier, *Ralph Waldo Emerson*, 38.

19. See Sonnet 68 where he claims that style cannot extend beyond genius: *"che stilo oltro l'ingegnium no si stende."*

20. Nietzsche, *S*, 127, 129; *Ecce Homo* (Leipzig: Kröner, 1930), bk. 3, para. 4 (my translation); *The Gay Science*, trans. Walter Kaufmann (New York: Vintage, 1974), para. 338; hereafter cited as *GS*.

21. Ludwig Wittgenstein, *CV*, 3, 53, 78.

22. Nietzsche, *Will to Power*, para. 559, 584, 635. I explore this aspect of Nietzsche's metaphysics and its relation to deconstruction, pragmatism, and analytic philosophy in *Pragmatist Aesthetics* (Oxford: Blackwell, 1992), 2d ed. (New York: Rowman & Littlefield, 2000), chap. 3.

23. For Emerson, see *SR*, 44. For Nietzsche, see the subtitle of his *Ecce Homo: Wie Man Wird, Was Man Ist*. The idea also appears in *The Gay Science* as: "What does your conscience say? —You shall become the person you are" (para. 270). Remember that when Nietzsche wrote *The Gay Science*, he was rereading Emerson, and the first edition of the book bears a quotation from Emerson as its epigram. For more details, see Walter Kaufmann's introduction to his English translation of the book.

24. In the citation from *Ecce Homo*, Nietzsche distinctly speaks of style and art in the singular ("viele Möglichkeiten des Stils," "die vielfachste Kunst des Stils," i.e., "many possibilities of style" and "multifarious art of style") rather than using the plural *Künste* or *Stillen* (to suggest "arts of style" or "art of styles" or "possibility of many styles"). In using the last phrase, Hollingdale's translation (London: Penguin, 1979), 44, seems misleading.

25. Quoted from the biography by Ray Monk, *Ludwig Wittgenstein: The Duty of Genius* (New York: Penguin, 1991), 17–18.

26. I treat these matters in considerable detail in *Practicing Philosophy: Pragmatism and the Philosophical Life* (New York: Routledge, 1997), chaps. 1–3, 5, where I also emphasize the crucial social dimension of self-realization that is sometimes obscured by the often one-sided individualism of Emerson, Nietzsche, and even Wittgenstein. Social contexts and cultural traditions are, I

argue, precisely what provide the individual with the resources for distinctive self-expression, including the crucial critical feedback that can warn or reform the self when it is going astray. Indeed, one way to explain the difference between individual genius and cranky eccentricity is in terms of there being some kind of productive fit between the individual genius and society, a fit that need not be mere conformity.

27. See Ralph Waldo Emerson, "Circles," in Poirier, *Ralph Waldo Emerson*, 168; and "The Transcendentalist," in ibid., 105.

28. See Friedrich Nietzsche, *Twilight of the Idols*, trans. W. Kaufmann, in *The Portable Nietzsche*, para. 44; and *GS*, para. 283, 305.

29. Emerson, "Works and Days," 181; "Circles," 175.

30. Emerson, "Art," 42. See also Ralph Waldo Emerson, "Civilization," in *Society and Solitude*, 27: "You have seen a carpenter on a ladder with a broad-axe chopping upward chips from a beam. How awkward! At what disadvantage he works! But see him on the ground, dressing his timber under him. Now, not his feeble muscles but the force of gravity brings down the axe; that is to say, the planet itself splits his stick." Emerson typically emphasizes the natural cosmic forces, like gravity, that bring to genius a power beyond "our own" personal force. But we should also include the power of society and cultural tradition as part of the more-than-personal "infinite force" that comes together to galvanize and transfigure a mere individual into a genius.

index

Abrahams, Roger, 230n8
absence, 96–111, 240n3, 241n6, 241n13
action, 43–44, 72, 94, 138–39, 153, 168–72, 178–79, 181, 183, 201–2, 216, 251n15, 252n16
Acuff, Roy, 83, 85, 237n16
Adorno, Theodor, 17–19, 37, 41–45, 48, 54–55, 74, 118, 154–55, 159–61, 226n18, 228n47
advertising, 137, 151, 160
aerobics, 155, 157, 159
aesthetic, the, 43–44, 54–57, 60–62, 71–74, 103, 108, 189
aesthetic experience, 2–4, 7, 9, 15–34, 221nn9, 14–17, 222nn18, 23–24, 223n26–27, 29. See also experience
aesthetics, 3–5, 9, 31–33, 56–57, 72–75, 103–4, 142, 189
African-American culture, 47, 52, 61–62, 66–72, 75, 83–84, 191, 197, 230n8, 231n9
African culture, 44, 75, 197, 226n21
agent (agency), 148, 161, 202. See also action
Alberti, Leon Batista, 15
Alexander, F. M., 140–41, 157, 164, 166–81, 251n12, 252nn19–20, 24
Altman, Robert, 80
American culture, 57–59, 77–79, 82–83, 118, 184–86, 190, 197–99, 227n42
anaesthetics, 9, 15, 31
anorexia, 143, 151
Applebome, Peter, 79

aristocracy, 58–59, 187, 229nn50–52
Aristotle, 15, 43, 65, 100, 119, 201–2
art, 1–11, 49, 70–74, 103, 189, 201–3, 205–6, 213, 221nn9, 14, 15, 17, 223nn26, 27, 228n47
and aesthetic experience, 16–34
autonomy of, 35, 55–56
end and ends of, 1–11
of living, 9–11, 56, 156, 182, 189, 201–2
art for art's sake, 6, 16, 65
artist, 51–52, 189, 202, 256n14
art world, the, 7, 32–33
asceticism, 36, 42, 169
Asian culture, 190, 196–97, 240n5, 241n6, 251n6, 254n7
audience, 43–44, 48–53, 63, 228n46
Augustine, Saint, 176
aura, 2, 18–19, 87
authenticity, 74, 79–92, 187–88, 237n16, 238n19
autonomy
of art, 2–3, 5, 10, 16, 18, 53, 55–56, 61, 74
of individual, 148, 181, 195–96
Autry, Gene, 77, 237n16

Baker, Houston, 70
Bakhtin, Mikhail, 8
Barthes, Roland, 20, 240n5
Bataille, Georges, 152
Baudelaire, Charles, 101–2, 106–10
Baumgarten, Alexander, 4
BDP (KRS-One), 66, 73–74, 231n14, 233n34, 234n44
Beardsley, Monroe, 15, 22, 24–27, 32, 222nn18, 20, 23, 24

Diogenes Laertius, 197
disinterestedness, 53–54, 74
distance (aesthetic and critical), 54, 72, 74–75
distinction, 55, 188–90, 204, 206–7, 109–10
Dorfman, Ariel, 227n42
Douglass, Frederick, 70
Dreyfus, Hubert, 247n34
drugs, 47, 66, 73, 156
Duchamp, Marcel, 15, 64
Duke, Daryl, 80
Dylan, Bob, 49

Edison, Thomas, 215
education, 46, 73, 86, 162
Eisenman, Peter, 240n4
Eliot, T. S., 1, 30, 49, 53, 66, 120, 183, 195–96, 202, 223n25, 238n20
Emerson, Ralph Waldo, 137, 182, 202–4, 206–9, 211–16, 255n6, 256n14, 258n30
emotion, 26, 84–86, 88, 92, 139, 152–53, 174–76, 181, 238n18
ends, 171–72, 179. See also art: end and ends of
Engels, Friedrich, 101
enjoyment, 30, 165, 223n25. See also pleasure
environment, 164–66, 174–75, 194, 201, 251n12
epistemology, 138, 141, 166–67
eros, 109, 118, 174, 242n18
essence (and essentialism), 4, 189–94
ethics, 140, 168–69, 187–89, 201–2
ethnicity, 52, 77–79, 107–8, 110, 183–86, 190, 194–95, 197
evolution, 94, 153, 163–65, 170, 175, 223n26, 252n19
experience, 2, 15–34, 139, 143, 149, 152, 156, 177, 220n8, 221n11, 222nn20–21. See also aesthetic experience

experiential somaesthetics, 142–43, 152–53, 159–61

feeling, 7–8, 21, 23–24, 26, 28–34, 84–86, 88, 94, 105, 139, 142–43, 149, 152–53, 159, 167, 174–76, 189
Feldenkrais, Moshe, 140–41, 148, 162, 168–70, 178–81, 251nn6, 13, 253nn26, 29
feminism, 51, 78
film, 50, 77, 80, 150, 230n3, 235n4. See also country musicals
Fish, Stanley, 116, 124, 133, 247n33
Fiske, John, 48
flâneur, 106–11
Flavor Flav (Public Enemy), 234n40
Fonda, Jane, 151
Ford, Henry, 83
form, 53–55, 65, 72, 118–20, 159, 241n13
formalism, 30, 118–20, 228n47
Foucault, Michel, 140–42, 149, 152, 156–57, 162, 165, 202
foundationalism, 115–16, 120–24
fragmentation, 32–33, 65, 70, 148, 162
Franke, Astrid, 239n30
freedom, 70, 102, 105, 157, 182–84, 188, 229n2, 252n20
French culture, 57–60, 186, 198, 242n18
Freud, Sigmund, 162
function, 53–56, 73
Functional Integration (Feldenkrais), 179

Gadamer, Hans-Georg, 19–21, 116, 122–23, 126, 128, 131, 193, 221n11, 245n20
Gates, Henry Louis, Jr., 230n8
gender, 140, 142, 151
genius, 11, 52–53, 189, 201–17
 and talent, 205, 207, 214

Nietzsche, Friedrich, 115–20, 123, 147–
48, 152, 154, 195, 202–4, 206,
208–16, 254n6, 257nn22–24

ontology, 141, 210–11. *See also*
metaphysics
oral culture, 50, 61–62, 68, 87–88
ordinary, the, 132–33, 136, 207
Origen, 146
originality, 47, 49, 64–65, 205–6,
209–15, 227n29, 231n14
other, the, 158, 183, 187–88, 192–200,
254n10

pain, 139, 152–53
Parker, Charlie, 88
performance, 63, 139–40, 143, 167–
68, 179, 247n35
Petrarch, Francesco, 209
phenomenology, 17, 21, 26, 28
philosophy, 9–10, 16, 21–22, 56–57,
73, 77, 138–44, 154–57, 161,
163, 166–70, 181, 196–200,
212, 221n15, 254n6
Plato, 15, 36, 42, 56, 75, 100, 119,
145–48, 201, 248n9
pleasure, 5, 16–19, 25, 30–32, 36–43,
55, 72, 147–48, 152–53, 158,
163–64, 169, 221n9, 225n12
pluralism, 110, 122–23, 150, 186,
214
poetry, 73, 202, 223n25
politics, 10, 19, 48, 70–74, 108, 110,
140, 150, 160, 165, 195, 202
popular art, 7–9, 32, 35–60, 76, 202,
224n2, 225n4
postmodernism, 3, 33, 53, 61, 64, 66–
67, 70, 74–75, 103, 156, 162–
63, 195, 202, 233n33
power, 74, 140, 147, 160, 208, 232n21
pragmatism, 21, 56, 73, 94, 96, 103,
109, 121, 157, 199, 214, 219n4,
244n13
prejudice, 41, 121–23, 193

Presley, Elvis, 49
Pride, Charley, 83
Public Enemy, 59, 68–69, 74, 230n3
purity, 56, 61, 72, 75, 80, 82, 84,
91–92, 146

Quebec, 184, 188
Queen Latifah, 75
Quine, W. V., 126

race, 151, 183–86, 190, 233n28,
252n19
radio, 63, 68–69, 77, 150, 234n2,
236n5
rap, 8, 11, 47, 52, 60–76, 78, 183, 191,
231nn13, 14, 232nn19–21,
233n28, 236n8
Rauschenberg, Robert, 64
reality, 46–48, 55–56, 66, 73, 84–85,
91–92, 95, 141, 144–45, 147–
48, 206
reason and rationality, 45, 72, 75, 138,
156, 161, 163, 166, 169–75,
178, 181, 208, 252n20
recognition, 189–92
Reich, Wilhelm, 140–41, 165, 174–76,
252n23
religion, 1, 16, 58, 72, 146, 157, 163,
186, 206, 239n30
Ritter, Tex, 77, 237n16
rock music, 37–39, 44–45, 47, 49, 77,
79, 226n22
Rodgers, Jimmie, 83, 85, 197
Rogers, Roy, 77, 84
Rorty, Richard, 8, 126, 129, 191–92,
246n29
Rosenberg, Bernard, 37, 227n39
Rousseau, Jean-Jacques, 187

Schiller, Friedrich, 72
Schopenhauer, Arthur, 197, 212
Schwarzenegger, Arnold, 141
science, 1, 16, 22, 26–28, 72, 94,
206

Wilde, Oscar, 15
will, 139, 168, 170, 178, 181, 208,
 215–16, 251n15, 252n20
Williams, Hank, 83, 197
Wittgenstein, Ludwig, 34, 125, 127,
 130–31, 202–5, 209–10,
 213–16, 245n18, 247n30,
 254n6

Wollheim, Richard, 4, 223n27
Wordsworth, William, 100, 241n7

yoga, 139, 142, 152, 155, 158, 178,
 251n6
Young, J. Z., 223n26

zazen (Zen), 139, 142, 152, 251n6